W9-AFE-056

WITHDRAWN

LITERARY CONJUGATIONS

Richard T. Gray, Series Editor

LITERARY CONJUGATIONS investigates literary artifacts in their cultural and historical environments. Through comparative investigations and case studies across a wide array of national literatures, it highlights the interdisciplinary character of literary studies and explores how literary production extends into, influences, and refracts multiple domains of intellectual and cultural life.

THE TOOTH
THAT NIBBLES
AT THE SOUL

≋ ESSAYS ON MUSIC AND POETRY ≋

Marshall Brown

A McLELLAN BOOK

UNIVERSITY OF WASHINGTON PRESS
Seattle and London

The Tooth That Nibbles at the Soul is published with the assistance of a grant from the McLellan Endowed Series Fund, established through the generosity of Martha McCleary McLellan and Mary McLellan Williams.

The book's title comes from Emily Dickinson's poem "This World Is Not Conclusion."

UNIVERSITY OF WASHINGTON PRESS
P.O. Box 50096, Seattle, WA 98145 U.S.A.
www.washington.edu/uwpress

LIBRARY OF CONGRESS CATALOGING-IN-PUBLICATION DATA
Brown, Marshall, 1945–
The tooth that nibbles at the soul : essays on music and poetry /
Marshall Brown. — 1st ed.
 p. cm. — (Literary conjugations)
Includes bibliographical references and index.
ISBN 978-0-295-99005-7 (hardback : alk. paper)
ISBN 978-0-295-99006-4 (pbk. : alk. paper)
1. Music and literature. 2. Music—Philosophy and aesthetics. I. Title.
ML3849.B88 2010 780'.08—dc22 2009043761

For the musicians in my life

Contents

Preface

MUSIC made a media splash a few years ago, when it was alleged that listening to Mozart in the crib would improve test scores and help children get into college. The wave subsided pretty quickly, although the Web site mozarteffect.com continues to promote the claim. On the face of it, the theory sounds pretty crude, but it is all the more interesting for the cultural atmosphere that might spawn it. Behind it lies the presumption of a musical mystique. Music is moving. It is powerful. It has effects, and they are intangible. The power of the effects is a function of their intangibility. Because we cannot measure them, they must be immeasurable. A voice from the heart, uttered without response by a composer and channeled through performers serving the great man's genius, music exists for a time in this world but speaks as if from beyond.

Music's evanescence is part of its magic. Though it can be archived in print and in recordings and can be mechanically recreated, it can be experienced only in the moment of sounding. All the arts entail a certain degree of vicariousness, to be sure, and consequently all may be thought to join to a point in the Mozart effect. The eye follows the bounding lines of a de Kooning abstraction, and with them leap the virtual muscles of the mind. Shakespeare's roles forge human nature. Music has no exclusive share in these imaginative—arguably imaginary—virtues. Still, music, or so this logic goes, has a privileged place because it is especially rarefied. Horace considered his poetry a monument more durable than stone, even Stevens had his jar in Tennessee, whereas *musique concrète* was always a willfully naughty paradox. Unlike a poem between covers, let alone a portrait on canvas, music on the page is not the real thing. The effects of music cannot be materialized.

Music exists in the real world, at least for a time, but it points beyond. Traveling the air waves, it is somehow in a fashion that cannot be fully mastered, *literally ethereal*. Surely that is the presumption lying behind the Mozart theory. In the words of the wonderful poem from Emily Dickinson from which I have taken my title phrase, music is a tooth that nibbles at the

soul. This might be said of other arts, too, but in this conception, music is their paradigm. I do not know if such notions exist in other cultures. Certainly, the ancient Greek understanding of the musical modes is fundamentally different. Greek music had a direct and calculable effect on listeners, especially in communal dramatic performances. A Mozart theory on the Greek model would instruct us to expose our babies to noble E-flat major tones and to steer clear of nervous G minor. There is, indeed, no doubt that Mozart regularly associated keys with such effects. But the Mozart theory is predicated on stealthier mechanisms that trip it up by their very subtlety. It is not reasonable, after all, to predicate tangible effects from intangible means. A tooth that nibbles at the soul does not have the right conformation to nibble at SAT scores. If music has results, they are not the sort that can be computed.

My book explores the effects of music that belongs to the genuine Mozart tradition rather than to the spurious Mozart effect. Some of the chapters touch on the theory of music's operations. But it remains unclear what a theory of the soul might be, and I certainly make no attempt to legislate one. Rather, I offer a range of case studies and more general topics or perspectives. My aim is definitely not to separate music from the other arts, but rather to join them together. I try to pinpoint music's bite and then to reflect on the magic that literature shares with music. "Negative Poetics" is perhaps the most general reflection, in the sense that it makes no attempt to specify the locus of the bite but only to portray how a particular song and some sample poems stand at a distance from single, concrete meanings.

Other chapters turn to particular dimensions of musical effect: psychological (the two Anacreontic essays and the essay on abjection), formal-mimetic, historical, social. The dialectical maneuvers that pivot between the concrete and the abstract, as between body and soul, real and transcendental, are most explicitly featured in chapter 10 on *Don Giovanni*, though even that chapter finally turns its gaze on music's political tooth. Throughout the book, my concern is with concrete expressive devices that can be seized on the fly, as it were—by stopping the music to inspect its workings, by slowing the reading of a poem down to a crawl—but that will never completely settle down. Any musical analysis, indeed any poetic analysis, leaves its subject pinned and wriggling on the wall, an awkward proofrock, a rocky proof of a vital force. Perhaps the only possible result of my essays is a negative poetics, teaching that there is more to heaven and earth than is dreamt of in our philosophies. In an age when critique has too often taken

on the hard edge of condemnation, I would be happy with such a cautionary result. Let us not use the human imagination to beat down others but rather to soften our own certainties. In Wonderland, Alice had to learn to take fortune in very small bites. We too live in a world where our croquet mallets are liable to curl up or walk away from us. Such a world is ripe for music, and for the musicalization of experience.

The first two chapters discuss the nature of music. The third is a survey of the music aesthetics that are fundamental to my approach. The two remaining chapters in the first, theoretical half of the book look at literature from the perspective of music. The essays in the second half are practical criticism; of them, chapter 8 is exclusively literary (though closely bound to chapter 9), chapter 6 is exclusively musical (though commenting on texts often taught under the rubric of "literary theory"), while the others cross over, albeit with variable weighting. Though the musical analyses have no pretense of scaling the heights of music theory, they will not be uniformly accessible to readers without substantial musical experience. Where the going gets tough, it should be possible to skip ahead to the concluding discussions, which are meant for scholars of literature and of music alike.

The following chapters have been previously published and have been revised for inclusion here: "Rethinking the Scale of Literary History," in *Rethinking Literary History*, ed. Mario Valdés and Linda Hutcheon (Oxford: Oxford University Press, 2002), 116–54; "Negative Poetics: On Skepticism and the Lyric Voice," *Representations*, no. 86 (Spring 2004): 120–40; "Mozart, Bach, and Musical Abjection," *Musical Quarterly* 83 (1999): 509–35; "Passion and Love: Anacreontic Song and the Roots of Romantic Lyric," *ELH* 66 (1999): 373–404; "Haydn's Whimsy: Poetry, Sexuality, Repetition," truncated, in *Haydn and the Performance of Rhetoric*, ed. Tom Beghin and Sander M. Goldberg (Chicago: University of Chicago Press, 2007), 229–50; "Music and Fantasy," in a collection of essays for Lawrence Kramer (hence the systematic reckoning with his work), *Musical Meaning and Human Values*, ed. Keith Chapin and Lawrence Kramer (New York: Fordham University Press, 2009), 79–100. The last two sections of "Non Giovanni: Mozart with Hegel" have been published under that title in *Mozart-Jahrbuch* 17 (2008): 57–76. I thank the publishers for permission to reprint.

"Music and Abstraction" was written specially for this book. "German Romanticism and Music" was written for a survey volume on German romanticism but ultimately not used there; I print it here because there

is no comparable overview combining philosophical, literary, and musical perspectives of these materials, which are fundamental to many of my discussions. "Moods at Mid-Century" was presented in 1993 at the Aston Magna Institute as "Handel's London" and subsequently reworked for a book that never came to pass.

Uncredited translations are my own throughout. Uncredited italics derive from the original sources. Kant's works are cited in standard form by page number from the first (A) or second (B) editions. Hegel's *Phenomenology* is cited by page number from *Phänomenologie des Geistes*, ed. Johannes Hoffmeister (Hamburg: Meiner, 1952) and by paragraph number from the English translation (modified where necessary, and without Hegel's distracting italics) by Terry Pinkard, currently publicly available at http://www.mac.com/titpaul/Site/Phenomenology_of_Spirit_page.html.

As for acknowledgments, where might they end? I can only say where they begin. First come my music teachers: Fernand Lhoest, Victor Gottlieb, and (more briefly) Edgar Lustgarten and Zara Nelsova on cello, and Mario Castelnuovo-Tedesco for what little of theory and composition a wayward fourteen-year-old could absorb. Next come the colleagues in musicology who have kept my foot from wholly choking me: Tom Bauman, Tom Beghin, Keith Chapin, Ray Erickson, Ed Goehring, Stephen Hefling, Doug Johnson, Derek Katz, David Kopp, Larry Kramer (with special thanks for his detailed reader's report), David Lawton, John Rahn, Charles Rosen, Stephen Rumph, Manfred Schmid, and Richard Will. I am grateful to the foundations and universities whose support over the years has been generous with funds and patient with results: for this book, the University of Washington and the Walter Chapin Simpson Center for the Humanities, the Woodrow Wilson International Center for Scholars, and the Rockefeller Foundation. After that, I lose track of the colleagues, students, and listeners at hospitable institutions whose advice, sympathy, intelligence, and skepticism are indispensable and who constitute the public without which our books would not come to be.

Ever and always, there is Jane, encouraging my passions and teaching me more than either of us can reckon. For a change, though, my deepest debt goes not to her but to the intimate and worldwide fellowship of musicians who have been my companions through so many decades—above all, the life-giving circle of Music House Party. Nothing restores faith in the possibilities of world harmony as quickly as a well-tuned C-major chord.

THE TOOTH THAT NIBBLES AT THE SOUL

Introduction

MUSIC AND ABSTRACTION

> Es ist nur Narrheit, daß man Symphonien in nichts als Noten schrei-
> ben will, man kann sie auch in Worte bringen, wenn man sich die
> Mühe giebt. Sind unsre meisten Bücher etwas anders? Sind viele
> unsrer Symphonien etwas mehr als ein einziger armer Satz, der immer
> in Gedanken wieder kömmt, und sich nicht von andern Gedanken will
> verdrängen lassen?
>
> —Ludwig Tieck, *Die verkehrte Welt*

WHAT does music mean? Three questions are rolled up into this one:
What does music say? What does it intend? What does it signify?
Or, in other terms: What are the contents of a piece of music, the effects,
the consequences? I pose these questions generically, though the essays in
this book concern only a slice of European concert music, and I cannot say
how well they might universalize or even generalize beyond the examples
offered.

The term I focus on in this introduction to characterize musical expres-
sion is abstraction. In *Noise*, Jacques Attali sharply distinguishes three
historical phases of musical expression, termed sacrifice, representation,
and repetition. "Representation" is his idiosyncratic term for the era of
European concert music whose function he describes thus: "representation
entails the idea of a model, an abstraction, one element representing all the
others."[1] In line with Attali's historical account, musical abstraction may
be said to have withered into the elitist democracy of the dodecaphonic
system (all tones equal, but only for initiates in Schoenberg's "Society for
the Private Performance of Music"), leaving concert music angry, anxious,

or merely nostalgic, while mechanical reproduction gave the mass experience of music the physicality and violence inscribed in the terms "rock" and "hit" ("Schlager" in German). Abstraction did not disappear, but it did perhaps pass into other modes of expression. At least for a while, though, its core was music.

My introduction feeds a number of threads into a loose weave around its core topic. It touches on philosophy, modernist painting, poetry, and music. It is meant to work more as texture than as text, more as evocation than as argument. In conformity with my title, here I will be nibbling at the problem, leaving the upcoming essays to take larger bites (in the more practical close readings) and gulps (in the more general and theoretical chapters).

1. GEORG WILHELM FRIEDRICH HEGEL. I will start by getting Hegel out of the way. Hegel is in the way as the grandmaster of abstraction, as a spirit who presides over some of the ensuing chapters, and as a philosopher who was, on my reading, clueless about music. And indeed not just on my reading, for Hegel's posthumously published lectures on aesthetics repeatedly apologize for the limitations of his knowledge and understanding. Music appears to have puzzled him. Yet the spirit of dialectic has the resources to turn a puzzle into an opportunity. Hegel puts music down on account of its obscurity, yet the negativity of music should be inviting for a dialectician.

Whatever his feelings about music, Hegel did love musicians and musical events. He and his wife were well-known patrons of the opera; he was teacher and friend to Felix Mendelssohn; Goethe's favorite composer, Zelter, was a regular whist partner. But abstract music without words left Hegel cold. Evidently, he warmed to the social occasions, not to the intimate expressiveness. Indeed, decades earlier the *Phenomenology of Spirit* sums up music under the rubric of "unhappy consciousness," at the moment when Hegel discusses "devotion," which he calls "the shapeless whoosh [*das gestaltlose Sausen*] of bells, or a mist of warm incense, or a musical thought that does not amount to concepts, which would themselves be the sole, immanent, objective mode of thought."[2] The book's only other independent reference to music comes shortly thereafter and is perhaps even less promising.[3] For, at the nadir of the unhappy consciousness, music becomes entangled with the devil. "However, the enemy is found therein in its ownmost shape. In the battle of hearts, the individual consciousness exists merely as a musical, abstract moment" (*Phänomenologie*,

p. 168; *Phenomonology*, par. 223). Poor music! Only one conclusion seems possible. Not too privileged in his youth, Hegel's early musical knowledge was formed by the church and by his unhappy time as a theology student. In that context, music is not spirit but at worst anti-spirit and at best only an occasion for spirit to manifest itself—and preferably not in the company of incense and bells.

Yet to conclude thus would be to falsify the Hegelian dynamic. For proper Hegelian doctrine privileges the end of a process. If Hegel came to enjoy musical events, that should be because the enjoyment was, in essence, latent within him from the start. And Hegelian doctrine likewise privileges the negative. If music is the counter-spirit, then it is indeed the sounding board for spirit's revelations. Indeed, the continuation of the second passage leaves no doubt: "In work and enjoyment, as the realization of this essenceless being . . . this suppression is in truth a return of consciousness back into itself, and, to be precise, into itself in its own eyes as the genuine actuality" (p. 168; par. 223). Certainly, the struggling *Gemüt* of the prior quotation (the collective noun translated as "hearts" above) is not *Geist*. Yet it is linked to *Geist* in its lack of particularity. Mere reasoning power is too concrete, even hidebound. Music, as this paragraph says, cancels out its limitations; indeed, devil that it evokes, music smites down selfhood, strikes particularity to earth in the mutuality of "thankful acknowledgment" (such as one might imagine in a communal, Lutheran hymn). Hegel here uses, both as verb and as noun, the word *niederschlagen*. Perhaps the strongest term of negation in the entire *Phenomenology*, *niederschlagen* emphatically evokes a characteristic result of dialectic—not, to be sure, the well-known logic of preservation through sublimation, but rather the equally fundamental, indeed more foundational, logic of *Zugrundegehen* (sometimes spelled, to bring out the pun, *zu Grunde gehen*), of foundering and founding, of tearing down to the ground and tearing down so as to ground. As thought (*Denken*) becomes devotion (*Andacht*), so music, sounding from the heart, tears down the edifice of particular thought so as to re-found it as spirit. Abstraction removes the outside world and elevates the soul.

Andacht returns once more, much later in the book, in evidently conscious evocation of its earlier appearance: after the "unhappy, so-called beautiful soul . . . vanishes like a shapeless vapor dissolving into thin air," a "quiet confluence of marrowless essentialities" constituting conscience leads to the religion of art, which is a "spiritual stream" of "pure inward-

ness," manifesting itself in devotion "whose inwardness . . . has existence in the hymn." The transfiguration that takes place at this moment in the book is now called "pure thought" (pp. 463, 496; pars. 658–59, 710). Hegel's suspicions of music here evaporate into communion (evaporating is Hegel's term for the dialectical process at its least palpable), revealing abstraction in its purity.[4]

Thus, musical abstraction may be seen as a critical adversary to musical ideology. Indeed, two sides repeatedly confront one another in discourses about music. Beethoven and Rossini—absolute and popular music. Brahms and Wagner—rational process and mythic vitality. Bruckner and Mahler—piety and sarcasm. Schoenberg and Stravinsky—intellect and impetus. Symphony and opera—universal and national expression. At the time of their articulation, such oppositions have often seemed absolute. To later ears, however, they are replayed within many of the works, as an inner *Kampf des Gemüts*: the dialectic of universality and ethnicity looms in Brahms as in Wagner; the popular impulse is as genuine in Beethoven's programmatic and popular works as it is in Rossini's. Hence the abstraction endemic to music does not free it from its dynamism but replays the dialectical currents as internal differences. Music produces a challenge to thought, not a denial. Indeed, if Bacchic revelry is the theme linking Hegel with Nietzsche, then the perpetual motion of music must be equally compatible with the thought of both.[5]

No documentation links Tieck's 1798 musical farce (from which my epigraph comes) with the paragraphs on "the inverted world" that are the craziest pages of the *Phenomenology* (pp. 96–100; pars. 157–69).[6] Yet, if Hegel heard the music Beethoven was composing in the period of the *Phenomenology*, he would have encountered the "absolute restlessness of pure self-movement" (p. 101; par. 163) that he, like Tieck, links with the topsy-turvy world. "This simple infinity, that is, the absolute concept, is to be called the simple essence of life, the soul of the world, the universal bloodstream. . . . It is therefore pulsating within itself without setting itself in motion; it is trembling within itself without itself being agitated. . . . The unity . . . is the abstraction of simplicity, which stands in contrast to distinction. However, since it is an abstraction . . . it is given that it is division. . . . Infinity, that is, this absolute restlessness of pure self-movement . . . is, to be sure, already the soul of all that came before . . . but infinity first freely emerges as explanation" (pp. 100–101; pars. 162–63). Absoluteness, abstraction, pulsation, movement, division touch the soul; through them the understand-

ing "has for its objects positive and negative electricity . . . and a thousand other things, objects which constitute the content of the moments of the movement" (p. 101; par. 163). Music is the subtext, even if not the text, and it takes only a little poetic license to translate Hegel's trembling into nibbling. Music unsettles and animates—gives soul, gives life, animates and nourishes, both sides at once. From both sides of all the great divides splitting our musical traditions, music ran current in the blood of nineteenth-century Europe.

2. MODERNIST PAINTING. To pursue the question of abstraction, I will take a detour into the field most commonly associated with abstraction, modern art. The fondness of the cubist painters for instruments and scores suggests their ambition to displace music.[7] In a mechanized world, the round contours of musical instruments increasingly stand in for those of flowerpots, bottles, and fruit (Braque, *Man with a Violin*, Fig. 1), and their quasi-natural forms, human craftsmanship, and modern manufacture all have a hand in the increasingly disrupted, jagged, dimensionally challenged surface of the twentieth-century table (Braque, *Musical Instruments*, Fig. 2). For many of the painters' iconographic choices there are unquestionably "formal" motivations, as when the shape of a mandolin "rhymes" or "chimes" or "harmonizes" with that of a woman—at least when the woman's shape is reconfigured to resemble the instrument's (Picasso, *Woman with a Mandolin*, Fig. 3). And before long, the remaining traces of natural shapes become indistinguishably those of musician and instrument, either one of which might be said to provide the curves and diagonals that minimally lyricize the hard edges and grainy browns of the compositions (Picasso, *Woman with a Mandolin*, Fig. 4). Still, purely "abstract" or "formal" reasons do not fully account for the particular obsession with musical instruments, not all of which modernize "natural" shapes (Braque, *Harmonica and Flageolet*, 1910–11). Music envy or music desire must surely play some part. After all, not just instrumental form but musical expression starts to appear in the canvases—a score here (Braque, *Violin and Musical Score*), a generic name, "VALSE," there (Braque, *Clarinet and Bottle of Rum on a Mantelpiece*).

In a few works, the names of composers stand out with a clarity otherwise spurned in the era of high cubism; in one case, the great musical abstractionist Bach, in another, the great musical genius Mozart (Braque, *Homage to J. S. Bach*; *Violin: Mozart/Kubelick*; *Bal*). It becomes evident that cubist abstraction aspires specifically to the condition of music. Not that this is any new discovery. It has long been recognized:

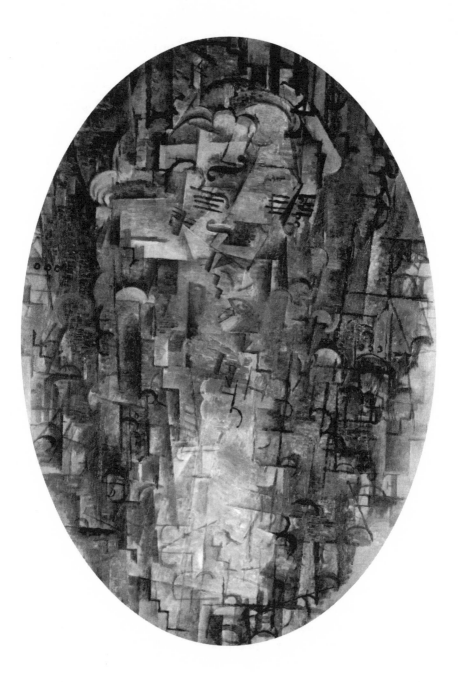

FIGURE 1
Georges Braque, *Man with a Violin*
Oil on canvas
Foundation E. G. Bührle Collection, Zürich

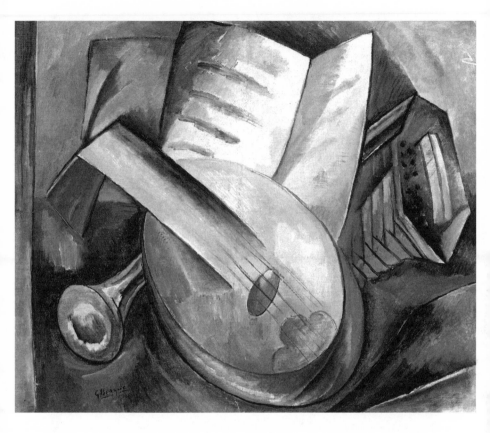

FIGURE 2
Georges Braque, *Musical Instruments*, 1908
Oil on canvas
Courtesy The Bridgeman Art Library

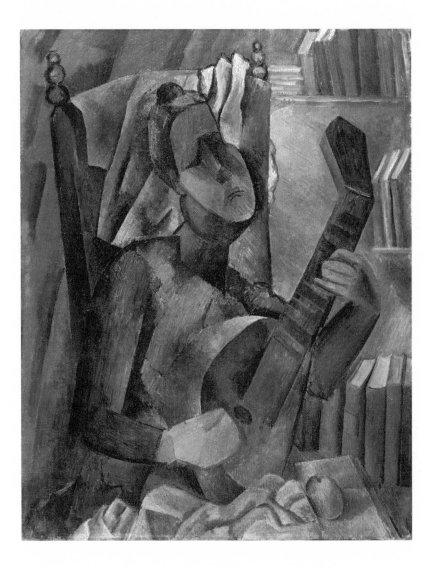

FIGURE 3
Pablo Picasso, *Woman with a Mandolin*, 1908
Oil on canvas
Private Collection / © DACS / Photo © Christie's Images
Courtesy The Bridgeman Art Library

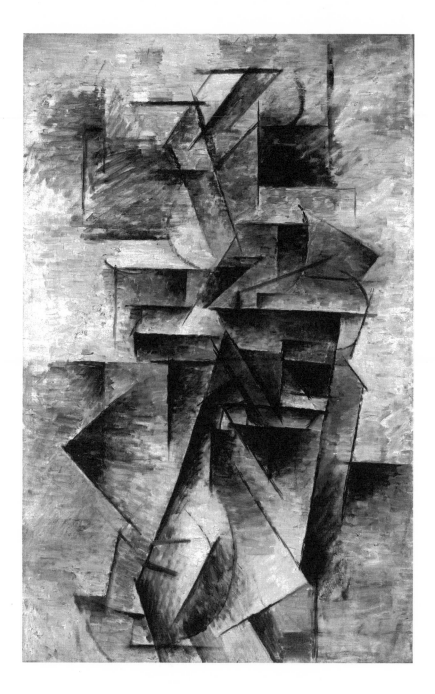

FIGURE 4
Picasso, *Woman with a Mandolin*
Museum Ludwig, Cologne

Just as Schoenberg makes every element, every voice and note in the composition of equal importance—different but equivalent—so these painters render every element, every part of the canvas equivalent; and they likewise weave the work of art into a tight mesh whose principle of formal unity is contained and recapitulated in each thread, so that we find the essence of the whole work in every one of its parts.[8]

Indeed, as the art critic continues, it turns out that pictorial abstraction aims not just to join music but to displace it.

But these painters go even beyond Schoenberg by making their varia-tions upon equivalence so subtle that at first glance we might see in their pictures, not equivalences, but an hallucinated uniformity.

Uniformity—the notion is antiaesthetic. And yet the pictures of many of the painters named above get away with this uniformity, however meaningless or repellent the uninitiated may find it. This very uniformity, this dissolution of the picture into sheer texture, sheer sensation, into the accumulation of similar units of sensation, seems to answer something deep-seated in contemporary sensibility.

On this account, the pure visibility of abstract painting plays the same tune as musical formalism. What was "theme" in Brahms's propagandist Eduard Hanslick, *Ursatz* in the massively influential (and thoroughly antimodern-ist) musicologist Heinrich Schenker, and representation in Attali ("one ele-ment representing all the others") appears virtually unchanged as Clement Greenberg's "essence."[9]

Yet surely the "sheerness" attributed to abstraction by Greenberg is an illusion. Even the spatial arts that claim all-around stability live in time. As the later twentieth century's greatest musicologist wrote, formalism "tends to dissolve esthetics into history."[10] Greenberg's modernism and Schenker's classicism equally reflect the embedding of abstraction in a life-world. More than a century earlier, before any such painting existed, Hegel already diagnosed the temporality of white painting in a passage from the preface to the *Phenomenology* that deconstructs and thereby animates the illusions of formalist abstraction. One need not agree with his evaluation in order to acknowledge his insight into the generated (and hence, by dialectical process, potentially generative) character of abstrac-tion.

This style culminates in monochromatic, absolute painting since it is ashamed at the distinctions existing within the schema and thus looks on them as affiliated with reflection; it thus submerges them into the void of the absolute, from out of which pure identity, a pure formless whiteness, is produced. The monochromatic nature of the schema and its lifeless determinations, together with this absolute identity and the transition from one to the other, are each and every one the result of the same lifeless intellect and external cognition. (p. 43; par. 51)

While abstraction, as representation devoid of represented content, is the purest form of the aesthetic, it is also, on this account, the most timebound. Meaning nothing in itself, it must carry its meanings in relationship to its origin and purpose. It is produced by a process; it has come into being and, as a dead end, must pass away again. It creates an illusion of permanence, but it can endure only in transition, caught between an indeterminate identity and an unidentifiable determination.

Abstraction, we know, did not last. No sooner did it triumph then it folded. It yielded to minimalism, ceded to pop, flowed into color fields, disseminated into postmodernism. Of course, all these successor movements are abstractions, even when Marilyn Monroe is part of the picture. One need only look at the two-dimensional sculptures of Roy Lichtenstein exhibited in 2003 in the roof garden of the Metropolitan Museum of Art. They are representational as all get-out, but they are abstractions of representations, not the thing itself. Is that because they are two-dimensional? But three-dimensional statuary is also abstracted; it lacks, after all, color. The only thing not abstract is the thing itself. Yet pure abstraction, really pure, if it exists, is nothing at all, Hegel's "void of the absolute." Who, after all, wants to look at nothing at all, all the time, even if one could? And it is not possible, because the very act of looking turns the viewed into an object, a trick that Duchamp invented and that many contemporary artists have learned. Pure abstraction is better than Medusa because one can glance at it. But if you really look at it, you turn it to stone.

The truth is, abstraction couldn't last. That is to say, it can't last without dissolving into history by becoming something in its own right.[11] Right away, then, it is no longer abstraction, but a school, a form, a style, or, worst of all, an identity. Mark Rothko became a great painter when he went abstract, but he still wasn't abstraction. He was Rothko, and all the more intensely personal, deeply meaningful, strongly felt, the less he was painting

the towns and people of his youth. Abstraction not only represents nothing, it nihilates (to use Heideggerian vocabulary); that is, it creates nothing. It is the negation of depiction, only masking as the depiction of negation—action screened as if it were contemplation. That is its curse and its bliss.

I am tracing the lines that constitute abstraction as the energy of form, asserting its priority by canceling substance and hence intrinsically linked to the nondenotative, formal energies of music. I have passed through modernism because of the temptation to link the two. My aim, indeed, is to rupture that habitual linkage and establish a different one. For abstraction is a mode, not a period. Really, it should always have been obvious that abstraction is not identical, coterminous, or even distinctively close to modernism. No aficionado of Near Eastern carpets or of the Roman art industry could ever fall prey to such an illusion. Pure design, or pure visibility, has always existed—at least as a counterweight to representational art, and often enough, as the core of art itself.

But what constitutes the purity (Greenberg's "sheerness") of pure forms? And how is purity related to the negativity that is equally characteristic of abstraction? After all, Near Eastern art originated in a rejection of figuration. It wasn't simply abstract but, like all abstraction, it was self-consciously abstract. It did not ignore figure but denaturalized it, turning signs into symbols and symbols into designs. What is a design, indeed, if not a de-sign, an un-sign, a sign negated?

Did Attali go too far in claiming that all representation is abstraction? I think not, though, to be sure, eventually there needs to be a particularized account of the kind of doubly self-conscious representation that claims the name of abstraction and thus figures—or defigures—the process that all representation undergoes. But abstraction was never the unique property of the modernists. To take what might be thought a difficult example, one can find the reflective dynamic of abstraction just as well in Claude Lorrain, often accounted the most lyrical nature painter of all time. It has been said by many for centuries that no one has more perfectly captured the beauty and purity of a landscape. So be it. But do you have a landscape when you have captured it? Can nature be pure, or does purity belong to the divine presence that lurks behind Claude's landscapes in a mysterious sunlight? Claude's lyricism is the result of pure technique, of a saintly devotion to his minuscule brushes, of an ascesis that may not have been biographical—no puritan he—but that still made of his art a method. It may be accounted pure representation, to be sure, but not in the sense that his landscapes are

documentary. On the contrary, though "representational," or at least representative, they are typically invented. And, as such, they are landscapes of a very particular kind, classical, or romantic, noble, or humble, empty yet pulsing with life.

One may ask, what is particular about a landscape that can be almost anything? Well, isn't that its particularity, that it creates its timeless generality out of abstracting any particularity. Not that it lacks the genres and the narratives for which many of the paintings are titled. But it so alienates them that it hardly seems to matter what the paintings depict or what they narrate. Sometimes the titles have even changed over the centuries, with hardly any effect on the paintings. (One is reminded of Hanslick's famous quip that Orphée's lament in Gluck's opera would be just as lovely if the words were not "J'ai perdu mon Euridice" but "J'ai trouvé mon Euridice.") "Pure" representation is thus unmasked as abstractive process that voids narrative and history. And yet Claude's paintings are full, even obsessively full, of life. That haze on the horizon, that time of day that is preserved without letting a viewer know whether it is dawn or dusk, those imaginary ruins, in what sense are they full of life? In themselves, they aren't: coming or going, the sun never seems to be on the move. But hidden away in the depths of many of Claude's paintings are little settlements, villages, boats, commerce—too small to be seen in a reproduction, too small to be seen at the distance from which the paintings are best viewed, sometimes too faint to have been visible at all under the varnish that covered many of them for centuries. But they are there. The paintings are full of life, but it is buried or hidden life—life denied or abstracted, not presented. Behind the Italian landscape is, often, a Dutch genre painting, not waiting to get out but occulting itself precisely so that the intention of the idealization can become clear. Hawthorne got him right: "the golden light which he used to shed over his landscapes" lies somewhere between Hegel's monochromatic abstractions and the meaninglessness of Chomsky's classic model sentence, "colorless green ideas sleep furiously"; as Hawthorne continues about Claude's "land of picture," "he could never have beheld [the light] with his waking eyes till he awoke in the better clime."[12] Nowhere and never lies the realm of the aesthetic, not because it denies life but, quite the contrary, because it facilitates release from the here and now.

Only as that kind of dialectic, always outwrestling its presuppositions, can abstraction be understood in itself. But since the in-itself is always struggling to become the for-itself, the in-itself-for-us, and, finally, the in-

and-for-itself, abstraction in itself is abstraction in movement, abstraction as a movement, abstraction that is moving. Claude's landscapes may be timeless, but it is a shimmering timelessness, trembling, nibbling, always on the edge of death or of bursting revelation, undecidably abstraction or representation. Sure, Rothko's work radiates deep peace, but only insofar as it carries viewers into a depth of transcendence, transforming them as the paintings transform the nature of color and of vision. The 2003 Malevich exhibit at the Guggenheim revealed the astounding energy of static forms—the cross atilt and bursting out toward the edge of its frame, the margins all a-jitter, the constructions flying off and tumbling over. Even the sad condition of the paint becomes an element in the movement, as the death of the surface reflects the life it has undergone, despite or because of the purity of the black that its mystical painter wanted to evoke.

Even in a white painting by Robert Ryman, the nubbly, almost fabric-like canvas can direct attention to the materiality of the work itself, to the materials that underlie the work, and hence back to the real world. There is a reason why the musical movement closest to abstract painting in its heyday was called *musique concrète*. Atonalism couldn't last either. For Schoenberg himself it was but a transition toward a system (twelve-tone composition) and, at least for a while, toward a renewal of classical forms; more generally, the lack of an anchor in tonality requires some other recognizable code (Attali's "model") to sustain the discourse. And the abstract poetry before World War I was known as imagism in English, or created *Dinggedichte* in the German realm. Pure abstraction or pure representation? Where exactly is the difference? For, really, the timelessness of pure representation is just as much a denial of romantic empathy or expression as is the timeliness of the moment of abstraction. Abstraction withdraws, draws away, and hence—as we fortunate English speakers can punningly say about modern art—in the linearity or texturality of modernism, abstraction "draws on."

In the Princeton University Art Gallery, there is a wonderful 1969 Frank Stella image titled *River of Ponds II* (Fig. 5). It is an abstraction with a title—already an oxymoron, and all the more so since the title compounds stillness with movement and denies identity by its serial number. The colors and the lines are strong, but what do they assert? The paradoxical title suggests the paradoxes of the form. Squared-off and rounded sectors interfere with one another. Nothing looks much like a river, or much like a lake, but the contrasts do look as if something is happening. (Early twentieth-century

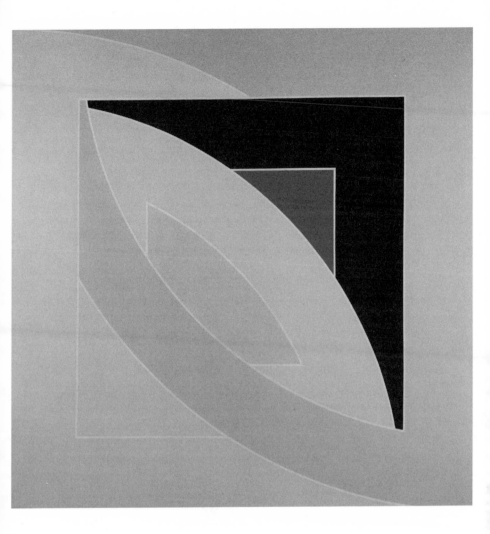

FIGURE 5
Frank Stella, *River of Ponds II*
1969. Acrylic on canvas
Princeton University Art Museum; gift of Paul W. H. Hoffmann
and Camille Oliver-Hoffmann. Photograph by Bruce M. White

Kantianism defined imagination as the "as-if," a condition instanced in countless abstract representations.) The colors have varying degrees of depth; the canvas texture shows through the yellow and the beige, to a small degree through the green, hardly at all through the black and the pink. The yellow is repeated and the beige is echoed in a slightly varied tint, and the eye wants to connect the related patches. There is a suggestion of depth, with green arching across the yellow and the beige sectors, but only the notion of depth is present, not really its notation. For one thing, there are too many levels; for another, the black functions as a covering pigment yet a receding value. Stream or dam, flow or form, primary pigments or grass and flower colors (but hardly grass, since it's a fluorescent green), and not, at all events, water colors, let alone watercolors. The boundaries between the sectors are blank spaces, about one inch wide, with a narrow line drawn down the middle; the intersecting lines may die into one another, cross, or stop short, and there is a possible echo of the lines in the visible line of stapling along the edges of the stretcher. The median lines are painted but give the visual effect of pencil. The fascination is endless, even magical to my eye, captivating, anything but abstracted. The painting is full of movement and reflection both. That is the meaning I see in the title, as it is the nature of abstraction itself. But it is also the nature of water, and so the painterly abstraction reverses into a representation, not of a visual image but of a concept—though a concrete concept, a *Begriff,* and not an abstract concept. What, indeed, would an abstract concept be—a concept, that is, without a content?[13]

Abstraction as Greenberg conceived it was grounded in the three categories of surface, visuality, and form. Tabletops were the mode. To my mind abstraction is characterized instead by decided linearity (Blake's "bounding lines"), edge, crumpled tablecloths that chew up the surface and thus make it new. Modernism is a condition, always at risk, not the culmination, let alone the end of anything. Genuinely "pure," sheer abstraction would be just a mound of colors giving at best visceral pleasure. That sort of thing disgusted Kant, and to my mind rightly. But then artists are typically found experimenting, and in the frequent series like Stella's, diacritical effects replace the dialectic of representation and thing represented with a dialectic of differentials, aesthetics dissolving into sequence, halfway to history. Of course, there's nothing inherently nonrepresentational about series; Monet did hayricks and cathedrals long before Rothko and Stella and Morris Louis came on the scene. But then Monet's light effects are abstractions,

as are Whistler's compositions. There is nothing anti-abstract about a figure. Abstraction only means looking at the figure, inspecting it. As Goethe said in the preface to his *Farbenlehre*, in one of my favorite utterances, "We theorize with every attentive look at the world."[14] Every artist is a theorizer, an abstractionist. That means, every artist has a line, and not just a plane. And the line always comes from somewhere and goes somewhere.

3. HEGEL, REPRISED. But how does an attentive look become an abstraction in movement? To be sure, the question answers itself for time-of-day painting such as Monet's. However, these are only passing examples of a universal principle. For a more general account, I turn to a satiric little squib, "Who Thinks Abstractly?" written by Hegel in 1807 or thereabouts.[15] Even the *Phenomenology* has its surprises, its continual transformations and revelations that come upon one with the suddenness of a great comedian, as the great twentieth-century philosopher Ernst Bloch once divined.[16] But in the little 1807 sideshow to Hegel's masterpiece, the comedy verges on the ribald.

Abstraction can't last, Hegel shows, because, by definition, it doesn't exist. Hegel doesn't say so in so many words, to be sure. That would be to say it abstractly. And unlike the question, "what is abstraction?" the alternative, "who thinks abstractly?" asks for a personal answer. But it turns out that, turn where one may, abstraction is always fleeing. Abstraction proves quicksilvery. Certainly, Hegel says, it isn't the *beau monde*, which thinks in generalizations rather than abstractions. Abstraction is too high for it, too special; abstraction is, says Hegel, an *espèce* (p. 115; par. 577). Now, *espèce*, in elevated or abstract usage, means a scientific generalization, the species rather than the individual. But *espèce* is also another of Hegel's jokes, for it is used in cursing expressions: "espèce de chien" is a French equivalent for "dirty dog." In fact in the *Phenomenology*, Hegel quotes the French philosopher Denis Diderot saying that *espèce* "expresses the highest level of contempt" (p. 352, par. 488). If abstraction is an *espèce*, then it is the height of lowness.[17] Hence Hegel's little essay goes on to turn abstraction on its head. For if the abstract thinker isn't in high society, then he gives you the lowdown. It is the hoi polloi who see in a murderer nothing but a murderer, whereas a connoisseur sees all the personal details that complicate the crime until it disappears under the veil of circumstance. (Hegel here instances Goethe's *Werther*.) But if lowbrows abstract the criminal into the uniformity of his crime, the personal touch of high feeling conversely dissolves the crime by abstracting it away into psychology. But (Hegel's romp

continues) should one really then call such personalizing sentimentality abstraction? No, high-flying sentimentality turns the murderer's gallows into a cross and thereby redeems him from his abstract guilt. But for sentimental weakness Hegel has nothing but scorn; it is "a reconciliation à la Kotzebue [the arch-sentimental melodramatist], a kind of slovenly sociability between sentimentality and badness" (p. 117; par. 579).

But if abstraction migrates into emotional generalities and delusive Christian pieties, then the upper classes are no better than the common people, equally impoverished, no fuller of meaning. All are abstractionists, and of the bad sort. The unearned redemption of the criminal who refuses to acknowledge his wickedness is merely the flip side of what happens down below, when a maid who has a spat with a market woman refuses to see any good at all in her. Her eggs are rotten, her clothes are rotten, her ancestors were rotten and eaten by lice. If the *beau monde* gives us bad abstraction from on high, here we have bad abstraction from below, as an epidemic of particulars rather than as a rose-colored haze. Masters and servants (as in Diderot's *Jacques le fataliste et son maître*), officers and common soldiers— they all reify one another, that is, they all abstract from the individual, that is, they all generalize, that is, they all persecute and crucify one another, that is . . . Well, Hegel concludes, "it could drive one to make a pact with the devil" (p. 118; par. 581). For everyone acts and reacts by instinct. That is what it means to think abstractly. The only thing no one does in this wonderful squib is think. Thought is always slipping away, out of sight. That is what abstraction is, though Hegel doesn't say it, indeed doesn't even need to say it. Abstraction is the antithesis of thought because it is the movement of thought.

The premise of Hegel's essay is that we know abstraction when we see it, implicitly: "That everybody present should know what thinking is and what is abstract is presupposed in good society, and we certainly are in good society" (p. 115; par. 576). Hegel's move turns abstraction from a logical or metaphysical question into a social one. Abstraction is an identity, if only we can find it. But Hegel's examples suggest a giddy contentment to abstraction. The abstractor is self-satisfied, a bundle of clichés, ignorant of the realities of the surrounding world. An identity so happy in itself can only be unhappy for us; therein lies the essay's satirical punch. Abstraction is the bad conscience that haunts the good feelings of the social whirl. The devil is in the details, and he does come out when the maid besieges the fishwife. In ending with master and servant and then with officer and

soldier, Hegel is surely thinking of what became the most famous section of the *Phenomenology*, published in the year the squib was probably written. To be sure, the servant in the squib is a *Bedienter* not a *Knecht*; still, behind the high spirits and even high jinx of abstraction lies what the master-servant dialectic in the *Phenomenology* unveils as a persistent anxiety about identity. Abstraction itself is a mask covering a life-or-death struggle of social classes, whether manifest as the polite aversion to murder or the rude confrontation of the marketplace. It is evident that Hegel stacks the cards when he characterizes the question "who?" in terms of groups rather than individuals. But then any thinking capable of communication must use a language shared with others, a language of groups, the language of the drawing room or the language of the streets, the rarefied German of the philosopher or the Swabian dialect that Hegel here also invokes. Thinking is not an individual activity but a shared activity that puts the individual at risk. And what goes for thought goes, in spades, for abstraction.

Abstraction is the other of the real thought whose vehicle (for Hegel) is the concept. Abstractors, as here portrayed, are jerks. (Jerks is my version of a primal word related to *Aufhebung*: jerking preserves meat but animates and even elevates the torpid.) But othering is exactly the distancing reflection needed in order to arrive at comprehension. Hegel's sarcasms in this essay are the symptoms of abstraction nipping at his soul. Abstraction flattens, creates edges, sharpens wits.

4. EMILY DICKINSON. Dickinson, one of our most abstracted, most reclusive poets, has given the best name I know of for the incision in consciousness made by the almost nothing that is abstraction. Music, she says, is—and I propose that all other forms of abstraction likewise are—"the Tooth / That nibbles at the soul."[18]

To be sure, music in Dickinson's poems is almost always religious or natural, hymns or birds. But as a girl and young woman she had played the piano and attended concerts in Amherst and Boston, and traces of those formative experiences remain in her poems about music. "The Earth has many keys" (895A): whether piano keys or scale keys, these are memories of composition, from a lost soul. "Where Melody is not," the poem continues, "Is the Unknown Peninsula." By itself, however, nature offers only a residue of the beauty that the poem calls "Nature's Fact": "The Cricket is Her utmost / Of Elegy, to me." Nature's music is typically a shock, grounded in a lack. It might be termed the revenge of matter, calling out to the spirit denied by the very fact of its embodiment.

The Birds declaim their Tunes—
Pronouncing every word
Like Hammers—Did they know they fell
Like Litanies of Lead—

On here and there—a creature—
They'd modify the Glee
To fit some Crucifixal Clef—
Some Key of Calvary— (398)

Yet back in the depths of Dickinson's soul resounds a different, more ener-
gizing melody, whose hammers are not construction tools. Such are the
instruments of which she dreams:

Over and over, like a Tune—
The Recollection plays—
Drums off the Phantom Battlements
Cornets of Paradise— (406)

Other instruments show up elsewhere: pianos, violins, trumpets. Still,
the music in the ear is not the essential expression. As nature's music and
the church's music prop themselves on the music resonating in Dickinson's
memory, so that music too remains oblique to the spiritual essence after
which she yearns.

There's a certain Slant of light,
Winter Afternoons—
That oppresses, like the Heft
Of Cathedral Tunes—

Heavenly Hurt, it gives us—
We can find no scar,
But internal difference—
Where the Meanings, are— (320)

Heavenly hurt, the nibbled soul—these moments are in tune with Hegel's
account of recognition and reconciliation: "The wounds of the spirit heal
and leave no scars behind" (p. 470; par. 669). The push of internal differ-

ence, markedness, the incisions that inscribe meaning—and the pull of spirituality, intuition, orientation—these are the components of beauty targeted by Dickinson's tragic sense, as by Hegel's. Tragic because redemption comes by way of sacrifice, which Hegel at one point calls "the death . . . of the abstraction of the divine essence" (p. 546; par. 785). And so, too, Dickinson, in the poem that gives me my title. Disturbance, dissonance, what a too little regarded book terms "man's rage for chaos"—these are the quirks that keep art alive.[19]

> This World is not Conclusion.
> A Species stands beyond—
> Invisible, as Music—
> But positive, as Sound—
> It beckons, and it baffles—
> Philosophy, don't know—
> And through a Riddle, at the last—
> Sagacity, must go—
> To guess it, puzzles scholars—
> To gain it, Men have borne
> Contempt of Generations
> And Crucifixion, shown—
> Faith slips—and laughs, and rallies—
> Blushes, if any see—
> Plucks at a twig of Evidence—
> And asks a Vane, the way—
> Much Gesture, from the Pulpit—
> Strong Hallelujahs roll—
> Narcotics cannot still the Tooth
> That nibbles at the soul— (373)

It is a curious religion of art that Dickinson propounds. For her, art is not a propaedeutic to faith nor beauty a symbol of morality. Morality is, indeed, hardly an issue in her verse. The Civil War may have been raging and even affecting people from her community, but it maintains an angled presence in her consciousness.[20]

> Flags, are a brave sight—
> But no true Eye

Ever went by One—
Steadily—

Music's triumphant—
But the fine Ear
Winces with delight
Are Drums too near— (414, dated 1862)

Apocalyptic sensations are constantly named, but only to be evaded by art's "finer tone," "the intricate evasions of as," as Keats and Stevens have it. Revelations come in small ways, most familiarly, perhaps, from the "narrow Fellow in the grass"; from the snake, to be sure, she feels an ecstatic "transport," but only one of "Cordiality" (1096). Art presses away from grand insights toward minor sensations, the things that matter all the time, even though below the horizon of awareness. Dickinson calls herself "Queen of Calvary," but really thinks of herself as no more than a queen bee, her sting a counterforce to the grand pronouncements from the pompous pulpits of the great. Here, in full, is a last musical poem, from which the last phrase comes, to illustrate the spirit I aim to evoke in this book.

I dreaded that first Robin, so,
But He is mastered, now,
I'm some accustomed to Him grown,
He hurts a little, though—

I thought if I could only live
Till that first Shout got by—
Not all Pianos in the Woods
Had power to mangle me—

I dared not meet the Daffodils—
For fear their Yellow Gown
Would pierce me with a fashion
So foreign to my own—

I wished the Grass would hurry—
So when 'twas time to see—

He'd be too tall, the tallest one
Could stretch to look at me—

I could not bear the Bees should come,
I wished they'd stay away
In those dim countries where they go,
What word had they, for me?

They're here, though; not a creature failed—
No Blossom stayed away
In gentle deference to me—
The Queen of Calvary—

Each one salutes me, as he goes,
And I, my childish Plumes,
Lift, in bereaved acknowledgement
Of their unthinking Drums— (347)

The quasi-religious mysteriousness of Dickinson's voice should not mask its wryness. Every utterance is, if not effaced, at least unnerved by its successor. The first robin powers in, grows routine, and hurts both by its over-familiarity and by its residual inhumanity as the kind of servant who retains power over his master. Dickinson drinks in the sounds of the landscape from which she has secluded herself and which she can barely see. "Gentle deference" suggests both nobility and humility, a child's delusions of glory. As there is no end for a Dickinson sentence, so there is no word of resolution (neither backward-looking solution nor forward-leaning resolve), though there is the kind of "acknowledgment" that, for Hegel, too, smooths the discord between master and servant. The yearning for apocalypse wants to stop time, but that would mean to deny presence: the speaker here yearns either for a persistence of the bee-less past or else for a luxuriant future. But bee-ing (the usual Dickinson pun), as we so perfectly say in English—using a better idiom than Heidegger's neologism, "the world worlds"—comes to pass: the unthinking drums are music's measure of the unstoppable course of time, its alertness, its hurt.

These passages in Dickinson's verse characterize the effect of music and of poetry as I portray them in this book. Different kinds of mastery are represented in the mid-eighteenth century by Handel's national celebrations

and by Matthew Green's breezy coyness, then in later decades by Mozart trumping Bach and cheerily celebrating Don Giovanni's demise and by Schubert's serene ironies, and then, continuing further into the nineteenth century, by Schumann's formal play and Mendelssohn's buoyancy. Yet the hurt is always nipping away at self-satisfaction, whether in abjection, obsessive sexuality, or the alienation of the foreigner and the convert. The kind of artistic expression that I love, and that I try to honor in this book, refuses ever quite to come to ground; it remains a trembling of the atmosphere, a hallooing of the air. It says "yes" to life, at the end, as Hegel does (p. 472; par. 671), but the course of its particulars sustains life by remaining unsettled. As any innocent reader of Hegel will tell you, abstraction is the denial of meaning. That is, it denies ease, conventionality, mere facticity. It outsoars its moments, lifting them on wings of sublation, or it burrows beneath them to spread their roots in the ground.

5. GABRIEL FAURÉ. It is time for some preliminary examples of the cutting edge of music. Since the music in the ensuing chapters comes exclusively from the German tradition, I have selected a French composition. Like many of the pieces to come, it is texted music, since the intersection of text and setting makes the action of music particularly graphic. And like many art songs, the text seems a poor springboard for the high flight of the music.

Charles Grandmougin, *Poème d'un jour, 1:*
Fauré, op. 21, no. 1

J'étais triste et pensif quand je t'ai rencontrée,
Je sens moins aujourd'hui mon obstiné tourment;
Ô dis-moi, serais tu la femme inespérée
Et le rêve idéal poursuivi vainement?
Ô, passante aux doux yeux, serais-tu donc l'amie
Qui rendrait le bonheur au poète isolé,
Et vas-tu rayonner sur mon âme affermie,
Comme le ciel natal sur un coeur d'exilé?

Ta tristesse sauvage, à la mienne pareille,
Aime à voir le soleil décliner sur la mer!
Devant l'immensité ton extase s'éveille,
Et le charme des soirs à ta belle âme est cher;
Une mystérieuse et douce sympathie

Déjà m'enchaîne à toi comme un vivant lien,
Et mon âme frémit, par l'amour envahie,
Et mon coeur te chérit sans te connaître bien.

~

I was sad and pensive when I met you,
I feel less today my persistent torment;
Oh, tell me, might you be the unhoped-for woman
And the ideal dream pursued in vain?
Oh, sweet-eyed passer-by, might you be the beloved
restore the lonely poet's happiness,
And will you shine on my strengthened heart,
Like the native sky on a heart in exile?

Your wild sadness, comparable to mine,
Loves to see the sun set on the sea!
Before the immensity your ecstasy awakens,
And the charm of evenings is dear to your fair soul;
A mysterious and sweet sympathy
Already chains me to you as a living tie,
And my soul shudders, invaded by love,
And my heart cherishes you without knowing you well.

In this poem, the minor impressionist poet Charles Grandmougin struggles to find a language of ineffability. Buried in his past yet absorbed in his present, the speaker reports the indefinite incident from an uncertain perspective. The woman in the vision is real or imaginary, a permanent ideal or a fugitive delusion, alien or native. "Pensif" hardly means thoughtful, "pareille" could confirm or mistakenly assert affinity, "comme" could mark identity or remain resigned to a crucial residual difference. The conditional "serais" leaves the poem utopian or merely optative; "déjà m'enchaîne" seems to preclude the very excitement the final lines seem to promise. Before the meeting the speaker was apparently starved for emotion (I say apparently because it is a little hard to reconcile the wistful "triste et pensif" with the resentful "mon obstiné tourment," except by understanding the latter as some kind of gnawing neurosis[21]); now he is filled with her radiance, yet without leaving any certainty as to whether that is real or potential. The atmosphere rather resembles the future perfect

at the end of Flaubert's *Sentimental Education*: a glorious sunset predicts a warm but posthumous future, settling into the surrogate consolations of a cherishing charm, sounding like fireside evenings rather than majestic nights. There is a touching vagueness about the whole thing, which remains far more shadowy than the famous epiphany of Baudelaire's "A une passante" that it seems to echo. It is all a little vague, a little colloquial ("sweet-eyed," "loves to see," "sweet sympathy," the concluding "without knowing you well," and the informal compound past tense). Soul intuits soul, but as if grasping at straws. The tender hopelessness constitutes the charming reticence of a poem that succeeds to the degree that it relieves the encounter of any defined experience. Memory builds from hypothetical questions through the direct future of "will you shine" to the projected knowledge of the kindred "fair soul," creating an illusion of proximity that Grandmougin only manages to label as "a mysterious and sweet sympathy." We now have the word "empathy" for kindred soulship. Lacking the word, however, Grandmougin also lacks the thing. Not quite fine enough a poet to fuse satisfaction with disillusion, he plumps down on the heavy-handed, deflating irony of the closing phrase. There is neither *Erlebnis* nor *Erfahrung* in a passing moment that comes down to a mere encounter.

The poem, one might say, expresses an emotional situation. Its impressionism lies in the supplanting of concrete incident by the haze or glitter of affective response. The three poems in Grandmougin's brief cycle resemble the times-of-day series paintings by Monet and others. They are soft-focus snapshots whose inwardness coordinates with a negation of time; as the third poem, "Adieu," says—its versification quasi-pictorial in a mechanical way—"Les plus longs amours / Sont courts" (The longest loves / Are short). The spirit of Poe continues to hover over verses that privilege situation over incident, even if some shadowy occurrence supposedly remains the pretext. Full consciousness is never achieved nor, indeed, aimed at. The speaker's sadness at the opening matches the stranger's at the start of the second half, but recognition is replaced by further dulling: "I feel less today." He imagines her awakening into immense ecstasy (though Fauré's sole 2/4 measure cuts the music short at this point), and the projected contentment ("est cher," "is dear") is undermined by the concluding verbal echo, when his contentment ("te chérit," "cherishes you," slyly marked forte, heightening the mezzo forte of the first half) is confessed to be ignorance. Immensity and indistinctness, emotional intensity and absence of knowledge are roughly equated by this kind of sentimental impressionism.

The marvelous setting by Fauré (Ex. 1.1) offers an entirely different order of experience. Fauré is rightly known as the suavest, most placid of the great composers. In this song, as is typical of his music, the rhythmic pulse is steady, indeed all but unvaried, the harmonies are oddly wandering, and the solo line is characterized by swells and falls, often continuing across rests by resuming with the same note on which it had left off, or a neighboring one, and without the chiseled shape that creates a memorable melody. It mimics the course of pensive thought rather than that of passionate expression. But the music nibbles at the souls of the speaker and the mysterious enchantress. With its reminiscences of a courtly gavotte rhythm, it nibbles

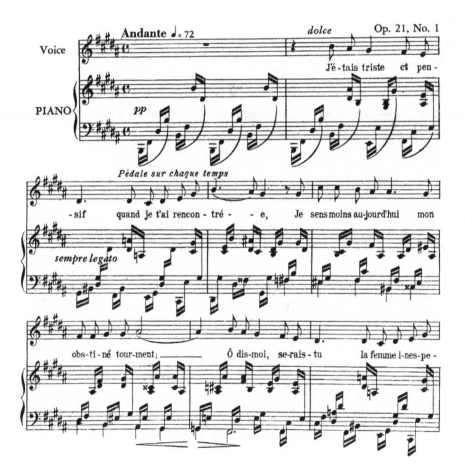

EXAMPLE 1.1 Gabriel Fauré, op. 21/1, "Rencontre"

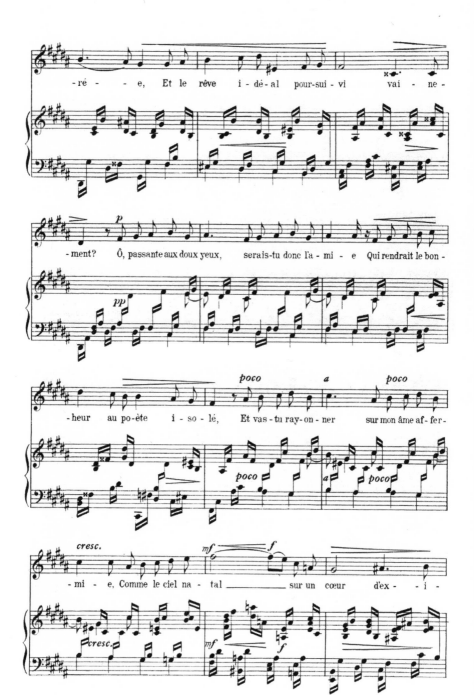

EXAMPLE 1.1 (cont.)

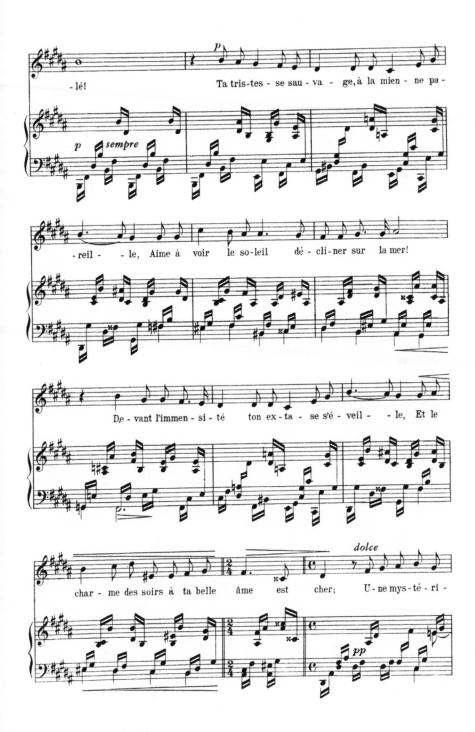

EXAMPLE 1.1 (cont.)

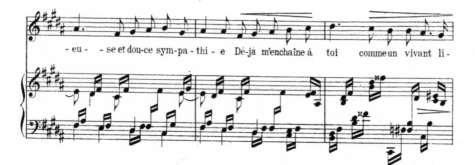

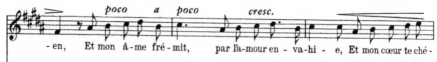

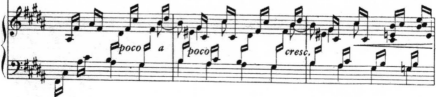

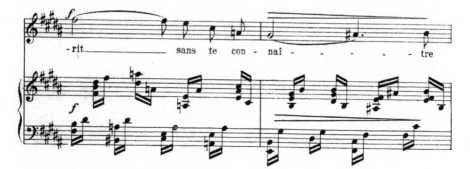

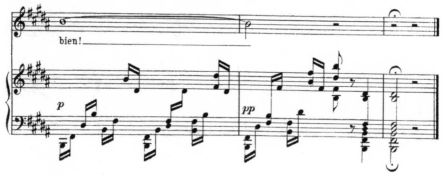

EXAMPLE 1.1 (cont.)

at her soul by withholding the implied eroticism; it turns her into a dancing creature who is charming in only the most limited, sociable sense, leaving her "belle âme," the kind of vapidly beautiful soul mocked by Goethe and by Hegel. And it nibbles at his soul by undermining the sincerity of the utterance.

In this connection, the lighting on the pronouns is the key. In the poem, first-person pronouns decline from two in the first line to one in each of the two subsequent lines, then only one each in lines 5–8 and 9–12, returning to one in each of the last three lines, for a total of nine in all. There are ten second-person pronouns, including two in the final line. Thus the numbers are roughly equivalent. But the opening lines feature unemphatic nominatives, "je" and "j'"; there are also an abbreviated direct object "m'" and three possessives in unstressed position. Only "moi" in line 3 and "la mienne" in line 9 bear any stress, but not contrastively: "moi" is paired against a strong "tu," and "la mienne" claims to match her sadness with his. Meanwhile, "tu" also appears three times, but always with some degree of stress and with full ictus in line 3. Second-person possessives in lines 9–12 have little prosodic weight, yet she is an eager observer whose ecstasy is awakening, a far cry from the speaker, tremblingly invaded by love and enchained "à toi," the most commanding pronoun in the poem. Despite the roughly equal numbers, the itinerary passes the torch from the smitten speaker to the cherished stranger. The poem's speaker enacts his absorption in his vision. But the song is different. The musical setting disturbs French prosody by stressing several of the first-person nominatives and correspondingly deemphasizing the second-person pronouns. Fauré reveals absorption in a vision as self-absorption. The high notes are struck on "ciel natal" and "te chérit"—struck and then held, to a degree that risks straining the voice, denaturalizing the native strand, puncturing the fervor. And the final note in the vocal part is marked to be held softly throughout two entire measures, though the recordings I have heard either raise the volume or do not sustain the note to this degree. The singer staggers to the end, unwilling to let go of his willfully held and emphasized vision.

Thus, song transforms poem. Expression yields to exposé. The poem speaks from the heart; its addressee is the mysterious stranger, and its silent voice is (so to speak) merely overheard by the reader, who functions as a ghostly third in the communion of souls. The song, by contrast, is performed, like the poems I examine in "Negative Poetics." Fauré puts the speaker on stage and fosters a judgment of the stresses and strains of his

utterance, as foregrounded by the ductility of the music. The poem suppos-edly reflects a compact, if somehow extended, moment, but the flow of time is inescapable in the song, with its regular sixteenth notes and direction to pedal each quarter note. Musical expression underlines the parts of the single utterance; for instance, by linking "mon obstiné tourment" to "O dis-moi," it suggests a logical yet self-indulgent consequentiality of need and demand. The ideal woman thus seems to grow out of the speaker's self-pity rather than remotely to have caused it; "serais-tu" is no longer a polite way of asking for confirmation ("might you be?") but rather a self-pitying plea ("could you possibly serve as?"). Passing tones are a skeptical mimesis char-acterizing the "passante" as an unsettling figure; they are singled out for emphasis where they are notated in the accompaniment as quarter notes rather than sixteenth notes, and they become conflictive in measures 12–14 and 16–18, where two dissonant lines are present, his and hers, displaced from one another by an eighth note. In this climate (and ever more graphi-cally as Fauré's music grew ever stranger), suavity can be no more than imaginary compensation riding atop a gnawing anxiety.

Yet I would not finally want to pit music as some kind of bulldog against poetry as some kind of sacrificial lamb. For one key contention of this book is that music is not alone in its edgy (or, as a later chapter says, its skeptical) abstraction. Poetry is not toothless. It too abstracts, takes a view from the outside, undoes sensual certainties from the outset. Indeed, all language is general, shared, and hence more or less inadequate to its occasions. No utterance beyond a yelp or a sigh speaks the language of the self without appropriating the language of the other. It is always more or less out of tune, whether because it falls short, or, at least as often, because it betrays by excess, saying more than is meant. This disproportion of language to intention has, in particular, been the lesson of deconstruction. As Der-rida discussed in one of his earliest publications, ideas are idealities and never strictly correlatable with presence. Presence always slips away into re-presentation. Signs, he says, are crises, which I take to mean turning points, slippages.[22] And if utterance in general, so poetry in particular. No text, he says, "resists . . . absolutely," but poetic or literary texts are "richer and denser."[23] There is no originality in Derrida's definition of poetry here and in the ensuing remark on "the difficulty of theorizing the economy" of poetic expression (46). But no harm is done if critics have never managed to become diacritical enough to cordon poetry off from the rest of language and experience. The Dickinsonian dialectic of meanings and wounds is

inescapable, even if pointed far more stringently—or skeptically—by some expressions than by others.

6. MARCEL PROUST. I chose Fauré's "Rencontre" for an example because it is a particular, long-time favorite of mine and also to compensate for the German-Austrian musical heritage otherwise exclusively represented in the ensuing chapters. But the Fauré also serves as background for one final expression of the credo animating this book. For if Proust's famous evocation of the power of music is not directly based on this song, it surely expresses an abstracted evanescence absolutely congruent with it. Here is Swann's reaction after first hearing the "petite phrase" of the violin sonata of Vinteuil:

> He had been filled with love for it [*elle*: the musical phrase, in the
> feminine]. . . . But when he returned home he felt the need of it: he was
> like a man into whose life a woman he has seen for a moment passing
> by [*une passante qu'il a aperçue un moment*] has brought the image of
> a new beauty which deepens his own sensibility, although he does not
> even know her name or whether he will ever see her again.
> (*Remembrance*, 1:228–29; *Recherche*, 1: 210)[24]

The minuteness of Vinteuil's phrase allows its repetitions to be recognized and to etch themselves into consciousness and memory. Music evades a clear meaning, and therein lies its power, the ideality of its ideas:

> Swann had regarded musical *motifs* as actual ideas, of another world,
> of another order, ideas veiled in shadow, unknown, impenetrable
> to the human mind, but none the less perfectly distinct from one
> another, unequal among themselves in value and significance.
> (1: 379–80; 1: 349)

The power of music is not different from the power of ideas, merely finer, harder to seize, with its "cloudy surface" (1: 380; "surface obscure," 1: 350) edging us out of our complacencies. In fact, the composer Vinteuil is beset with a *furor poeticus* ("the loss of his reason," "aliénation mentale," 1: 234; 1: 214) that Swann acknowledges without understanding it (and that, in the order of the novel's narrative, has already led to his tormented death, before the insertion of the retrospective narrative of Swann's passion for Odette):

[Cottard] insisted that signs of this could be detected in certain pas-
sages in the sonata. This remark did not strike Swann as ridiculous; but
it disturbed him, for, since a work of pure music contains none of the
logical sequences whose deformation, in spoken or written language,
is a proof of insanity, so insanity diagnosed in a sonata seemed to him
as mysterious a thing as the insanity of a dog or a horse, although
instances may be observed of these. (1: 234; 1: 214)

Much later in the novel, Vinteuil's septet reawakens for the narrator
the mystery of an expression beneath and yet more powerful than words,
"what might have been—if the invention of language, the formation of
words, the analysis of ideas had not intervened—the means of communica-
tion between souls. . . . This return to the unanalyzed was so intoxicating
that, on emerging from that paradise, contact with more or less intelligent
people seemed to me of an extraordinary insignificance" (3: 260; 3: 258–59).
The power of the septet, no less in its small way than the power of Wagner's
operas, is as intoxicating as Hegel's Bacchanalian revel.

This music seemed to me something truer than all known books. At
moments I thought that this was due to the fact that, what we feel
about life not being felt in the form of ideas, its literary, that is to say
intellectual, expression describes it, explains it, analyses it, but does
not recompose it as does music, in which the sounds seem to follow
the very movement of our being, to reproduce that extreme inner
point of our sensations which is the part that gives us that peculiar
exhilaration which we experience from time to time. (3: 381; 3: 374)

Such is the spirit of music that I cannot hope to recapture in a work of
criticism—since its nature is to be unfixable—but can at least conjure up
through pointing and circumscription.

My essays aim, then, at what a just-published manifesto by Jerome
McGann calls "a general deconceptualization." His instance is George
Meredith's poem about "the pain / Of Music," titled "The Promise in Dis-
turbance" and published as a preface to the sonnet cycle "Modern Love."
And his moral is that "thought is here conceived (first) in an analogy with,
and (then) as a structure of, musical form and the powerful if fleeting pres-
ences of those forms."[25]

The negativity of music and of art in general is highlighted to different

degrees in the chapters of this book. It is most central in "Negative Poetics," where a musical example is immediately followed by several strictly verbal ones. The notion that art has an oppositional character is widespread these days. But most often oppositionality has been conceived in more or less political terms: art sends a message from the margins of gender, class, or empire. I have learned much and agreed often with many such studies, the closest to the matter of this book being perhaps the work of Lawrence Kramer,[26] yet to my mind art's negativity is typically more central—more internal and querying—than cultural studies makes it appear. The margin has a way of staking its own counter-imperial claims, the subaltern of turning from an energizing supplement into a confrontational alterity. My temperament favors quieter resistances, with, to be sure, an acknowledged risk of quietism. The remaining essays are all written in the same spirit as "Negative Poetics," but with focuses that ramify into issues of individual and general history, psychology, and public consciousness, Mozart facing Bach, Handel representing the nation. (The Handel chapter, written as a kind of introduction, features the negative only in its historical dynamic, questions of voice being so difficult of access in the overwhelmingly public personality and art of this particular composer.) Most of the musical examples— indeed, all the principal ones—are either texted or programmatic, allowing their skepticisms to surface more visibly, or else (in the case of Mozart and Bach) written with a determinable purpose. They are all tendentious, even though the tendency may be identified through as delicate a gesture as a tempo indication, Andante Pastorale. Indeed, with the massive exceptions of the Handel chapter and of *Don Giovanni* (itself as lighthearted a tragedy as has ever been written), the texts I have landed upon are delicate to the point of evanescence. The selection of materials may have more than a whiff of the self-fulfilling prophecy. Indeed, as I hesitate to claim universality for the working of a particular, historically conditioned art, so I hesitate to claim that all concert music is poetic and lyrical after the manner of the present essays. A theory is a way of looking, and it is proper that there should be more than one, as even the present essays diverge from one another in important respects, looking at different genres, different styles of music and of poetry, different facets of skeptical artistry.

≋ 2 ≋

Music and Fantasy

L AWRENCE KRAMER's brave book, *Why Classical Music Still Matters*, climaxes with an account of the saving grace of Beethoven's *Pastoral* Symphony. The music, he says, imagines "an unbroken continuity of tradition."[1] Is this really imagining? Well, not exactly. He hedges a bit: "imagining . . . that is, in music" (197). And then he hedges some more: "It is never just a simple image of a lost paradise. . . . Rather . . ." (200). Kramer's moments of hesitation stem from the association of imagination with images, hence with visual experience. Imagining "in music" is never "simple." To be sure, pictorialism was an old tendency in music, but with the exception of onomatopoeic sound imitation, it was never natural but always mediated conceptually: down for us was up for the Greeks. Romantic aesthetics, however, upped the ante. Starting in the later eighteenth century, imagination acquired a heightened prestige, transcending the merely pictorial. Musicians might envy the imagination but they were hard pressed to capitalize on it. That pressure and the resistance to it are the subject of my reflections.

GENRE

What does music say to imagination? The *New Grove Dictionary of Music and Musicians* has no entry for image or imagination. "Images" as a musical title seems to originate simultaneously with Bartók and Debussy, followed by Ibert. "Bilder" starts with Schumann's "Bilder aus dem Osten" for piano four hands, with few successor titles beyond Musorgsky's imitation of paintings. (Musorgsky actually uses the diminutive "Kartinki," suggesting prints deriving from the paintings and hence a derivative or inferior status for music.) Music typically has other ways to think than in images.

Meditation is a possible alternative to imagination, but the *New Grove* has no entry for "meditation" either, and as far as I can tell from checking my library catalogue, composers have been less into meditation than packagers of recordings have been; Massenet seems to have started the belated fad, such as it was, but the sporadic examples from Tchaikovsky, Widor, and Ravel hardly ground a counter-tradition to visuality. As musical genres, neither image nor meditation offers much.

Instead, composers fought back with the term "fantasy." Fantasy derives from the Greek word for imagination, but the Greek verb *phainomai* is not as decidedly visual as the Latin noun *imago*, and a phainomenon could be any kind of appearance or manifestation. Hence Hanslick, following the aesthetician Friedrich Theodor Vischer, defines "Phantasie" as "the organ for the perception of the beautiful," characterizes its mode of perception as "looking with understanding" (*Schauen mit Verstand*), then detaches perception from visuality by shifting terminology from "Schauen" to the Kantian "Anschauung." "Moreover, the word 'intuition' [Anschauung], long since transferred from visual representations to all sensory manifestations, corresponds admirably to the act of attentive hearing."[2] By highlighting the divide between the two closely related aspects of the mind—imagination and fantasy—I intend to suggest a direction for listening to Romantic music that differs from commonly accepted analytic forms.

As the Romantic imagination transcends the older pictorialism, so fantasy in Romantic usage (and as I propose to employ it) supersedes earlier meanings. Fantasia appears early and commonly in musical titles for either a free-form or a purely instrumental composition. These older usages survived into the eighteenth century, when, as Grove reports, the term generally declined, with all the most important examples apart from Mozart's four piano fantasias coming from the Bach family. Haydn also used the term occasionally, and there are many variation sets and more or less free-form medleys or potpourris with the title Fantasia by Reicha, J. B. Cramer, Czerny, Spohr, Schubert, Mendelssohn, and others. But the term gained a new extension when Berlioz began its association with reverie that Schumann then consolidated, beginning with his *Fantasiestücke*, op. 12, which were inspired by E. T. A. Hoffmann's collection of stories, the "Fantasiestücke in Callots Manier," themselves inspired by a graphic artist, Jacques Callot. The rivalry with visuality is thus built into the modern usage of the genre term *Fantasie*. (Following the new German orthography, I spell the musical genre with an f.)

Hoffmann's collection incorporates his writings about music, and Jean Paul's preface to it emphasizes its musical dimension. The preface speaks of the author's "camera obscura" or "darkroom"; the brief opening sketch dedicated to Callot concerns the fantastic quality of his fantasy, and it is followed by "Ritter Gluck" (Squire Gluck), with its ghostly appearance of the composer in an opera box. Visualization in Hoffmann's *Fantasiestücke* is thus Romantic not enlightened, dark not light, more visionary than visual. Fantasy here is inseparable from reverie; "Fantasiestück" joins another title shared by Hoffmann and Schumann, "Nachtstück."

Between Mozart and Schumann (and following the precedent of C. P. E. Bach) came Beethoven, who wrote a free-form fantasy for piano solo and another as a piano prelude to the Choral Fantasia. More important to the genre history, though, are Beethoven's two piano sonatas, op. 27, both subtitled "quasi una fantasia." While the sonatas share some characteristics and sonorities, the first one is more closely associated with the earlier tradition, marked by a free-form first movement and by the linkage of all four movements through "attacca" designations—whereas the second was perceived to be in the reverie mode early on and was given the label that Kramer has written so brilliantly about, "Moonlight."[3] The moral of this genre history is clear. Fantasy changed meanings with the Romantic movement and became the musical alternative to imagination as a dark, brooding or dreamy, meditative kind of thought. Romantic fantasy overlaps with Enlightenment fantasia in the Beethoven sonatas, but overall, the later meaning displaced the earlier meaning rather than continuing it.

AESTHETICS: KANT

The divide between imagination and fantasy emerges in Kant, who variously credits imagination with both perception and representation. As perception, imagination reproduces and schematizes immediate sensations to make them accessible to understanding; as representation, it is productive and deals in imagined situations as well as imaged realities. A striking comment in Kant's *Anthropology* defines its wiles: "We often like to play with the imagination; but the imagination (as fantasy) just as often plays with us, sometimes very inconveniently" (*Anthropologie*, §28; B80).[4] Whereas the reproductive imagination regulates mental processes, the productive imagination, otherwise known as fantasy, threatens to disorder them again. "The imagination, insofar as it produces spontaneous imaginings,

is called fantasy. Anyone who is accustomed to regard these as (inner or outer) experiences is a fantasist [Phantast]" (§25; B68). The true and false, or good and bad, versions of imagination are hard to tell apart; for the bad, productive kind, Kant has the adjective "unwillkürlich," which I translate as "spontaneous," but "Spontaneität" is also crucial to the operations of the good, reproductive kind. Still, it seems evident that there are two kinds, and that the kind called *Phantasie* is not to be trusted.

But Kant's resistance to music and to fantasy also implies temptation.[5] As a philosopher of the late Enlightenment, Kant wants universal judgments of taste based on knowledge and subject to concepts. But as a philosopher of incipient Romanticism, he wants them to be free. Consequently, the relationship between imagination and clarity remains highly problematic.[6] The crucial ninth section of the *Critique of Judgment* persistently speaks of "play," "harmony," and "accord" (*Stimmung*). To be sure, these are not self-evidently musical terms, but it is hard to assign them to any other terrain. Surely Paul Guyer's translation of "proportionierte Stimmung" (§9; A31) as "mutual agreement" loses the flavor of the phrase.[7] Kantian "free beauty" belongs to families of brightly colored birds that Kant most likely had never seen and "presupposes no concept of what the object should be" (§16; A48); it "represents nothing" (A49), and its climactic instantiation, in this paragraph of the *Critique*, is musical "phantasies (without a theme)" (A49; a rare variant in the third-edition text has "Phantasieren," phantasizing, which is even more dynamic and less conceptual). Guyer surveys alternative readings of the free play of imagination as precognitive, multicognitive, and (his proposal) metacognitive, but these various pigeonholes constrain a freedom whose thrust is, willy-nilly, more nearly anticognitive. While Kant, like his contemporaries, recognizes that music is based on mathematical relationships that schematize the sonic spectrum, he also says that mathematics has "not the slightest share" in musical charm and affect (§53; A220).[8] Nightingales sing freely, not subject to rules, and their song gives more pleasure than any human music. Nightingales must be "unwillkürlich" (spontaneous; "General Note to the First Part of the Analytic," A73; the same word used for "Phantasie" in the *Anthropology*); if their song is consciously imitated, Kant twice writes, the resultant artificiality is profoundly disenchanting (§§22, 42; A73, 172–73). And so, Kant's praise of the spontaneity of birdsong leads immediately to the contrast of imagination and fantasy that concludes the "Analytic of the Beautiful."

An unremarked pun hints at the divide between the imagination

that orders perceptions and the free play of that other imagination properly known as fantasy. For the German word for the nightingale's song is "Nachtigallenschlag." In musical renditions by Beethoven, Schubert, Schumann, and Brahms, even the nightingale's song sounds like beats, often distantly echoing. But the true *Schlag* of the nightingale is not the mathematically regular imitation found in songbird songs. It is productive, not reproductive; "it seems to contain more freedom and therefore more for the taste than even a human song" (§22; A72), and its freedom, surely, leaves it more like a "Herzschlag," or heartbeat, than like a drumbeat. The true beauty of music belongs, after all, to fantasy rather than imagination.

Traditional "musical logic" seeks the inspired coherence of the work in a dialectical process proceeding from initial statement via developmental analysis toward a resolving synthesis. I associate it with the lucid clarity of the imagination, Coleridge's "In-eins-Bildung," or esemplastic power. Even the richly plural treatment of classical form in Charles Rosen's *Sonata Forms* evinces a bias toward unification: for Rosen, even tonal drift or denial of closure merely provides alternative kinds of "integration," which is his term for structural unification. Only in some works of Schumann is this book prepared to acknowledge an "attack on . . . the integrity of classical form" that is genuinely "inexplicable by classical aesthetics."[9] The last chapter of Rosen's later book, *The Romantic Generation*, then portrays Schumann as the hero breaking through the barriers of classical sense. Schumann here is the musician's musician, the true man of fantasy. He is likewise the hero of John Daverio's *Nineteenth-Century Music and the German Romantic Ideology*, which pivots on the Opus 17 Fantasie, understood as "a musical critique of the very idea of unity."[10] I would like to suggest, however, that Schumann did not so much break with musical tradition as consummate it, and therefore that he may not be as special as these accounts claim.

Suppose we take unity not as the substance of music, but rather as the foil for expression. While a Bach fugue, after all, displays the composer's constructive power, it revels in the ever-changing inventions of horizontal and vertical spacing and overlapping pulses. Haydn's jokes are not disruptions of form, but explosions of its potential. Mozart is being himself when he introduces a new theme at the beginning of a development section, as is Beethoven when he drops into a radically unexpected key. Musical thinking is not made by predictability, grammar, or logic, but by fantasy, and the extremity of Schumann's more daring works does not indicate that he

EXAMPLE 2.1A Beethoven, op.59, no. 2, first movement, mm. 11–14

EXAMPLE 2.1B Beethoven, op.59, no. 2, first movement, mm. 151–54

was rejecting his predecessors, but that enough territory had been occupied that it was harder for him to achieve results like theirs. Already the first movement of Beethoven's String Quartet, op. 59, no. 2, barely touches on the tonic chord. The cello finally sustains the root of a tonic only at the recapitulation of the second theme in the first group, but the movement drives to the dominant from the opening pair of chords, and dissonant overlays make the rendition in the recapitulation less stable than the version in the exposition, where the bass pedal is a B (Ex. 2.1a and b). Joseph Kerman thinks that performing the written repeats would clarify the logic: "If both repetitions in the E-minor movement were played, the compressed flow of ideas might sit in the ear less cryptically than it is apt to do in most current performances. The symmetry would have to be coped with."[11] The bias in favor of the mathematical imagination is evident in Kerman's invocation of symmetry. But I don't think this quartet shares it: the first ending at the second repeat undertakes a genuinely weird slippage down a minor

EXAMPLE 2.2 Beethoven, op. 59, no. 2, first movement, mm. 208a–208d

second that is anything but clarifying (Ex. 2.2). More to the point, we might not want to replace mystery with symmetry. Fantasy is what music is all about. Beethoven loved the fierce energy of minor-second clashes; there are some slashers in this movement, and they are no easier on the ear the second time around. Endings are difficult because in them music comes to rest, and that is not its natural forte.

Painting, arguably, does its job when it frames the continuities of the visible world to give them shape. But the job of music, on this account, is to shake up the mathematical regularities inherent in pitch. Of course, it cannot shake regularities up if they are not first recognized: it depends on the pitches to introduce harmonic and melodic surprises, as it depends on the formal models to destabilize them with ironies, to unsettle them with anxieties, or even to propel them toward calm. But it remains thought in motion, resisting teleologies as long as it can. Perhaps the most representative function of sonata-form repetitions is not to allow the ear to rest but to alienate the sense of logical progress.[12] As an eighteenth-century commonplace has it, while painting depicts, music moves.

POETICS: VERLAINE

Still, fantasy is not license. The fancy etches its visions with precision; it is a distinct mode of thought, not to be associated with vagueness or anti-thought. To a post-Romantic sensibility, fantasy comes tarred with the feather of impressionism, the exemplary art of fancy, especially in the dreamy soft-focus of the musically named Whistler's Nocturnes. In literary impressionism, too, much seems to imply a linkage of fantasy with the

dreamiest of reveries. In his poem "Harmonie du soir" Baudelaire writes of a *valse mélancolique et langoureux vertige* (melancholy waltz and dizzy languor), leading the musical reader to think perhaps of Musetta on Prozac. And in "La Musique et les lettres," Mallarmé writes of the "vibratory near disappearance" of natural facts, as if thinking of church bells in the fog. But freedom remains the goal, not the means.

Even in impressionism, the musical imagination that I am calling fantasy has sharp contours. The impressionists were craftsmen, first and foremost, and their mastery precedes their reverie. Careful students of impressionism have no reserves about the nature of its best practices. To take just one classic example, Jean-Pierre Richard concludes his massive study of Mallarmé with pages on the poet's "presque," but Mallarmé's ambiguities and approximations prove for Richard to be conduits toward a "total structuration" in which chance will be absorbed into a prismatic geometry.[13] Among scholars crossing the music-poetry divide, I could mention the brilliantly meticulous essays of David Code, as well as Elizabeth McCombie's attempt to specify what she calls the poetics of discontinuity in Mallarmé and Debussy in terms of a repertoire of particular Boulezian gestures—*éclat* and *explosion fixe, déchirures* and *intrusions*.[14] Fancy and its impressions do not make their mark if shorn of rigor.

But a focus on Mallarmé could stack the cards in favor of wit over fancy. Verlaine is a better test of the parameters of musical fantasy. For the signature line of Verlaine's "Art poétique," "De la musique avant toute chose," appears to proclaim that impressionistic poetry should bypass words in favor of sounds, subordinating meaning to sensation. The characteristic tracery is evident in lines like these, from Verlaine's poem "Kaléidoscope": "Un instant à la fois très vague et très aigu . . . / O ce soleil parmi la brume qui se lève" (A moment at once most vague and most sharp . . . / Oh this sun amidst the mist, rising). Most sharp, perhaps, but the vagueness washes over it, leaving uncertain whether it is the sun that is rising or the mist. But "music before everything" certainly means musicality within language— not music denying rhythm and grammar—for Verlaine immediately continues with his prosodic recipe: "Et pour cela préfère l'Impair" (and for that prefer uneven lines). Nor does the call in "Art poétique" for nuance and dream come dreamily. The traditions of poetry are to be wrenched into shape: "Prends l'éloquence et tords-lui son cou" (take eloquence and wring its neck). The demand on the poet is for more technique, not less. Speaking of his bugaboo, weak rhyme, Verlaine writes, "Quel enfant sourd ou quel

nègre fou / Nous a forgé ce bijou d'un sou / Qui sonne creux et faux sous la lime?" (What deaf babe or what mad black / forged this groat's-worth jewel / that sounds hollow and false under the file?). Verlaine's diction both soars and sinks—the latter, for instance, in the Anglicism "toute chose" and the piquantly anti-poetic "cela"—but never casually. He wants to use the file, not to discard it. His verse is, and has, pro-file. Indeed, the signature rhythm, the *vers impair*, is anything but free verse. Of the poem's thirty-six lines, all but one have a word break after the fourth syllable, and all but three of those have a caesura there. The rhythm is regular, the gesture decisive: a weighty first half-line, sometimes with four monosyllables of equal importance, offsetting a swifter second half-line with only two beats in five or (with a feminine ending) six syllables. The hold-and-release pattern is essential: the method, like the doctrine, entails not freedom per se but a determined liberation and discharge.

In sum, the vagueness that characterizes musicality and fantasy is an achieved effect. Hence, Verlaine calls for attentive supervision of the rhyme, for joining the indistinct to the precise. Vague yet sharp, musicality needs to be bracing, like a strong herb: "Que ton vers soit la bonne aventure / Éparse au vent crispé du matin / Qui va fleurant la menthe et le thym" (Make your verse an escapade / loosed to the wince of the morning wind, / smelling of mint and thyme). Verlaine's music can be languidly Swinburn-esque, to be sure, as in the well-known "Chanson d'automne": "Les sanglots longs / Des violons / De l'automne / Blessent mon coeur / D'une langueur / Monotone" (The long sobs / of autumn / violins / wound my heart / with monotonous / languor). "Flitting among the shadowy dead," decadence, in its full efflorescence, appears to be shorn of cadence, approaching "unheard sound," "opening vistas of music hitherto unseen."[15] But the sharp wind can just as easily pick up, as in the self-pastiche, "A la manière de Paul Verlaine": "Des romances sans paroles ont, / D'un accord discord ensemble et frais, / Agacé ce coeur fadasse exprès; / O le son, le frisson qu'elles ont" (Romances without words [the title of an earlier collection of his poems], With a harmony discordant at once and fresh, / Have vexed this mawkish heart on purpose; / Oh, the sound, the thrill of them). "Accord frais"—"frisson"—the quasi-echo, quasi-pun is poetic self-indulgence raised to the pitch of genius. Verlaine is hardly a difficult poet, and I don't know how much of the sharp wit in his languid effusions really needs to be pointed up. Suffice it to say that his impressionism does not succumb to the sensations of a moment but fixes them for an eternity. And thus, finally, "De la musique

avant toute chose" does not mean "music first" but "music foremost," not "before something else" but "above all."

The counterpole to Verlaine may be seen in the musical realism of Liszt in his symphonic poems.[16] To the extent that it suggests a narrative model, Liszt's genre label is misleading. Formally, Liszt's symphonic poems and successor works by the likes of Franck, Saint-Saëns, and Dvořák are episodic, their true models being not poems but certain musical predecessors, notably Schubert's Wanderer Fantasy and some of Beethoven's more picturesque and episodic works such as "Les Adieux" and the late string quartets. There are indeed affinities with the other arts, but chiefly when the other arts approach the dreamy logic of music, as does Byron's poetry, which is often as episodic as Liszt's music. The twelfth symphonic poem, *Die Ideale*, evokes atmospheric fragments rearranged from a philosophical ballad by Schiller, but the words elucidate the direction of the music more than the music illuminates the words,[17] and the poem finally proves less illuminating than the added section titles, "Aufschwung," "Enttäuschung," "Beschäftigung," and the concluding "Apotheose," which has no parallel in the poem. *Hunnenschlacht* (Battle of the Huns), the eleventh symphonic poem, is based on a painting rather than a poem, privileging color over story (the term in the score is "Kolorit") and rendering a battle without audible sides, until a chorale emerges to allegorize the Christian victory. Brief motifs permeate these works and provide a simple unity: an identity constituted by repetition rather than organic development. Conversely, the pseudo-narratives separate parts, thus creating an illusion of symphonic variety that falls short of a logic of connections.

But the symphonic poems are vitiated by their representational aims. A picture envy undermines the potential for musical fantasy. Swelling or subsiding energy, often scripted by Liszt's calls for tiny accelerations or retards, replaces actual development. The best known of the works, *Les Préludes*—again referring to a poem (in this case by Lamartine) that Liszt rearranged to suit his convenience—takes its initial motto from the "Muß es sein?" motif in the last movement of Beethoven's op. 135 string quartet, but renders it static by turning Beethoven's questing, minor-key sequel into a harmlessly pentatonic diatonicism.[18] Liszt was capable of fantasy in other works, and indeed in direct transcriptions of the music of other composers, but the symphonic poems, on the whole, figure in my argument as negative examples of a music that substitutes energy for pulse and tableau-like portraiture for the kind of fantasy that is music's riposte to the shaping spirit

of imagination. Their conduct is oratorical, pompously affirmative in tone, even though it is never in the nature of music to specify contents. But short of imputing irony to the sententious repetitions, it is impossible to align Liszt's compositions with Verlaine's impressionist fantasy. "Take eloquence and wring its neck" is Verlaine's line; the affirmative character of the symphonic poems has a stentorian grandeur innocent of Verlaine's wry bent. Of course, Verlaine often fell into a Liszt-like religiosity that reduced musicality to a cheering chorale.[19] And conversely, as Kramer has eloquently shown, Liszt at his most interesting, in the *Faust* Symphony, approaches imaginative realization full of the dark hesitancies of fantasy.[20] But the characteristic gestures of the symphonic poems surge forward too enthusiastically into the steady light of the ideal. Aiming at imagination, they betray fantasy.

MUSIC: MENDELSSOHN AND BEETHOVEN

Liszt has more in common with Mendelssohn than either composer was ready to acknowledge. They share fireworks, sententiousness, religiously tinged kitsch, bright fleetness with an inclination to the demonic that is, of course, common in Liszt and only occasional in Mendelssohn. These surface similarities suffice to set off the more deep-seated contrasts. For when Mendelssohn's genius emerges, it takes the form of a fantasy that defies logic. I will instance the Overture to *A Midsummer Night's Dream*, perhaps too easy an example for my case but still a good illustration of what I mean by fantasy. It is full of surprises of a kind too rare in Liszt.

The Overture is, of course, in perfect sonata-allegro form. After a brief introduction, the exposition consists of a tonic area composed of a series of themes beginning with the minor-key fairy music and continuing with march rhythms that come to be combined with a major-key variant of the fairy music, followed by a transition to the dominant that is securely approached by way of eight measures of its dominant seventh. The second key area features a lyrical, relatively chromatic love theme followed by the donkey music and a closing, fanfare-like motif. Predictable development and recapitulation follow, with the expected harmonic transformations, and phrases throughout are almost monotonously in repeated four-measure units, yielding a textbook example of Riemannian *Achttaktigkeit*. The music closes by returning to the introduction, replacing a Beethovenesque teleology with an equally recognizable, cyclical alternative. An image of "musical logic" remains audibly in place.

EXAMPLE 2.3 Mendelssohn, Overture to *A Midsummer Night's Dream*,
op. 21, mm. 1–8

But there is little corresponding process. What I have called themes are really more like character motifs. As in many opera overtures, the real aim is to set a mood or to define a range of moods; the overture is the foundation, not the building. *Thematische Arbeit* would undermine the nature of the enterprise. The motifs are tossed around, sometimes combined, never significantly transformed. But whereas, for instance, the similarly busy overture to *Così fan tutte* operates with a facsimile of sonata form, bandying about a motif even if not altering it, Mendelssohn's overture systematically confounds formal expectations. It begins with a curiously notated introduction, slow and unmetered to the ear but subsumed to the eye under the Allegro di molto designation (Ex. 2.3). Strings take over from the winds, and then are twice briefly interrupted by winds in turn. The fortissimo tutti march abruptly replaces the pianissimo fairy music, which proves in retrospect not to have been in the principal tonality of the piece but in the tonic minor. Displacement rather than development marks the entire work, in evocation of the superimposed worlds in the play. The retransition to the recapitulation takes a form that became almost standard practice with Mendelssohn of a relaxation toward stasis, sometimes followed by a quick crescendo, sometimes, as here, by a dissolve into the opening. Rosen quotes it in *Sonata Forms* (261) and says it "is not a climax but the lowest point of tension"; in *The Romantic Generation*, he calls it "an effect of extreme exhaustion after an access of passion" (583). Given that the quiet espressivo in measures 376 through 393 follows sixty-four measures of pianissimo

or piano, these narrativizations strike me as illusory. Tension, climax, and exhaustion are Beethoven characteristics that could not be more pointedly countered here. The movement simply falls asleep and dissolves back not into the first subject but into the introduction (which explains why the introduction is notated as part of the allegro). The final chord of the introduction motif is sustained for longer than in the opening, and the violins now overlap with the winds, but the shift to the minor is just as sudden as at the start (Ex. 2.4, mm. 390–404).

Fanciful transubstantiations replace the imaginative transformational process throughout. There is an anti-organicism that critiques the notion of identity as *Bildung*. The themes (or motifs) here are personae, not persons, and Mendelssohn's fancy brings the overture into a dream world of fixed extremes that displaces the daylight world of midlevel volumes and ongoing labor. That is how extreme speed can come to coexist with the motionless chords that begin and end the overture and also how major and minor can alternate without disorientation.[21] Fast or slow, the overture goes nowhere but rather exists in the delight of its moods. (So, for instance, the descending half-note scale motif first appears in measures 78–83, with four overlapping entries and every note marked with an accent. This is theatrics, not melody [Ex. 2.5].) The fancy lies in the dissolve of structure; music's appeal is in the joints more than in the flow.

One moment stands out from all this—or, at least performed as I envision it, should stand out. The recapitulation adds to the fairy music a set of punctuations. Pizzicatos had joined the continuation of the fairy music in the exposition; here the fairy music begins with a viola pizzicato note, echoed by an oboe pip two measures later, then, always at two-measure intervals, clarinet and flute half notes, then held low notes in bassoon and horn. The ophicleide in the deep bass comes next, yields to a drum-beat in the timpani, only then to return with an eight-measure low G (Ex. 2.4, mm. 428–36). The ophicleide solo is my favorite moment in the piece. Otherwise the instrument appears chiefly in forte and fortissimo massed sonorities (sometimes with the brass marked mezzo forte to keep them from dominating). The pedal tone here is unearthly, harmonically unproblematic but hermeneutically almost uninterpretable. Sonority typically belongs to character rather than structure, and the swampy buzz of the keyed serpent links the imagined, romanticized heavens back to the earthly flesh. But I call it uninterpretable because the dark fantasy flesh is only a challenge to the rational, imaginative order of recapitulation; the ophicleide does not

make a statement or enter into a dialogue. Instead, it punctures the fabric, reconstituting the terrain under the aegis of reverie rather than reason. It marks the perfect sonata form as merely the most delightful of Mendelssohn's illusions. Kramer has punningly adopted the term "scoring" for music's disruptive, attention-grabbing force.[22] That is the kind of listening encouraged by reorienting from imagination to fantasy.

Shakespeare weaves his fantasy around an ass named Bottom. In his spirit, I suggest, then, a donkey's-ear approach to the *Midsummer Night's Dream* Overture. As in the play, the most distinctive element in the music is the donkey's bray. Formally, this is the second theme in the second group. The entire second group is virtually ignored in the development section, and its main body is repeated measure for measure in the recapitulation. In that sense Bottom has a merely mechanical presence; his motif is not even first in its own section and it is impervious to any devel-

EXAMPLE 2.4 Mendelssohn, Overture to *A Midsummer Night's Dream*, mm. 390–436

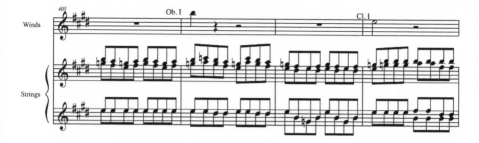

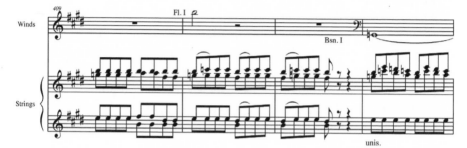

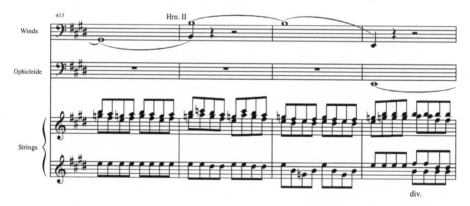

EXAMPLE 2.4 (cont.)

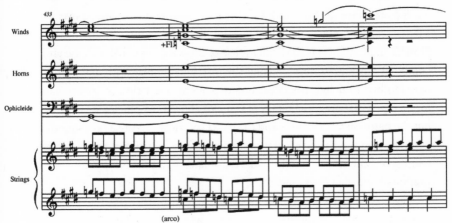

EXAMPLE 2.4 (cont.)

opmental logic. It remains in the ear partly because it can't be dealt with. But let its huge leap downward define an alternative hearing of the whole piece. Over the ophicleide buzz, for instance, wind notes pitted against the fairy music sink downward and spread out in length. But especially listen to the introduction and its later repetitions upside down. The first flute takes the lead, rising through a first inversion tonic chord. But the distinctive aspect is the increasing spread as instruments are successively added and the fundamentals move rapidly into the bass (Ex. 2.6). It is awkward enough at the start of the overture, and sounds perilous no matter how perfectly it is played. In the coda the oboes are omitted; the chord spacing grows more open, and a timpani roll with a swell is added, slightly unnervingly, on the dominant (Ex. 2.7). The music has stretched out temporally; it also stretches out spatially, but it doesn't exactly relax. Fantasy keeps it on edge.

The task for an interpreter or listener is to determine which way the edge of fantasy cuts. What categories are disrupted, what expectations dynamited? The notable absence in the overture is eroticism. The love theme proper has a quietly contemplative, hymnlike texture, and the only swell that might code an outbreak of passion leads abruptly to the donkey's bray. Upon its recapitulation, the pounding half notes with their comical fortissimo enter earlier, overlapping with the build-up. We know now what is coming, and it is only a delusion. There can be no genuine erotic union in this work built out of so many displacements. Many other elements of Shakespeare's play are omitted here as well: the rage, the tyranny of authority, the luxuriant exoticism. But if threats to selfhood are glossed over by Mendelssohn's fantasy, the compensation is a celebration of individuality. Notable, for instance, is the brilliant use of the winds in constantly varying combinations and textures, letting the instruments play with and around one another, in delightful, occasionally piquant sonorities. (Measure 434, for instance, elaborates a fantasy of C major above the ophicleide's G pedal, but the flutes on low C and G and the bass C pizzicato create a rare sonority while leaving the harmonic status shadowy—root position if the pizzicato counts, second inversion if the pedal dominates—and the Neapolitan function momentarily in suspense.)

The play of lights is never oppositional; indeed, by the time the overture concludes with a resumption of the initial wind chords the integration of major with minor has become naturalized as part of the work's vernacular (already as early as a passing I-IV-iv-I progression in a triumphant,

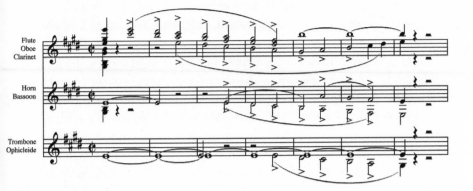

EXAMPLE 2.5 Mendelssohn, Overture to *A Midsummer Night's Dream*, mm. 76–84
(winds)

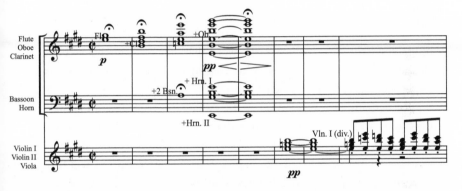

EXAMPLE 2.6 Mendelssohn, Overture to *A Midsummer Night's Dream*, mm. 1–8

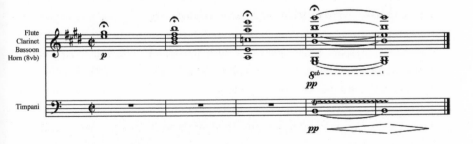

EXAMPLE 2.7 Mendelssohn, Overture to *A Midsummer Night's Dream*, mm. 682–686

unclouded fortissimo at m. 77). Regular symmetry and clear boundaries make character stand out with unmistakable definiteness, yet all kinds of fluid combinations and sudden illuminations become possible. Thus the whole principle of form is transmuted as desire yields to dreamy submission to the passing moment, as character (in the form of sonority) loses its positivity and becomes combinatorial, and as logic revels joyously in the perfection of its accomplishments. Mendelssohn mastered the art of the narrow escape; he can find the way out of any sonic trap. A light and sociable tone is constructed out of remarkably diverse elements, high and low, as with the opening chords, where the flute arpeggio projects social order, while the traveling bass line grounds it in diversity of identity. The hymnlike moments and plagal cadences may suggest a reverential or confessional attitude toward social harmony, but in the generally humorous context they can hardly be felt to imply a rigorous discipline. Mendelssohnian fancy is as alien to Adornian critique as to Ernst Bloch's messianic utopianism, though if Bloch had not been so fixated on intensities of expression, he might have been able to open himself to Mendelssohn's way of making light of formalism.[23] The word that echoes throughout Puck's closing speech in the play is "mend," and Mendelssohn behaves as if his very name had made him Puck's heir.

But perhaps an evocation of the fancy in early Mendelssohn is making too easy a case. Everyone knows that the *Midsummer Night's Dream* Overture is fun, even if it is not always so readily accepted that good cheer can be a quality of deep cultural significance.[24] Consequently, I will turn to a final example that probably has never been called a dream vision— Beethoven's Fifth Symphony. Yet I hear it too as a work of uncanny fantasy rather than of imaginative logic. The symphony is short and compelling, and some of the more interesting readings have pointed out numerous features that make it taut and tense rather than persuasively triumphant.[25] It fights its way toward its fabled logical integration.

Fantasy raises the question of the boundaries of the work, and the Fifth Symphony presents those questions with particular acuteness.[26] Apart from the two pastorally tinged symphonies in F major, Beethoven's symphonies all have some kind of introduction: 1, 2, 4, and 7 have formal slow introductions, 9 has its mysterious gestation out of silence, and even the heroic 3 has two preparatory chords. In all of these, it is easy to say where the introduction ends. There are frame and content, setting and substance, invitation and dance.

The Fifth Symphony is different. As its first movement is the shortest of the nine, so it is the most compact and inwrought in its utterance. And so it begins swift, yet with immediate fermatas, first on what might be the tonic but eventually proves to be the mediant, then an even longer fermata on a note evidently belonging to the dominant area. But only thereafter is the key definitely established as C minor rather than E-flat major. This much introduction passes too quickly, yet hesitates too much to establish a firm tonality. For a bit longer, the symphony might be thought to enact a more extended introduction, if at an eccentrically fast tempo, leading up to the well-prepared dominant in measure 21—a crashing orchestral chord (unlike the unison texture at the beginning, strings and clarinet alone)—though with everything dropping out from beneath, leaving only the isolated first violin G to be held through. Point of arrival, or only point of passage? In English we have the same word for both, "landing," depending on whether it is a boat landing or a staircase landing, and indeed the genius of the symphony lies in its willful confusion of the two. Then an urgent hush, rising to yet another climax, this one, however, already being the transition to the relative major key area and to the second subject, with unison horns landing solidly on the dominant of the tonic major. Finally, we have firm ground after the frenzied bustle of preparation, whether the first subject is decoded as preparations for war or as Machiavellian maneuverings in the palace.

In a noted essay on anxiety in the work, Joseph Kerman drew attention to the opening fermatas and to the frequent stuttering effects throughout, though to my mind he still did not articulate how thoroughly it problematizes the entry of music into ideas.[27] The dominant chord steps aside for a louder crash, strings and woodwinds together, though the trumpets and tympani drop out. And if the entire first subject is regarded as an introduction, what does that do to the balance of the movement? Indeed, it never quite finds its grip. Asymmetries ruffle the feathers of the second subject (Ex. 2.8). It comes in four-bar units, with the fourth measure always the point of arrival. The pattern is set by the horn call (mm. 59–62) and then supported by the regularly appearing motto in the bassi (with points of arrival in mm. 66, 70, 74). As notated by Beethoven, the melody is phrased 3+1 when it sounds in full, then 2+2 in measures 75–82, when it is reduced to its stepwise motif, but still with the motto and the feminine ending every fourth measure. The violins then reverse the large beat; their part (in mm. 83–93) is phrased 3+2+2+4, and the stepwise downward pair that had been

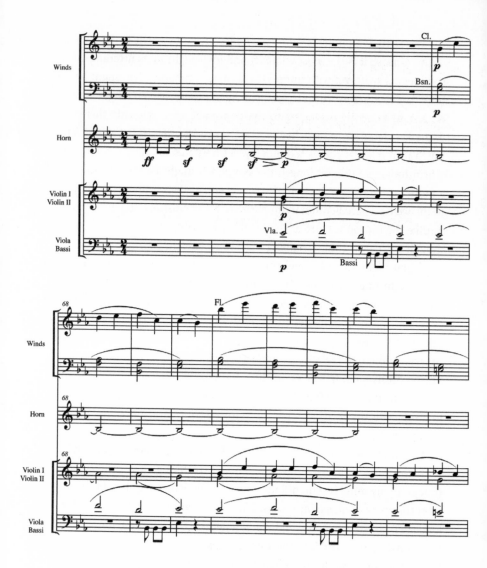

EXAMPLE 2.8 Beethoven, Symphony No. 5, op. 67, first movement, mm. 59–94

the arrival notes abruptly become the launch notes, starting rather than concluding the larger patterns. In a further destabilization, the crescendo lasts ten measures (mm. 84–93), with the violins playing the same figure four times, then varying it for an asymmetrical fifth to arrive at the next fortissimo crash. It would have been easy to cut two measures to balance the passage, but balance is precisely not the effect sought. Nor—to advance

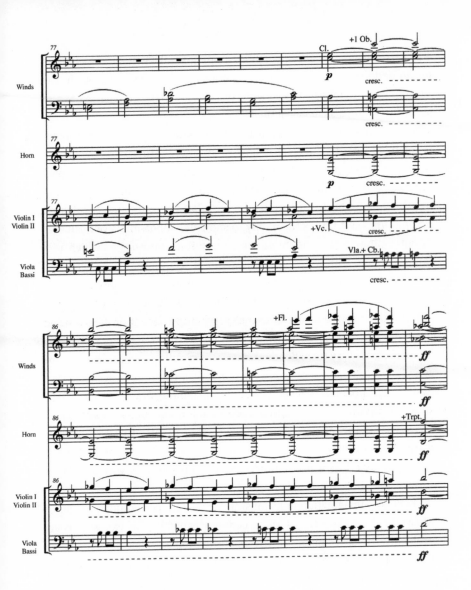

EXAMPLE 2.8 (cont.)

into the development—does Beethoven strike a balance in the long passage in half notes alternating between strings and winds (mm. 196–227), where the ear grows confused as to which voice leads and which follows.

The Fifth Symphony is full of obvious structural surprises, expressive clashes, and raw humor. It does finally end triumphantly, though the last-movement coda is notoriously reluctant to have done with it. But along the

way it is constantly pulling up short, tipping tipsily, halting the progress for an odd little oboe cadenza, a misterioso quickening (più moto in the slow movement) followed by a meditative relapse, many more fermatas and abruptly unended snatches of theme (in the scherzo), and the return of the scherzo in the finale. My reference to some details in the first movement is intended only to underscore how much more attuned the symphony is to questioning than to responding and settling doubts. In its compact intensity, it is a triumph of form, for sure; the blending of introduction and implementation brilliantly fulfills the postulates of Kantian or Schillerian organicism. Yet it fulfills them only to show the impossibility of form ever disentangling itself from the spooky, mysterious energies in which it is implicated and with which it is activated. If it seems ever on the verge of a grand statement, or even to be making a grand statement whose content is uncertain, that is because it never finds the proper way to open its mouth. It has Lisztian magniloquence in abundance, but the sententiousness is never beyond doubt. Liszt's own idealism flowers into transcendence, marking boundaries at every turn; Beethoven's idealism pulls punches nonstop. The symphony is as much a *dramma giocoso* as *Don Giovanni* is. It mixes Dionysian and Apollonian elements, shadow and light, storm and repose. To be sure, the mixtures that constitute successful form are not a smooth blend, the Kansas of the imagination. And the lumpiness that gives each work its distinctive expressivity can be both horizontal—an alternation of roles or, to adapt Hölderlin's word, of tones—or it can be vertical, with a polished surface covering a dis-ease beneath.

Fantasy—imagination in its musical form—is a questioning presence.[28] Musical answers come, if at all, in codas. Meanwhile, the expositions are problems, the developments analyses of the problems, and the recapitulations memorial reprocessings. And sonata style guarantees that the problematics of contrast will infect phrases and melodies even under the aegis of different large-scale organizational schemes. Musical erotics, as Kramer has tirelessly argued, destabilize gender identities, but the musical fantasy equally questions the claims of power, sociable ease, ethnic localization (forgetting the great example of Dvořák, think even of the tensions between color and form—Norway and Germany—in Grieg), historicism (since, given the impossibility of the continuous fabric of a timeline, the past must appear as an alien bloc), and any other concept it is able to propose. The underlying reason is the lack of a statement form to shore up against the restlessness of a pulse. The imagination proper operates upon

the counters of language; the fantasy operates outside them. Where fantasy doesn't audibly trouble the musical surface, the absence of trouble itself becomes problematic, forcing the questions: What means the repetitiousness of Beethoven's pastoral? What swirls within Debussy's sea and clouds? What is Steve Reich driving at? And musical mysticism (Messiaen, some of Glass, parts of Ives) can seem so powerful precisely because of its fantastic triumphs over fantasy, as the realism of Messiaen's bird calls—above all in the piano music—appears to wrest an impossible victory by reproducing and stabilizing seemingly unanalyzable noises.

Again, though, the Fifth Symphony might be the paradigm. Heinrich Schenker's monograph on the symphony opens with a careful argument that the opening motif is the complex of eight notes, two interlaced thirds, rather than the simple motto of the first four.[29] The argument is inevitably rendered uncertain because it depends on counting measures for locating phrase boundaries in a score where the caesuras make the count unrepresentable to the ear. But more significant is the mere fact that the point is arguable. The struggle to draw the line between motto and motif proves no line can be drawn. For so percussive a work, the musical contours remain disquietingly sinuous: the lyrical second subject of the first movement weaves in and out of its ascending and descending fourths; the triumphant ascending scales in the opening of the finale rise in waves of overlapping fourths; the eighth-note motif of the scherzo trio sounds its brief bass bursts in triple groups that resonate as 6/8 meter cutting away at the notated 3/4. The work's beating, its *Schlag*, would like to persuade us that it is drawing an imaginative picture of a *Menschenschlag*, a race of (heroic) men, but every little tic upsets the large tock of its grand clock.[30]

Musical fantasy is incisive in the etymological sense: it cuts gaps in the complacencies of logic.[31] For that reason, a fine account by Rainer Cadenbach has emphasized the destabilizing effects in the symphony.[32] He pairs it as part of a diptych with the *Pastoral* Symphony, expressing "Zeitvertreib," or whiling, as opposed to the *Pastoral*'s endurance. Both symphonies employ the precise fretwork of fantasy to ruffle the smooth currents of time. There is one work, however, that has outdone even Beethoven, though it is not a work any of us has ever been privileged to hear, or ever will. That is the Septet by the impressionist composer Vinteuil that makes its appearance in the last installment of Proust's great novel. Here is the narrator's description of Vinteuil's meticulously precise fantasy:

This music seemed to me something truer than all known books. At moments I thought that this was due to the fact that, what we feel about life not being felt in the form of ideas, its literary, that is to say intellectual expression describes it, explains it, analyzes it, but does not recompose it as does music, in which the sounds seem to follow the very movement of our being, to reproduce that extreme inner point of our sensations which is the part that gives us that peculiar exhilaration which we experience from time to time.[33]

This is what I take Deleuze and Guattari also to mean in the brilliant pages on music in *A Thousand Plateaus*. "It is not really known," they write, "when music begins."[34] So it is with Beethoven's Fifth, which begins before the beginning, or with the *Midsummer Night's Dream* Overture, which is full of undertones and overtones but never wakes up into reality, or indeed with the *Pastoral* Symphony, which begins and remains in the middle of a shoreless flow. The machined voice, the Mozartean zigzag, the delirium of Schumann's piano works—all the effects of the diagonal that make, for Deleuze and Guattari, Schumann's mad cello concerto the archetype of musical freedom—these are the kinds of effects I have been trying to evoke, linking music to a different kind of meaning that might rescue society from the tyranny of its principles.

⇛ 3 ⇚

German Romanticism and Music

NEXT to the riches of poetry, a classical aesthetic could only regard music as defective. Music could and did delight, but, lacking words, it could not instruct. Its role was secondary: it accompanied social occasions, decorated dramatic performance, moderated the courtly discipline of dance, adorned the home. A well-known line from Pope's "Essay on Criticism" (1711), even if not specifically about music, captures its derivative status: "The sound must seem an echo to the sense." Music was allowed grander functions as well, but the contexts were then supernatural: the perfection of numbers measured out the music of the spheres, the ancient modes commanded the passions with the divine (or potentially infernal) power of an Orpheus or a Saint Cecilia. But it remained peripheral to human experience. Lessing's comments about music, for instance, are scattered and incidental either to poetry or to operatic drama,[1] and for Kant music is either birdsong or "pleasure rather than culture" (*Critique of Judgment*, §53; A218). Only in the later eighteenth century, and chiefly in Germany, did music emerge as a human art worthy of being set side by side with the traditional Sister Arts, painting and poetry.[2] The equal dignity of music, in this case under the impact of Kantian formalism, is promulgated by Schiller in a 1794 review of landscape poetry by Friedrich Matthisson:

> There is indeed one generally loved and powerful art that has no other object than this very form of sensations. This art is *music*, and insofar as landscape painting or landscape poetry has a musical effect it is a representation of the power of sensation, consequently an imitation of human nature. In fact we regard every pictorial and poetic composition as a kind of musical work and submit it in part to the same laws. We demand from colors too a harmony and a tone and, so to speak, a

modulation as well. We distinguish in every poem the unity of thought from the unity of sensation, the musical stance from the logical one, in short, we require every poetic composition, in addition to what its content expresses, likewise to be an imitation and expression of sensations through its form and to affect us like music.[3]

Music here preserves its traditional nonconceptual status but converts it to transcendental advantage; logic is a limitation overcome by the pure voice of feeling or by hearkening to what William Wordsworth (in *Lines Written a Few Miles above Tintern Abbey*, 1798) called "the still, sad music of humanity." Schiller, however, hardly ever again mentioned music; his eloquent praise remained a promise for others to echo and develop.[4] In this chapter I will sketch some lines in the elevation of music to what E. T. A. Hoffmann called "the most romantic of all the arts, one might almost say, alone genuinely romantic, for only the infinite is its project."[5] I will emphasize discourse about music by Romantic poets and literary theorists, but will also briefly suggest perspectives from musical practice, musical experience, and philosophical aesthetics, as well as from the image of music in Romantic poetry and fiction.[6]

In 1797 the young friends Wilhelm Heinrich Wackenroder and Ludwig Tieck (both born in 1773) published a collection of small essays and sketches titled *Heartfelt Effusions of an Art-Loving Friar*; a second collaboration, *Fancies about Art* (1799), followed after Wackenroder's early death. These epochal, widely read works are appropriately the traditional starting point for German Romantic aesthetics, and they open this chapter because of their profound influence on thinking about music. The essays in *Effusions* are all about painting, but the work concludes with a fictionalized autobiographical narrative authored by Wackenroder, "The Remarkable Musical Life of the Composer Joseph Berglinger." *Fancies* is divided into two approximately equal parts, the first (mostly by Wackenroder) about painting, the second (half by Tieck) about music.

Much in these collections remains within the conceptual orbit of the Storm and Stress: the cult of genius, the emotional sublimity (especially in Tieck's essays), the exaltation of nature. Numerous Italian painters are portrayed in probing psychological accounts, as is the German Albrecht Dürer. Among the new or relatively new elements are an exaltation of the imagination, an emphasis (under the Enlightenment rubric of "tolerance") on the

variety of the productions of genius despite the uniformity of the ideal, and—in the sections concerning Italians—many expressions of Catholic yearning. Art and emotionalized religion go hand in hand, yet, especially in Wackenroder's contributions, sublimity is regarded as no more than calmly exalting, even being called "charming" at one point.[7] New tendencies combine with established, late-eighteenth-century sensibilities.

On music, the collections are dramatically bolder. While the sections on painting are a mixture of the old and the new, those on music are more radically innovative. Both Tieck and Wackenroder call music "the youngest of all the arts" ("Das eigenthümliche innere Wesen," P217 [W], "Symphonien," P242 [T]).[8] They sometimes evoke the ancient alliance of music with mathematics, but for the most part music is uncharted territory. Thus, while old painters and even Watteau are praised or blamed individually and at length in the two collections, not a single composer is named, though Mozart and Gluck were dead and could have been exalted without invidiousness, and certain older composers (Palestrina, J. S. Bach, Handel) were already classics. The painting essays mention "harmony" routinely a few times, incidentally refer to music as an art or a diversion, and report Luther's high estimation of music, but none of these forecasts the music enthusiasm; nor do some early passages on Raphael's Madonnas and his Saint Cecilia that some critics have linked to the *Stabat Mater* of Pergolesi that inspires Berglinger. In fact, as is not always appreciated, the turn to music in each collection remains decidedly abrupt and unsettled.

Within their brief compass, then, these collections touch on numerous topics, not always easy to reconcile, that would make music, for many, the distinctively Romantic art, standing high for Hegel, higher yet for Schelling, and on the summit for Schopenhauer. While Wackenroder's nominal spokesman, the friar, regards the sublimity of painting as contemplative and devotional, his fictionalized self-representative Berglinger is seduced by "the power of tones" and by their "frenzy," in a proto-Nietzschean jubilation: "he wanted [his soul] to dance off in wanton exuberance and to exult to heaven, its origin" ("Joseph Berglinger," 1, H132, 133, 131 [W]). The friar's famous slogan, *"superstition* rather than *system"* ("Einige Worte über . . . Toleranz," H89 [W]), is all but refuted by Berglinger's realization, "Yes, system begets in remarkable fashion many wonderful new twists and transformations of sentiment that leave the mind astonished at its own nature" ("Das eigentümliche innere Wesen der Tonkunst," P220 [W]). And while an essay on painting by Tieck attributes to music a merely ornamental delight

as the "accompaniment to the play of color" ("Die Farben," P191 [T]), his musical essays culminate—as if anticipating Beethoven—by calling for a "victory symphony" to "portray the future" at the conclusion of Goethe's *Egmont* ("Symphonien," P246 [T]). The marked cleft of tone and sensibility between the painting essays and the musical essays in these collections intimates a dramatically transformed understanding of the nature of art.

But the musical essays are also divided in themselves. Music may be the newest art, but it is also the oldest: "the earliest Greek and Biblical history, indeed the history of every nation, begins with music" ("Die Töne," P236 [T]). (In *Ideas toward an Aesthetic of Music* [1806], a posthumously published city-by-city survey of composers and performers, the Storm and Stress poet Christian Friedrich Daniel Schubart [1739–91] explicitly distinguishes "Tonkunst," the art of sounds, from the natural music of birds, which Herder and Rousseau had previously linked to the origin of language. "Tonkunst," Schubart writes, is "as old as the world": "Without a doubt the first human pair already sang."[9]) Music may be loud and energetic, but it also composes the soul toward conventional devotion, playing a large part not just in Protestantism but also in the Catholic conversion of a German painter described in one of Tieck's sections. Yet in contrast to almost everything said about painting in these collections, music is more than just affect and genius. Berglinger's life is divided into two chapters: the first concerns the power of music over his soul, but the second, which is quite different, concerns his professional accomplishments and growing alienation from the public. Whereas in the first chapter, music is affect, in the second it is in large part technique. The specialization that divides music from the more "natural" plastic arts becomes a frustration,[10] but it is also an opportunity: it liberates music from dependence on nature. That is why music can form the foundation of culture as well as its future. And the thrust toward liberation is repeated within the musical sections, for after numerous chapters devoted to music sung and played in church or (less prominently here) for dancing, the *Fancies* conclude with Tieck's "Symphonies," a paean to the new ideal that Richard Wagner later christened "absolute music." Song and instrumental music should not mix, but each should be "pure and distinct by itself" (P242). Sonatas and "artificial" (*künstlichen*, P244) trios and quartets pave the way for pure symphonic music, which should displace or supersede the other arts. Tieck disdains mere overtures and describes at exalted length a musical rendition of *Macbeth* that we would call a symphonic poem. (He implies the autonomy of music by describing the piece

as if it were imaginary; in fact, the description concerns a composition by Johann Friedrich Reichardt, who is best known today for his settings of Goethe songs.) On the way, a key paragraph echoes the Kant-Schiller view of art as the free play of imagination and parallels the exactly contemporaneous writings of Friedrich Schlegel in linking triviality with sublimity: "But in instrumental music art is independent and free, prescribes her own laws, fantasizes playfully and aimlessly and yet fulfills and accomplishes the highest aim, follows all her darkest drives and flirtatiously expresses the deepest and most wondrous things" (P243). Music belongs to the future (as in the hopeful first chapter of Berglinger's biography) or to the past (as in the tragic second half where, mastery accomplished, possibility is lost), but never to the present: "The splendid future has become a miserable present" ("Berglinger," 2, H140). (Music, says one of the characters in Jean Paul's novel *Titan* [1800], "is a *loud past* or a *loud future*"; 8th Jobelperiode, 44th Zykel.) Divided from painting, divided in itself, music distills the German Romantic aesthetic.[11]

The *Effusions* are often portrayed as the expression of an emotive religion of art;[12] in fact, they are much more mixed. Music is primitive and sophisticated, pure emotion and pure calculation, devotion but also sublime play—all things other than a mere reproduction or expression of the social and historical present. To be sure, Wackenroder and Tieck were not the first to attribute such contradictory tendencies to music. Similarly competing tendencies—a metaphysical rather than sentimental aesthetic, "classicizing" totality, Kantian autonomy, "Romantic" yearning, and art religion—can all be found in the work of Goethe's friend Karl Philipp Moritz (1756–93), in advance of more famous codifications.[13] But Moritz parcels his different characterizations out among different writings, whereas Wackenroder and Tieck bring them together in synthetic works and in pointed opposition to painting. Thereby they give a crucial new impetus to a nonutilitarian, potentially metaphysical view of music. In music as the founding and future embodiment of culture, imagination finds its ideal form.

In assessing the musical utopia characteristic of German Romanticism, it is salutary to recall the limited presence of music in actual life. Kant's deprecation merely reflected his experience; in Königsberg, a provincial city with an intermittent musical culture, his principal musical encounters were semi-professional readings hosted at the home of Count Keyserling.[14] (That J. S. Bach's Goldberg Variations were dedicated to Keyserling's father

says something both about the kinds of connections that could be made and about how thinly spread they were.) By the later eighteenth century, theaters regularly presented operas, which could be patronized by the public in major cities and at some courts. And there was music in church and sometimes at school. But composers through the time of Mozart were typically low-status court servants.[15] And except in a few capitals opportunities to hear symphonic music were very limited, while serious chamber music was generally restricted to domestic performance in noble houses. Of the music that for us defines the era, few would have heard more than the operas, the simpler sonatas, and possibly amateur renditions of piano reductions of the larger instrumental pieces. Second hearings to appreciate the music's formal qualities would be rarer still. Some writers were musically trained and talented: Hölderlin was a gifted flutist impatient with the amateur university orchestra in Tübingen; Kleist played the flute and the clarinet; Goethe was an amateur cellist and flutist who cultivated music and musicians around him, though he remained conservative in his musical tastes. Others, like Hegel, had no musical background and little ear. Another Königsberger, E. T. A. Hoffmann, did indeed become a prominent composer and conductor and a leading writer on music before he embarked on his literary career.

German Romantic authors knew about Haydn and Mozart and, typically, saw and enjoyed Mozart's operas. After the earliest years of the new century, they also heard about Beethoven's genius. But until at least the late 1820s, the great musical center was Vienna, far from the north German towns where the influential writers lived. (As Dahlhaus wittily puts it, theory was Protestant, while musical classicism was Catholic; see *Klassische und romantische Musikästhetik*, 91–93.) Nothing about music was routine. Published music was expensive to engrave and ephemeral on the market; professional performance remained heavily dependent on manuscripts produced by professional copyists, of whom the most famous was Jean-Jacques Rousseau, a successful composer and influential music theorist. To write his important review of Beethoven's Fifth Symphony, Hoffmann was supplied with orchestral parts and first had to prepare his own score laboriously from them. To be sure, Germans were proud of the renown of their composers throughout Europe and of the growth of musical culture in their cities. Music was becoming big business. Berglinger's reference to the "power" of music might imply its emotional force, but surely also the vastly increasing size and volume of sonic production, which many

would have experienced in the popular battle symphonies, even well before Beethoven's *Wellington's Victory*.[16] (In a review of Spontini's *Olympia* in the last year of his life, to clarify the issue, Hoffmann introduced a distinction between *das Gewaltsame*, like "the sudden discharge of thunder into deepest silence," and *das Gewaltige*, "intensification to the utmost."[17]) A Handel opera might call for six soloists and an orchestra of a couple of dozen, with many players silent for much of the duration; *Don Giovanni* has eight soloists, an active chorus, a virtuoso orchestra that can hardly be less than forty, and three stage bands requiring another twenty or so players.[18]

Power in the sense of volume might give music more immediacy. But even for those to whom the fashion of volume was not anathema,[19] the great music was felt to be almost superhuman. A reporter in the *Allgemeine musikalische Zeitung*—the dominant journal in the field—found it "a great piece of daring" when Beethoven's "colossal" *Eroica* Symphony was performed in 1807 in Mannheim (until recently a leading musical center) and expressed doubt that it could ever be repeated. A reviewer in the same volume found the first movement of Beethoven's Piano Sonata, op. 54—one of his smaller-scale sonatas—full of "wondrousnesses and bizarreries" and almost unplayably difficult.

Music was thus by nature the stuff of legend, or else a rare and precious gift or commodity. Even what to us would seem the most ordinary musical experience was readily charged with emotion. Something like the atmosphere that must also have prevailed in Germany is recorded in George Eliot's novel *The Mill on the Floss*, set in a small town in the years around 1830. The sensitive Philip Wakem says at one point to the heroine, Maggie Tulliver, "Certain strains of music affect me so strangely—I can never hear them without their changing my whole attitude of mind for a time," and she agrees: "*I* feel so . . . At least . . . I used to feel so when I had any music: I never have any now except the organ at church." And when the superficial Stephen Guest and Lucy Deane flirt over the music of Adam and Eve from Haydn's *Creation*, Eliot comments: "In the provinces, too, where music was so scarce in that remote time, how could the musical people avoid falling in love with each other?"[20] Combine the preciousness of music with the manifestations of its power and with the romantic aura surrounding Papa Haydn, the boy genius Mozart, and the daring rebel Beethoven, and you have the atmosphere in which an almost religious cult of an artistic ideal could readily emerge.

Indeed, the Jena Romantics soon invoked the mysteriousness of music

more routinely than Wackenroder and Tieck. Friedrich Schlegel's first published aphorisms, "Critical Fragments," allude occasionally to music, but never as much more than a joke. Subsequent fragment collections are less frivolous, though hardly more specific. The most substantial allusion comes late in the "Athenaeum Fragments" (no. 444); here Schlegel talks about thoughts in musical compositions and the self-created "text" in "pure instrumental music" and calls music "the language of feeling."[21] Schlegel's notebooks contain scattered references to music, often groping toward a place for music in a cosmic system of human intellectual life, but this is nothing special: countless other fragments grope for systematic orderings of many other intellectual enterprises. Some fragments are quotably mystical: "If *music* is the telluric basic art, then all language must dissolve back into music"; "The *world*, considered as music, is an eternal dance of all beings, a general song of every living thing, and a rhythmic current of spirits." A little of that sort of thing goes a long way, and there is not all that much in the vast corpus of the notebooks, nor in Schlegel's other published writings (for instance, the second book of *Wilhelm Meister*, according to Schlegel's review of Goethe's novel, "musically repeats the results of the first," producing a "harmony of dissonances" that "is yet more beautiful than music"; *Kritische Schriften*, 455–56). Evidently, Schlegel considered music a necessary component of an aesthetic system, yet in a fashion more auratic than specific. Schlegel reflects the utopian or nostalgic atmosphere around music—the *Stimmung*, to use the ancient pun evocative of Pythagorean world-harmony studied by Leo Spitzer—more than he contributes to it.[22] The same is true of Novalis, with even more mysticism and less system. The poet's "words are not general signs—they are tones—magic words"; "a fairy tale is a *musical fantasy*"; and (like Hoffmann and more pointedly than Schlegel), "our language . . . must again become *song*." Another topos shared with Schlegel is the role of dissonance: "Every nucleus is a *dissonance*." A similar formula, better known, occurs in the preface to Hölderlin's *Hyperion*: "The resolution of dissonances in a specific character is neither for mere reflection nor for mere pleasure." And musical eroticism pervades the fiction of Friedrich Schlegel (last chapter of *Lucinde*), Dorothea Schlegel (apotheosis of Saint Cecilia in chapter 18 of *Florentin*), and Novalis.[23]

Probably the most significant writer in this vein, however, was Jean Paul Friedrich Richter. As son of an organist and composer, Jean Paul enjoyed a more musical upbringing than some of the others. His *Aesthetic Primer* (1804, expanded 1813) is actually a poetics not a general aesthetics, so it

does not contain an extended discussion of music. But musical imagery is ubiquitous. For Jean Paul, music is the quintessence of Romanticism, regularly associated with indefinite infinity, genius, and *Stimmung*. But he had a pragmatic and exact strain as well, and the culmination of the main text (§86, "Wohlklang der Poesie") contains pages on the music of style that are very attentive to the specifics of prosody. In the mixture of the mystical and the concrete he foreshadows Hoffmann and, indeed, he deeply influenced the language of Hoffmann's music criticism, as well as the flamboyant irony and sentimentality in the criticism of Robert Schumann, in addition to providing the program for Mahler's First Symphony, *Titan*. The *Primer* itself came too late to have affected Novalis (who died in 1802) or Schlegel's initial writing, but Jean Paul's earlier novels contributed a number of episodes and images that helped to establish nightingale song and music played on romantic instruments like the religious organ, the folksy mouth harmonica, and the ethereal flute as the realm of transcendence, yearning, and passion. When the flute's "sphere-sounds seemed to surge out from the sun, which was dying as a swan does, rapturously in gold mist and in joyous dew in the red of dusk before God" (*Hesperus*, 38th Hundposttag), who could blame the hero for weeping tears of thanks? The example of Jean Paul's fiction, which was popular throughout the nineteenth century, precedes the related but mostly unpublished effusions of the Jena Romantics themselves and was undoubtedly more influential on the language in which music was talked about.

The polar tendencies of Romantic music aesthetics subsequently recombine in the work of E. T. A. Hoffmann. Hoffmann is not the only composer in modern German letters—Franz Grillparzer, Annette von Droste-Hülshoff, and Friedrich Nietzsche also wrote music of no great merit, and Kleist dabbled—but with a successful opera to his credit along with a large corpus of other dramatic, orchestral, chamber, and solo works in a harmonically up-to-date if structurally mechanical style, Hoffmann counts as one of the very rare, full-blown double talents. He also wrote many musical reviews and essays for the *Allgemeine musikalische Zeitung* (*AMZ*) and other journals (running to about 400 pages in the Winkler edition). The first two thirds, up until 1814, are discussions of publications; the remainder—mostly less interesting—are reviews of performances from 1814 until his death in 1821. Anonymous publication was the norm, and most of the reviews were attributed to Hoffmann only long after his death, along with a number of spurious attributions. But Hoffmann incorporated

less technical abridgments of four of the most important *AMZ* pieces into the dialogue "The Poet and the Composer" and the frame of *The Serapion Brothers*. Through these, and the well-known series of musical fictions beginning with "Squire Gluck" (also first published in *AMZ*), he made an enduring name for himself in the history of music criticism.

The reviews are typically descriptive and evaluative paraphrases of the music, with reasoned admiration or disparagement and illustrative musical examples. One can read more concentrated analytic reviews in several modern-day German newspapers and often in German program books; as with the *Effusions*, Hoffmann's remarkable achievement can be appreciated only by sifting his procedures and comparing them with writings by his contemporaries. One significant predecessor was Wilhelm Heinse, the Storm and Stress novelist to whom Hölderlin's elegy *Bread and Wine* is dedicated. Heinse's novel *Hildegard von Hohenthal* (1795) combines thinly plotted soft-core pornography with a veritable encyclopedia of eighteenth-century opera descriptions. Hoffmann in one essay refers with justifiable derision to its pedantry (*Schriften zur Musik*, 345). Yet Heinse's novel was both popular throughout the nineteenth century (Wagner was a devoted reader) and influential in the transmission of information about earlier operas that the author had conscientiously studied in Italy. With taste in advance of his principles,[24] Heinse painstakingly reports the qualities of each work, scene by scene and aria by aria, praising or blaming with an adjective or two and sometimes mentioning an isolated effect. Journal reviews of the period are little better and (until the founding of the *AMZ* in 1798) typically much briefer.[25]

The merits of Hoffmann's reviews jump off the page after even a small dose of his predecessors and contemporaries. Most of his reviews open with generalizing paragraphs: Hoffmann thereby encourages thinking about the music one listens to. Where Heinse offers an adjective to label the effect— charming, moving, masterful, etc., and often in the superlative—even Hoffmann's earliest reviews aim at the "character" of the music (often using that word). His focus is on the whole work, not on individual segments, as with the prayers in Andreas Romberg's *Pater Noster*: "The reviewer cannot refrain from going more deeply into the richly effective treatment of the various moments of these prayers, which expresses the above indicated character of the piece" (*Schriften zur Musik*, 31). Hoffmann's synthetic view leads him to introduce the phrase "musical drama" that had so great a destiny with Wagner, first in connection with a symphony by Friedrich Witt

and then, more prominently, in a review of Gluck's *Iphigénie en Aulide* (24, 64). Since dramatic character, in Hoffmann's sense, is expressed not by the words but by inward passions, it is as natural to purely instrumental music as to the more familiar vocal music. Thus, Hoffmann makes the case for Haydn's and Mozart's symphonies as, "so to speak *the opera* of the instruments" (19). Hoffmann led the charge in the preference for instrumental music over the typical (i.e., non-Mozartean) opera. Instrumental music has a different kind of meaning from vocal music: it expresses spirit (*Geist*), not feeling. When he writes in this vein, Hoffmann transcends the emotionalism of his predecessors.

In order to define the spirit of music, Hoffmann's earliest reviews sometimes resort to metaphor: "this idea of genius makes the effect of a cheerful ray of sun amid dark storm clouds," a theme "resembles a young, beautiful maiden who, in grief, instead of sobbing softly, yells and screams" (20, 21). But such pictorial language did not altogether satisfy Hoffmann, and in the review of Beethoven's Fifth Symphony he takes writing about music to a new level. (This important assignment was only Hoffmann's fifth known review for the *AMZ*; so quickly was his genius recognized and rewarded.) No longer is he concerned with the rhetorical effect on listeners, but with feeling his own pulse in response to the music: he "is penetrated by the object" and will "strive to put in words all that he has felt in the depths of his spirit at that composition" (34). The review, unlike the later abridgment, is rich in musical technicalities outlining devices that contribute to the dramatic unity of the symphony, and at the same time it emphasizes the profundity of the music's meaning. Phrases like "the realm of the infinite," "the magic of music," and "premonition of the infinite" (35) may sound today like cliché, but at the time they struck a radically new note in the response to music. "The inner structure of Beethoven's music" (37) is a phrase from the review that one might best relate to Wilhelm von Humboldt's notion of "inner form." Mystical and technical at once, music reaches beyond the logic of linguistic expression. Hence for Hoffmann the fundamental characteristic of music (all music, not just Beethoven's) is longing or yearning. By nature music is "romantic."[26]

In sum, Hoffmann's view of music is at once synthetic, hermeneutic, and mystical. Music—and preeminently wordless, instrumental music—becomes the prototype for a new kind of higher meaning. As such, it sets the standard for poetic writing. The key phrase appears in a review of Méhul's opera *Ariodant* (in 1816, to be sure, so after Hoffmann's initial suc-

cesses as a writer of fiction): in preference to *Singspiel*, or music interrupted by dialogue, Hoffmann writes: "We should find ourselves in the higher poetic realm in which language is music" (311). It is clear from this formulation how Hoffmann's career as a music reviewer launched his literary career. For his stories abandon the rational world of the everyday to aim at inner truth and higher power. With or without Kreisler, Gluck, or Donna Anna as characters, his stories and novels turn linear, earthbound experience toward a pure, spiritual communication. They make life into music.

Thus, one can distinguish three stages in the German Romantic image of music: mysterious yearning (Wackenroder), passionate desire (Jena), and finally transcendental intuition (Hoffmann). Hoffmann encapsulates all three stages in a sentence of his early story "Don Juan": "through love, through the enjoyment of woman, what dwells in our breast merely as celestial promise and what puts us into immediate relation with the supernal can be fulfilled here on earth" (*Fantasie- und Nachtstücke*, 75). Here, to be sure, the fulfillment remains a demonic illusion both for Don Juan and for the narrator, who is mysteriously visited in his box by the soprano who sings Donna Anna, but on the day of her death. So music remains a "distant, unknown realm of the spirit," a "Djinnistan full of splendor" (78).

The various tendencies in the understanding of music find abundant representation in the literary output of German Romanticism. While musical entertainment or consolation is common enough in earlier poetry and drama, as are lyrical evocations of birds and pictorial representations of divine or courtly music, there is no precedent (nor parallel elsewhere in Europe) for the profusion of music and musicians in the German writers.[27] One might well begin with *Faust* as a compendium of the older traditions that include hymn, ballad, incantation, devotional organ, music of the spheres, and mystical chorus, complemented by the din of the dawn in the scenes "Prologue in Heaven" and "Pleasing Landscape" but with only the most incidental and comic allusions to birds. (After the very early poem "Mailied," Goethe rarely mentions nature's music.)

Among the Romantics in the narrower sense, music is both nature and spirit (most abundantly both in Eichendorff); musician figures include both natural or primitive singers or bards and sophisticated composers and performers, inevitably either inspired or demonic, as are the virtuoso figures who include the Gypsy violinist Michaly (based on a real figure) in Clemens Brentano's story "The Numerous Wehmüllers and Hungarian

National Portraits" and the historical Paganini in Heinrich Heine's "Florentine Nights"; the effect of musical performance is invariably transporting. Folk song is of course an important inspiration; the word itself was coined by Herder (1744–1803)—the son of a church cantor—who as early as 1769 had associated musicality with language (*Fourth Critical Grove*) and whose collection of folk songs then inspired the Romantic period collection *Des Knaben Wunderhorn* and associated essays by Achim von Arnim and Brentano. Sociability is rarely if ever the topic, as it is in drinking songs earlier, in contemporaneous novels of manners, or later in the numerous visits to the opera in realistic novels.[28] Rather, musical episodes and figures negotiate the conflicting tendencies that challenge or controvert empirical experience and rational understanding. The contradictions find direct representation in Hoffmann's gothic: the mad composer Kreisler or the singer Antonie in "Counsellor Krespel," who is instrumentally embodied in the title character's violins and who is condemned to die from the perfection of her voice.[29] (A later story, "Das Sanctus," however, has a parallel figure who is redeemed.)

It is less often noticed that the contradictions of musical expression are just as likely to be represented in the forms of irony and even, redemptively, of comedy: Hoffmann's "The Poet and the Composer" is a defense of musical humor, while Eichendorff's comic novella "From the Life of a Good-for-nothing" and Brentano's satiric "BOGS the Clockmaker" are as authentic a reflection of the newly perceived complexities of musical experience as are the nervous ironies of Hoffmann's novel *The Life and Opinions of Murr the Cat* or the tragedy of Joseph Berglinger. The potential violence of music is the topic elsewhere, as in the figures driven insane by song in Tieck's story "Fair Eckbert" and in Kleist's "Saint Cecilia, or the Power of Music."

The three great achievements of Romantic philosophical aesthetics grew out of the currents of speculation I have already described, but they achieved greater resonance later and will only be cursorily mentioned here. The earliest published, Schopenhauer's *The World as Will and Representation* (1819), discusses music in the last section about representation. Music does not imitate objects or concepts but is "the objectivation and effigy of . . . the will itself." It is, "as if in abstracto, the essence," the "abstracted quintessence," the "heart of things."[30] Hence, it presents states of feeling in their pure form, not in particular instances. It precedes any specific representation; therefore, the music of an opera takes priority over the words, with Rossini as the quintessential melodist. Freed by its repre-

sentation from the terrors of actual experience, will finds its consolation in the pure objectifications of art. Schopenhauer's ideas about music tend toward the intense psychologism of the later century and indeed achieved lasting recognition only in the later writings of Wagner and the earlier ones of Nietzsche. Hegel's lectures on aesthetics (delivered 1820–26), published later (1835–38) but influential immediately, reflect admittedly limited knowledge and an exclusive taste for music that accompanies words, chiefly Mozart and Rossini.[31] Still, the work delivered two core Romantic ideas to the influential music critics of following generations: the view of music as sounding inwardness and the treatment of musical forms as dialectical tone structures. Finally, Schelling's aesthetic lectures (delivered 1802–3 and 1804–5, published 1859), though evoking little response, are of great interest as a formalization of the anthropology of rhythm developed in August Wilhelm Schlegel's 1795 "Letters on Poetry, Meter and Language." Dahlhaus argues persuasively that Schelling is paradigmatic in characterizing time as a constitutive expressive element rather than as a quasi-Kantian, merely formal category (*Klassische und romantische Musikästhetik*, 73–74, 248–56).

One might sum up the musical aesthetics of German Romanticism via Eichendorff's famous quatrain titled "Wünschelrute" (Divining Rod, 1835).

Schläft ein Lied in allen Dingen,	Sleeps a song in every thing
Die da träumen fort und fort,	That for e'er in dreams lies bound.
Und die Welt hebt an zu singen,	And the world begins to sing
Triffst du nur das Zauberwort.	If the magic word be found.

The sentiment here comes straight out of Hoffmann; Eichendorff could have read it in "Johannes Kreisler's Indenture" ("might the musician not relate to the nature surrounding him like a magnetist [hypnotist] to a somnambulist, since his animate will is the question that nature never leaves unanswered"), or equally well in "Counsellor Krespel" ("it seemed to me, when I first played on [this violin], as if I were the magnetist who is able to stimulate the somnambulist to proclaim her inner intuition in words").[32] The poem's distinctive music derives from the tense structure, with its sequence of differently inflected present tenses, surviving from the past ("Die da träumen"), projecting into the future ("hebt an"), unexpectedly declarative (initial "Schläft," in a syntax that would more typically be conditional, directed to the future), and an optatively colored hypotheti-

cal ("triffst du nur"). The voice is similarly dispersed: the unstressed "da" could point to a place, but it can also merely inject a spot of liveliness without specific location; "in allen Dingen" and "die Welt" suggest the wisdom of a seer, whereas "du," in the sometimes informal diction of this short song, suggests the intimacy of a friend. Hoffmann's formal pathos painting the soul-enhancing, soul-destroying powers of harmony is replaced by the immediacy of an executant sharing the flow of temporal experience. Causality is invested in mere succession ("und"), and the poem dissolves the boundary between sleep and waking (between the song in all things and the singing that begins, as between the overlapping enchantments of Hoffmann's sleepwalker and hypnotist).

The world comes alive through the breakdown of all dividing lines. From Herder forward, music was understood as the art of time, and Eichendorff's music lies in the fluid temporality of his manner, comparable to the "fluctuating life" Schumann praised in Chopin's waltzes or, in a different review, to the "poetic trait, something new in the form or in the expression" in each of Chopin's mazurkas.[33] Schumann's criticism regularly links formal individuality to expression, and it must be Eichendorff's innovative formal temporality, not the sensual surface, that led Schumann to compose a selection of his poetry at a time when Eichendorff was far less prominent than other poets Schumann set.

The musicalization of expression can take many forms in the rich textures of Romantic writing. Too many studies link music more or less exclusively to phonetic effects like Tieck's rhythms or Brentano's vowel harmony.[34] More telling are the counterpoint of theme and tone in Hoffmann's multilevel stories, the semantic extasis in the more daring formulations of Hölderlin or Goethe, the intersection of noise and sense (as with the musical opening of Tieck's farce *The Inverted World*), the aura of reverie that so often exalts feeling over meaning. One might find the telos of the tradition in Grillparzer's novella, "The Poor Musician" (begun 1831, published 1842), which transmutes a satire on content-free emotional aesthetics (the "musician" plays a music so pure that it is mere scraping to anyone else's ear) into a triumph of pity-filled nostalgia. Life dreams on and on; that is, it goes on and on, freed from the steering forces of rational enlightenment—such is the mood in which Haydn's whimsy, Mozart's genius, and even Beethoven's passion are felt to speak to the inner heart, transcending all the achievements and woes of the outer world.

I conclude with a passage from a draft review of Carl Maria von Weber's

opera *Der Freischütz* written in 1821 by Grillparzer, whose intimate involvement in Viennese musical life is attested to, among other things, by his authorship of a eulogy delivered at Beethoven's funeral. At the end of an era, Grillparzer sums up its message on this topic as eloquently as anyone I have encountered:

> This is the mark that distinguishes music above all other arts—that symphonies, sonatas, concertos are possible, that is, works of art, that, without denoting anything precise-definite, please purely through their inner construction and the accompanying *dark feelings*. Precisely these *dark feelings* are the actual territory of music. Here poetry must yield. Where words no longer suffice, tones speak. What shapes are unable to express, a sound paints. Speechless yearning; silent longing; love's wishes; melancholy that seeks an object and trembles at finding it in itself; vaulting belief; murmuring and stammering prayer; everything that goes higher and deeper than words can belongs to music. There it is unsurpassed, in everything else it yields to its sister arts.[35]

≋ 4 ≋

Negative Poetics

ON SKEPTICISM AND THE LYRIC VOICE

Never. Never. Never. Never. Never.

Das *kann* nicht sein, kann *nicht* sein, kann nicht *sein*.

No, no, no, no, no.

No, no, no, no, no, no.

L'expérience nouvelle dit non à l'expérience ancienne. . . . Mais ce non
n'est jamais définitif pour un esprit qui sait dialectiser ses principes.

Poetry is a game we play with reality.

Es ist gleich tödlich für den Geist, ein System zu haben, und keins zu haben.

WHO tells a poem? Whose voice is it? What is the relation of recitation
to citation? Foolish questions, one might say. Narration is a problem
for narratologists, not poeticians. Poems come from the heart. They are the
true voice of feeling. So said Sir Philip Sidney, at the birth of the English son-
net tradition: "'Foole,' said my Muse to me, 'looke in thy heart and write'"
(*Astrophil and Stella*, 1). Petrarch poured out his grief in song; Keats went
into the fields and warbled with the nightingale. It must be true; he wrote
about it in a letter. Poetry is utterance that wells up from the core of being.

So goes one account. On the other side lie equally powerful accounts of
poetry as the perfected craft of language. Poems are "fictive utterances"—
ideal objects, universal and hence impersonal.[1] Surely, not even Shake-
speare or Shelley wrote their lyrics on a lark. Poems do not pour themselves
into fourteen lines any more than water pours itself into containers. Just
look at Wordsworth's manuscripts, let alone Hölderlin's, with their obses-

sive, groping revisions. What speaks in a poem is Language itself (says the other side, in its most extreme formulation). Utterance is outerance, a voice from the beyond. The lark sings at heaven's gate.

Put in these terms, the debate is very nearly spurious. Capitalize the nouns, and the Core of Being becomes virtually indistinguishable from the Beyond. Emotions so pure and rarified that they become eternal float free of persons. The pure voice of feeling *is* the pure voice of language. Hence poetry cannot really be so simple, so uniform; rather, there must be a tension or a distance within lyric. Its very immediacy must be mediated. As Gottfried Benn writes in his best-known manifesto, lyric poets "are not dreamers, the others may dream, but these are utilizers of dreams. . . . They also are not actually spiritual beings, not aesthetes, they make art, that is, they need a hard, massive brain, a brain with eye teeth."[2] The distance of poetry—its hardness, its bite—is the subject of this chapter. For the poet is at once within and outside the poem. "I will fly to thee," says Keats, mooning to the nightingale, and then, four lines later, having lost his syntax, he exclaims, "Already with thee!" Rather then being fixed to a spot, poems are here and there at once—with us and with objects, with the speaker and with the listener, within and without. To the Grecian Urn, Keats says, "Thou dost tease us out of thought." And yet the utterance remains a thoughtful one, as he meditates or ponders the urn and its invitation to self-extinction. Artfully, Hölderlin offers his ode to Heidelberg as "an artless song" (*ein kunstlos Lied*). Such a poem—any poem of value—is doubly reflexive: it reflects a subject, and it reflects on it.

There are two voices in a poem. Too often, far too often, poem and speaker or poet and speaker are conflated. "The poem says," "the speaker says," "Wordsworth says." In everyday critical usage these three assertions become indistinguishable. But they should not be. Instead, there is a speaker and there is a poet who gives the speaker voice. And there is a poem, which is a combination of the two voices—speaker and poet. The speech and the voice that re-cites the speech operate in tandem to give poems their depth. Arnold Schoenberg invented the *Sprechstimme* or uncanny fusion of speech and song that contributed to the distinctness of some of his most striking compositions. My topic is not a fusion but a disjunction, which I mark in writing with a sign of separation: *Sprech-Stimme*. The object—or, if you will, the subject—of this chapter will be the doubling that, in my view, turns speech toward song and thereby constitutes the music of poetry.[3]

An occasional but characteristic tic of poetic language hints at the indwelling distance of poetry; namely, poets love to issue denials. Indeed,

lyric poetry bears a natural affinity to the negative. There is something in the transcendental character of the aesthetic, something in the purpose-lessness of its purposes, that encourages denials of the ordinary and the familiar. What Murray Krieger once, and powerfully, discussed as the "still movement of poetry" makes its eternities out of nonfinitudes.[4] "Thou wast not born for death, immortal Bird!" So, too, Sidney, directly after the instruction to look in his heart, writes: "Not at first sight, nor with a dribbed shot / *Love* gave the wound, which while I breathe will bleed" (*Astrophil and Stella*, 2). Not for nothing are so many of the best-remembered lines of verse negative in formulation.

> A maid whom there were none to praise,
>> And very few to love.

> No motion has she now, no force,
>> She neither hears nor sees.

> I cannot paint what then I was.

> I cannot see what flowers are at my feet.

> No, no, go not to Lethe.

> Bird thou never wert.

> Noch unverrückt, o schöne Lampe.[5]

Nor is it only Romantics, of course.

> Pace non trovo, e non ho da far guerra.

> Let me not to the marriage of true minds
> Admit impediments.

> So let us melt, and make no noise,
> No tear-floods, nor sigh-tempests move,
> 'Twere profanation of our joys
> To tell the laity our love.

Tears, idle tears, I know not what they mean.

Nothing is so beautiful as Spring.

That is no country for old men.

O dieses ist das Tier, das es nicht giebt.

Blüte des Primären
Genuines Nein
Dem Gebrauchs-chimären
Dem Entwicklungs-sein.[6]

Such examples could be multiplied limitlessly. From them it does not follow that the lyric is essentially or necessarily negative, a proposition that could be just as limitlessly refuted. Still, they do imply how the lyric conceals what lies closest to its heart. The ensuing commentary, arising out of three memorable poetic negatives, does not specifically concern negation, but rather a form of skeptical restraint that underlies and impels lyric negation. The negatives reflect, so to speak, the prosaic sobriety that makes lyric effusion possible.[7]

The epigraphs to this chapter, to be sure, are neither skeptical nor lyric. Instead, they demarcate the possibilities of lyric from without so as to lead gradually toward the topic. The first epigraph is a notorious climactic line from *King Lear*, thundered or thunderstruck with the violence of what I would call tragic negation. With more biting cleverness, the stance recurs in the second epigraph, an equally famous line from Schiller's *Don Carlos*. The third epigraph, perhaps a little less familiar, is again Shakespearean. In a play whose first word is "Nay," its multiple denials are addressed by Antony to Cleopatra on a stage crowded with attendants—although, not long before, Antony's lieutenant has called him "our courteous Antony, / Whom ne'er the word of 'No' woman heard speak" (1.2.229–30). *Antony and Cleopatra* is a play of tacks and jibes, inconstant as the wind and leading to belated and stagy apotheoses. While I will not make the whole argument here, I would call it a play of cynical negations. Again it could be paralleled: add a sixth "no" and you get a line in the opening aria of Mozart's *Don Giovanni* (the repetitions are only in the music, not in da Ponte's text): "No, no, no, no, no, no, non voglio più servir." (The libretto's first word is "Notte," and its first letters, consequently, "No.")

Next among my epigraphs is a powerful modernist call for a dialectical negation. "A new experiment/experience says *no* to the former one. . . . But this no is never definitive for a mind that knows how to dialecticize its principles."[8] As with the preceding epigraphs, the source of this one too, Gaston Bachelard's *Philosophie du non*, does not seem, on the surface, a skeptical credo. Still, the provisional character that Bachelard in particular attributes to dialectics helped motivate a great philosopher of science to become a great visionary of the human imagination. To dialecticize one's principles is to utter a "no" that is "never definitive." Understood this way, dialectic plays with reality from a knowing distance: a kind of skepticism powers Bachelard's dialectics, after all.[9] And a similarly rich form of skepticism likewise stands behind the memorable negations of lyric poetry.[10]

* * *

Ich lad euch, schöne Damen, kluge Herrn,
Die ihr zuweilen hört was Gutes gern,
Zu einem funkelnagelneuen Spiel
Im allerfunkelnagelneusten Stil.

~

I invite you, fair ladies, wise gentlemen,
Who betimes delight in hearing something good,
To a spanking new play
In the spanking latest style.

Such are the improbable opening words of Wilhelm Müller's tragic lyric cycle, *Die schöne Müllerin*. Franz Schubert, whose setting of the lyrics is one of his greatest masterpieces, omitted the prologue containing these lines and the matching epilogue. Lacking the framing ironies, the sentimental conventionality in the lyrics is easier to grasp, but harder to swallow. They sound self-indulgent in the extreme—emotional effusion of the most obvious sort, lacking thought. But Schubert found a better way to introduce the distance that evidently even Müller felt essential to poetic effect. The cycle concerns a love-sick lad who drowns himself after his lass is seduced by a dashing hunter. The song that speaks directly to skeptical negation has curiosity as its topic. By itself "Der Neugierige," on the brink of the brief flaming of love, generalizes too drastically to do justice to an individual destiny.

Ich frage keine Blume,	I ask no flower,
Ich frage keinen Stern,	I ask no star,
Sie können mir alle nicht sagen,	None of them can tell me
Was ich erführ' so gern.	What I so wish to learn.
Ich bin ja auch kein Gärtner,	I am no gardener,
Die Sterne stehn zu hoch;	The stars are too high
Mein Bächlein will ich fragen,	I will ask my brooklet,
Ob mich mein Herz belog.	If my heart lied to me.
O Bächlein meiner Liebe,	O brooklet of my love,
Wie bist du heut' so stumm!	How silent are you today!
Will ja nur eines wissen,	Just one thing I want to know,
Ein Wörtchen um und um.	One little word over and over.
Ja, heißt das eine Wörtchen,	Yes, is the one little word,
Das andre heißet Nein,	The other is No,
Die beiden Wörtchen schließen	The two little words enclose
Die ganze Welt mir ein.	My whole world.
O Bächlein meiner Liebe,	O brooklet of my love,
Was bist du wunderlich!	How wonderful you are!
Will's ja nicht weiter sagen,	I won't pass it on,
Sag', Bächlein, liebt sie mich?	Say, brooklet, does she love me?

"Ja, heißt das eine Wörtchen, / Das andre heißet nein. / Die beiden Wört-chen schließen / Die ganze Welt mir ein." Wilhelm Müller's youth does himself in by the strictest and most balanced of logics: leaving no margin for error, he longs for a perfected soul knowledge. Neo-Platonic shadings are muted in Müller's cycle, but they are surely present in the desire for a purified love vision mirrored in a clear brook and in pure colors and leading to a merging of the lover's self with his complementary other. But in lieu of fulfillment, the narrative offers only the fusion of deadly immersion in the brook. The dilemma is pitiless: love or hate, life or death, transcendence or condemnation.

But Schubert's setting (Ex. 4.1) transcends the pallid occasion of the verse. Its musical, lyric skepticism qualifies the definitive logic of the poem.

The music is notably hesitant, accentuating the negatives and pauses. The singer turns from "Blume" and "Stern" with the rising inflection of an unanswered question; he turns to the brook with a flamboyant variation (mm. 17–18) of the monotonous nonresponse, confined in its range, withheld by flower and star (mm. 9–10). Lest there be any doubt of the musical mimesis, "fragen" repeats the same notes as its long-distance rhyme word "sagen," but in rising rather than setting order.[11] Music in this tradition naturally moves from the home key (B major in this case) to the dominant (F-sharp), which is felt to be livelier and more intense. Though this song is through-composed, it behaves initially as if it were strophic by falling back to the tonic both at the end of the first verse (m. 12) and, after a more florid version of the dominant cadence (m. 20), at the end of the second, though now via a piano postlude (mm. 20–21) that temporarily holds back its resolution when it subsides. Conformity to an expectation becomes a drag on the music.[12] As the singer edges toward the fatal question, the music slows from "slow" to "very slow," and he is back in the tonic key, having gone nowhere. Rhythm and musical prosody now strongly emphasize what in the text is a merely incidental particle, a delusional "ja" ("will *ja* nur eines wissen"). When the real "yes" is uttered ("Ja, heißt das eine Wörtchen"), the rippling accompaniment pauses: the brook is silent when it should be sounding. The genre shifts from lyric to recitative and the expressive mode from mimetic (the rise and fall of question and answer, the purling brook) to dramatic (recitative, with swelling and then abruptly quiet dynamics), but it is a monodrama.

Schubert inserts a surprise at the negation, "Das andre heißet . . . nein," pointing up the moral with an abrupt shift of harmony into the remote key of G major. The hopeful affirmation of "yes" is undermined by the jarring slide harmonically upward into "no." Both words, the speaker says, enclose the whole world, but a sudden hush at "ganze Welt" again betrays the singer's anxiety. The music knows him better than he knows himself. The interlude in measures 35–41 is in the conventionally pastoral key of G major—also, in this case, the flat submediant (a minor sixth above the tonic), often favored by Schubert as a region of harmonic depressurizing—but here the key, so unconventionally arrived at, is another delusion: it remains in a parlando tone (almost exclusively one note per syllable and limited melodic contour), with the repetition of lines 15–16 of the poem marking the reluctance to come to the point. In another expressive detail, the added appoggiatura makes the melody at the second occurrence of "*schließen die ganze* Welt

EXAMPLE 4.1 Franz Schubert, D. 795/6, "Der Neugierige"

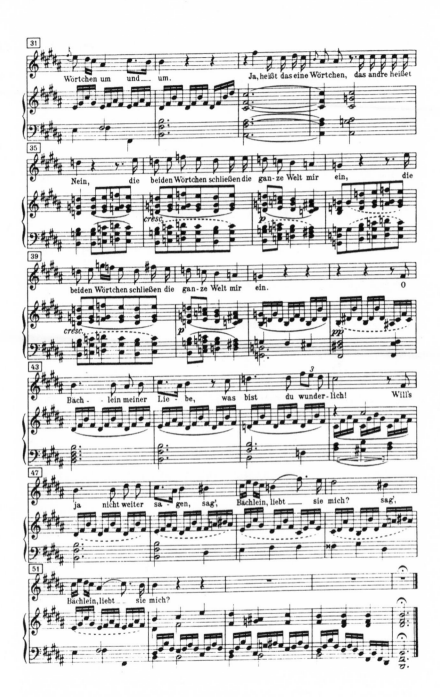

EXAMPLE 4.1 (cont.)

mir ein" identical to that at "wie bist du *heut so stumm*": the world's totality imagined by the inquirer is made equivalent to the silence of the brook.

Schubert's characteristically sad handling of the major key is crucial to the effect of "Der Neugierige." Minor-key colorations and descending patterns depress exaltations, while the harmonic resolutions that qualify the singer's bleakness remain subdued (*pp* in mm. 23 and 42) and come, in the first instance, with a hushed silence; in the second, with a very unusual and initially unstable arrival on a second inversion of the tonic chord.[13] His subjective involvement contrasts with the pensive music. As also often happens, the title becomes not a verdict exactly, but a wry and dispassionate characterization forming a silent part of the song's expressive strength.[14] Naming the speaker puts him in his place. One has a sense of always looking over the singer's shoulder; the musical articulation is a kind of entitlement to watch and to participate without being sucked in. At the end, the accompaniment subsides slowly into a murky depth, without a true cadence to resolve the suspensiveness of the song.

The whole cycle is composed of such extended moments of expectation, doubt, elation, jealousy, resignation, and finally despair. The poet seems to have wanted the plot to remain a symbolized essence: the easily inferrable true story of which the poems are condensed reflections. The stanza forms are resourcefully varied, yet the consistent poetic diction (as with the diminutives of "Der Neugierige") links them into its single psychodrama. The musical settings, however, heighten the contrasts of mood and supplement them in the middle of the cycle with radical shifts of key so as to pull plot apart. When even imitation is a mere and highly palpable convention, music disengages representation from its immersion in materialism and returns attention to the psychic ground of experience. The modulations of pacing and urgency, the repetitions and departures, the haunted echoes and the vexed crossings (from one key or tempo to another, between piano and voice, among dynamic registers) become the focus of attention. The moods emerge as the substance of life.

Thus does the music comment on the singer's self-pitying moans. Yet, as a nonsemantic medium, music replaces contradiction with the slowness of deferral or deflection. Yes and no are decisive in the poem "Der Neugierige," speculative in the song. (Indeed, even in its tragic concluding song, the cycle musically figures the death-plunge as a slow, repetitive lullaby. The key here is E major, an infinitely sad tonic functioning as a subdominant to the lover's B majors, the initial tonic of the cycle, last heard angrily

just three songs earlier).[15] The accompaniment separates feeling-tone from linguistic expression, while the formal musical structure envelopes the emotions with a reassuring placidity. In being spun out, the music gives the feel of suspension and wonderment. Song converts logic into mood, negation into hesitation, and hence dialectic into an existential skepticism—a *Haltung*, or stance, never definitive, at play with reality.[16] Song issues an invitation to observe with sympathy, to enter but not fall in, to remain open to the possibility that both circumstances and feelings might be otherwise without condemning them for being as they are.[17] In his book *Music and Poetry*, Lawrence Kramer introduces the useful term "overvocalizing" for "the purposeful effacement of text by voice," typically accomplished by "the disintegration of language by melisma, tessitura, or sustained tones."[18] And while his initial discussion of the "movement from the expressible to the ineffable" (135) suggests forms of ecstatic transport, the actual examples are first the word "sanft" in Beethoven's Ninth Symphony, and then the "exalted passivity, [the] supreme letting-go" at the conclusion of Schubert's song *Ganymed* (136). Overvocalizing of this more skeptical sort is found in countless effects of which the piano postludes of Lieder may be the most evident. Its most characteristic effect is to lay to rest the turmoil of immediate feeling.[19]

The particular dilemma of curiosity that seems to call for music is implied by Hans Blumenberg's study, "The 'Trial' of Theoretical Curiosity." Blumenberg describes the tensions in the Enlightenment between objectivity and interest and between collective and individual motives for inquiry. Starting from Voltaire's "economical skepticism" that seeks to rein in scientific hubris for prudential reasons, he traces a course to Kant's more rigorous, critical skepticism.[20] "Neugierde" hovers uneasily between curiosity and appetite. Blumenberg shows as much, but since he is digesting philosophical writings he does not put it in such emotive terms. For though philosophers and scientists were often sensitive to the tensions troubling the progress of knowledge, they were not poets. They left it to the poets to stand aside from utopian hopes and rigorist demands and to portray the human situations that both propel and encumber curiosity. The musical pacing in Schubert's song portrays how his "Neugieriger" fears the very same knowledge that he seeks. Presented as an adventurer from the start of the cycle, the lover falls into the pit of desire and deception that all curiosity threatens us with. It is left to the lyric overvoicing to rescue us from the dangers that beset him.

* * *

Die schöne Müllerin needs music to add density to the transparently emotional verse. Better poems have their own music. The great lyrics of the Romantics maintain a cool distance from the experience that they portray. I am not sure when a pure "Erlebnislyrik," or confessional lyric of experienced emotion, was ever successfully cultivated, but surely not in the era to which the term has traditionally been assigned. Romantic poets are practitioners of a wise knowledge of the emotions, and they know the reasons of the human heart better than it does itself.[21] Skepticism is, indeed, what saves them from narcissism. As an example, I choose a famous, seemingly pure nature lyric, by Joseph von Eichendorff. Writing about this poem forty years ago, I heard in it a Heideggerian immediacy in which what lies farthest from consciousness is closest to truth.[22] In the reveried and reverential voicing of earth resides a whisper of essence, disclosing the fundamental temporality of existence. That is what the speaker says. But his declamation now seems to me more a prayer than a confirmation, and I hear another and calmer voice behind his quietly fervent utterance.

Der Abend

Schweigt der Menschen laute Lust:	Silent is mankind's loud joy/desire
Rauscht die Erde wie in Träumen	As if in dreams murmurs the earth
Wunderbar mit allen Bäumen,	Wondrously with all its trees,
Was dem Herzen kaum bewußt,	What the heart scarcely knows,
Alte Zeiten, linde Trauer,	Old times, mild grief,
Und es schweifen leise Schauer	And gentle showers/shudders range
Wetterleuchtend durch die Brust.	With lightning through the breast.

Who—I now ask myself—who knows what the heart barely knows? And whose heart is it anyway? Between the plural of the first line and the singulars of the soul parts (heart and breast) lies a divided awareness. "Laute Lust" is perhaps best translated "clamor"—an emotion that faces both backwards in satisfaction and forwards in impatience, both tumultuous self-satisfaction and a thirsting *vox clamantis in deserto*, destined to be satisfied by the poem's heaven-sent moisture. It takes but one assured line of verse to silence the noise, or perhaps to conjure it up in order to wish it away. The bearer of the poem's assurance is, assuredly, not the same as the possessor

of the beating heart, since the former hears what the latter barely senses. But such a formulation polarizes too much an utterance better described as unfocused. There is a gap between the quietness of "leise Schauer" and the drama of "wetterleuchtend," but perhaps less an irony than a hesitation: lightning is here less than enlightenment, and softer than epiphany.[23]

What persists is the pervasive sense of uncertainty, the hushed mystery of tone. Yet there remains the overvoicing that screens off the intensities of personal involvement. For someone makes a judgment—"Wunderbar," a wonderful judgment in a tone that combines wonderment with wondering. The sly skepticism of this grammatically uncertain predication (German does not distinguish in form between adverbs and predicate adjectives) can hardly be overestimated. Is it an objectively wondrous rustling—a kind of natural miracle in the dark—or is it a subjectively wondered-at, total impression verging on deception? Maybe, in a poem where nothing definite emerges, there is nothing after all. Maybe, after all, Heidegger was wrong in his paeans to "das Geläut der Stille."[24] Indeed, however full of emotion the poem seems, no individual is actually specified in any way by the discreet plurals and generalizing definite articles of the diction. Negation here is reduced to "kaum," "scarcely"; it refuses to contradict, yet still pulls back from participatory self-involvement. The depth of emotion is something to be wondered with, but also wondered at, and without the skeptical wondering the existential wonderment could never be distanced enough to be sensed.

The lyric, that is, communicates both emotion and a knowingness about emotion. A poem is not a primal cry from the heart. The precision of utterance removes it from the immediacy of exclamation. But for all its artifactuality, a poem is also not a self-conscious reflection. Lyric disjunction is missed by theories of "Erlebnislyrik," lyric involvement by theories of ironic distancing. Eichendorff's "Der Abend" might fall into an easy irony if any thunder accompanied the quiet lightning, but instead it remains a hushed intimation, not quite rising to intimacy. The first line hovers on the brink of a social critique but holds off from articulating one.[25] The inversion of subject and verb in the first line puts silence strangely before the noise it interrupts; it thus hints at a deconstructive chiasmus, but the minimalism of the utterance forestalls any intrusive, self-undermining commentary. Conversely, while the same minimalism evokes inwardness, it nevertheless keeps self-indulgence at bay. In that way it resists the reductions to a kind of immediate self-absorption that Paul Fry argues for. Fry claims that poems accomplish precisely nothing, except to suspend the bustle of his-

tory and tune into the hum beneath; their permanence, he argues, arises from their resistance to history. Much in his readings is exactly notated—too exactly, indeed, for the generality of his conclusions. Rather, a poem like "Der Abend" performs a meticulous disclosure, not of the contents of any particular experience but rather of the attitudes with which we approach experience, compounded of wariness, observation, and the accompanying aestheticizing visualization. The aestheticization, however, is also a theorizing, illuminating with its quiet lightning the modes of encounter with the world. Irony, critique, deconstruction all come in for scrutiny by a poem that puts them all in their place.[26]

<p style="text-align:center">* * *</p>

An even purer, more thematic example of poetry's skeptical negation can be found in a famous Goethe poem, "Meeresstille," of 1796.

Tiefe Stille herrscht im Wasser,	Deep calm rules the water,
Ohne Regung ruht das Meer,	Without motion rests the sea,
Und bekümmert sieht der Schiffer	And the worried helmsman sees
Glatte Fläche rings umher.	Smooth surface round about.
Keine Luft von keiner Seite!	No air from no side!
Todesstille fürchterlich!	Dead calm, fearsome!
In der ungeheurn Weite	In the immense expanse
Reget keine Welle sich.	No wave bestirs itself.

The poem of stasis is full of both semantic and syntactic negations. Yet, as becalmed as its utterance appears to be, it lacks a direct propositional "nicht." Negation here has the character of suppression rather than denial. It remains hard to put one's finger on the featureless mystery of the utterance. The blank is unsettling, but what are the feelings? Though the ocean surface seems to mirror the helmsman's mood, the repetitious brevity leaves little purchase for a depth psychology. A classicizing pictorialism puts a damper on the terror.[27] In particular, the urbane term "bekümmert" underplays the strength of feeling asserted later in the poem. The helmsman is both central (looking around him to all sides) and yet distanced; the poem's view is from above or from around, not from within. For who speaks lines 5–6? Who puts the exclamation points on them? Is "fürchterlich" the expression of an emotion, the judgment of a state of affairs, or the narration

of a mood—fearful, fearsome, or fearing? Description blends with mono-logue, distancing both. After four verbless lines, the last line brings the only action verb in the poem, but "reget" is both indirectly negated and reflexive.

It is a poem in the middle voice, without a subject, without transitivity. There is something unruly about the uncanny scene, but an unearthly force keeps the lid on. "Regung," the animation insistently denied in the second and last lines, is trumped (in a pun no more deeply buried in the German than it would be in English) by the regency of the regnant divinity, "Tiefe Stille": motionlessness is both tyrannical suppression and anarchic disorder. The poem's skeptical overvoicing thus proceeds both in a vertical stratification of heaven and earth that suggests legitimate hierarchy and in concentric circles of breadth, man and nature, suggesting dissolution into the void. The dominant effect is that of the scene's potential—the power waiting to be unloosed—and the mastery of the perceiving conscious-nesses. One familiar term for this effect in Goethe is impersonality; even more familiar, perhaps, is objectivity. In the paired successor poem, "Glück-liche Fahrt," energy takes over, yet it retains its impersonalizing distance.[28] "Es rührt sich der Schiffer": he moves, indeed moves himself, yet the line is governed by "es." This poem concludes: "Es naht sich die Ferne / Schon seh ich das Land!" In the "ich," the two voices of helmsman and observer fuse, yet it is "die Ferne" that moves, not the persons: the reflexive, self-motivated action remains with the abstract distance, not with the human individual. Unrhymed in this second poem are terms for isolation: "zerreißen," "löset," "Ferne," and, as a tell-tale, "Schiffer." Joining is performed by the rhymester, confident of his rhetorical powers. The skeptical knowing consciousness rises above the scene as he brings the errant individual home.

* * *

The skeptical, depersonalizing, quietly commanding voice is that of the lyric poet. The aim of lyric poetry is to penetrate and control emotions. Its voice is compounded of wisdom and detachment, making all poems, to some degree, into *Rollengedichte,* or dramatic monologues.[29] What Helen Vendler says about Shakespeare's sonnets applies generally: "The author, who is arranging the whole poem, has from the moment of conception a relation of irony to his fictive persona."[30] Wordsworth is one poet often associated with a poetry of feeling, but his actual theory of poetic composi-tion is far more complex than that. Poetry, "the spontaneous overflow of

powerful feelings . . . takes its origin from emotion recollected in tranquillity," then the emotion arises anew in the mind. That already is complex enough, but it is only the starting point for writing poetry. For the emotion is both sustained but also "qualified by various pleasures, so that in describing any passions whatsoever . . . the mind will upon the whole be in a state of enjoyment." The poet must be careful to "temper . . . the painful feeling." Wordsworth's term for the skeptical overvoicing I have been describing is "caution." "Now, if Nature be thus cautious in preserving in a state of enjoyment a being thus employed, the Poet ought to profit by the lesson thus held forth to him, and ought especially to take care, that whatever passions he communicates to the Reader, those passions, if his Reader's mind be sound and vigorous, should always be accompanied with an overbalance of pleasure."[31]

We conventionally call lyricism haunting; the adjective names the poem's overbalance of pleasure and characterizes it as an aura. The aura is an added value; the haunting, that of a voice from outside inhabiting the speaker's role. Aura in this sense (which is, of course, not Walter Benjamin's) must be distinguished from magical notions of lyric as a music *within* the sounds of the poem, such as Northrop Frye portrayed when he defined "*melos*" as "charm."[32] The posthumously published Norton Lectures of Jorge Luis Borges, titled *This Craft of Verse*, exemplify all the poverty of a magical view of poetry, though they are finally saved from incantatory emptiness by the charming diffidence with which Borges refuses to define poetry's charms. "Somehow, though I love English, when I am recalling English verse I find that my language, Spanish, is calling to me. I would like to quote a few lines. If you do not understand them, you may console yourselves by thinking that I do not understand them either, and that they are meaningless. They are beautifully, in a quite lovely way, meaningless; they are not meant to mean anything."[33] This in a lecture entitled "Thought and Poetry"! Borges, it seems to me, is skeptical, but not skeptical enough. He is right about the limitations of cognition, but he avoids facing the ways that poems provoke us to think—and think skeptically—about our limits. Skepsis, in all its senses, is the value that lyric aura adds to consciousness.

However much the poems I have sampled may typify pure lyric utterance, it would take more than a few subdued lyrics to develop a richer sense for the force of a stance that objectifies without abstracting. In a more expansive discussion, I would choose poems from other periods and countries as well, ranging from the urbanity of Horace to the pious wit of

George Herbert, the orphic cleverness of Mallarmé, the guarded mysticism of Yeats, and the pseudo-mysticism of Stevens.[34] And the most thoroughgoing and multifaceted of all theories of skepticism is undoubtedly to be found in Goethe's *Faust*, whose presiding skeptic is Mephistopheles, the spirit of negation. All in one way or another can be seen to fulfill the criterion of lyric formulated by the author of my penultimate epigraph of this chapter, R. P. Blackmur.[35] Blackmur thinks of skepticism and like a skeptic, even though he doesn't use the word. Here is what he writes: "The edge between sense and nonsense is shadow thin, and in all our deepest convictions we hover in the shadow, uncertain whether we know what our words mean, nevertheless bound by our conviction to say them. . . . Words, like sensations, are blind facts which put together produce a sensation no part of which was in the data."[36]

But lest I conclude with only Romantic examples in hand, I will move toward a conclusion via an account of poetic composition by a recent American, James Merrill, who actually speaks of skepticism and of the formative power of skeptical wariness.

As for *belief* I've spent too much time trying to be of two minds—
because that seemed to be the most fruitful way of writing the poem,
and feeling about the material—I've spent too much time doing that
to settle permanently for one or the other, for skepticism or credu-
lity. I have been very skeptical, usually in the early stages; I've also
been extremely credulous at high exciting moments, simply because
there was not room left for doubt, there couldn't be—the excitement,
the thrill of the patterns you saw consolidating was such that you
did believe. But this is exactly what Yeats said: that in the heat of the
dictation you shape things instinctively, your experience gets stylized
in spite of yourself, kind of like the tulip that doesn't know it's grow-
ing. . . . I don't think that just because it turns out to be a system that
there's anything against it; it seems to me that everybody's belief is a
system of one sort or another.[37]

Merrill brings me to the last of my mottos. "It kills the spirit equally to have a system and to have none." Friedrich Schlegel's aphorism (*Athenaeum Fragments*, 53) has two meanings in the present context. First, lyric poetry is dialectical. No code without noise, but also no noise without a code. Expression and form, emotion and intellection, passion and wisdom

cannot exist separately within a poem. That is perhaps the defining difference from narrative, where sectioning is possible. *War and Peace* can end with a treatise on history, *Wilhelm Meister* can burst into song, breaking the mold of the form; but even concrete poetry and *musique concrète* are instinctively recuperated as representations of decadence or nonsense. Yet, second, insofar as Schlegel names an impossibility and not a capacity, he suggests that the poetic dialectic is unresolved. The sublimity of poetry does not arise from sublimation but from its opposite, a haunting irresoluteness. As the poetic utterance does not communicate *Erlebnis,* so too it does not arise from the inexpressible justness of orientation that Walter Benjamin's essay "The Storyteller" calls the wisdom of *Erfahrung.* The poet "knows better" only in the skeptical Socratic sense of portraying how far beyond any comprehension the emotions lie. The essential mystery of lyric is its way of being of two minds.

In making this claim, I part company with a long tradition. The belief that poetry speaks with a single voice has seduced many philosophers—above all Heidegger and his wake (Staiger, Blanchot, Agamben)—and persists into a more recent treatise on poetics that is destined to have a long shelf life, Susan Stewart's *Poetry and the Fate of the Senses.*[38] Stewart's book opens with images of transcendence. For her, poetic language brings "light into the inarticulate world that is the night of preconsciousness and suffering" (3) comparable even to "the figure of Christ as a light in the darkness" (12). While these opening pages concern plotted forms—the *Iliad,* the Bible, Milton's *Samson Agonistes*—later moments also speak of "a moving model of eternity" (242) within the lyric strictly speaking, in a model of achieved communication: "The poet *intends* toward another" (12), "Forms are a legacy from the dead and to the future" (252). I don't think that idealisms such as these can hold. So, in a sentence particularly pertinent to the present essay, Stewart begins: "Unheard melodies, things not yet imagined, selves unsullied by the world . . ." But the sentence immediately pulls back: ". . . appear only by means of their negation, only in a relation that is both historical and material." On negation we can agree, and perhaps even that negations are not limited to the historical and the material, that is, to the concretizations of a completed dialectic. For the passage continues: "However, they also draw us back from any paradoxical idealism regarding the status of the historical and the material" (252), and the fate of the senses remains, it seems to me, in question throughout the book.

Poetry's questioning is of the essence.[39] It has been overlooked by the

believers mentioned in the previous paragraph and by unbelievers as well. Poetic piety, as voiced by Heidegger, says that the poet "receives primal knowledge of what task is assigned to the poetic saying, what sublime and lasting matters are promised to it and yet withheld from it. The poet could never go through the experience he undergoes with the word if the experience were not attuned to sadness, to the mood of releasement into the nearness of what is withdrawn but at the same time held in reserve for an ordinary advent."[40] The tragic or melancholic mood raptly attributed to poetic experience by Heidegger seems to me part of the same conception that led a well-known classicist to criticize modern (i.e., post-Enlightenment) poetics: "As the name and idea of lyric in the past two hundred years have tended to take on the narrow connotations of solo poetry and *Erlebnisdichtung* ('poetry of experience'), so the name and idea of selfhood have increasingly come to define only the private individual in his inwardness or in his isolation from, his opposition to, his victimization by, the world outside him. That concept of selfhood, in a way, suits solo lyric in all times and all places."[41] To the defect of solitary lyric, the author of this quotation, W. R. Johnson, prefers the ancient choral lyric. Notorious, along similar lines, is Bakhtin's dismissal of poetry for its solitary character.[42] But rather than being absent, dialogue—or rather what Bakhtin calls multivoicedness—is precisely what the lyric counterpoint of roles provides. Whether called music, aura, or haunting, the interior distance achieved by lyric is an opening onto a dynamic mental space whose power has often been felt, even if rarely formulated. Still, it has often been intuited. "But what is Nothingness?" asks Georges Poulet about Mallarmé. "It is thought, any thought."[43]

* * *

Why should the words about life penned by a poet who wasn't very good at living be taken as persuasive insights about poetry? I wonder, but I also believe. Therefore, let the last movement of this chapter be guided by the presiding spirit of this book, Emily Dickinson.

> The fascinating chill that Music leaves
> Is Earth's corroboration
> Of Ecstasy's impediment—
> 'Tis rapture's germination
> In timid and tumultuous soil

A fine—estranging creature—
To something upper wooing us
But not to our Creator—
(1511)

Poetry's estrangements are not transcendences. Rather, they are antiphonal to the hymnic strains that regulate belief systems. Immersion in a poem or a song is not like participation in a choir. Nor is it much like the carnival body that joins the community in a festival celebrating release. In this way, a poem is more tensed than a novel, for its haunting refuses to settle into a comforting meaning or outcome. The best even Wordsworth can hope for is an overbalance of pleasure, a slightly tipsy, rocky sensibility, the dizziness of a Lucy, "Rolled round in earth's diurnal course, / With rocks, and stones, and trees." Poems occasion such motions, and they also stand outside of them enough to irradiate them, lucidly, lucily. Luckily.

≋ 5 ≋

Rethinking the Scale
of Literary History

De la musique avant toute chose
—Paul Verlaine, "Art poétique"

"**L**ITERARY history used to be impossible to write; lately it has become
much harder."[1] Such was Lawrence Lipking's opening salvo to a volume on literary history that I edited a few years ago. Despite the challenge, literary history undoubtedly enjoyed a remarkable revival in the past couple of decades. A number of multi-volume projects have been undertaken, such as the Cambridge and Columbia Histories of American Literature; *Literary Cultures of Latin America*, edited by Mario Valdés and Djelal Kadir; Cambridge Histories of Chinese and Japanese literatures, edited by Stephen Owen and Kang-i Sun Chang and by Edward Kamens; and the vast projects sponsored by the Comparative History of Literatures in the European Languages, currently published by John Benjamins. To be sure, these are collaborative works with many specialist authors involved. Lipking was focusing on problems of accountability and evidence confronting individual scholars. He was perhaps in agreement with an emerging consensus that literary history can only be assembled, not written.[2] Large-scale, single-author works have also appeared, such as Victor Terras's *History of Russian Literature* and Gregory Woods's *History of Gay Literature*. But they read even more like compilations than the collaborations do: a string of lives or works, animated by persistent themes or questions, yet disjointed. It hardly seems conceivable to recover the epic sweep of the great classics

of literary history—Taine, de Sanctis, Scherer—nor would many wish it.

Indeed, the New Historicism of the 1980s had appeared to turn literary history on its head. History was distilled into tiny incidents reflecting the irresistible pressures impinging on the creative intelligences. Time was to be sampled, not experienced. As Joel Fineman put it in a memorably irreverent essay, the anecdotal form so characteristic of the literary histories of that movement was intended—or at least ought to have been—to bring life to the past by resisting the totalizations of the grand, "Hegelian" historiography.[3] That is the spirit of the award-winning *New History of French Literature*, edited by Denis Hollier, and its successor, David Wellbery's *New History of German Literature*, written in short chapters dated to years and aiming to seize the past by moments. Still, as Fineman argued, anecdotes are rarely independent of the grander interest brought to them by the historian. It is easier to write a reduced history than an alternative one.[4]

This chapter responds to the concerns suggested by Lipking and by Fineman. It is intended to offer an approach for what individual literary historians might contribute to literary history. For an alternative to mere reflections or representations of ideological interests, I look to music, as a nonmimetic, nonrepresentational medium. The first half of the chapter reviews distinctive episodes in the theory of literary history over the past half century. While the approaches and materials vary, a buried fascination with music surfaces throughout. Following a pause for definition, the second half then moves toward examples of what the history of literature might look like from the vantage point of music.

LITERARY HISTORY

> As a determination historicity is prior to what is called history.
> —Heidegger, *Being and Time*

.

Published at a time when literary history was decidedly out of vogue, Paul de Man's essay "Literary History and Literary Modernity" was an important reflection on time and the literary experience.[5] While the essay—like much else about de Man's works and life—suffers from significant confusions, both its insights and its blindnesses make it a good launching pad for rethinking literary history in today's more receptive climate. It shows what was on the horizon and what remained beyond the horizon at the heyday of an anti-temporal structuralism. I read de Man as having tried, in a very

preliminary way, to restart thinking about literary history. He is instructive both for what he initiates and for where he falls short, as he pretty spectacularly does. De Man begins with "the latent opposition between 'modern' and 'historical'" (145). Aspiring authors want both to make their works new and to make them last. Aesthetic value abolishes time; to be the latest and best is to stake a claim that none hereafter may escape from your sway. Thus de Man laid out the quarrel between literature and history that was felt to be foundational in the era of New Criticism.[6] And his heritage remains with us, among those who believe that "the phrase 'literary history' has always been a species of oxymoron."[7]

In what may be his first extensive engagement with Nietzsche, de Man links the aesthetic to the ideal of forgetting in Nietzsche's essay "On the Use and Abuse of History." De Man might instead have turned to some of his favorite authors, Walter Benjamin or Jean-Paul Sartre. Either one would have provided a more self-evident image of the aesthetic as a reflective remoteness, which Benjamin calls distraction and Sartre, suspension. But de Man's enterprise here is better served by Nietzsche. For unlike distraction and suspension, forgetting establishes a relationship to time in the very act of denying it. Whereas distraction and suspension are constituted as aesthetic by looking aside, forgetting actively turns away. In the mode of Sartre's nothingness, distraction and suspension blank out time, but forgetting rejects the past in order to turn toward the future. Thus, the first impulse in de Man's Nietzschean turn is to transform literary history from a paradox into a dialectic.

Yet it was willful to draw from Nietzsche, as de Man well knew. For "The Use and Abuse of History" in fact has nothing to do with art. De Man confesses as much. "Nietzsche was speaking of life and of culture in general, of modernity and history as they appear . . . in the most general sense possible" (151). The writer's problem is fundamentally distinctive, "a special problem" (153), for "unlike the historian, the writer remains so closely involved with action that he can never free himself" (152). And so de Man arrives at an already recognizable de Manianism: the writer confronting his historical dilemma cannot quite face it, but "hides instead behind rhetorical devices of language that disguise and distort what the writer is actually saying" (152). (Rhetorical) hiding, however, is fundamentally different from (historical) forgetting; after using Nietzsche to construe literature as a dialectical negation, de Man then abuses him so as to construe the negation as mere rhetoric. Retracing Baudelaire's essay, "Le Peintre de la

vie moderne," de Man invokes its account of the painter Constantin Guys's fascination with "geometrical figures"; he boldly insists that this transparently literal description has a "radically metaphorical" character. He then pursues the tactic of emptying writing into rhetoric through an allusion to Baudelaire's word for Guys's activity of sketching, *sténographier* (shorthand); he literalizes it as "narrow" writing and then specifies the domain of narrow-writing as "the confinement of literature" (160). Literature is an unhappy consciousness that "knows itself to be mere repetition, mere fiction and allegory, forever unable to participate in the spontaneity of action or modernity" (161).

De Man's entire impasse, or aporia (the term of art he insists upon here and elsewhere), arises not from the matter itself but rather from the artifices of a contorted argument. Criticizing structuralism at a time when a passion for systematic, scientific order was at its height, he highlights the temporality of literary expression. Yet against the older positivism that still reigned, he preserves the ideal autonomy of the aesthetic by arguing, as he later would not have done, that "history is not fiction" (163, a position he has already reversed by the end of the essay two paragraphs later); for if history is not fiction, then fiction (in the sense of poiesis) is remote from history. De Man's skewed reliance on Nietzsche thus offers him a temporality that then turns away from actual experience in time. With its stress on "categories and dimensions that exist independently of historical contingencies" (167, from the companion essay, "Lyric and Modernity"), "Literary History and Literary Modernity" conceives literature as a historicity without history.[8]

De Man invokes history only to turn away from it again. It is easier now to imagine psychobiographical roots beneath de Man's resistance to history than it was at the time of publication. But whether or not there were deeper motivations for an attack on history camouflaged as a revival, the evasion remains as an indicative half-step forward. Yet few remain satisfied these days with the slender empirics of de Man's essays or with the stenographic narrowness of his canon. We want some history in our literary history.

De Man's essay is worth exhuming both for its precarious position and for the lessons of its nonchalance. It comes from a time when even historicity was difficult to recover, let alone history. And in the face of current criticism that often confuses historical information with historicist meaning, de Man's polarization gestures toward what I consider a proper hierarchy. Literature's historicity precedes its history and is found in what an earlier essay by de Man called its intentional structure—in the tense encounter of

the enduring and the new, of what is inspired and what inspires. The history of literature does not come to it from outside but is the sedimentation of its intentions.[9] No, literature does not forget the past. Quite the opposite, it remembers the past. And its memories are constitutive position-takings. An external, found history subsumes temporality into itself and relegates artistic expressions to the status of mere documents or representations. Although de Man's essay pivoted the wrong way in claiming that literature is ultimately fiction and untruth, it was pivotal in its revelation of the fundamentally temporal character of art. Literature is open to history because, first and foremost, it is open to time. Without the inner life of its works (Wilhelm von Humboldt called it their "inner form," meaning, I think, the same thing), histories remain large or small panoramas.

Such was the newest view of literary history around 1970. I move to consider the history that literature confronted in the 1980s.

HISTORY

> We normally think of space as a visual quality, as something we *see*,
> but we may speak of hearing space as well.
> —Hans Kellner, *Language and Historical Representation*

The end of history is its motive. Therein lies a puzzle—initially a puzzle for ends, but subsequently a puzzle for history as well. For a motive is a starting point, not a goal line. Motive and end, that is, fall together only by virtue of the pun or equivocation that allows us to take the end as a beginning. Their coincidence posits the end of history as purpose or intention rather than as result or outcome. The Big Bad Word is teleology. If we could only purify history of teleology, then we could aim at—no, better not aim at anything—we could hope for, we could arrive at, we could—what?—we could fall into an objective, value-free history. Knowledge could be emancipated from interest.[10]

If we could rid ends of purpose and motive, we would fall into history in itself—free-standing, over against us, an object of contemplation, pure and simple. What interest could we possibly have in that enterprise? History would be rarified nature—an aesthete's history, if only we could purge aesthetics in its turn of interest and purpose. It would not speak to us, but only show us—and it would not show anything in particular. Objective, value-free discourse is, finally—no, not finally, nor in the last analysis,

just *is*, happens to be—discourse without meaning. It is, simply, events in themselves. Events without distinction as to whether they are natural or cultural, for the very distinction of nature and culture is made in the effort to understand the nature—that is, the ends, the meanings, the purposes—of events. History as event does not need our help; indeed, it suffers from observation, let alone analysis. The minute we set pen to paper, creating history as story, as analysis, as discourse, that very minute history as event vanishes. Every name we give turns nature into culture, event into story, impulse into purpose.

That is why, in a certain sense, we are and must always be the center of our histories. They are told by and for us. "History is therefore never history, but history-for";[11] this is a truism, yet its force is often overlooked. History self-evidently has to be told in a language, the language has to have a meaning, and the meaning a destinee or recipient, and thereby it acquires an end, despite our best intentions. Hegel, the Big Bad Wolf of historiography, said it, I suppose, best. History must always center in the present and in those by whom and for whom it is told. Otherwise it has no interest and falls short of discourse. Hegel's historical narrative in the *Lectures on the Philosophy of History* ends with the Prussian state because that is the locus of the historian and his audience. (One can imagine a different specification of Hegel's here-and-now than the Prussian state; that is legitimate matter for exegesis and debate, but not the debate I am engaging in here and now.[12]) He does not mean, as is often alleged, that Prussia is The End of History, only that is the vanishing point and perspective of history as he is positioned to see it. The theoretical introduction of the *Lectures* concludes profoundly with the declaration that the past, "wie groß sie auch *immer* sei" (however big it is, my italics)—that is, the past, "always" growing and always haunting the present—is just as eternal in its way as "eternal presence" is, and in neither case can the eternity possibly be confused with any of its moments.[13] Teleology lies in the spirit—indeed, in the wake of Kant, teleology *defines* spirit—not in the matter.

While it may be obvious that history belongs to us and we to it, that still apparently has to be said from time to time. A signal instance may be found in *The Historian's Craft*, the wartime reflections of the great French historian Marc Bloch. Bloch had met people (aging high-school teachers) who would claim that the present is either a clear break with the past or else so entangled in it as to remain inexplicable, as if history could only concern gone-by times and must remain befuddled by the present. To them,

Bloch answers that our best means of knowing ourselves comes from (as he entitles one chapter) "understanding the present by the past." The motives for history lie in its present ends, and nowhere else. But how then might we know the past in order to gain leverage on the present? Only, of course, from its present resonances, from "understanding the past by the present."[14] It all circles around us, and must do so. The circle is not vicious, but it is hermeneutic in Schleiermacher's sense, dependent on intuition as well as on method to get it right. That is why history could never be a science, but always a *métier*, a craft.

In their lucidity, Bloch's reflections reveal the persistent problem. The nearness of the past troubles his high-school teachers, not its distance. It is too much with us: in order to circle, you have to get off the dime. Hence the historian's craft begins with his skill in putting distance between himself and his materials. It becomes an effort of sifting, first systematized by Leopold von Ranke in his meticulous source critique and, in Bloch's wake, enhanced by the quantitative study pursued by the postwar *Annales* historians. All we have of the past, says Bloch, are traces, and they must be cleared of falsifying overlays if we are to have any hope of a meaningful dialectic.[15] Corresponding to the equivocations on ends and on history, then, is a double aim of historical method. The divided character of the enterprise is enshrined in two time-honored formulas, to recover the pastness of the past and then to make the past present.[16] Find the matter, then find the meaning. Without the distance of the past, its presence would be merely empty. Far from being a despoliation of significance, positivist source critique enables an account of development. Its implied motto is the French proverb, "reculer pour mieux sauter."

Recast into Hegelian terms, the motto says that the historical in-itself can only be seen in the light of its teleology, "for us," while conversely its for-us—its sense—must be seized in itself, at a meaningful remove from the present. The complexity of the enterprise is often underestimated, even by those who go back to the Rankean source. Ranke's famous slogan, to know the past "as it actually was," is often mistaken for hubris, as if he were pretending to master it whole hog. He is actually a good deal more modest: the mildly colloquial, verbless German, "wie es eigentlich gewesen," expresses humility as much as pride.[17] Still, there is an aim, to show the forces linking the actuality of the past with the *actualité* of the present. In "eigentlich" there really are, as is often recognized, hints of possession, as if the past, brought into its ownness (*Eigentlichkeit*), will become a property (*Eigen-*

tum) of the present. But the ends have to be played off against the middle. Ranke, for his part, turns to God to juggle the tensions: history becomes for him an unfolding that is not merely a human expression of national spirits, but a cunningly transcendent revelation.

Facing the divide between past fact and present meaning, the more secular historians of the 1980s had to make do with an anxious self-examination. They replaced cunning with ironic deflation. So, famously, Stephen Greenblatt wrote of having his historical cake and eating it too. "I had dreamed of speaking with the dead, and even now I do not abandon this dream."[18] He took difference to be a ground for identification that is then rescued from hubris through dispossession. "But the mistake was to imagine that I would hear a single voice, the voice of the other. If I wanted to hear one, I had to hear the many voices of the dead. And if I wanted to hear the voice of the other, I had to hear my own voice. The speech of the dead, like my own speech, is not private property." A dynamic of sublimation in a tone of sublimity: it is hard to imagine a more deeply Hegelian sentiment than that. Yet for all its potential resonance, Greenblatt's formulation lacks Hegel's confidence in the centrality of the self or of the mind. His concluding, ironizing negative would have to be subsumed in its positive in order to find its Hegelian telos.

If speech is not private property, then whose property is it? Who, properly, speaks? Hegel's answers at various stages of his enterprise are clear; the suprapersonal—by no means anti-personal—voice is that of consciousness, the concept, or spirit. The fragmented postmodern ego, however, hears not a chorus, but noise. As result or as origin, cacophony subtends both ends of postmodern history.[19] Development relapses into difference, time into space. As Foucault writes: "Time became the foundation of space . . . creating a vacuum within the Same. . . . It is this profound spatiality that makes it possible for modern thought still to conceive of time."[20] The other is around and within. Anthropology and psychoanalysis magnetize attention; panorama and spectacle become self-sufficient goals. If we see the other, we see ourselves as the other's other. History in this mode dispossesses us of understanding.

I think we should resist the pull toward spatialization. Space is not a redemption or recuperation of time but a renunciation or even an abandonment. Seeing the ends of history in ending history, spatialization deludes itself. Rather than a correction of mistaken teleologies, it is (to use the Heideggerian phrase) a deficient mode of them. I will plead for a return to his-

tory, in antithesis to spatiality, as the form of human (humane) knowledge. In its spatial externality, the present (including present traces of the past) is a thing seen. The past is more ghostly and naturally imaged as a thing heard, such as the voices Greenblatt dreams of hearing. Its natural expression is within the concept or the spirit, not in material externality. It begins and proceeds in language and, preeminently, in writing.

The debate between space and time was played out in anthropology. Ethnography seeks to relocalize the so-called primitive within the present, typically by refiguring something like "the preliterate" as "the non-Western." Thereby, it struggles to respect otherness while making contact, to authorize a way of knowing that is relational without becoming possessive. Its temptation was, however, the furtive usurpation of meaningful, historical identity that James Clifford has deplored as a "relegation of the tribal or the primitive to either a vanishing past or an ahistorical, conceptual present."[21]

The spatializing urge dominates in the work of Clifford Geertz. I single him out because of his profound influence on New Historicist critics and to a lesser extent on other schools of cultural studies. Geertz's work was dominated by visual tropes. The great classics of ethnographic description make one "feel that one is looking through a crystal window to the reality beyond."[22] It is not by chance that the very definition of thick description borrowed from Gilbert Ryle instances eye movements.[23] The binaries of outside and inside pervade Geertz's writing, such as in the terms *experience-distant* and *experience-near* that he borrowed from Heinz Kohut or in the description of his abrupt acceptance as a "visible" presence in the village described in his famous cockfight essay.[24] The worlds he encounters are spectacles (*Local Knowledge* even carries an epigraph about drama from Denis Diderot's theatrical dialogue *Entretiens sur "Le Fils naturel"*), and he is their more or less comprehending spectator.[25]

From the pure performance theorist Erving Goffman (see *Local Knowledge*, 24–27) Geertz differs by wanting to understand meanings and not just strategies. The most literary of anthropologists, he draws deeply on imaginative writing and on literary criticism and in consequence has been fraternally received among us. (James Clifford's not infrequent use of literary texts and theorists seems almost incidental or decorative in comparison, though by no means inept.) While he appears most affected by highly systematic theorists, notably Kenneth Burke and Northrop Frye, more sustained engagements are provoked by the moral criticism of Lionel Trilling and Paul Fussell and by

philosophical aesthetics of the Suzanne Langer–Nelson Goodman variety, the arch-humanist discourses of the 1950s and 1960s. But the aims of Geertz's interpretations prove to be "generaliz[ing] within cases" (*Interpretation*, 26), that is, reinserting particular incidents within a framework of "broader unities or informing contrasts" (*Interpretation*, 453).

Geertz preceded Greenblatt in construing the anecdote as the core observation; the payoff comes from linking "the most local of local detail" with "the most global of global structure" so as to reveal "a total pattern of social life" (*Local Knowledge*, 69, 67). Eliding agency or intention, he wants to know not what this or that cockfight means, but what "the" cockfight says. Thick description returns theory to its etymological root as no more than going and looking.

In Geertz's world, and as a virtual consequence of his kind of visualism, history runs into trouble. Bali in particular—and Geertz's renown surely rests on his Balinese essays—is an unchanging world, "a motionless present, a vectorless now" (*Interpretation*, 404), not necessarily untouched by history but uncontaminated by it. Geertz forebodes change from outside but predicts resilience from within. History is the disrupted cockfight writ large. It is irrational, unpredictable, and, by definition, discontinuous, since any continuity signifies a coexistence within the larger present. "Culture moves"—if it does—"by disjointed movements of this part, then that, then the other, which somehow cumulate to directional change. Where . . . in any given culture the first impulses toward progression will appear, and how and to what degree they will spread through the system, is, at this stage of our understanding, if not wholly unpredictable, very largely so" (*Interpretation*, 408). If James Clifford will have us see history crumble into stories ("Identity in Mashpee," *Predicament*, 277–346), Geertz prefers to keep it at a comfortably seismic remove—too big to do anything about, too infrequent to insure against.[26]

Claude Lévi-Strauss, whose influence waned as Geertz's waxed, is the other side of the coin. Betrayed by his metaphor, Geertz accuses Lévi-Strauss of a bad transparency that sounds not so different from Evans-Pritchards's good one: Lévi-Strauss's "books seem to exist behind glass" (*Works and Lives*, 48). Structuralism is often berated for denying history. The charge is valid in other cases, but blind with regard to Lévi-Strauss, and with consequences that the rest of this section will pursue.

In *The Interpretation of Cultures*, Geertz charges that *The Savage Mind* "annuls history" (354). He is not wrong, but he mistakes a dialectical nega-

tion for a terminal one.[27] The discussion of history in Lévi-Strauss's book is a polemic, not a balanced formulation. Elsewhere, both early and late, Lévi-Strauss proclaimed the essential importance of history, even if his assertions tend more toward the olympian than the perspicuous. According to "Introduction: History and Anthropology," the early essay that opens *Structural Anthropology*, "everything is history . . . because only the study of historical development permits the weighing and evaluation of the interrelationships among the components of the present-day society."[28] He later repeats the credo in the peroration of *From Honey to Ashes*. "In stating the claims of structural analysis as vigorously as I have done in this book, I am not therefore rejecting history. On the contrary, structural analysis accords history a paramount place, the place that rightfully belongs to that irreducible contingency without which necessity would be inconceivable."[29] And in the shrewd interview-memoir that fixes the image he would like to leave behind, Lévi-Strauss declares that history and ethnology were once rivals, as his earlier texts reflect, but have since become complementary partners, as they should be.[30] Increasingly, he came to acknowledge and practice the "hope of using structural analyses to arrive at historical hypotheses" so as "to afford a clearer vision of the history of American communities and of the concrete relationships between them" (*From Honey to Ashes*, 355, 437).[31]

In Lévi-Strauss's accounts structure is spatial and discontinuous; history is temporal and continuous. The former appeals to the outer sense, the latter dwells within (see, especially, *The Savage Mind*, 256). History is known by, structure is known for; these are my terms for Lévi-Strauss's contention that history is conscious, structure unconscious. His books and his life-work are framed by pronouncements about structure, but if they are read in their details, from the inside out—even if the reading appears to other structuralists to be, indeed, inside-out—he can be seen probing toward empathy and understanding within difference. Hence his Terentian refusal either to declare superiority to "savages" or to salvage a disinterested, objectifying difference.

The juncture of two anthropologists helps to define a thesis about literary history. Geertz, a steady-state visualizer, is a deficient mode of Lévi-Strauss, whose structuralism is drawn toward history as its telic other. Geertz looks for patterns and calls them structures (he can be observed five paragraphs above using the two terms interchangeably). But pattern is another deficient mode of structure—the thing informally, without its dialectical rigor.[32] Space and time are a coordinate pair only so long as time

is counted, and it is the measures of history that Lévi-Strauss's attack on Sartre deconstructs in *The Savage Mind*. But both spatialization and measurement are deficient forms of time as energy. Dramatic space is a represented or signified unconscious, narrated time an expressed consciousness; both find their fulfillment in the conscious unconsciousness, the unsystematized significance, the articulated continuity that is music. Thus does the reconciliation of space and time, or of outer and inner senses, come in music. Music has always played a leading part in Lévi-Strauss's metaphoric expression, and its role in his own textual unconscious is crucial. To this dimension of experience Geertz appears not to hearken; Lévi-Strauss, while confessing to a degree of "incompétence musicale" (*De près et de loin*, 245), finds himself ever more drawn to it, as the intuited, unconscious medium and goal of his studies.[33] In another essay it might be appropriate to consider more fully the implications of music for structuralism. But here my topic is what music means for the unwittingly structuralist historians who wished to displace Lévi-Strauss but only succeeded in occulting him. To put it in a nutshell, literary history is the unheard music of cultural studies.

LITERATURE

> The mind of man is fashioned and built up
> Even as a strain of music.
> —Wordsworth, *Prelude* (1799) 1.67–68

But what is literature? New Historicism has aged, but its questions and challenges linger, and the last year of the twentieth century, when this chapter was written, brought a number of books seeking to define literature and defend its place in the university. To define, as Tristram Shandy memorably says, is to distrust. While the urgency of tone varies, all seem worried and some positively panicky. Literature has become "an embattled profession."[34] We are present at the "dismantling of literature."[35] The study of literature is threatened on one flank by what Bill Readings has called the techo-university—"The New Technology Calls All in Doubt" proclaims one of Alvin Kernan's chapter titles—and on the other by that sometime ally, sometime rival called cultural studies.[36] Our vocation is embroiled with a crisis.

Crisis is nothing new, to be sure. Literature departments have been in turmoil as long as I am able to remember. Maybe we should finally decide

that a modicum of crisis is useful. Self-evidence is an opiate; we benefit from pressures to consider and explain what we think we should be doing. One sign that we do not simply run in place is that the name of the crisis changes periodically. Even though I can't prove that the crop of books is more than a chance occurrence, I propose in this section to reflect on what we may learn from presuming that the current name of the crisis is literature. Something draws us to it, and yet something is wrong with the orientation of the magnet. We can use the crisis, or apparent crisis, as the fulcrum of a turning point.

What is literature?[37] The question is an old one. As background to my book selection, it is instructive to return to a time when literature named the solution and not the problem. For, celebrating the Liberation with a powerfully influential book on the topic, *What Is Literature?* (1947), Jean-Paul Sartre began with one certainty: Literature is not music!

Literature, according to Sartre, was not music and, then, for the same reason, not painting. "Notes, colors, and forms are not signs."[38] "The painter is mute," and while the musician makes sounds, his sounds have no meaning and hence no endurance: "the signification of a melody—if one can still speak of signification—is nothing outside of the melody itself. . . . It will always be over and above anything you can say about it" (*What Is Literature?* 4). Writing, by contrast, is engaged. It addresses readers, and in so doing it liberates them from bondage to their situations. Even the greatest or most committed painting—Picasso's *Guernica*—is mere "emotion become flesh" and hence "unrecognizable, lost, strange to itself" (5), whereas writing appeals to readers to find and make its meanings. Writer and reader become free "collaborat[ors] in the production of [the] work" (40). Together they produce an "aesthetic joy . . . a transcendent and absolute end" (52). Unlike self-regarding Kantian formalism, Sartrian absolute freedom belongs to real writers and real readers in real situations. The writer is ahead of his time, but "ahead" is a distinct relationship to it—a more strenuous version of Nietzsche's forgetting. And so, after having written chapters called "What Is Writing?" ("action by disclosure," 17) and "Why Write?" (to engage in this difficult, free, generous spirit), Sartre gets on to his main business, "For Whom Does One Write?" and "The Situation of the Writer in 1947."

"For Whom Does One Write?"—the crux of *What Is Literature?*—is an extended essay in literary history. In bold gestures yet impressively modulated detail, it narrates the evolution of the writer's freedom from the ancien

régime to the Enlightenment, the Revolution, and the bourgeois era. In every period, the writer operates as the *"guilty conscience"* of the race (75). Even in his most characteristically accommodating guises, when he merely mirrors the world around, the writer provokes reflections and destabilizes the world he aspires to join. By virtue of being *of* his time yet addressing himself *to* it, the writer maintains his independence through effective action. Short of a "utopian" regime of full self-consciousness in a "society without classes" (154), the writer's proper goal is *"renewal"* through "spiritualization" (152). Hence, though Sartre's historical world-picture comprises a traditional set of well-defined stages, they project a sense of continual change that he denominates "perpetual revolution" (75).

Can the activist conception of the writer function as a model for today's literary history? Unfortunately not, to my mind; rather, it is a warning example. For what was introduced by a theory of writing and engagement eventuates in a history of disembodied Literature. As a "magician who frees himself from history and life by understanding them" (136), Sartre's writer has only a phantom agency and rejoins history only by "miracle" (99). Such themes permeate and subvert Sartre's account. In the real world, "books are inert" (262), and so "almost in spite of himself, the mirror which he modestly offers to his readers is magical" (89). He reflects society, but only as a vessel or abstract consciousness; the true agency is not writing but Literature, abstractly personified. "Hence, literature . . . became conscious in him and by him of its autonomy. . . . Literature suddenly asserted its independence . . . it identified itself with Mind" (96–97). Writing does not embody literature but impedes it. Since "the literary object, though realized *through* language, is never given *in* language" (38), "the materiality of the word and its irrational resistances" turn out to be the writer's curse. "He radically distinguishes things from thought" and in consequence "has always had a special understanding of Evil, which is not the temporary and remediable isolation of an idea, but the irreducibility of man and the world of Thought" (108). The writer's story is a tragic one, culminating in Gustave Flaubert's solitude; hence the grim compromises that the long last chapter about the writer in 1947 imposes on its addressees, as it exhorts them to master the media and "squelch our scruples" (262). Writing remains existentially powerless.

What has gone wrong? An element that my summary skipped over contains the essential clue. For after excluding music and painting, Sartre declares that genuine writing—literature—is also not poetry. The triple

exclusion—with music as the root and poetry as the climax—dooms the enterprise. It may be that poetry was inherently too old for Sartre.[39] It may be simply that the French poetic tradition, as he encountered it, offered too much bath water and not enough babies. But in any event, *What Is Literature?* inevitably fails as a history of literature for the reason that it limits writing to its mimetic dimension: it becomes a history of writing situations and not of writings.

The poet, says Sartre, encounters words as things; the prose writer, as names. The poet is "a pure *witness*," whereas the prose writer affects what he portrays: "anything which one names is already no longer quite the same; it has lost its innocence" (16). Sartre never quite confronts the contradiction that flows from this initial premise. For the realm of ideas and the world of thought need to preserve their utopian strivings and their spiritualizing tendencies. Loss of innocence corrupts the writer as well as his objects: "Naming implies a perpetual sacrifice of the name to the object named, or . . . the name is revealed as the inessential in the face of the thing which is essential" (6). The year 1947 was not a time of miracles, or at least not of miracles wrought by the magic of naming. Sartre confuses an aesthetic freedom-from with a political freedom-to; he condemns the former as mere Kantian "play" (41), yet wants to tap its resources. Maybe he was telling the truth in professing to love poetry so much that he wanted to keep it pure from the filth of modern times (5–6; *Les Temps Modernes* was, of course, Sartre's journal). But "the world of the novel . . . must also be an imaginary engagement in the action" (55). There is no disinterested contemplation and no revelation not also complicitous in and responsible for the things it discloses. In subordinating writing to its objects, Sartre invalidates the very freedom that he would promulgate. The writer has his cake and eats it, too, but in the process loses his soul to the machinery of events. He has lost his poetry, his word-painting, and, first and foremost, his music.[40]

The best answer to Sartre's failed project of literary history lies in the work of Fredric Jameson. To be sure, it isn't easy to extract from Jameson's examples a working model of practical criticism, and his resolute abstractness may have propelled him above history into the imaginary utopias of postmodernism.[41] But despite his utopian or totalizing impulses, Jameson's studies of fiction have also been concerned with the specific insight and impact of the writing, for which his term is *point of view*. In *Marxism and Form*, he offered an acute analysis of Sartre's views on history. On the one

hand, he says, Sartre aimed to critique Marxist reductions of historical process to bloodless abstractions; that is the motivation for his return to "what is essentially a novelistic vision."[42] On the other hand, Sartre's own historical vision succumbs to a different sort of idealization when it glorifies momentary action over continuous transformation. Perpetual revolution may have been the watchword, but the reality was still too punctual, "an overestimation of the moment of group formation" and "a mystique of apocalypse" (*Marxism and Form*, 268).

In effect, Jameson finally—and I think correctly—rejects a heroizing dimension in Sartre's literary history. By exalting signs, imitation, reflection, plot, and experience—all the different aspects of the novelistic vision—Sartre misses the very possibilities of everyday human action that novels not by Flaubert typically celebrate. Hence, Jameson advocates a return to the kind of close reading that Sartre practices only in moments of polemical critique, such as his pages on Guy de Maupassant. While I am connecting moments in *Marxism and Form* that Jameson does not himself explicitly link, I believe it is proper to see his concluding proposals for dialectical criticism as a direct response to the problems he sees in Sartre's *Critique of Dialectical Reason*. For at the end of his book, Jameson propounds a "Marxist theory of plot" and a "theory of character" (397–98) that clearly grow out of his analysis of Sartre's abstracting of plot from its embedding in a work of writing, and he prefaces these with "a Marxist stylistics" (397) that draws the most important, if in some perspectives the most controversial, implication out of his critique. "The art-sentence itself, as it has been so variously cultivated and practiced in modern times from Flaubert to Hemingway, may be seen alternatively as a type of work or mode of production, and as a type of commodity as well. . . . In modern literature, indeed, the production of the sentence becomes itself a new kind of event *within* the work, and generates a whole new kind of form" (397). Jameson concludes with a section entitled "Marxism and Inner Form" (401–16), establishing a vitalist response to the abstraction of plot and theme as the culmination of his reflections on where literary history might head.

What Is Literature? is perfectly coherent as history, but not as a history of writing. Jameson leads to the missing element through his attention to the action of texts, which takes place continually at the micro-level. For a Marxist, production is a glamour term to apply, but Jameson subsequently warns against misunderstanding it.

Insofar as the idea of textual production helps us break the reifying habit of thinking of a given narrative as an object, or as a unified whole, or as a static structure, its effect has been positive; but the active center of this idea is in reality a conception of the text as *process*, and the notion of productivity is a metaphorical overlay which adds little enough to the methodological suggestivity of the idea of process.[43]

However different they may be in their concrete applications, Jameson's notion of textual process is as stenographic as de Man's, and hence closely related in spirit to de Man's sense of the historicity of texts. Something in the notion of the aesthetic urges toward a utopian timelessness, but something in the notion of the literary or the artistic urges equally forcefully toward temporality.

Temporality is the element to preserve—or, perhaps, to recover. The books to which I now turn are anxious precisely about literature's temporality, and then, less overtly, about its musicality. Behind the guise of a tolerant eclecticism, one strand of current defensiveness opts for bath water at the expense of any possible baby. Such is the case with the following, in a book meant to be genial.

We academics need to say in a letter to the world what we can show in the classroom, that reading profound literature is fun, that unlike addictive narcotics it can both brighten and deepen the reader's ordinary life day-to-day. We need to discover, describe, and propagate current fiction that affords deep and lasting pleasure. That such intensely superior fun rests on epistemological uncertainty should be a minor issue in a society losing touch with the printed page. Outside the college teacher lies a reachable world. It is a greater value for future legislators, employers, and patrons to know what literature can do than to know how it does it.[44]

Even more than *fun*, *brighten*, or *deepen*, the unanalyzed term here is *lasting*. It ignores the unarguable terms Sartre had used in praising Richard Wright: his works must speak to a real audience and could last only by virtue of the resourcefulness of their multiple address, for "the abstract eternity of glory . . . is an impossible and hollow dream of the absolute" (*What Is Literature?* 149; see also 71–74 on Wright). Sartre's critique of abstract

pleasure should be heeded, even if not his historically unfounded reduction of literature to narrative in dependence on a society that it addresses merely in reflection.[45]

Peter Widdowson's *Literature*, in the New Critical Idiom series, pursues an Althusserian line related to that of Jameson, whom he does not mention. The literary communicates a "vision [that] is somehow itself in motion: turning, pivoting, swinging round a point."[46] More animated than a mirror traveling along a highway, literature is "poietic": it contributes to the making of history and then illuminates for readers the history that it creates. "What we perceive here is 'the literary' as a proactive writing of history in order to discover—or rather, 'form out of nothing'—an identity in a social formation whose dominant discourses would consign a repressed group to silence" (135). Indeed, Widdowson finds a liberating antithesis between the formative and the reflective dimensions of literary works: "they also embody discourses which run counter to [their] original project but which are every bit as much a part of their totality. Hence, they offer future readers the opportunity to read the signs as they will, and so provide a different kind of 'social history' to the one they were inscribed by or believed they were providing" (148). As Widdowson follows Althusser in attributing to literature an imaginative social vision, so he draws on Raymond Williams for a more technical understanding of literary language as shaping pattern. Lyric poetry comes back into the picture. Not the meanings but the words themselves in their distinctive arrangement, "the linguistic textuality of the poem," construct the self-conscious resource that "enables us to 'see' the new 'reality' *being* created" (111).

Still, at heart, as the scare quotes and italics intimate, Widdowson is troubled by a more open version of the same contradiction as Sartre. If the action of literature can only be seen in relation to social history, its distinctiveness must then be seen in opposition to history. Widdowson doesn't evoke this traditional aesthetic dimension in his own words, but leaves it to a then-recent opinion piece by Diane Elam, whom he quotes twice. First, "Reading literature has the great potential to be totally useless. . . . Reading literature is not a guarantee; it is a possibility." And then, in conclusion, literature creates "spaces for waste, for potential uselessness, for seeming nothingness, [which] are the very same spaces that create the possibility for thought."[47] If the literary here is "in motion," then only in an undirected, even stochastic fashion. Certainly it is no longer envisioned as formative or shaping, nor as socially engaged, whether in Sartre's sense or even in

some weaker one. Reflection here has become so purified of its content, so reduced to Pure Poetry, that its reality is entirely imaginary. "Fox is poem and poem is fox, since both are created simultaneously and neither would exist without the other" (111).

My reason for dwelling on this rather predictably inconsistent book lies in what is left out. It is easy enough to see that social history and aesthetic abstraction make uneasy bedfellows; that is why Sartre and (if my sense of the primacy of close reading in his work is correct) Jameson each finally opts for only one of the two. But Widdowson's desire to reconcile them is admirable and timely. And I think it can be accomplished. However, it requires what Widdowson explicitly rejects. For the one thing that literature is not, in his view, is . . . music. "Even when [music] has 'words' associated with it, and that although it is, in a sense, 'written' (as sheet music or score), it is not 'read' in the same way as the linguistic textuality of literature is. We do not read music to comprehend a conceptual totality made up of words which have a social and cultural referentiality beyond their specific formation as 'the text', but in order to 'hear' it as a musical structure" (121). But hearing an otherwise silent pattern is precisely what Widdowson has admired in literary creation. Literature is valuable, it seems to me, precisely in its self-conscious freedom from merely conceptual reasoning; it stands outside the ideological elements, not, indeed, to liberate mankind from them (Sartre's impossible lyric utopia) but at least to create the possibility of bringing them into flux. Not the order of thought but its movement is at issue. And, as I shall be arguing, a history at least partially free of bondage to imposed conceptual frameworks comes into view at the point where literature and music lie closest to one another.

Ross Chambers's *Loiterature* develops a richly embroidered phenomenology of the notion of literature as a space for thought. Loiterature is the writing of the flâneur, the idler who takes in what is around him or her, free from preconceived notions or rigid organizational patterns. Its imagination is unpressured, its unfixed racial and gender identities fluid or marginal. Finding value in seeming triviality, the loiterer is a parasite (in Michel Serres's sense) who adopts peripheral or suspect social roles and occupations. Thus, loiterature has the ironically critical quasi-objectivity of an outsider, never a merely realistic reflection of things as they are, though also never too pointed a counterstatement. It is always a bit lost, characteristically melancholic in its present surroundings, yet uncomfortable with conceptual articulations, which tend to appear, if at all, in the guise

of mystically deep truths or unfulfilled allegories. It's a dog's life, currying cynicism (etymologically, doggishness, from the Greek *kuon*) in a mongrel, muttering, unfocused way. Its characteristic utterance is an undertone, a *murmuración* (a word Chambers borrows from Cervantes's "Dogs' Collo-quy").

Loiterature is a very specific kind of writing, with its own canon. Its eccentric luminaries are Laurence Sterne's capriciously whimsical Tris-tram Shandy and Diderot's captiously cynical Rameau's nephew. Yet at the same time, as a kind of writing purified of all forms of direct engagement, it "can even lay claim to being a *model* of the literary."[48] For my purposes, the significance of Chambers's counteraesthetic is its insistent spatialization. While an otherwise concordant study of Benjamin has claimed that "the medium of distraction is time itself,"[49] time for Chambers is but the empti-ness of reverie—"Time Out," as one of the chapter titles has it. Loiterature denies "linear consequentiality" (*Loiterature*, 135) and indeed is resolutely anti-historical (241–49). Rather, it wanders about the cities of the mind, constructing a "synchronous portrait" of its environment or a "spatializa-tion of the poet's memory" (97, 246). Its confessional mode is arch: the book opens with the sentence, "I have been giving up caffeine for years now" (3), suggesting a wish for a loiterly drowsiness the author can't quite manage to muster. And its motto, in the book's last sentence, is "Let's go hang out in the mall" (292).

But all this ease is more desired than experienced, in what is finally a brilliantly tough-minded book. Though Chambers loves writing sentences that drift and dally, the argument solicited by his well-chosen array of texts is persuasive and impassioned. It thus undermines itself: not caring is a pose in a book that sweeps its readers along. Chambers, like everyone else who engages with literature, finds it moving. That is why the encounter with music remains the most willful or even perverse moment in the book. For, on the one hand, music is the model of models. Music is the last resort of the murmuring cynic; it frees him from more pointed or cultivated nega-tions into a kind of expression that is at once self-absorbed and disengaged. In music "the natural and the cultural are fused" (50). One can loiter point-lessly in music, unencumbered by the demands of sense; hence its lovingly cynical emblem is the RCA Victor logo, the dog echoing His Master's Voice (208–11).

For Chambers as for Kant, music is the one realm that resolves the contradiction between involvement and disinterest.[50] Yet, on the other

hand, the noises evoked in Chambers's book are exactly the antithesis of the music. For Diderot's nephew and uncle, says Chambers, music is pure melody, not structure but "the animal cry of passion," in a phrase he quotes from *Rameau's Nephew* (50). In actuality, the music in Diderot's text is less even than melody, and rather than loitering it lasts only a moment. The passage continues with the following sentences that are not quoted: "These moments should tumble out quickly one after the other, phrases must be short and the meaning self-contained. . . . What we want is exclamations, interjections, suspensions, interruptions, affirmations, negations; we call out, invoke, shout, groan, weep or have a good laugh."[51] Diderot's ideal here is a time-denying utterance, not the time-filling pleasure experienced from talking machines, long-playing records, and their successor technologies. My essay began with the aporia of immediacy and eternity. The defenses of literature I have been discussing hint at its mediation in the form of duration and process, but then short-circuit the antinomy with a fusion that amounts to running in place. Loitering is an action that goes nowhere, echoed by an expression that remains intransitive. If Sartre's Literature is too much the reproducing dog, sitting within history's megaphone and alert only to its mastering voice, Chambers's loiterature is too much the rotating mechanism, communicating only to a willing ear sitting almost within its own organ, murmuring or barking but not truly speaking.

Permanent parabasis is Friedrich Schlegel's term for digression. Chambers posts the slogan at the gate of his book (10), and he shares it with yet another definer of literature, J. Hillis Miller. Miller highlights the pictorial imagination in order to resolve literature's antinomy into a permanent moment. "A picture . . . is a permanent parabasis, an eternal moment suspending, for the moment at least, any attempt to tell a story through time" (*Illustration*, 66). Its emblem in the 1992 book I have just cited—Miller's illustration of illustration, so to speak—is the sun in the form of "the whirling vortex of colors" in Turner's paintings: "To make a mock sun is the highest artistic act" (144–45). In Miller's *Black Holes*, the parabasis or vortex has intensified into its apocalyptic consummation: "Works of literature are black holes in the Internet Galaxy" (137). The critical function has dissolved into "the irreducible otherness of the work" (151). It doesn't even yap, but reverts to a pure absorption in which all individuality is lost: "When I read Trollope I enter into a world quite unlike the one in which I feel I actually live. I dwell for a time in a realm in which people have a marvellous understanding of one another" (201). Miller likes to loiter without strolling;

he replaces the flâneur with the pure visionary. The experience—if that is its proper name—is localized not just to a work, but to a moment.

Writing about a great Victorian love story, Anthony Trollope's novel *Ayala's Angel*, Miller describes the incomprehensible flash of passion that turns love into "an obsessive idea" (*Black Holes*, 281). Love is a black hole; its flame stops history in its tracks in an inexplicable eternity: "I declare that I have always loved him" (295). Miller loves literature, with an obsessive love that sinks him into an all-absorbing vortex. "The need to uncover this secret, though it turned out over and over to be impossible to do so, may be what drove Trollope to write novel after novel until the day he died. It may also explain why those who love Trollope read all those novels, which seem so similar. Each new novel gives pleasure but it also leaves a troubling uncertainty, and so we read another novel, and yet another . . ."[52] Not even music escapes being frozen into a picture. While music is epiphenomenal in *Black Holes*—the content of some passages Miller discusses rather than a topic in its own right—it is notable that its two appearances in the concluding essay on Proust deny it any temporal activity. First, Miller invokes the septet by Proust's fictive composer Vinteuil, a "permanent novelty [*durable nouveauté*]" (411): "Once it has occurred . . . it is durable, sempiternal, as long as the music goes on being replayed or even goes on being capable of being replayed" (411). Triumphant as the septet appears (particularly in the Schlegelian, eternizing transposition of the French "durable" as "permanent"), it is hence no better than an instant of "quasi-Platonic" insight (423). And then, at the end of Miller's book, the sun stands still at "the nadir in all Proust's work" (479), the song "O sole mio." Given the multiple denials of time, it should come as no surprise that music appears here as literature's black star.

Wherever literature is being defined, then, it comes upon music as its strange attractor.[53] All these books remain visibly drawn to a moving quality they then force themselves to resist. They resolve the antinomy of the momentary and the enduring, of expression and significance, into the oxymoron of an enduring moment, but they continually hint at a different resolution, in the duration of a process. Literary history is the denial of the eternity of literature, but can also be the consecration of its durability. But it must be found within literature, in the smallness of the work toward which all these defenses point. Literature as process redeems itself from the antinomies of literature as subjective or objective essence. And as it does so, it renders criticism dialectical and responsive rather than cheerfully or

bleakly cynical. As all these books intimate, music is the other of literature's fixation in moments or eternities. At least in the Western tradition, music shares with history the most evident characteristic of directedness. Hence my model of models will be music as it has functioned and as it captures, imitates, and orders the larger and less manageable movements of history at large. I close this section of my essay by returning to the book of Fredric Jameson that I quoted earlier, for Jameson begins his study just where I have now brought my discussion.

> So it is that Western music at the very outset marks itself off from the culture as a whole, reconstitutes itself as a self-contained and autonomous sphere at distance from the everyday social life of the period and development, as it were, parallel to it. Not only does music thereby acquire an internal history of its own but it also begins to duplicate on a smaller scale all the structures and levels of the social and economic macrocosm itself, and displays its own internal dialectic, its own producers and consumers, its own infrastructure. (*Marxism and Form*, 14)

<p style="text-align:center">*　　*　　*</p>

Fantasy-Interlude. Music, Jameson says, operates "on a smaller scale." I propose B minor as the key of literary history. Among the rarest of concert keys, it establishes grand national beginnings—the Latin Mass by the Protestant Bach and, in Borodin's Second Symphony, "the first enduring Russian work for symphony orchestra"—and consecrates exhausted traditions, linking the bourgeois undermining of symphonic heroism in Schubert's Unfinished Symphony with the triste close of Russian grandeur in Tchaikovsky's *Symphonie Pathétique*.[54] Working from within, it founds Haydn's witty compositional style in the groundbreaking String Quartet, op. 33, no. 1.[55] Unlike the more predictably majestic C major, the sublime C minor, or the cosmopolitan E-flat major, B minor is chosen for the anxious moments of passage when the constitution of national, cultural, and individual identities is in question. Just think of Tchaikovsky's minor masterpiece, with a tipsy court waltz in 5/4 and an unhappily militant march in the middle movements, surrounded by eerie silence, stormy passion, and exhausted return in the outer movements. I shall shortly have a few more words to say about nationalism in literary history. For now, I shall just reiterate that the message of literary history is: Be minor!

Writing about Kafka—a major figure by anyone's measure—Gilles Deleuze and Félix Guattari arrive at this resonant generalization: "We might as well say that minor no longer designates specific literatures but the revolutionary conditions for every literature within the heart of what is called great (or established) literature."[56] Literature, in their view, is, in the best sense, *insidious*. The "cultural book" is "a war machine in opposition to the State apparatus," and its study is "the opposite of a history," by which they mean to resist not time (or history in my sense) but synthesis.[57] However massive—Joyce and Proust are favorite examples—literature dislodges and, in their renowned word, deterritorializes its terrains. Dynamite!

> Names, persons, and things are crammed with a content which fills them to bursting; and not only are we present at this "dynamiting" of the containers by the contents, but at the explosion of the contents themselves which, unfolded, explicated, do not form a unique figure, but heterogeneous, fragmented truths still more in conflict among themselves than in agreement. Even when the past is given back to us in essences, the pairing of the present moment and the past one is more like a struggle than an agreement, and what is given us is neither a totality nor an eternity, but "a bit of time in the pure state," that is, a fragment.[58]

LITERATURE'S HISTORY

> Yet strangely fitting even here, meanings unknown before,
> Subtler than ever, more harmony, as if born here, related here,
> Not to the city's fresco'd rooms, not to the audience of the opera house,
> Sounds, echoes, wandering strains, as here really at home.[59]

I will make one more stop on the way to my musical cadence. If we want to know what literature can tell us about history, then it behooves us first to ask what history means to literature. At least in the West, literature has always been engaged with history. I would not presume to claim that the angle of its vision has been constant, nor that I possess an overview of its errancies throughout the millennia.[60] But for a glimpse of what history means to literature now, of what our literature might have to reveal, distinctively, about our histories, I offer a case. Following the time-honored legal principle that the exception proves (i.e., tests, validates) the rule, I have chosen an exceptional case—a literary history untroubled by any

mere facts. From the originator of the historical novel, the defining genre of literature's encounter with history in the modern West, it is a book whose value is purely exemplary, fulfilling de Man's dream of a historicity without history, though (unlike de Man) not resting there.

Though Walter Scott's *Redgauntlet* offers itself as a historical novel, it is a rather eccentric one, since it does not contain any recorded events. Rather, it reconstructs in full imaginative detail an incident that never happened. Twenty years after the last Jacobite uprising in 1745, Scott imagines a return to England of the aging Charles Stuart, known to the English as the Pretender, encouraged by a dwindling and mostly reluctant band of once-fervent supporters. Betrayed and surrounded in a humble north-country inn, the coterie is forgiven by the English General Campbell in the name of King George III and disperses back home or (in the cases of Charles and of Hugh Redgauntlet, the latter having led the abortive uprising) to France. The result is oblivion. The aim of this novel is thus to forget history. Animosities left over from the Glorious Revolution are finally put to rest in a book purportedly memorializing a loose end. It invents a story whose point lies in its insignificance. Nothing much can happen in the novel, for nothing much could have happened in reality. Time marches on over the shards of the past.

Like all of Scott's most characteristic work, *Redgauntlet* concerns the forging of a new society. It is difficult to say, however, whether it envisages a unified nation, a viable hybrid out of two parts, or a mere collectivity out of many clans and houses, given that its Jacobites come from all parts of Great Britain and its Hanoverians too from a range of sects, backgrounds, and even—notably in the case of the king's family—countries. The novel's hero Darsie Latimer, Hugh Redgauntlet's fatherless nephew, is brought up in Edinburgh by his English mother, who conceals his heritage. For complicated (and unspecified) legal reasons, he is out of his uncle's power provided he remains outside of England. Learning his identity is the worst thing that can happen to him, for it binds him to a rotten past and a violent (though, in Scott's fashion, sincere) uncle. Once he falls in, Darsie cannot escape until his past dissolves around him; helplessly, he witnesses the scene in which his fate is determined. Fortunately, the (fictional) revolt has no prospects, and Charles's followers abandon him; "the snow-ball's melting," as one of the minor characters poignantly characterizes the course of destiny.[61] Nor, once history lays its dirty hand upon him, does Darsie ever come into his own; the epilogue attributed to Dr. Dryasdust remains virtu-

ally bereft of information about Darsie's destiny. A broadside against the destiny of nations—at least in any traditional sense of inherited or ethnic nationality—*Redgauntlet* musters the power of imagination in the cause of a future that can overcome past strife. It encourages a history of literature in which literature becomes the power to break free of fate.

If it were simply a matter of the rival claims of poetry and of history to annihilate one another, then we might just as well return to Aristotle—or to Sartre. A perspective that idealizes literature as the essence of individual freedom cannot write a history of literature, but at best a chronicle of successive eternities. That is the New Critical dead end from which the current return of literary history seeks to rescue us. *Redgauntlet* is exemplary precisely because in the heart of the age of idealism—which was also paradoxically the age of historicism and of nationalism—it unmasks the escape from history: Darsie's victory over his past becomes a pyrrhic escape from self and into the pure myth of Scott's imaginary history. The most delusory myth of all is that of the freestanding hero.[62]

For even though *Redgauntlet* spurns the dead hand of the past, its dominating principle is fidelity, not liberty. Here lies the book's thematic answer to de Man's Nietzschean forgetting and Sartre's falsely heroic engagement. Scott's literary history—that is, his literary version of history—privileges those who steady their course ahead, like the general who speaks confidently on the authority of his king and the Quaker Joshua Geddes, who keeps his religion, risks his welfare defending his fishery and its men, and offers precious money for the freedom of his new acquaintance Darsie. Even the angry Redgauntlet musters "respect [for] the fidelity of your friendship" (342). While the smuggler Nanty Ewart (who is fiercely honest yet finally loyal only to money) and Redgauntlet's fierce servant, Cristal Nixon (who ultimately betrays his master to earn the reward offered for Charles's head), kill one another to become the book's only casualties, all human loyalties ensure survival, even though few ensure a place in history. Charles aborts the uprising and guarantees his own obscurity through obstinate devotion to his mistress. He is comically echoed by the idiot Peter Peebles, grandiloquently self-aggrandizing in pursuit of a lawsuit to recover his share in a failed partnership. Redgauntlet himself supports Charles even in his uxoriousness. He is loyal more to the person than to the cause, whereas the remaining rebels sacrifice the cause through spurning the personal foibles of their figurehead. Either way, collectivities dissolve before individual motivations. To run to his friend's rescue, Alan Fairford abruptly deserts his

first case and client, Peter Peebles, who haunts him for the rest of the novel. Indeed, even the Quaker, a comically hot-tempered pacifist who addresses others as "friend" and sometimes means it, continually skirts the edges of hypocrisy, for a perfect faith is another of the myths the novel explodes. In pursuing fidelity to individual experience, Scott's literary version of history spurns both the *longue durée* and the revolutionary transformation.

Literature's history is perilous and unsteady as it hovers quixotically on the border between the quicksands of the past and the windmills of the future. (The novel's quicksands are the Solway estuary, the dangerous link and separation between the united kingdoms.) Loyalties are naturally divided, for undivided loyalty is fanaticism, which has no place in the modern world. Hence the pathetic grandeur of the Pretender's fond valedictory: "I bid you farewell, unfriendly friends—I bid *you* farewell, sir (bowing to the General), my friendly foe" (374). Scott defines the past as that which is lost to the present and the future as that which betrays the past. A Machiavellian cunning is hardly the issue—and only the most hesitant kind of Hegelian cunning—for success comes by instinct and only provisionally, with a new novel and a new phase of history always pending. We navigate the present; we do not ride it either as a horseman commands his steed or as a surfer masters the waves.

That is to say, literature's history is made of people. Scott is rightly famous for his minor characters; the tide of history is propelled by the molecules swirling beneath the surface. Tolstoy (like Michelet) tried to make a science out of the dynamics of masses, but for Scott (like Carlyle and their joint heir, Dickens) there are always and only individuals lubricating and, inevitably, orienting the flow of events. Hence *Redgauntlet*, like the rest of Scott's novels, presents a tapestry of lesser figures carrying information and misinformation, leading the protagonists (themselves imagined as merely secondary to the actual historical personages) to their goals or astray, safeguarding or disrupting climactic encounters, and all of them—high characters and low—guided by profoundly articulated networks of personality, experience, and belief. Literature's history is made not by grand display—not even the great battle scene of *Old Mortality* corresponds to any possible overview—but by filigree. Literature exists in the interstices of history.[63] A history of literature, as I imagine it, will turn its attention to literature's insistence on what escapes the attention of mere documentation. Literature acts between the lines of history, and the history of literature should respond in kind.

Very commonly, the history of literature is linked to the history of nations.[64] Within the European arena, that very traditional enterprise can be dated to the period when *Redgauntlet* is set and its consolidation to the period when the novel was written. But its limits are palpable. In the national history of literatures, for instance (as Walter D. Mignolo points out), *Don Quixote* is peripheral to Fielding and Scott, yet no English fiction mattered more to these authors than the *Quixote* and several other foreign works did. Through Mignolo's notion of the colonial difference, one might invert the perspective and study the meaning of English novels to the fortunes of Cervantes, recognizing the diffusion and penetration, through literature, of a culture that England successively purported to hate, scorn, and ignore. Despite its apparent exclusion (and self-exclusion in the period of closed cultural borders), Spain seeps in and permeates. This is true and important. Yet even in inversion, the national perspective distills from the *Quixote* an attar of Spanishness. Should we rest there?

Scott is known as the greatest novelist of the Scottish nation. But what is the Scotland in *Redgauntlet*? The nation comes in for remarkably little attention. The brilliant panoply of minor characters ranges the gamut. Dialect characterizes the idiot Peebles and also the nostalgic blind musician Willie Steenson, who sends messages by playing highland airs with significant texts. But the Quaker speaks his sect's variety of English, and the others speak the common tongue, or something approaching it. The Jacobites are divided by religion, by family or clan (though this is much muted in comparison with *Waverley* and *The Heart of Mid-Lothian*), and by region, numbering an Englishman and a Welshman among their group. And most of the characters are in some sort of disguise or other: Hugh Redgauntlet is known as Sir Harry Redgimlet to Peebles, as Herries of Birrenswork in Scotland, and as Ingoldsby to the innkeeper Crackenthorp; Charles, who appears to Darsie as the French Father Buonaventure, is the Pretender to his enemies and the Adventurer or the Wanderer to the narrator; Darsie Latimer acquires the quaint hereditary designation, Sir Arthur Darsie Redgauntlet of that Ilk, and spends much of the second half of the novel in the forced disguise of a woman; and the minor characters are little more stable. Identity, heritage, and affiliation are no more determinate on the Scottish border than in Clifford's Mashpee.[65]

Of course, the heterogeneity and heteroglossia of literature can no longer be mistaken for cosmopolitanism. The cosmopolitan dream had its heyday in literary studies in the early twentieth century,[66] but really only

within European limits. The greater globality that René Etiemble called for throughout the postwar decades and that the International Comparative Literature Association exists to promote generates enormously fruitful interactions, but "feeling global" (to echo Bruce Robbins's brilliant title) is quite different from being it (hence his subtitle; "internationalism in distress"). We risk finding ourselves stuck with nothing better than the anodyne hope—formulated as the conclusion of one recent book—for a postmodern, more dispersed subjectivity for which "nation-state matters somewhat less than culture."[67] My hope is that the fluid richness of literature's history can put some substance into this timid "somewhat less."

Unique in Scott's output, *Redgauntlet* falls into two parts: it begins as an epistolary novel with narrative letters exchanged between Darsie and Fairford, and then continues in chapters when Darsie is kidnapped and unable to continue the exchange. It appears, then, to juxtapose the deluded subjectivity of the individuals who lose their way with the omniscience of a narrator in command of all the facts. Externally, it appears to be another fable juxtaposing poetry against history, though with history the winner this time in the guise of the narrative historian. But in fact the contrast of modes is far less stark than the generic framework implies.[68] As Darsie gets caught up in events, his letters grow less personal and more epic, and the chapters of the second half really continue the mode as they alternate between Darsie's narrative and Alan's. The narrator claims the historian's credentials from the start, yet follows closely and singly the gradually converging paths of the two young men, hews closely to their experiences, and while gradually expanding the penetration of the thoughts of other characters, carefully guards knowledge of future events and of disguised identities until they are revealed. Here, too, we have a virtual continuum of modes in which the long letters contain much overview and the narrative chapters leave much in the dark; finally it is Dryasdust who gives the outcome, and that still only partially. In one of its many ironies, the epistolary mode reigns at home and the narrative mode abroad: for Darsie the border between the two is the Solway where he is abducted; for Alan, the courtroom he suddenly flees. Subjective feeling reigns in Scotland; objective knowledge, such as it is, gradually emerges in the wilds of the north of England. In contrast to the earlier *Heart of Mid-Lothian*, the capitals here are blanks—George III is vaguely invoked as a distant authorizing figure, but of the shadowiest kind—and no firm center grounds or organizes the plot. There is little consolation here for the would-be know-it-all, and much

in both parts of the novel to remind us that the work of literature is getting at the insides of things, not getting them into our grip.

"Is this real?" exclaims Hugh Redgauntlet at the moment of crisis (373). Perhaps only the blind and peripatetic musician ever intuits the actual state of affairs.[69] The final dispersal thus represents the only true end of history. Peebles's Dickensian legal action has been a covert figure for the course of history throughout, and it remains so when he dies in a malapropic "Perplexity fit" (378) upon a settlement being proposed. Not outcomes but causes and processes, not meanings but motives, not actions but agents—these are literature's history. A history of literature that respects the mode of its subject matter will attend to such things without pretending to master the great world around.

THE MUSIC OF TIME

> Swann had regarded musical motifs as actual ideas, of another world,
> of another order, ideas veiled in shadow, unknown, impenetrable
> to the human mind, but none the less perfectly distinct from one
> another, unequal among themselves in value and significance.
> —Marcel Proust, *Swann's Way*

My essay has been concerned with the historicity too often concealed in the vast spaces of history or the rarefied essences of Jameson's "culture as a whole" (see p. 121). Time and again the yearning for time has been figured in the topic of music, the art of time. The more literature defines its distinctive perspective and frees itself from the constraints of external discursivity, the more it comes to resemble or to yearn for music. As a model for the study of literary history, then, I turn to a history that cannot readily be convicted of subjection to externalized regulation.[70] Preserved by its remoteness from linguistic meaning-making, music history has a certain autonomy from the social fatalities of the great world. The autonomy is only relative, to be sure. Indeed, if it were total, there would be no interaction with the historical world to make the historicity of music relevant to the present inquiry. In its conditions of performance and reception, in particular, music partakes directly of the dynamic of public existence. But in its creation, music of necessity filters historical or other external circumstance through the fine mesh of its recondite techniques. They force music history to think small.

One of the great cultural events in nineteenth-century Europe was the performance of Johann Sebastian Bach's St. Matthew Passion led by

Felix Mendelssohn in Berlin on 11 March 1829.[71] The audience included the leading musicians and music critics, of course, but also the royal family, Friedrich Schleiermacher, Hegel (whose impressions figure in his *Aesthetics*), Heinrich Heine, Rahel Varnhagen von Ense, and the young Gustav Droysen, destined to be the great historian of midcentury Germany. The demand for tickets was overwhelming, the impact (as recorded in numerous published and unpublished accounts) tremendous. Why Bach? Why just then? What is the significance of this event for musical history? What is its significance for cultural history?

In order to approach the issues from the inside, in their minor dimension, I propose reformulating them in terms of the musician and the music most centrally involved, radiating out from there. To be sure, a brief space and a relatively nontechnical discussion cannot propose satisfactory answers to the many questions raised by the performance. Rather, I shall merely point out what some of the questions are and how they are related. My aim is to present methods and possibilities of music history, with as little of the content as seems feasible. Starting small, then—and by small I do not mean easy—I propose to approach the questions: What did Bach mean to Mendelssohn? What did Mendelssohn learn or take from Bach? How did the young genius respond to the old master? Then, what did the culture take from the event, and what is the ratio between the composer's response to his predecessor and the culture's response to its musical past? And, finally, what might the study of literary history learn from a musical case such as this?

Mendelssohn studied composition from masters whose methods and materials derived directly from Johann Sebastian Bach. Mendelssohn's student notebooks are extensively preserved, so we know not just the general nature of his studies but their precise content. Three techniques form the core of the pedagogical tradition: figured bass, chorale, and fugue.[72] Mendelssohn regularly employed chorales and fugues or fugatos (fugue-like episodes) throughout his career, and in absolute music just as much as in texted or programmatic pieces (such as the *Reformation* Symphony) where they might be thought to have some special pertinence. And often his handling of the bass line, too, resembles that in baroque music, as I shall illustrate below. In material terms, thus, it is surprisingly easy to locate what the later composer took from the earlier one.

But are such recognizable archaisms merely fanciful displays of tech-

nique—here a baroque fugue or a chorale, there a classical minuet or rondo, and now a romantic reverie or impromptu—or do aesthetically and culturally significant attitudes attach to the choice of forms? When Mendelssohn spent years wrestling with his splendidly showy, baroque-revival Preludes and Fugues for Piano, op. 35, did the difficulties relate to the felt purpose of the project, or was it merely a chance succession of bad days that might have impeded any other piece?[73] Much musical scholarship still practices modernist formalisms restricted to abstract descriptions as remote from any meaningful language as possible. But earlier accounts of music were more expressive, and in the last decades the so-called New Musicology, in touch with the question of cultural meaning, has radically revived and updated them.

So in Mendelssohn's fugues we can recognize the aspirations of nineteenth-century historicism. It becomes evident that his struggles were not contingent products of deficient technique, but constitutive. The renewal of a past form was a complex endeavor played out in remarkable richness in the compositional process.[74] The fugue was an old form, but also rational, enlightened, hence "at once archaic and progressive."[75] It represented tradition but also demonstrated mastery. The precocious yet dutiful Mendelssohn, piously devoted to his family's new Christianity while tolerant of its former Judaism, advanced into the future by utilizing the inherited forms he had so well absorbed. The surface ease of his music thus covers and partially resolves tensions that animate the composer as they do the culture in which he triumphed, both as composer-prodigy and as scrupulous expositor of the music of the ancients.[76]

The dominant character of Mendelssohn's music, throughout his life, was speed. He raced ahead, joyfully but also compulsively.[77] In the advance toward the future, Bach's music was a point of anchor and also one of resistance. One senses the competition with Bach in the extraordinary piano fugues, op. 7, no. 5, and op. 35, no. 1, where Mendelssohn subjects the measured pace of the fugue to a constant, ultimately wild acceleration, although the latter piece modulates into a chorale texture (so labeled in the score) and ultimately ends peacefully.[78] And Example 5.1 shows in full score the opening of the last movement in one of the adolescent composer's signature masterpieces, the Octet for Strings, op. 20. Here the fugal texture rising through the ensemble is clearly visible. Following the rapid but very quiet close of the third-movement scherzo, a whirling dance begins with a loud and furious rumble in the lowest register of the cello. It is evident even

EXAMPLE 5.1 Felix Mendelssohn, Octet, op. 20, fourth movement, mm. 1-26

to the untrained eye how the accompanying lines also imitate one another at distances of four measures, then two measures, then one measure, until by the end of the example they have coalesced into triumphant (fortissimo as opposed to the initial forte) and regular rhythms of melody and accompaniment. Mendelssohn does not so much wrestle Bach as absorb the running eighth-note character of the fugal subject into the motoric modern style. The friendly tussle of historical validation with modern initiative becomes a triumphant romp.

The other techniques learned from Bach and his heirs likewise become complexly motivated. Chorale for Mendelssohn always signals devotion, sometimes in relaxation of modern tensions, sometimes in competition with modern energy. Either way, the past was slower than Mendelssohn's present. A notable example is one of his rare adagios, the third movement of the Cello Sonata No. 2 in D Major, op. 58, where the piano articulates a rich, full-voiced chorale, to which the cello then adds an impassioned recitative, eventually imposing its character on the piano, until the contest of the two instruments subsides in exhaustion.[79] As for the bass line, while Mendelssohn did not compose with the actual textures of figured bass, his writing does often evoke its character as perceived in the period. "Abbé Vogler argued against the inclusion of continuo playing in performances, claiming that it was more or less invalidated by the rapid tempi and complex harmonies of modern music" (Todd, *Mendelssohn's Musical Education,* 20, where other, less temperate critiques are also adduced). Baroque music simply could not keep up with the modern style. The opening of the Octet (Ex. 5.2) is a particularly rich instance. The slowly moving base line in the second cello is a typical baroque progression. Example 5.3 is a parallel example from Bach's Fourth Suite for Cello Alone. The two passages are in the same key, with identical notes in the bass, underlying harmonically identical E-flat major arpeggios (first violin in the Octet). The affinity is palpable even though the two pieces sound entirely different: the broken chords of the cello suite, always lying in the same register, express stable deliberation, whereas the fiery ("con fuoco") Octet begins with a soaring rush, over pulsing accompaniments and swelling in no time from piano to forte. Such neo-baroque conduct comes naturally to Mendelssohn, unprepared at the opening of the Octet (and quickly moving into chorale episodes, which are common throughout the piece) but integrated into his headlong modern energies.[80]

This is in no sense a full analysis of Mendelssohn's complex relationship

EXAMPLE 5.2 Mendelssohn, Octet, first movement, mm. 1-4

EXAMPLE 5.3 Johann Sebastian Bach, Suite for Cello Alone, no. 4,
first movement, mm. 9-11

to the music of Bach and, more generally, of the baroque. Still, it is enough
to provide a simple illustration of lessons that can be drawn from music for
the study of literary history. For Bach's significance to Mendelssohn is a
three-dimensional complex. It is composed of a set of formal techniques in
which Mendelssohn was trained, of values attached to the techniques (rea-
son, piety, stability), and of an aura or ethos. Ethos is the intangible, non-

discursive, yet readily perceived expressive spirit of the composition in its engagement with its material: examples would be the conversational humor that Charles Rosen has highlighted in Haydn, the Beethovinian thrust that Carl Dahlhaus has characterized as teleology and Susan McClary as phallocracy, or Mendelssohn's speed.[81] It is the variable element in performance, yet sometimes regulated by verbal texts and often—in Mendelssohn and other nineteenth-century composers—by expressive labeling in the scores. The ethos of a musical composition is its movement in every sense—its emotive and its intellectual power as well as its stance toward past, present, and future. How Mendelssohn handled what he learned from Bach is an important, definable, and analyzable component of the meaning of his music for him, for his listeners, and for us.

"His," in my last sentence, was deliberately ambiguous. It refers to Mendelssohn's significance, but also, through Mendelssohn, to Bach's significance, as Mendelssohn communicated that to his times. The anchored excitement, the sense of power rooted in but also transforming the past, the headlong rush of reason, the adolescent lightness self-conscious (as the young Mendelssohn always was) in its precociously willed poise, the confessional nationalism of the chorale style presenting a bounded conventionality as a human universality—such characteristics, in ever-nuanced variations, compose the Mendelssohnian spirit triumphant in mid-century Germany and then, plushly overstuffed, in Victorian England.[82]

What the Bach revival meant to Germany is, in a more diffuse form, what Bach meant to the Mendelssohn who inspired and personified it. The many testimonials collected in Geck's study of the early performance of the St. Matthew Passion show all the variations that might be expected from an assortment of individuals, without the precision of impact that we see in the composer's own absorption of Bach. Still, in their consensus and even the occasional dissent—for cultural studies needs to keep in mind that not even mass sensations are universal—they converge on the kind of historicity and emotion that can be recognized in Mendelssohn. Here are excerpts from one particularly symptomatic response, in a letter to the famous writer (and Shakespeare translator) Ludwig Tieck, written by a professor of history at a military academy, Johann Wilhelm Loebell.

> A new, previously unknown artistic world opened up to me. . . . It is with Sebastian's extraordinary severity as with Shakespeare's atrocity. . . . Sebastian is certainly severe and serious, but—with all the mon-

strous seriousness of this subject, with the deep pain, the complaint, grief, remorse, and repentance—delight and joy of existence still break forth most wonderfully, indeed blossom directly from them. I must tell you, I believe that here I have found the composer whom I have long sought, the one who can be compared with Shakespeare. He seems to me, indeed, the most dramatic of all composers. He, the great master of perfect execution and construction of musical thoughts, has refrained from all decoration wherever speaking characters are introduced, so as to present everything in its particularity with powerful and pithy brevity. At times an involuntary cry of innermost sensation appears, the irresistible breakthrough of a heart in distress with every impression of nature herself in the notes, and yet all is art and sober consideration. Alongside the dramatic element not just a lyric one is manifest, but also epic. . . . chorales and choruses of religious sentiments, and feelings of a pious congregation, which observes the events and presents with utmost variety pain, anger, and consciousness of the original sin from which this all arises. And this almost prophetic element of a community and church of Christians is so wondrously fused with the real event, and in this unity of the work of art appears such greatness and depth, that words cannot describe it.

(quoted in Geck, 46)

Here is the tension of confrontation with a great master of the past, speaking—beyond words—for and with the people, impressing his antiquity on the modern day and eliciting a response both awed and proud, a cry of triumphant pain that Tieck, of all modern Berliners, would have been the best person both to feel and also to measure himself by with some satisfaction. This is the kind of thing that was prompted by the aura of Bach as filtered through the ethos represented by the already famous youth of twenty, from an old and honored family, who was leading the performance. But in Mendelssohn's music and its encounters with Bach, we have not merely the kind of thing but the thing itself. There, writ small yet in undiminished intensity and full complexity, we have the encounter with the past that a history of music—and, *mutatis mutandis*, a literary history—may engage most directly. At the intersection of a form, an ideology or set of values, and an ethos or spirit, lies the impact of arts on history. Beyond the power of our words to reproduce in any other way, as Loebell artlessly says, or "beneath interpretation," as an essay by Paul H. Fry artfully puts it,[83] the

force of art is intangible but not illusory nor beyond our power to report, analyze, and reckon with.

LA MUSIQUE DANS LES LETTRES

> Schläft ein Lied in allen Dingen,
> Die da träumen fort und fort.
> Und die Welt hebt an zu singen,
> Triffst du nur das Zauberwort.
> —Joseph von Eichendorff, "Wünschelrute"

To illustrate the musicalization of literary history, I will return in conclusion to Paul de Man. One of de Man's most sustained pieces of close reading is his introduction to a 1972 French edition of Rainer Maria Rilke's poetry, published in English with the title "Tropes."[84] Between languages, constitutionally displaced, Rilke was (in Deleuze's terms) a minor writer in the same way as Kafka, and indeed as de Man himself. De Man constructs a brilliant developmental logic in Rilke's verse.* Beginning with figures of reversal in the early poems, he pursues Rilke's meditations on the nature of figuration. Figure by definition turns language inside out; hence Rilke discovers that what he thought were his own inventions were actually invented by language for him. His freedom turns sour; compulsion displaces exaltation, lie supplants truth. The inside of things is as hollow as the violin that is the figure of figuration. The word de Man insists on in this essay is totalization: there can be no totalization because there are no stable meanings for the poet to add up. The sympathy readers willingly feel for Rilke turns out to rest on a linguistic rather than a psychological kinship, for Rilke has brought himself into the "disenchanted concession" of a "conformity with a paradox that is inherent in all literature" (54, 50).

* In de Man's translation, the poem at the center of the essay, "Am Rande der Nacht" (At the Borderline of the Night), reads as follows: "My room and this wide space / watching over the night of the land—/ are one. I am a string / strung over wide, roaring resonances. // Things are hollow violins / full of a groaning dark; / the laments of women / the ire of generations / dream and toss within . . . / I must tremble / and sing like silver: then / All will live under me, / and what errs in things / will strive for the light / that, from my dancing song, / under the curve of the sky / through languishing narrow clefts / falls / in the ancient depths / without end . . ." (34, Rilke's suspension points).

Music takes over as meanings are evacuated to create a poetry of almost pure sound.[85]

The Rilke essay is an exercise in literary history in two senses. First, it narrates a development within Rilke's oeuvre. While de Man contends that different phases overlap, an inherent destiny drives Rilke's poetry toward its destined outcome. Future tenses that are conventional mannerisms of French academic style gather pathos in de Man's self-translation, which starts to sound like this: "Hence the prevalence of a thematics of negative experiences that will proliferate in Rilke's poetry" (50). In the grammatical "will," determination and determinism, prophetic vision and fatal weakness coincide. Though de Man repeatedly denies that there can be any totalization, it is evident that the visionary critic poses as a know-it-all and exempts himself from the curse that he willingly pronounces on "all literature" and on the writer who is "forever unable to participate in the spontaneity of action or modernity" (*Blindness and Insight*, 161, quoted p. 101 above). In the commentary on Rilke, we surely hear echoes here of Martin Heidegger's resonant pronouncements about poetry as the ringing of silence. De Man repeatedly refers to skill and technique rather than inspiration (30, 32, 45), again invoking Heideggerian craftsmanship and foreshadowing de Man's later concern with what he came to call the materiality of language. The fatalist logic of the readings leaves no margin for large-scale histories, though it does allow biography to explain a poet coming into command of his medium. There is, then, an appearance of development compromised by the credo that only emergence is conceivable with no possibility of fundamental change, yielding another version of de Man's historicity without history.

But if the account is unnerving, it is also predicated on a second, skillfully hidden literary history. There is a continuing reference to one particular predecessor against whom Rilke's achievement is measured. That poet is Baudelaire. Rilke, in de Man's account, is finally more radical than Baudelaire, but he certainly takes his cue from the French poet (22, 36, and 49). The Baudelairean topic of correspondence (35) becomes the basis for the deconstruction of the truth function: since Rilke's statements have no objects, they cannot portend a coinciding of mind and world.[86] But what if we position Rilke differently in literary history? Baudelaire's "Correspondances" has its music, but it strikingly lacks what Rilke's poetry obsessively invokes, a singer. Suppose we posit instead a history of poetry in Rilke's native language. The reference poem might then be the famous quatrain

entitled "Wünschelrute" (Divining rod) that I have cited in my last epigraph (and already discussed in different terms in chapter 3). Its author is another displaced person, a dispossessed Austrian aristocrat with a distinguished career in bureaucratic service in the north of Prussia, Joseph von Eichendorff.[87] It translates as follows:

> Sleeps a song in every thing
> That for e'er in dreams lies bound.
> And the world begins to sing
> If the magic word be found.

Here is another musical awakening of the world, with many of the same elements as in Rilke's poem. My translation, to be sure, finds no place for Eichendorff's addressee. "Du" here is the divining rod of the title, but also the speaker in a self-exhortation, and, behind him, any brother poet who might be similarly inspired. Mechanical craft has no role in a poem whose force depends on the brilliant naivety of its diction.[88] While in the tradition of Baudelaire, music is crepuscular harmony, here it is dawning eloquence, discovery rather than concord. Such music is invented by individuals transcending any linguistic compulsion, as indeed Eichendorff's subtly innovative grammar constantly does. If the divining rod were a technique or tool to be mastered in a way that constrains its operator in turn—or if the violin were—then we would be in the world of de Man. And we would be in the world of Heidegger if the song in things were always the same song—"*ein* Lied," with the qualifier stressed. But whereas generally Eichendorff's nighttime world is permeated by the uniform rustling of waters, the daytime world that dawns in "Wünschelrute" is typically atwitter with the joyful noises of countless birds. In this tradition light and song are slender, local, but endlessly animating.[89] And given the similarities in diction, this tradition could as readily be found in Rilke's poem as the one de Man presumes. Reading Rilke through Eichendorff reconfigures his poem as a vitalist vision of literary history rather than a deconstructive one.

Can such minute readings be erected into a theory of literary history? Does anything license interpreters to take Rilke's speaker as a historian and his violin as the figure of his history? Does the literary historian, indeed, need a license, any more than de Man as deconstructor needed one for his allegorization of the violin as language? And what awards the license, if not

literary history itself, as we attune the pitch of Rilke's meaning through its similarities and differences from his models.

One moral of my account, to be sure, is that there can be no single history. The symbolist Rilke and the post-Romantic Rilke, using the same words, have different measures of truth (correspondence or revelation), different curves of feeling (depending on how the poem's concluding suspension points are read), and different grammars. As with Mendelssohn, so too with Rilke, the historical meaning or force of utterance lies at the convergence of ideology, ethos, and form, and in encounters that are never predictable or single-voiced. The one error to be avoided at all costs in a history of literature in the minor mode is totalization. One understands in biographical hindsight why an anti-historical fatalism of "all literature" (and, *a fortiori*, all language) seduced the de Man who needed to escape from history, as "the culture as a whole" seduces Jameson who wants to see in music a duplicate of "all the structures and levels of the social and economic macrocosm itself." The self-betrayal in de Man's essays leaves them as a valuable if tainted provocation. My plea is to turn music to better account than does de Man's gruesomely tone-deaf characterization of Rilke's violin as a "box (so fittingly shaped like the algorithm of the integral calculus of totalization)" (37).

The music in letters is their variance from any predictive meanings. If our histories are to resist fixations—including those in national and racial essences—and if, at the same time, our diagonals and continental drifts are to take shape and reveal purpose, it must come from our ability to seize their motion on the fly.[90] Understood as the music in words, as their feel, defined by their position in the history of expressions, literature, ever in crisis, deterritorializes by unsettling certainties.[91] And literary history then orients. Let us rethink literary history in sym-phonic guise, as a sounding together in temporally ordered form of the disparate voices and strands of utterance claiming our attention from the past. The literature in literary history—that is, the aesthetic element—will then be the intangible tone and the key of utterance, and the history in literary history will be the resonance of that tone in the culture where it is heard. As literary and other artistic expression sounds a mood, it gives a meaningful shape to events. Rilke's poem, as I understand it, metaphorically articulates the thesis that art sets the tone for life. Between the Scylla of the trivially anecdotal (though not all anecdotes are trivial) and the Charybdis of totalizing systems (though not all systems are rigidly hege-

monic), histories sensitive to swerve and nuance—the kind of history that a less-than-heroic individual can write, the kind of history responsive to the temporality de Man found in literature—can recover the marks of expression before they congeal, for better or worse, into configured signs of the times.

≋ 6 ≋

Mozart, Bach, and Musical Abjection

Bach's problem . . . was this: how is harmonically meaningful
polyphony possible? With the moderns the question presents itself
somewhat differently. Rather it is: how is one to write a harmonic style
that has the appearance of polyphony? Remarkable, it looks like bad
conscience—the bad conscience of homophonic music in the face of
polyphony.

—Thomas Mann, *Doctor Faustus*

I AM concerned here with the relationship of classical to baroque style. My
point of departure is the above quotation from Thomas Mann.[1] *Doctor
Faustus* is the fictional biography of a modernist composer named Adrian
Leverkühn, purportedly the work of his teacher, Serenus Zeitblom. While
Leverkühn is modeled to a considerable extent on Arnold Schoenberg,
the quoted sentences from a discussion of Beethoven's music between the
young Leverkühn and Zeitblom closely echo a passage in Alfred Einstein's
study of Mozart, which Mann read while working on his novel: "Mozart's
difficulties in connection with Bach or with polyphony . . . were real difficul-
ties, a true crisis of creative activity. Mozart was too great and fine a musi-
cian not to feel deeply and painfully the conflict produced when his habit of
thinking in terms of *galant* and 'learned' music was shaken by the encoun-
ter with a living polyphonic style."[2] Despite the novel's twentieth-century
setting, then, the passage in question can easily be taken as a commentary
on the modernity of an earlier era: Mann here gives us some penetrating

hints about how to understand the musical origins of Romanticism.

Mann and Einstein share the ambition to move beyond a pure musical formalism. Each assumes a correspondence between structure and affect. Their accounts thus raise an issue that has become crucial for present-day music history. For a decisive aspect of the enterprise collectively referred to as the New Musicology is a widespread desire to re-energize the architectonic stasis projected by much traditional analysis.[3] Whether by restoring a personal (or interpersonal) psychology to disembodied pattern or by restoring a collective, social thrust to the private listening experience, practitioners of the New Musicology have wanted to get music on the move. As my initial quotes illustrate, there is nothing revolutionary about such ambitions. And there is much that is invaluable in their recovery of both social contexts and affective dimensions to musical expression, grounding the intuitions of an Einstein or a Mann in firmer empirics and more rigorous theoretical reasoning.

Even the extremes of New Musicology have been valuable in the empirical and theoretical responses they continue to provoke. The age-old ambition to account for the unquestioned communicative power of a non-communicating medium is hard to resist. Yet there have been excesses, as all acknowledge. Too often new readings do not so much supplement forms with meanings, sound with sense, and resonance with body, as displace the former with the latter. The risk is evident in the kind of study that cites little or no music, potentially supplanting text by context. But even studies that engage in detailed analysis can unbalance the factors they aim—or should aim—to bring into alignment. I shall be considering one such study shortly, for my aim in this chapter is not merely to discuss an instance of the transformation of baroque into classical style but equally to reflect on the balance of form and emotion inherent in that transformation.

More clearly than Einstein, Mann foregrounds the complex logic of style change. Unlike Einstein, he separates the technical and the emotive aspects of innovation. For Einstein, being "a great and fine musician" intrinsically entails feeling formal issues "deeply and painfully," whereas for Mann linking form to feeling is "remarkable" and guilt-prone. It is important to keep in mind the disequilibrium between Mann's two protagonists: the sentimental yet pedantic Zeitblom loves the remote and formal Leverkühn, who is understandably not in love with him. Older yet inferior, Zeitblom both immerses himself in his student and takes revenge on him in writing his life. The bad conscience attributed to the modern (Mozart, Beethoven, or

Schoenberg) really projects the bad conscience of Zeitblom, who resents his idol's abstract compositional skills. As Leverkühn's utterance transmitted by Zeitblom, the passage from Mann's novel thus can readily be apportioned between the two friends: Leverkühn represents the formalist whose purely technical judgments are psychologized and demonized in Zeitblom's report. The juicier, Zeitblomish formulation about bad conscience in the last sentence will be more appealing to many readers, but beware: Leverkühn is the real musician, and Zeitblom is a frustrated failure. Whereas Einstein highlights a situation, Mann portrays a dynamic—but, if my reading of the narrative situation is correct, he portrays it in inversion, through an unreliable narrator. Modern uses of the past "look like" bad conscience, but in truth they rise above such crude pathos, as Leverkühn—problematic as he is in other ways—does in his Bavarian seclusion.

For the literary criticism of a few decades past, Harold Bloom was the writer who defined the norm of history as the struggle of modern or modernizing creators with their forebears. Against the kind of formalism that envisioned a disembodied "art history without names" (the often misunderstood slogan of the early twentieth-century art historian Heinrich Wölfflin), Bloom popularized the notion of an agonized struggle of present writers with past giants. In a project that continued straight into his Shakespeare worship, Bloom's schematisms psychologized form even as he formalized psychology. "Perhaps there are texts without authors, articulated by blanks upon blanks, but Milton, like the Jahvist and like Freud, has the radical originality that restores our perspective to the agonistic image of the human which suffers, the human which thinks, the human which writes, the human which means, albeit all too humanly, in that agon the strong poet must wage, against otherness, against the self, against the presentness of the present, against anteriority, in some sense against the future."[4] So much of the surrounding world bears in upon creators that they risk being crushed. The massive otherness outside is the consolidated form of everything that blocks self-realization. In this view what Leverkühn or Zeitblom describes as bad conscience is the all-too-human defensiveness of the belated and belittled composer.

FORM AND ITS OTHERS

While Bloom offers the most familiar and general identification of the issues of transmission and innovation in artistic expression, my more immediate

concern here will be a related contemporaneous figure, Julia Kristeva, whose work has resonated in musical scholarship. In a widely debated essay, "From the Other to the Abject: Music as Cultural Trope," Lawrence Kramer has brought to bear on the history of musical expression a dialectic drawn from Kristeva, pitting "form [as the] dynamic principle of containment or regulation" against the discomforts of "sensuous plenitude."[5] As preparation for the ensuing Mozart analysis, I will present and critique Kramer's influential account of the impersonal otherness he calls alterity and the responding bad conscience that, following Kristeva, he calls abjection.

Kramer begins his critique of static formalism by invoking the traditional internal oppositions of content against form, richness against unity, or movement against closure. Despite the apparent self-evidence of the terms, he argues that these oppositions fashion a "logic of alterity" that is "far from stable" (*Classical Music*, 34). Binaries are inherently "hierarchical" (37) and spread an infection of domination and submission. The terms are not neutral; they spontaneously get valued or, conversely, devalued. Traditionally, for instance, form, unity, and closure have appeared to be goods and their opposite numbers to be seductive threats, as Rossini appears in confrontation with Beethoven in Carl Dahlhaus's version of nineteenth-century music. Initially, music may be taken for a value-free pure system—a realm beyond experience rather than a polar opposite to experience—but its impunity doesn't last, for "the logic of alterity operates not only internally, within a musical terrain, but also externally, upon music as a whole" (36). A sorcerer's apprentice, alterity "proliferate[s]" (38) and takes over the world, as with the supposed impersonality advocated by Matthew Arnold, where "a depersonalized authority . . . becomes the object of an eroticized submission" (41). As music migrates from outside to outsider—that is, as indefinability becomes its identity—it feminizes. It is in the nature of music to be insinuating: "Reversion to a supposedly mastered other is above all *musical*" (43). The point of a composition, on this account, is to upset apple carts, to emotionalize, to energize: "Music is pocket carnival" (63)—and if not the point of a composition, then of a performer, who is supposed to operate "at very high voltage" (61), and of a listener supposed to "operate in a mode of acknowledged fantasy" (65). "Music is the site reserved for deviance"; indeed, "it helps produce the very category of deviance" and provides the "collective affirmation" of those labeled as deviants (63). "To hear music made is *dangerous*" (59). On this account, the power of music reveals the instability of traditional ideals of form.

All this is keenly argued and cleverly exemplified. Feminization aims at redeeming and transvaluing abjection: "The postmodernist musicology for which I am pressing in this volume is ultimately an attempt to transfer disciplinary value from the logic of alterity to such performative listening" (65). But there remains an unargued premise, namely that alterity entails hierarchy. Negation is presumed to go hand in hand with domination, or else with submission. The casting may vary, but the roles are scripted: "Many such reversals willy-nilly repeat the key terms of dominant structures in the very act of resisting them" (38). We know the stories music can tell before we have listened to it. The hope is that performative listening that identifies with the other can break the bondage of "submissive listening." Even though the "conceptual apparatus" of structuration "has proven to be virtually inescapable" (64), the performative listener can refashion alterity into "a mode of acknowledged fantasy" and thereby escape the "imperative to reconcile [understanding and pleasure] or [to] order them hierarchically" (65).

I prefer a less pugilistic version of alterity that I identify with Hegel. The Hegelian other does not challenge and undermine identity but precedes and shapes it. Hegelian identity, that is, does not begin fixed and conflicted, but fluid, with undefined sensation in the *Phenomenology* and inchoate being in the *Logic*. The other is the lack of self through which the self comes to determine and to know itself. Self and other define themselves conjointly; the other is as mysterious and as open as the self, in a relationship of mutual and ongoing accommodation and regard. Only at one passing stage in its developmental process—the moment when emergent self-consciousness is defined in terms of mastery and servitude—does the self fall prey to the structures of domination that Kramer identifies with the whole of alterity. And even there, hierarchy proves delusional. In "this truth of pure negativity," says Hegel, "all durable existence becomes absolutely fluid" (*Phänomenologie*, p. 148; trans. Pinkard, par. 194). Identity takes shape neither in the master nor in the servant, but in the "negative middle term, th[e] formative activity" (p. 149; par. 195), the work in which each can recognize identity, the worker more directly than the master. In this view, identity is constantly being produced and recognized in differential relationships, not subverted and reasserted in conflictual struggle. The work has value, then, not as a star vehicle but as a condensate that reflects the participant's capacities and thus his identity: "Therefore, by way of this retrieval of himself by himself, his own sense arises precisely in the work

in which there had seemed to be only another's sense" (p. 149; par. 196). Like all Hegelian processes, the resolution of the master-servant dialectic is intricate, with continually shifting positions, and fraught with the negative emotions associated with the risk of losing one's identity—fear, trembling, anxiety. But the outcome is a liberation of self-consciousness. Through the mediation of the other, says Hegel, the self learns to think, when "the object moves for thought not in representations or figures, but in concepts" (p. 152; par. 197).

The logic of the other, in short, by no means inevitably falls in with the logic of hierarchy and domination. (It is too rarely remembered that the subordinate in this Hegelian scheme is neither a servant [*Diener*] nor, certainly, a slave [*Sklave*—a word that does appear in earlier versions but that Hegel replaced] but a *Knecht*—not really a "knight" or apprentice *Herr*, but maybe a nobleman's helper, even so.) There is neither a single relational structure nor the kind of homology that Kramer postulates between different domains. Personal others, material others, conceptual or abstract others—these are different spheres, and each comes in numerous configurations, developing through its encounters with us. Indeed, Kramer's logic of the other looks to me very much like what Michel de Certeau calls the logic of the same. The logic of the same is the scientific rule of categories that identifies entities or persons with prescribed values. Its modality is structural and its greatest contemporary practitioner Michel Foucault. Certeau contrasts him with Freud, who situates understanding in the mythic and literary domains where thought is free from the constraints of system. "The literary text is like a game . . . a somewhat theoretic space . . . where the artful practices of social interaction are formulated, separated, combined, and tested." Like Jean-François Lyotard's pagan institutions or Clifford Geertz's local knowledge, Certeau's logic of the other allows for reconfigurations, or, as he says, for "alterations, inversions, equivocations, or deformations" of the conceptual space. This version of othering yields transformations, not renamings or other objectifications.[6]

MOZART MEETS BACH

The foregoing reflections on varieties of otherness will be my context for the ensuing reading of Mozart's encounter with Bach. There can be no doubt that Mozart encountered Bach as a remote yet hallowed voice from the past.[7] Fugal texture imparts a self-consciously temporal dimension to

classical-period music in a way that was largely unprecedented and with an immediacy that is not duplicated by the revivalist fugues of Romantic composers, from Cherubini to Strauss. Warren Kirkendale, the leading authority on the topic, puts it this way: "The essential charm of classical fugato technique lies in the way it traverses the styles of two different periods. No composer of later date imparts this historical dimension to a work by means of a fugato with such masterly assurance."[8] Yet the issues of alterity, abjection, and feminization complicate the picture. What kind of charm is at play—delight, fascination, or mesmerization? And who masters whom when an assured fugue intrudes on a homophonic composition? How should we interpret the otherness of the historical predecessor at this juncture in the development of Western music?

In 1782, already a mature composer, the twenty-six-year-old Mozart was introduced to a number of works of Johann Sebastian Bach and Georg Friedrich Handel by the Viennese collector and patron Baron Gottfried van Swieten. While Mozart had studied and composed many fugues previously, they remained distinctly academic and were not integrated into his general compositional style. A number of Haydn's string quartets before 1780 had concluded with elaborate fugues that energetically display contrasting motifs and contrapuntal virtuosity, but Mozart avoided Haydn's way of playing with the past, nor did Haydn continue the practice in his last decades. The intensive encounter at Baron van Swieten's, on the other hand, was transformative. Mozart transcribed a number of fugues, wrote others, and, what matters most, integrated elements of fugal style into his compositional practice. Notable among the van Swieten music is a set of six fugues transcribed for string trio with slow introductions. Two of the introductions are also transcriptions, but four are original. Representing a remarkably direct encounter with the newly discovered music of the past, they are known as Mozart's K. 404a. While the manuscripts are late and cannot with certainty be attributed to him, no better candidates have emerged, and the handling of the viola (which I will touch on below) is additional stylistic evidence supporting his authorship. The first half of the set, which contains three of the four original introductions, is the more interesting; my analysis concerns the style of these pieces, in particular the first (Ex. 6.1).

Bach fugues engage in a controlled transformational process. In the first of the transcribed fugues the viola states the subject. (Indeed, five of the fugues chosen by Mozart open with the alto voice, while the exception, no.

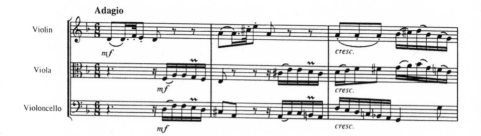

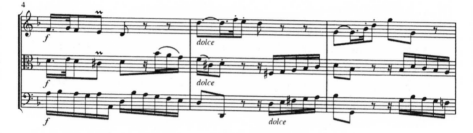

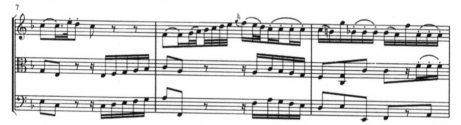

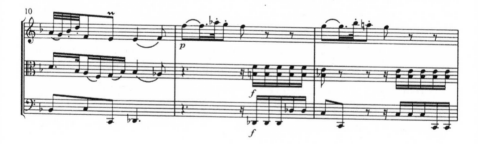

EXAMPLE 6.1 Wolfgang Amadeus Mozart, K. 404a/1, introduction and beginning of fugue

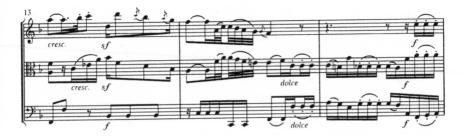

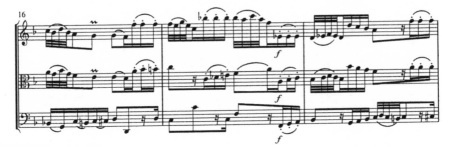

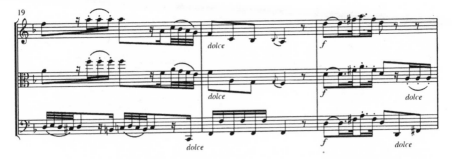

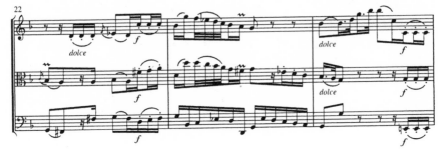

EXAMPLE 6.1 (cont.)

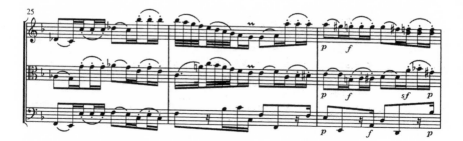

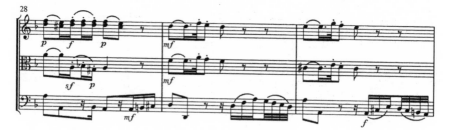

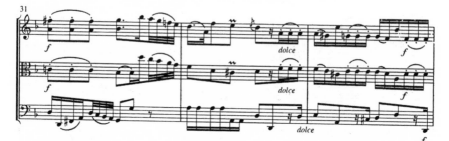

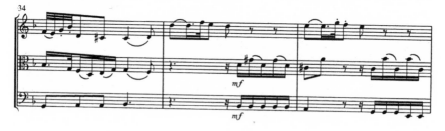

EXAMPLE 6.1 (cont.)

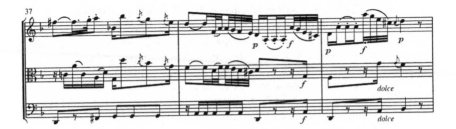

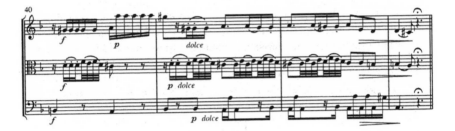

Fuga

EXAMPLE 6.1 (cont.)

5, is a double fugue in which violin and cello play together for the first eight measures, while the viola alone is silent.) As is often the case, the tonic is established by implication rather than by cadence. The subject encompasses only the first six notes of the scale, and the answer at the dominant introduces C-natural well before the first C-sharps in measures 7 and 8.[9] There is no intention to establish a classical-style tonal home base, and for the rest of the piece the almost continuously moving eighth notes prevent any real settling in.

Indeed, this fugue subject has an unstable character that fosters continuing movement rather than dramatic contrasts of keys. While it begins on a downbeat D, the tonic note sounds initially like a pickup to the higher and longer A, and there are moments where a three-beat rhythm seems to confuse the common-time meter.[10] As is standard, fugal entries come at unpredictable times and at varying distances from one another. Bach conspicuously delays an emphatic possibility offered by this subject: answering a tonic statement at pitch. (In mm. 44–45, the violin answers the inversion at pitch; the stretto in m. 52 has answers at its original pitch, but it is in the subdominant moving to the relative major.) The deliberately weak tonic lets ambivalence prevail over assertion and encourages the transformations that display the composer's resourcefulness in keeping the music afloat. The multiple permutations of the subject—a fifth plus a second, a fourth plus a third, a fourth plus a major or minor second—give shape precedence over tonality. In measures 21–22, where the trilled end of the subject is tossed back and forth between viola and violin,[11] fragments take on a life of their own, and again in measure 24, where the rising motif echoes in close stretto among all three instruments, starting on different pitches and with slightly varied continuations. By measures 52 and 54, close stretto presents identical notes in all three instruments, and near the end, in measure 77, the last imitative passage dazzlingly displays the fugal subject moving in three different octaves and at three different speeds, yet at identical pitches.

Harmonic divergence finally yields to convergence. Yet the original form of the subject has long since been abandoned; indeed after the first cello entrance and one pair of appearances on the dominant in measures 19–20, it regularly begins with a rising fourth (and in inversion mostly with a descending fifth), so that in its rare tonic appearances after measure 45 (61–62 in the viola and then the final stretto beginning in 77) the tonic note is delayed and deemphasized. Indeed, the final statement of the subject (in the viola again, beginning in m. 80) begins on the fifth-scale degree but

continues in the subdominant key, a masterful achievement at encompassing the tonic rather than restoring it.

The structure of such a fugue is progressive and explicative. Its excitement comes from the steadily increasing pace and from the power of contrapuntal discovery. Whereas baroque variations are ornamental displays of what the composer or performer can produce over and around the theme, fugues show his resourcefulness *with* the fugal subject. New combinations continue to emerge, enlarging the sphere of resonance without either repetition or dramatic transformation. Even the virtuosity characteristically lies in control rather than display: by measure 78 in the original of the first transcribed fugue, the keyboard player has to span a tenth while transferring the middle voice seamlessly between the two hands. A controlled release of power gives these fugues their cumulative, motoric, seemingly irresistible momentum. Their governing principle is production rather than either aristocratic refinement or the dynamic mercantilism of classical-period balances of forces—a self-sufficient economy, yet, by Bach's time, also one with considerable power of expansion. But the ethos remains artisanal, emphasizing skill rather than power and free from structures of domination. The roles are not sharply divided (each voice, for instance, gets a turn at playing the theme in augmentation), and the structural role of each voice is lucid moment by moment.

Baroque expression is often called linear, but that term can be misleading. In an important sense, a fugue by Reger (to take an extreme case of neo-baroque) is more linear than one by Bach, because Bach's fugues are also harmonically (vertically) intelligible whereas Reger pits chromatic opacity against thematic regularity to the point that the horizontal element overcomes the vertical. The Bach fugue is linear in a different sense. Its expression remains successive; the combinatorial effects are local and depend little on long-range understanding.[12]

In *The New Grove Mozart*, Stanley Sadie observes the "stylistic incongruity" dividing Mozart's slow introductions from Bach's fugues (90). It is hard to argue with that assertion, but I do not agree with his qualification that the introductions are "oblivious" to the incongruity. On the contrary, my purpose will be to show how direct and significant this encounter with Mozart's musical other is. The original slow movements in K. 404a are not preludes in Bach's manner but introductions. That is, these four slow movements are not self-contained pieces ending in the tonic as the transcribed number 4 is; instead, they end on dominant half cadences to

create an expectation of continuation. One might ask why the fugues seem to need introductions, but I prefer to turn the question around. What happens to the fugue through being introduced? And that question turns out to be related to a second one, what happens to the fugue through being transcribed for three instruments?

The first introduction plays bo-peep with the tonic chord. It begins with a single, unharmonized D. The violin line in measure 1 implies a I-V-I harmonization, and so does the answering line in the lower strings. They amplify the spare solo violin by outlining the D-minor triad, and the second measure likewise amplifies the implied harmony of measure 1 by introducing the dominant triad in both upper and lower strings. In contrast to Bach's fugitive tonic—always departing from D but never getting very far—Mozart thus begins with a classic, cadential affirmation of the key. Or at least so we might anticipate. But in this piece the D minor in the third measure sounds initially in first inversion (F in the cello), then in root position only for an instant, on the weak second beat, where the cello immediately passes through a C-natural toward G-minor sonorities. While full triads on other roots are common, D-minor sonorities either lack the fifth or appear broken (like the cello arpeggio in m. 29—a surprisingly brief return to the opening material, and with its mf marking now slightly subdued in the context of the surrounding fortes) or in passing (as in the first half of m. 19, where D minor is encapsulated within the relative major). At the end of measure 32, the D-minor cadence, where a full root-position triad actually sounds on the final sixteenth, initiates an echo of the piece's long middle section (leading to the deceptive cadence in m. 34) and the stormiest music of the piece in the dissonant viola line of measures 35–36. The same deceptive cadence denatures the expected tonic in the middle of measure 39, and the music moves off into the dominant close. On rehearing the first two measures (in contrast to m. 30), with their more dynamic dominant seventh, one might indeed take them as another half cadence, without a substantive resolution. But even the half cadence would have a structural function, foreshadowing the close—a large-scale effect of a kind not found in Bach. The alternative readings of the cadence generate a local instability and energy, fused with a long-term consolidation, since full and half cadences assert the same tonic. The tonality is actually locally less secure than in the fugue, though weightier in the aggregate.

Following Mozart's introductory measures, the opening of the fugue sounds more emphatic. The forte marking weights the tonic downbeat; the

first pair of notes audibly recapitulates the tonic-dominant sequence opening the introduction, and the trills added to the penultimate note of the subject (here and elsewhere) confirm the landing point. Indeed, it is plausible to hear the structural contrast of tonic and dominant now realized in the fugal subject: the keyboard fugue was in D-sharp minor, but as a result of transposition each instrument can begin its statement on an open string, giving the effect of a drone on the fundamental supporting a turn on the fifth note of the scale. The fugal subject thus appears as a decorative variation on the structural harmonic motif with which the introductory movement opens. Even the rhythm is wittily echoed: the introduction opens with the violin playing the first note and the last three notes of Bach's fugue subject, in essentially their original rhythmic values. Overall, then, there is an exchange of qualities between the two pieces. Despite its initial harmonic assertiveness, the introduction acquires some of the harmonic idiosyncrasy of the fugue, while the opening of the fugue acquires something of the forward momentum of classical harmonization. Two different kinds of balance confront one another, and each is inflected by the other.

The rhythms likewise interchange qualities. In the fugue subject, as I have said, it is hard to perceive any hierarchy of beats, especially without the weak-beat ending of the introduction and the forte to clarify the downbeat. The 6/8 introduction has, of course, an inevitable alternation of strong and weak beats. But the relationship between the halves of the measure is indeterminate. Which is stronger, the violin's first D, unprepared, or the second D, resolving and coming to rest? Does the V^6 chord that opens the second measure assert the dominant or lead toward it? (The second entry in the fugue is clearly in motion, since the violin's second pitch remains the tonic D instead of the E that an exact imitation would yield; the tonic harmony is only confirmed with the cadence at m. 8.) By the opening of measure 3, we hear a downbeat that is clearly en passant; sixteenth-note motion continues unvaried, and the violin's repeated As crescendo toward a resolution that really only arrives with the unison D in the middle of measure 4. Indeed, repeated notes so regularly appear as upbeats in this piece (eighths at first, then also sixteenths) that the effect of metric displacement is virtually inescapable. The first four measures form a phrase, but not a strictly symmetrical one; measures 5–8 are a second unit in the lower two voices (which play in thirds with the same pulse throughout), but the violin changes character at the beginning of measure 8, and the four measures in F-major run from 7 to the interruptive cadence in 10. Mozart stiffens Bach; Bach loosens up Mozart.

It is customary to think of fugues as rigidly intellectualized forms. And the academic fugues in the learned style that Mozart was accustomed to writing may well be regarded as such. But Bach's rhythmic and tonal freedom encourages a responding fluidity in Mozart's writing here—not a new quality in his writing, to be sure, but present to a striking degree in these introductions. The second introduction is perhaps the most flamboyant, with a chromatic bass line supporting incessant V-I progressions, leading to a rising circle of fifths in measures 9–10, while the typically Mozartean high viola lines turn imitation into a kind of athletic competition.

The first introduction is also strikingly modulatory. It sags rather than soars. A descent through the circle of fifths in measures 5–8 (marked dolce in the score) leads from D minor through G minor and C major to F major, arriving at the relative major through a process of continual relaxation.[13] From the start, moving sixteenth notes have prevented resting on the tonic, and the F-major key area, beginning with the complete scale in the violin in measure 8, turns into an alternate region of repose. The most revealing notes are the B-naturals, which are mostly heard in passing off the beat, and never on a main beat until the final bar. B-natural is not part of the F-major scale, yet in the middle section it reinforces the F-major tonality: in both the violin line in measure 9 and its viola echo in 15, the transient B-natural lets G sound as a secondary dominant of F. B-natural continues as an F-major color tone in measures 16, 18, and 19, and it appears in a different but still key-confirming guise in the German sixth of measure 11 (misprinted as B-flat in the error-prone score). The piece has settled decisively into the relative major arrived at by way of subdominant modulations. Indeed, the middle section keeps moving away from F and then returning, as if that key were harder to leave than D minor is. As not infrequently happens in minor-key pieces, the two classical functions of the tonic are disjoined: D minor is the point of reference but F major is the point of repose, leaving the piece without a stable center. Instead, it ends on the dominant, making it a long structural upbeat to the D-minor fugue. The tonic is always going or coming, never quite there, which is what creates a dynamic rather than a static effect in the music, even at its very slow tempo. Instead of rationalized polyphonic control we hear expressive intensities.

Unlike the second and third introductions (and also the fourth, transcribed from a Bach organ sonata), the first introduction does not put polyphonic or even imitative features on display. But they are present in the background and arouse the appearance of polyphony within a harmoni-

cally active composition. In the first measure, the violin's phrase shape is imitated by the cello; then, in the second measure the greater compass of its phrase is outlined by cello and viola taken together. However, while the violin lands on its starting notes in harmonically static phrases, the lower strings move past their starting notes to land on a new chord (m. 2) or to energize movement (m. 3). Voices multiply: first one instrument, then two voices synchronized, then (first half of m. 2) overlapping voices, and finally, in measure 3, three independent voices. Through this composite of motivic echo and linear autonomy the piece acquires some of the texture of polyphonic music.[14] While the opening measures are the most striking in this respect, the principle of cumulating voices operates throughout. Notable is the way the viola keeps separating from the cello then rejoining it. Even where no motivic imitation is involved, the return to parallel sixths or parallel thirds evokes similar effects in polyphonic music, with many examples in the ensuing fugue, beginning in measure 8. Because of the alternation between solo voice and paired voices, the harmony creates the impression of interwoven polyphony. Intermittent parallelism is the classical composer's answer to polyphony.[15]

The character of polyphony is thus retroactively transformed. The fugue has an unchanging expressive or topical character (and steady pulse) throughout and depends for its development on structural variation—contrasted entries, contrary motion, and controlled fluctuation in phrase structure. Polyphony equates with internal contrast. In the introduction, however, the imitative effects are both intermittent and expressively stable (motion in thirds and sixths), while serving to vary the texture of the piece: they are not the foundation but the coloration. Limited to three voices, Mozart masterfully weaves his structural and textural contrasts to condition polyphony to the classical era. The opening measures pit the dramatic dotted rhythms of the violin against a smoothly flowing accompanying ensemble. Even with limited forces, there is an unmistakable feel of solo voice contrasted with ripieno accompaniment. By the third bar, however, the viola joins the violin in a trio sonata texture. After the more relaxed middle section, the abrupt unison in measure 21 (with a new texture and a new key) resounds like an orchestral correction that relegates F-natural to the status of a dissonant appoggiatura in measure 22. When the opening music returns in measure 29, however, the viola is with the violin and the dramatic recitative is now located in the cello part. The violin's notes are identical to the beginning, but their textural function has changed. The

violin repeats in measures 35–36, but now the viola bears the weight of an innovative voice with its dramatically arpeggiated double stops (a tritone followed by a minor seventh). By the end, imitation has yielded to independence; each instrument repeats its own phrases in identical notes rather than echoing or pairing with a different instrument, though the viola retains reminders of the violin's initial D-F-E-D sequence on beat 6 of measure 41 and beat 3 of measure 42.

The viola is the swing voice throughout. While not given an independent or obbligato role as in the second and third introductions, respectively, it is here, more subtly, the determiner of texture and hence of character. Alternating between partnerships with the cello and with the violin, its choice regulates the prevalence of homophonic or imitative textures, of integrated or opposing voices. Even more striking than the rhetorical pathos of the dramatically varied moods I have described is the means by which the composer economically accomplishes his aims. Simply by shuttling between tenor function and alto function, the viola guides the shifting character of the piece. In polyphonic music successive entries of the subject (and of countersubjects) provoke shifts of attention from one voice to another. The introduction shifts just as rapidly and hence recreates the animation of polyphony, but it does so from within, as it were, and in terms of mood rather than of developing structure.

Part of the pleasure in listening to a fugue lies in being able to name the parts: imitation, transposition, inversion, augmentation, diminution, and so forth. The rhetorical topics of later eighteenth-century music furnish a different sort of recognizable and nameable units. But in this introduction the parts shift so rapidly that a determinate narrative can hardly be the issue. Rather, it is what Mann reports: the incorporation of a polyphonic feel into a structure organized harmonically. Whereas imitation once served throughout to link the voices, it now appears fitfully in connection with distinctions of tone and texture; whereas variation was once a necessary compromise to permit the unfolding of the structure and to display the composer's virtuosity, it now becomes the dynamic of movement at the core of the musical gesture.

And dynamism goes hand in hand with individualization. I have discussed the distinctive role of the viola in the first introduction, alluded to its varied roles as a tenor, alto, and (rising above the violin in the second introduction) soprano voice, and mentioned its initiatory role in the fugue transcriptions. Earlier I posed a question about the effect of transcribing

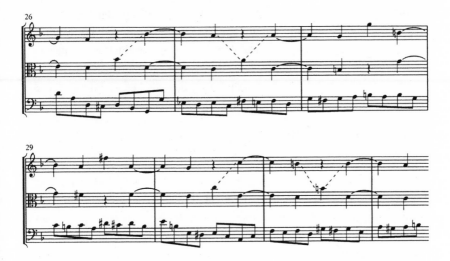

EXAMPLE 6.2 Mozart, K. 404a/3, mm. 26–31

a keyboard fugue for string trio. While performance characteristics will vary, surely some degree of individualization is inevitable in this respect as well. Nor is individualization merely an accidental effect. The close spacing that is inevitable when three lines are played by two hands becomes more clearly articulated in the transcription. Notes passed from one voice to another and crossing lines all become clarified in the transcription, as in measures 26–27 and 30–31 of the third fugue (Ex. 6.2), where the composer has allocated repeated notes between violin and viola (B-A-C-H in German nomenclature, as it happens), or in measures 35–36 of the fourth fugue, where eighth-note repetitions of B-flat and E are sorted out between the crossing lines. Voices that are blended in the keyboard fugue are individualized in the introduction and are fruitfully heard with greater individuation in the fugue as well.

The close provides a small yet dramatic test case for Mozart's rehearing of Bach. While both the first introduction and its fugue are in the key of D minor, both end with major sonorities, the expectant dominant in the introduction, and the expected D-major Picardy third in the fugue (also without a fifth; of the twelve pieces, only the fourth and sixth introductions conclude with a full chord). Whereas Bach's Picardy third is entirely conventional and unremarkable, Mozart's introduction creates a motiva-

tion for it. As in the F-major section, B-naturals are again the crux. In the fugue they normally pass tonally to C-sharp, in the introduction chromatically to B-flat or to C-natural. Hence, in the introduction's D minor, downward scales predominate, as do downward chromatics in the middle section, and even F-sharp rises only into a flat-side key, G minor. Yet in the penultimate measure of the fugue, while the viola's rising scale adopts the sunken pitches of the cello's falling scale, the violin rises chromatically, revising F to F-sharp and B-flat to B. In these contexts, the Picardy third at the end of the fugue is heard not as a neutral convention but as a course correction. The viola's concluding F-sharp becomes an uplift; it completes the motion of the previous bar—the viola's D-E-F- . . . F-sharp echoing the same sequence in the violin in measures 85–86—and thereby definitively settles a question that the introduction had worked to unsettle.

The fugue pursues a flexible and unpredictable course of gradually increasing intensity. It shows the composer's power to extract significance out of a virtually featureless theme. As such, it is a triumph not of imagination but of intellect and of will. Mozart imbibes its combinatorial freedom; at the same time, he naturalizes its expression. Tonic becomes home, grounded in cadence, imbued with characteristic moods, and recognizable in departure and operatic return. Key is programmatically arbitrary in *The Well-Tempered Clavier*, but the D minor to which Mozart assigns this piece is firmly rooted in his key sensibility, and the same applies to the keys into which he has transposed the second and third fugues. Rhythm and rhetoric become expressive; while there is no narrative, everything that in Bach was mere energy here becomes recognizable gesture and expression. The Bach work flows free of the performer; the Mozart piece is made by the performers, not just realized through them. Despite the current popularity of body criticism, however, I think it is a mistake to corporealize the effect. Labor is seen as part of the value of the work in a new way corresponding to the self-respecting self-recognition of Hegel's servant; it is craftsmanship and skill, not the master's vision of sweat equity. The fugue is similarly transformed, though to an uncertain degree: at the very least, the forte marking at the stretto in measure 52 encourages the performers to dramatize this one moment where the eighth-note pulse pauses and to give a rhetorical rhythmic emphasis to each entry in turn, and the forte in the cello at measure 62 encourages a stratification giving authority to the augmented version of the theme. These things that would in any case be heard as elements of display are here foregrounded as elements of expressivity.

Introduction and fugue thus confront one another as two alternative conceptions of the nature of the musical work. Meaning, a relationship of exterior sound to interior feeling, is at issue only in the later conception; in the fugue the issue is will in relation to its materials. To that extent, Leverkühn's specification of the formal relationship of Bach to his successors reflects a modern understanding or dilemma. Bach's fugue balances harmonic movement with coherence; the question is not one of meaning but one of structure: how is a harmonically stable polyphony possible, without succumbing to inertia? Mozart, on the other hand, does assimilate an appearance of polyphony without falling back into the old forms, so Leverkühn's formulation of his situation—"how is one to write a harmonic style that has the appearance of polyphony?"—sounds more appropriate. Yet it is not entirely that either. For Mozart had already written many fugues and had no need to prove that he could master counterpoint. Appearances are not the issue. What Mozart's contrapuntal layering takes from Bach here lies in the vivacity and flexibility with which the slow tempo is handled. A composer might put the question Leverkühn's way, provided that the composer understood polyphony in terms of its inner drive rather than in terms of the rules of imitation formulated by theorists. Still, the encounter with Bach seems more like an opportunity seized than like a threat warded off.

BEYOND ABJECTION

When regarded as an instance of abjection or bad conscience, the historical other is treated as a personality invested with a role. The story would go something like this. Mozart meets an unfamiliar or unmastered psychological state in Bach's fugues, signaling a lack in his own psyche (or, less melodramatically, in his compositional achievement); he subordinates his own technique to that of Bach, regresses into imitation and becomes hesitant, giddy, and troubled. Kristeva speaks of a wounded narcissism arising from looking at one's reflection in muddy waters. The abject, as she says, is "an artist who practices his art as a 'business' [comme une 'affaire']. Corruption is its most common, most obvious, appearance [face]. That is the socialized appearance of the abject."[16] According to this account, art is most itself when most troubled, most contaminated; the demonic energy of wrestling with an incarnate fate is the true face of art and, we may suppose, the one to be brought out in performance.

Yet it is far from evident that Kristeva herself views abjection as the unhappy detritus of psychological malfunction. Kramer describes it as a reflex and a defense, "something within the subject that belongs to the sphere of fusion with the mother and must thus be cast violently out in order to maintain the subject's intactness" (*Classical Music and Postmodern Knowledge*, 58). But for Kristeva the abject is positioned as a sign of originary repression, a vertigo that precedes self-definition.[17] There can be no question of maintenance before there is something to maintain. "The abject confronts us ... with our earliest attempts to demarcate ourselves from the *maternal* entity even before ex-isting outside of her through the autonomy of language" (13, translation modified). Perhaps violent, but not in the agonistic sense that Kramer presumes, abjection is a passing condition analogous to the *jouissance* of sexual excitement: "the advent of one's own identity demands a law that mutilates, whereas jouissance demands an *abjection* from which identity is absent" (*Powers*, 54).[18] If so, then individuation is equivalent to the power of form, that is (in neo-Freudian language), to written language and to the castrating law of the father. But there can also be a writing that precedes language (see "A Scription without Signs," *Powers*, 73–75, a subsection of the essay "From Filth to Defilement"); its works emerge from the inchoate, disoriented space of the mother that Kristeva calls the *chora*, and, rather than suffering, they find an ecstatic absolution. In the Western cultural tradition, I need hardly point out, music is the preeminent example of an expression that is written but not spoken, hence of a writing that precedes language, leading Kristeva (in a paragraph about Giovanni Pergolesi's *Stabat Mater*) to write of "the subtle gamut of sound, touch, and visual traces, older than language."[19] Music is thus a "pure signifier" that is not semanticized (see *Powers*, 23 and especially 49). And, despite the binarism into which his conclusions sometimes lapse, no critic active today is better than Kramer at analyzing the "living experiences of music[al scores] as subjective, ineffable, or irrational" (*Classical Music*, 64).

Kristeva has two other terms for abjection, of which one fits the case of K. 404a, while the other does not. The term that does not fit is the sublime. These are little pieces, seeking a natural accommodation with the past; they have their dramatic aspects (particularly the last, in F minor, a key Mozart hardly ever used), but it would stretch credibility to claim that their definitions come accompanied with flamboyance or transcendence. Sublimation is a cultural engagement involving the superego and the Law; it is an identification with the other through which the self taps the mythic

powers of the community at the expense of a certain repression or sacrifice of individual experience. The finale of the *Jupiter* Symphony is a sublime engagement with baroque counterpoint in this way.[20] But in K. 404a there is neither fusion nor self-suppression. Mozart is finding his sea legs, not losing himself in the empyrean.

The Kristevan term that does fit is flux. Flux is also a Hegelian term, and indeed Kristeva's "From Filth to Defilement" concludes with Hegel, even though not in this connection. The trio transcriptions at least slightly loosen the joints of the keyboard fugue, and the introductions much more obviously slacken the reins of both classical and baroque style. Small in scale yet disjointed in sound, they seem more a theater of rhetorical effects than patterned compositions. Mozart (or whoever composed K. 404a) is coming to explore expressive possibilities, to recognize elements available for compositional forming, to know himself through knowing what he can make of the music of the past. "Bach" is also coming into his own—not as personality obviously (he was beyond that by the 1780s), but as a stage in Mozart's past.[21] The textural richness of the introduction confers a distinctive identity—a distinctive kind of sound experience and structural conformation—on the fugue. And the fugue liberates resources of interaction in the introduction. This is elemental writing, not sublime. Given its attention to nuance and its deconstruction of earlier compositional practices (Mozart's early practice as well as Bach's), such writing might well be termed *écriture mineure*. Indeed, has no one proposed the term decomposition for musical deconstruction?[22] Mozart's introduction here decomposes the resources of the fugue into local techniques of imitation and accumulation, and Bach's fugue decomposes the classical, dramatic manipulation of the beat into an ongoing, energized pulse. Still, I prefer the Hegelian term that is his alternative to sublimation (*Aufhebung*) and that evokes the primitiveness of the writing, the fracturing of effect, and the foundational character that goes along with its fluid lack of identity. That term is *Zugrundegehen*, founding through foundering. Mozart here gets under Bach's skin in order to define and learn to know Bach and simultaneously to know and be himself more fully.

As a person Mozart was undeniably troubled. But does domestic ontogeny necessarily recapitulate historical phylogeny? Maynard Solomon, for one, sees a possible trade-off rather than an equivalence between the different spheres. "Certainly, in his youth Mozart did not view the musical past as a melancholy burden but rather as an opportunity to be grasped. . . . It

may be overly simple constantly to see the live poets contending with the dead ones, projecting the family agon onto the screen of creative tradition. Frequently, a young poet or composer actually finds allies in such symbolic oedipal contexts precisely among his or her colleagues, past and present, who strengthen the will to resist and lend courage to defy taboos against being a separate individual, to prove that one has the capacity to leave a mark upon the world."[23] Music might then be regarded not as an instance of psychological encounter, but as an alternative to it, a different way of meeting the other and positioning the self. And Kristeva might even guide us in that endeavor.

Whether actually by Mozart or not, this set of introductions and transcriptions is part of the history of music. They are not historical because they made history, for they were little known, diffused only through some manuscript copies, and without influence. They are thus not, in any public sense, in history. But history is in them.[24] They are history as *chora*, the undemarcated space where identities are in flux, without fixed hierarchies and orders of precedence. It was the epic novelists of the nineteenth century who brought historical understanding down to the level of the ebb and flow of individual consciousness: as cumulation in Trollope, as gradation in Eliot, as satiric incomprehension in Flaubert (who shows how irrelevant the grand events could be), and, most elaborately of all, as turbulent mixtures of motivation and chance in the grand tapestry of Tolstoy's *War and Peace*.[25] Mozart's K. 404a has its rightful place, but in a different kind of history.

Interpreting K. 404a in the spirit of Zeitblom, as a psychological confrontation, would mean hypostatizing states of mind as preexisting conditions. But surely the effect of these quizzical little pieces is to explore and not to expose. There is nothing cathartic about them; they even seem to precede any narcissistic self-regard.[26] Discursive utterances, perhaps, are never entirely uncontaminated by engaged subjectivity (though aesthetics has often regarded poetry as language freed from subjectivity). But music is not discursive and so can draw its power more directly from a realm that escapes self-definition and is therefore exempt from the anxieties we attribute to persons, even if in worldly terms it looks abject, corrupt, rotten. Following Leverkühn by degrading K. 404a into a merely formal problem would entail externalizing and converting into the public realm a composition that was never an event. Really, these pieces are neither public nor private, for they preexist any such distinction of realms: they neither represent

a culture nor express a psyche. Rather, they come closer to what Theodor Adorno has called "the unconscious historiography of historical creation and miscreation."[27] We have no adequate language for the musical space that precedes language. But we can honor the novelist who can encompass and fuse both public and private in an imaginative world where they cannot really be separated into distinct realms.

At one level the entire utterance with which I began is Leverkühn's (the words are attributed to him), at another level Zeitblom's (he reports them); I speculatively distributed them, while Mann lets them belong to both characters at once. But, as any reader of *Doctor Faustus* knows, the two characters, the narrator and his subject, are inseparable faces of the disaster that overcame Germany in the twentieth century. Both abjects, both corrupt, both narcissists, they emerge in their separate identities as witnesses to the collapse of the free spirit of music when it enters the world of historical enterprise. At the same time, however, the creator, novelist as composer, remains above them, with his vision of the power of music to survive even the events it could not prevent. "More interesting phenomena"—so says Mann's radical, though hermitlike composer—"probably always have this double face of past and future, probably are always progressive and regressive in one. They display the equivocalness of life itself" (*Doctor Faustus*, 193).

⇒ 7 ⇐

Moods at Mid-Century

HANDEL AND ENGLISH LITERATURE, 1740–1760

THIS chapter arises out of talks given at an Aston Magna Institute enti-
tled "Handel's London." My task was to characterize Handel's oratorio
production in relation to the literary culture of his day. Since the primary
audience was musicologists, the emphasis in the chapter lies on character-
izing the writers. The manner is intended to be relatively introductory. The
synthesis, however, is får from conventional, both in its definition of the
period boundaries and in its characterization of the relationship of non-
fictional prose, fictional prose, and verse. A horizontal comparison among
diverse media gives a very different view from a longitudinal consideration
of a single creative figure or genre. To be sure, the thrust here is toward the
literary. That is, the very general characterization of Handel's oratorio style
provides a searchlight into a complex of literary developments in poetry
and, toward the end, also in prose. For musicologists, it is intended to sug-
gest a closer fit between Handel and his immediate public than tends to be
acknowledged, with implications for the specificity of musical periodiza-
tion in England. But it would require a different kind of study to shed new
light on Handel's music. I offer this chapter, then, as one, albeit partial,
model for characterizing a musical style in relation to a cultural style.

"Handel and His Times" is a rather worn topic, though not a well-worn
one. One can read that Handel was backward-looking, forward-looking, or
a man of his times. All three contentions have a certain surface plausibil-
ity. The "baroque" period was nearing its end, and its most representative
forms, fugue and opera seria, soon died out; Mozart tried the latter repeat-
edly but eventually had to turn to comic opera for lasting stage success. As
a baroque composer, Handel will always seem old-fashioned. Yet he inno-

vated with the new form of the English oratorio and helped build a mood of national pride that kept his *Messiah* alive, seemingly forever. On the other hand, the oratorio was certainly not the music of the future, but rather a nonce form with few successors: Handel was notoriously a tastemaker in his day, and links with the musical past or the national future cannot unfix his firm identification with the Age of Handel.[1]

The studies of Handel and his times differ widely. The conservative Handel is related to a broadly defined "court culture"; if his writing seems "far-reaching" and rooted in the seventeenth century, that is undoubtedly because features like picturesqueness, humanitarianism, and figurality don't really distinguish one century from another. The times to which this Handel belongs are themselves old-fashioned; a putative conservatism still does not make him antiquated.[2] Likewise overgeneralized are studies of Handel in relation to Pope and to a sensibility defined with reference to drama going back to the Restoration era.[3] Others, including East German Marxists, have undertaken to validate Handel's progressive credentials, but on the basis of vague categories or minimal details.[4] The framework is sometimes inappropriately taken from German cultural history; the discussions are sometimes compromised by a lack of sympathy for the ideas of Handel's day.[5] On both sides of the aisle, the cited studies share too general a characterization of the times.

Periodization is always a tricky enterprise.[6] Any generalization about the spirit of an age runs into the difficulty that ages are composed of people with different interests, agendas, and values, as well indeed as of people of different ages, complicating periods with generations. And any undertaking to historicize and dynamize the view of an age—such as, in particular, Raymond Williams's rightly influential notion of dominant, emergent, and residual cultures—is beset by problems of horizon: the more the conservative drag or progressive push is part of the spirit of the age, the more it belongs to the present rather than pointing back or ahead; the more it is an outlier, the less its presence is felt, leaving it more like a mere ideology, less like a historical dynamic. The long eighteenth century favored by many of the studies of Handel and his age can serve as a convenient cover to use the same impulses (the Handelian "baroque") both to root the composer and to uproot him again, most egregiously when Rudolph (in the essay cited in note 4) casts him as a radical for introducing a line of the deceased Tory Pope into a libretto. One cannot prescribe the shape of history, but the present investigation takes the middle ground of a generation as its basis, allowing a

more specific definition of both cooperating and conflicting impulses than a century-long, sometimes Europe-wide Enlightenment permits.[7] Handel's music itself is on the one hand always recognizably his, on the other, tremendously rich and varied within its stylistic parameters. A relatively close chronological focus permits enough nuance to recognize a complex profile, not just a single value or an assortment of independent values.

A literary perspective illuminates Handel from a different angle from the prevailing attention among musicologists to philosophical concepts and beliefs. To be sure, the literary writers of mid-century espouse doctrines, but more signally they communicate stances toward the doctrines. What impulses prompt the espousals, what do they accomplish, what troubles them? The conflicting tendencies and complex emotional undergirding of the writers reflect attitudes, but within a shifting terrain. They thus define a context for recognizing the different individual and collective characters and passions in a Handel oratorio as partial and experimental perspectives rather than as struggles defining old or new political and social positions. Times are complex, and they change, but only when a whole complex gives way. My undertaking here is to illuminate Handel's multiplicity in relation to the multiplicity of the culture in which he lived and worked.

For the musicologist, then, this investigation characterizes Handel as expressing the strains of a complex era. For the literary scholar, however, the recourse to music will tend to offer a complementary thrust. Whereas words particularize, music generalizes. In this essay Handel functions as a great consolidator of central impulses. A single mood may prevail in the music for several minutes at a time; the music sets contemplation before dialogue. Indeed, there is little evidence that audiences attended closely to the intricate ebb and flux of Handel's opera plots in the rapid-fire Italian recitative; they came to hear the arias performed by virtuoso singers who were not always talented actors.[8] And the oratorios leave most or all of the action behind. With its extended, highly charged yet static emotions, Handel's music speaks to and for the central passions of the age. Hence a musical history readily gravitates toward the middle ground. Generations and nations are its natural field.

THE MID-CENTURY FIN-DE-SIÈCLE

Literary critics do not customarily isolate the decades from 1740 to 1760 as a distinctive period. In music, of course, the middle of the eighteenth

century has traditionally been regarded as a dramatic turning point. Handel's London meeting with Gluck in 1745 embodies the ages that this period joined and separated. As an encounter of stylistic personalities, it is almost as if Pope could have rubbed shoulders with his fervent admirer and hater, William Wordsworth. But two long generations separate Pope's maturity from Wordsworth's beginnings. And in that time lag lies the problem. In English literary history, the latter half of the eighteenth century usually counts as some form of long runout of the Enlightenment. Philosophy was still empiricist; poems were still in heroic couplets and sonnets hadn't yet returned to fashion; the novel was still rising (still epistolary or picaresque, not yet into manners and Bildung); the theater was in the doldrums apart from a few belated revivals of the comic spirit of the Restoration; the American and French and Kantian Revolutions were still in the wings. Many accounts portray it as a long half-century of secondary or derivative manifestations, with letters, moral essays, and biographies as its most distinctive expressions. Scholars used to look for sparks among the ashes and call them pre-Romanticism, plucking (to change the metaphor) the few flowers from a soil that seemed exhausted. Clearly, though, no such sense of a fallow period will be terribly useful as a context for the marked changes in musical expression in the same decades. The apparent disparity between musical ferment and literary stagnation is the spur to highlighting what is unique about mid-century writing.

Just a brief reminder first of the political situation. Two decades of peaceful internationalism under the leadership of Robert Walpole broke down when the War of Jenkins' Ear erupted in 1739, leading to Walpole's fall in 1742. A series of small wars and peaceful intervals filled the rest of the century, and many, mostly short-lived, incompetent, and corrupt governments succeeded one another until the advent of the younger Pitt in 1783. The Highland invasion of 1745 was a low point, and a relative high point came around the time of Handel's death, with the euphoria of military success under the inspiring and patriotic leadership of the elder Pitt, beginning in 1757, and with the coronation of the English-speaking George III in 1760. The literary evidence to be described shortly suggests a generally depressed mood in the drifting mid-century decades, rising to the transient enthusiasm around 1760, which in turn was followed by a slow decline into the turmoil and repression of the revolutionary years. The second part of this chapter will then correlate these moods with Handel's turn from opera to oratorio around 1740. The shift in primary genre entailed

four important shifts in the emphasis of Handel's work, all of which correspond to changes in the literary landscape and (in the fashion that we read literature currently) in the cultural mood: from secular to sacred, from a focus on individuals to a prominence of groups, from foreign to native, from embodiment in stage action to narrative or quasi-narrative report.

There was unquestionably a marked generational shift in English letters around 1740. Samuel Johnson (1709–84) arrived in London in 1737. Pope admired his first important poem, *London* (1738), but the two never met. In the 1740s and 1750s, Johnson published his famous periodicals, *The Rambler*, *The Adventurer*, and *The Idler*, as well as his most important literary works, *The Vanity of Human Wishes* (1749) and *Rasselas* (1759), and the failed tragedy *Irene* (1749), and he produced his most arduous work, the *Dictionary* (1755). Thomas Gray (1716–71) wrote essentially all of his poetry during these decades, as did the short-lived William Collins (1721–59). In the novel, these are the years of Samuel Richardson (1689–1761), of Henry Fielding (1707–54), and of the dark and violent picaresques of Tobias Smollett (1721–71). Nothing more characteristic was appearing in the theaters than the light comedies of Coleman and Garrick, but mention should be made of the two most representative writers of discursive prose in the period (alongside of Johnson): the skeptic David Hume (1711–76), whose revolutionary *Treatise of Human Nature* appeared in 1739–40, and the cynical Lord Chesterfield (1694–1773), whose best-known letters date from the 1740s. Only one truly famous—though now little-read—writer spans the early and middle years of the century, Edward Young (1683–1765). Until 1740 Young wrote tragedies, Biblical poetry, and, most successfully, satires. However, the wife he married in 1731 died in 1740, and with that he became a changed man. His vast *Night Thoughts* appeared from 1742 to 1746, and in 1759, when he was seventy-six, he published "Conjectures on Original Composition."

There was a second change around 1760. Edmund Burke's *Philosophical Enquiry into the Origin of Our Ideas of the Sublime and Beautiful* appeared in 1757 (revised in 1759) and deeply influenced the tone of writing in the subsequent decades. Laurence Sterne began writing in 1759, as did Oliver Goldsmith, and that is also the year when Christopher Smart, a promising young bard in the 1750s, entered on his career as the first great mad poet in Western letters. Macpherson's Ossianic fragments started appearing in 1760, initiating a run of faked goods; Robert Walpole's son Horace originated the gothic mode with *The Castle of Otranto* in 1764; Johnson turned to editing Shakespeare and writing the *Lives of the Poets*, and to the

conversations recorded by Boswell, whom he met in 1763; Smollett became a humorist. Thus, the discontinuity of 1740 was repeated in an even more abrupt discontinuity in 1759–60.

The mostly younger writers who gained prominence after 1740 arrived at a moment of decline. Jonathan Swift, born in 1667, died in 1745, but since around 1740 he had been mentally incompetent—"a driveller and a show," in Johnson's famous phrase ("The Vanity of Human Wishes," 318). Swift knew that his era was ending.

> The Dean was famous in his Time;
> He had a Kind of Knack at Rhyme:
> His way of Writing now is past;
> The Town hath got a better Taste.
> ("Verses on the Death of Dr. Swift," 263–66)

This wry self-deprecation was perhaps prophetic when composed in 1731, but its elegiac tone was fatally accurate by the time of its publication in 1739. Meanwhile, Swift's younger friend Alexander Pope, born in 1688, had been pouring out masterpieces since his teens. He describes his knack in famous lines from the "Epistle to Dr. Arbuthnot":

> Why did I write? what sin to me unknown
> Dipt me in Ink, my Parents', or my own?
> As yet a Child, nor yet a Fool to Fame,
> I lisp'd in Numbers, for the Numbers came.
> (125–28)

Pope died in 1744; his only significant work after 1738 was the completion of the *Dunciad*, whose fourth and final book was written in 1741 and published in 1742–43. An age of prodigies was passing.

The ready mastery of the older generation is inseparable from their medium, for which the last-quoted lines can serve as an example. Because of their inherent asymmetry, heroic couplets like Pope's are a more complex meter than Swift's tetrameters. Four-stress lines favor simple balances or bold contrasts; the more prevalent five-stress lines force continual adjustment within the rigidly self-contained couplets. (Open-ended couplets like Chaucer's work entirely differently.) In the quoted lines from Pope the required caesura (mid line break) comes after the second foot. The

nominative pronouns (and most of the associated i-sounds) are confined to the shorter initial half-lines, as are all the expressions of personal agency. Writing belongs to Pope, while the weight of responsibility, falling in the longer segments of each line, belongs to the world. Writing is something that comes upon the poet, for which, however, he can then take credit if he has the knack to "*snatch* a *Grace* beyond the Reach of Art" ("Essay on Criticism," 155), as Pope put it in a famous line he wrote when he was about twenty-one. "Unknown" phonetically un-owns the sin Pope is trying not to own up to, and, in the only line divided into equal five-syllable halves, the poetic numbers merge into the numbers of adherents besieging the budding fool to fame. Right after this line Pope explains that he wrote because so many admirers begged him to, including Rochester, Arbuthnot himself, and others among "great Dryden's friends" (141). The "for" in Pope's last line is tricky. An excuse that's not quite an explanation, without the causal force of a "because" that would tie Pope too closely to the sin or the folly of the numbers besieging the poor innocent child, "for" explains yet releases Pope from bondage to the explanation. Couplets demand freedom within limitation and (in this style) are always exhilarating when handled with the required virtuosity. Sweet reasonableness and dyspeptic satire can be equally animated. Even the lesser poets of the early century—John Gay, Matthew Prior, Thomas Parnell—are capable of packing their diction in the same way, so that it crackles with precisely etched channels of meaning.

The third great poet of those decades, and perhaps the most popular of all, was James Thomson. Born in 1700 and thus a decade younger even than Pope, Thomson died but a few years after Swift, in 1748. Thomson's masterpiece, *The Seasons*, reached its first finished form in 1730; the patriotic "Rule, Britannia" dates from 1740, and subsequently his most important writings were additions to *The Seasons* and the 1748 Spenserian imitation *The Castle of Indolence*. Thomson is generally known as a sublime poet who inspired Haydn's last, most colorful and most Romantic masterpiece, and superficially his descriptive blank verse seems different from the witty couplets of the satirists. But fundamentally he shares their lightness and energy, especially in the pre-1740 poetry. The original *Winter*, in 1726, opened like this.

See! Winter comes, to rule the varied Year,
Sullen, and sad; with all his rising Train,
Vapours, and *Clouds*, and *Storms*: Be these my Theme,

These, that exalt the Soul to solemn Thought,
And heavenly musing. Welcome kindred Glooms!
Wish'd, wint'ry, Horrors, hail!—With frequent Foot,
Pleas'd, have I, in my cheerful Morn of Life,
When, nurs'd by careless *Solitude*, I liv'd,
And sung of Nature with unceasing Joy,
Pleas'd, have I wander'd thro' your rough Domains;
Trod the pure, virgin, Snows, myself as pure:
Heard the Winds roar, and the big Torrent burst:
Or seen the deep, fermenting, Tempest brew'd,
In the red, evening, Sky.—Thus pass'd the Time,
Till, thro' the opening Chambers of the South,
Look'd out the joyous *Spring*, look'd out, and smil'd.

Though Thomson's blank verse is expansive, his exaltation rarely carries him away. "Sullen" is etymologically "solitary," "sad" is "sated," but Thomson and his winter are neither; no sooner has he uttered the words than he reverts to his pleasing meditations. Thomson's soul rises only to thought and musing, that is, to poetry rather than to devotion. The poet's foot— the pun is surely unavoidable—disarms winter's roughness; the tempest becomes a celestial teapot; even the proliferating commas mince a text whose poise is falsified by lighter modern punctuation.

Some time ago I coined the phrase "urbane sublime" for this combination of the satirists' ready wit with Thomson's eager eye.[9] What the poets of the early eighteenth century are not good at is enthusiasm. The touchstone is a verse from *Isaiah* (40: 4) that all aficionados of Handel know by heart and many are probably heartily sick of: "Every valley shall be exalted, and every mountain and hill shall be made low." Occasionally Pope and his contemporaries try to exalt their every valley, but they do it without much conviction. "Bleat out afresh, ye hills," Thomson writes in 1830, in the concluding "Hymn to the Seasons";

 ye mossy rocks,
Retain the sound; the broad responsive low,
Ye valleys, raise: . . .

This is not an earthquake but the congregation answering the choir, and it prepares something more like a last shearing than a last judgment:

> . . . for the Great Shepherd reigns,
> And yet again the golden age returns.[10] (72–75)

The phonetic linkage retain-raise-reigns-again-returns bespeaks the ease with which He is hymned. And heard.

Pope's equivalent comes in the 1712 "sacred eclogue" called "Messiah" that Ruth Smith places at the start of a line of texts leading to Handel's *Messiah*.[11] Her lineage is correct, but it is nevertheless relevant that posterity has judged "Messiah" one of Pope's few outright failures.

> Lo Earth receives him from the bending Skies!
> Sink down ye Mountains, and ye Vallies rise:
> With Heads declin'd, ye Cedars, Homage pay;
> Be smooth ye Rocks, ye rapid Floods give way! (33–36)

Handel can set the word "exalted" to thrilling melismas, can trill "the crooked," and can level the rough places with monotones, but the speed of Pope's verse runs counter to such expressive devices. Pope implicitly distinguishes music from poetry, for the "Essay on Criticism" says that in poetry, "The *Sound* must seem an *Eccho* to the *Sense*" (line 365), whereas, according to *The Dunciad*, "Music meanly borrows aid from Sense" and acquires its true power when, "Strong in new arms, lo! Giant Handel" comes "to shake the soul" (4.64–67). Pope's "Lo(w) Earth" does not shake the soul; indeed, it does not even convincingly shake the earth.

> One Tyde of Glory, one unclouded Blaze,
> O'erflow thy Courts: The Light Himself shall shine
> Reveal'd; and *God's* eternal Day be thine!
> The seas shall waste; the skies in Smoke decay;
> Rocks fall to Dust, and Mountains melt away. ("Messiah," 102–6)

The run-on lines are Pope's mark of wildness, but they consign God to parallel tetrameter clauses—reduced, balanced, anything but sublime. And though Isaian desert threatens, the melting mountains—a detail absent from scripture—bid fair to replenish the oceans.[12] Thus, even though Thomson and Pope are in many ways contradictory spirits—a broadly admiring Edinburgh Whig versus a keenly moralizing London Tory—they

share a fundamental naturalism: human beings make the best of their situation keeping to the modest tenor of their way, serving God, learning to know themselves and the world around them, neither aspiring too high nor sinking too low. The intellectual and emotional compromises made by both poets are inscribed in the wit and temper of their style. Temptations to greatness remain, of course—particularly in parts of Pope's great didactic poem, *Essay on Man*—but the core of urbanity (the gradual transformation rapidly sketched with "decay" and "melt") constantly reasserts itself.

After 1740, however, the balance tips even in these poets. Thomson added hundreds of lines to *The Seasons* describing the fearsome sublimity of the equator and of the pole, and countless small changes raised the pitch of the poem throughout.[13] Thus, in the opening lines of *Winter* the "red, evening, Sky" became "the grim evening-sky." And Pope ends his career with the last *Dunciad*'s vision of "Universal Darkness." To be sure, that phrase had been in the original poem of 1728, but there it was a false nightmare, whereas in 1743 it is the end of things. And four new lines in the final paragraph suggest the new, grim spirit of things to come:

Religion blushing veils her sacred fires,
And unawares *Morality* expires.
Nor *public* Flame, nor *private*, dares to shine;
Nor *human* Spark is left, nor Glimpse *divine*! (*Dunciad*, 4.649–52)

Handel makes a heroic appearance in the fourth book of the *Dunciad*, but not even he could survive its universal darkness. Most scholars have regarded the portrait of "Giant Handel" standing "like bold Briareus" as a glimpse of relief from the general end-of-an-era gloom of Pope's poem, but that is surely wrong. Pope's lines look like warm praise, but they are spoken by a mincing harlot who is said to be "scornful" of "the prostrate Nine" (4.51). Given that Pope's letters never mention Handel and that Pope was generally considered "insensible" to music, we should be wary.[14] *The Dunciad* says that Handel-Briareus stirs, rouses, and shakes the soul, but in his translation of *The Iliad*, Pope greatly embroiders Homer's brief mention of Briareus to stress the violence of his rescue of Zeus:

Then, call'd by thee: the Monster *Titan* came
(Whom gods *Briareus*, men *Aegeon* name)
Thro' wondering Skies enormous stalk'd along;

Not He that shakes the solid Earth so strong:
With Giant-Pride at *Jove's* high Throne he stands,
And brandish'd round him all his Hundred Hands;
Th' affrighted Gods confess'd their awful Lord,
They dropt the fetters, trembled and ador'd. (1.522–29)

When the lines about Handel in the *Dunciad* are compared with Pope's Homer, it becomes clear that they reflect less admiration than stunned astonishment and that they participate directly in the post-1740 polarization, extremism, and disorder of the completed poem.

The passing of a generation must always give pause for reflection. But it was more than a generation that passed in the early 1740s, it was an era. It looks less that way to us, knowing as we do how many Georges were yet to reign and what turbulence was to rock the end of the eighteenth century. But in the literary culture of the time there is a definite feeling of losing touch with past glories. When Pope's "Epistle to Dr. Arbuthnot" alludes to his sponsorship by Dryden's friends, more is at stake than mere snobbery. For Dryden (1631–1700) was the link to the great events of the previous century. He had begun his career as a Cromwellian and knew Milton well; he tamed English versification in the years when Charles II was taming English fanaticism and beating back foreign invasion and when Milton was writing *Paradise Lost*. He was a witness to the Glorious Revolution of 1688, and his very last poem, the "Secular Masque" of 1700, was the first great fin-de-siècle poem in English, a text of just under 100 lines, with the refrain, "'Tis well an old age is out, / And time to begin a new." Pope, born in 1688 and the most precocious of all our poets, had actually seen the great man before he died and reports it in his earliest surviving letter, which was published in 1735 and hence known to the envious writers of mid-century. And Swift was even related to Dryden, able to speak familiarly of him and to criticize his versification with cousinly license. Their new age was continuous with his old one; the seventeenth-century pacification continued with the Union of Scotland and England, with the reign of Addisonian politeness and the taming of stage comedy from the excesses of Restoration license, and with the pax walpoliana of the 1720s and '30s. It was like the apotheosis of a long era of good—or at least moderately good—feeling.

When Dryden died, there was a succession. There was no such rhythm to the generational shift of 1740. Instead, people felt they had lost their bear-

ings. In 1757, Gray published an ode that he called "The Progress of Poesy" but that reads more like a decline of poetry. Writing of Dryden, Gray's last stanza bemoans the loss of poetic fire since the great old days.

> Hark, his hands the lyre explore!
> Bright-eyed Fancy hovering o'er
> Scatters from her pictur'd urn
> Thoughts, that breathe, and words, that burn.
> But ah! 'tis heard no more—
> Oh! lyre divine, what daring Spirit
> Wakes thee now? ("The Progress of Poesy," 107–13)

The short fifth line follows a metrical scheme established in earlier stanzas, but their short lines are not monosyllabic, as this exhausted one is. Even more symptomatic of feelings about the decline in poetic power in the modern age is Johnson's assessment of his predecessors. Boswell reports Johnson in 1769 praising the end of the *Dunciad* in the following terms: "It was worth while being a dunce then. Ah, Sir, hadst *thou* lived in those days! It is not worth while being a dunce now, when there are no wits." But Pope himself was a falling off: "in Dryden's poetry there were passages drawn from a profundity which Pope could never reach."[15]

Such sentiments of decline haunt the melancholy conclusion to Johnson's great "Life of Pope." In a famous comparison of Dryden and Pope, Johnson allots the greater genius to the earlier poet, the greater consistency to the later one. The difference in talents reflects the natural course of history, as options get used up and the possibilities for invention correspondingly narrowed. So just after comparing Pope's Homer with Dryden's Virgil, Johnson writes about the course of civilization, with explicit reference to antiquity but with his eye clearly also on the lesser history of England from the Revolution to the present:

> There is a time when nations emerging from barbarity, and falling into
> regular subordination, gain leisure to grow wise and feel the shame of
> ignorance and the craving pain of unsatisfied curiosity. To this hunger
> of the mind plain sense is grateful; that which fills the void removes
> uneasiness, and to be free from pain for a while is pleasure; but repletion
> generates fastidiousness, a saturated intellect soon becomes luxurious,
> and knowledge finds no willing reception till it is recommended by

artificial diction. Thus it will be found in the progress of learning that in all nations the first writers are simple and that every age improves in elegance. One refinement always makes way for another, and what was expedient to Virgil was necessary to Pope. ("Life of Pope")

The curve in Johnson's long, curving sentences runs from necessity to freedom and back to necessity again. In his world-weary tone, "elegance" is a direct synonym of "fastidiousness" and an affective equivalent of insubstantiality. And that is the tone on which Johnson concludes, a few pages later. The penultimate paragraph is more monitory than inspirational.

New sentiments and new images others may produce, but to attempt any further improvement of versification will be dangerous. Art and diligence have now done their best, and what shall be added will be the effort of tedious toil and needless curiosity.

And then Johnson delivers one of the most resoundingly half-hearted cascades of double negatives imaginable.

After all this it is surely superfluous to answer the question that has once been asked, Whether Pope was a poet? otherwise than by asking in return, If Pope be not a poet, where is poetry to be found? To circumscribe poetry by a definition will only shew the narrowness of the definer, though a definition which shall exclude Pope will not easily be made. Let us look round upon the present time, and back upon the past; let us enquire to whom the voice of mankind has decreed the wreath of poetry; let their productions be examined and their claims stated, and the pretensions of Pope will be no more disputed.

Johnson's majestic gloom has never been equaled; here note that he looks around and back but not ahead, that the inquirer's laborious trisyllables "productions" and "examined" deflate the poet's merely "stated" "claims," and that "productions" then decays into the echoing "pretensions." While the "Life of Pope" dates from 1781, it falls back into the mood of Johnson's own greatest poem, and closest approach to Pope's manner, the 1749 "Vanity of Human Wishes."

From 1750 to 1752, Johnson published (and almost entirely wrote) two essays a week for his periodical *The Rambler*. If any work captures the spirit

of the age, it is these magnificently gloomy effusions. The Tory satirists of 1720–40 could also be gloomy, but not like Johnson. As Louis Bredvold argued in a fine essay sixty years ago: Tory satire against Walpole expressed a serious, practical, and realistic anger at the government and was not melancholic, as Johnson and his contemporaries took it to be.[16] A typical run of the *Rambler* essays, by contrast, has the following topics: "The Various Arts of Self-Delusion," "The Folly of Anticipating Misfortunes," "The Observance of Sunday Recommended; an Allegory," "The Defence of a Known Mistake Highly Culpable," "The Vanity of Stoicism—The Necessity of Patience," "An Allegorical History of Rest and Labour," "The Uneasiness and Disgust of Female Cowardice," "A Marriage of Prudence without Affection," followed by two influential essays harshly critical of pastoral poetry. The titles are an editor's, not Johnson's, but they fairly catch the tone of the pieces.[17] Among these, the two allegories are, as their titles sound, less gloomy than the rest, but the first is not by Johnson but by a certain Miss Talbot, and the second is perhaps the dullest essay in the entire collection.

Short essays give regular but tolerably small doses of Johnson's long and majestic sentences. Their serious deliberations are varied by equally serious short narratives and by the occasional sally of somber humor. Effort is the order of the day. The world's glory times are past, and Johnson contrives to perch on the shoulders of giants only by borrowing their learned words and well-worn topics with the utmost refinement of measure and euphony. Johnson has to be the most musical prose writer in English, yet there is always the suspicion—in the *Ramblers* above all—that perfection of rhythm and phonetic harmony for their own sake endanger the sense. Emptiness, more decoratively named vanity, lurks as the all but inescapable topic of Johnson's muse.

My characterization of mid-century verse will finish by quoting at some length from one of the later *Ramblers*, number 154, titled by the same editor, "The Inefficacy of Genius without Learning," and then by ending with a surprise. "The mental disease of the present generation, is impatience of study, contempt of the great masters of ancient wisdom, and a disposition to rely wholly upon unassisted genius and natural sagacity." Curious in this sentence early in the essay is the alignment of genius with nature in a way that diminishes both the specialness of the former and the universality of the latter. The grave ironies pair genius with what amounts to a doubly negative adjective and nature with the weightiest Latinism of the utterance. Johnson then continues, with more barbed rhetoric,

The wits of these happy days have discovered a way to fame, which
the dull caution of our laborious ancestors durst never attempt; they
cut the knots of sophistry, which it was formerly the business of years
to untie, solve difficulties by sudden irradiations of intelligence, and
comprehend long processes of argument by immediate intuition.

The weary sarcasm of these lines is vintage Johnson. Conceptually, intel-
ligence should be aligned with comprehension as qualities of mind, and
intuition should go with irradiation as forms of sudden insight, not the
culmination of long processes. The misalignment of the terms undercuts
the pretense of literal praise. Indeed, by beginning the second half of the
sentence with a metaphor, Johnson renders all the mechanisms of thought
merely metaphorical. The light of radiation and the vision of intuition (ety-
mologically, "looking") lose all their idealist resonances and come to sound
as sophistical as the powers of darkness. Modern wit is enfeebled, though,
as Johnson later says, its debilities are readily discerned by those who have
retained the values of earlier generations.

The laurels which superficial acuteness gains in triumphs over igno-
rance, unsupported by vivacity, are observed, by Locke, to be lost,
whenever real learning and rational diligence appear against her;
the sallies of gayety are soon repressed by calm confidence; and the
artifices of subtilty are readily detected by those who, having carefully
studied the question, are not easily confounded or surprised.

Originality begins with learning: "The man whose genius qualifies him for
great undertakings must, at least, be content to learn from books the pres-
ent state of human knowledge." And while it proceeds by invention where
it can, in the modern world refinement is clearly the last, best hope of men
so burdened by the weight of their predecessors.

No man ever yet became great by imitation. Whatever hopes for the
veneration of mankind, must have invention in the design or the
execution; either the effect must itself be new, or the means by which
it is produced. Either truths hitherto unknown must be discovered, or
those which are already known enforced by stronger evidence, facili-
tated by clearer method, or elucidated by brighter illustrations.

These are by no means the gloomiest passages from this essay, which talks elsewhere of "the wastes of the intellectual world," of "the blast of malignity, and . . . the attacks of time," and the like. Rather, these extensive passages suggest a different point. Here is my surprise. For is not the reduced modern genius sketched by Johnson in fact exactly what the period admired in Handel? Rather than bold Briareus, was not Handel a figure of rational diligence and refined enlightenment, building on the accomplishments of his predecessors, producing now new effects, now new means, with invention in the design or in the execution, seeking stronger evidence, clearer method, brighter illustrations? And could one capture Handel's reported personality better than with Johnson's phrase, "the sallies of gayety are soon repressed by calm confidence"? Here is how a biographer sums up Handel's multifariousness:

> Handel is great in all these [directions], but his true greatness lies
> in their equilibrium, their exceptional dramatic impulse, and it is
> immaterial whether in particular he is borrowing from the means
> and experiences of his day, swimming on the whole with the current,
> or whether he is breaking the norm time and again. That belongs
> together and constitutes the quality, the realism of his art, which in
> details can and must be compared with the work of everyday composers but in its totality outsoars everything then composed.[18]

The modern scholar's heightened view of realism is identical in its core with Johnson's diminished view of genius.

Handel was a sublime genius. But the sublime of the 1740s was no more the sublime of Kant or of Burke than the sublime of Homer. It was the infinite capacity for taking pains, at a time well aware of its aging bones. It was in the spirit of those decades that Handel should have relented on his original wish to conclude *Saul* with a hallelujah. For all of his exuberance and wealth, craft and thrift are qualities that increasingly come to the fore, above all in the shift from the flamboyance of castrato opera to the relative sobriety of the oratorios. Apart from Hogarth, Handel stands alone among the enduring creative and intellectual figures of eighteenth-century England for successfully crossing the generational divide of 1740, and I suggest interpreting the mid-century accomplishments of his final decades in the light of the changed spirit of those years, even if it means

recognizing a more subdued, less exalted or exhilarated composer than is celebrated in, for instance, Andrew Porter's reviews. The subdued mid-century Handel is the figure who appears in John Langhorne's 1760 "The Tears of Music: A Poem to the Memory of Mr. Handel." Langhorne was a successful poet of rural nature of the mid-century and a particular favorite of Wordsworth's. His Handel is by turns melancholy, sweet, amorous, soothing, gloomy, seraphic, majestic, gloriously peaceful, sweet (again), joyfully triumphant, seraphic (again), glowingly virtuous, grieving, soothing (again), polished, and finally rousing, refining and exalting to love, Heaven, and harmony. Only one brief segment in this period view of Handel's British composition suggests energetic excitement; the rest is in the combination of moods that characterize the mid-century fin-de-siècle.[19]

ILLUMINATING THE DARKNESS

Johnson's weighty gloom provides an important perspective on Handel's weighty solemnity. The lassitude that set in after Walpole's fall displaced the verve of the poetry of the preceding decades. It is well worth hearing the Handel of the oratorios in that more subdued light, not as the proud and terrifying Briareus of Pope's *Dunciad* nor as the sublime patriot of the Hallelujah Chorus, but as a polished, labored, and balanced craftsman, whose unique contributions lie in his quieter affections. His most arresting moments are, over and over, moments of arrest, or of suspension rather than suspense.

But while Johnson does capture an essence, he was not the only ingredient in the brew, nor is the experience of listening to Handel identical to that of reading Johnson. If there was a pervasive feeling of belatedness most fully expressed by Johnson, there was likewise a reaction to that feeling. The reaction forms the core of the second part of this chapter, followed by a concluding balancing of accounts. I will chart three responses to the cultural malaise of the mid-century fin-de-siècle. First will be that of the philosopher David Hume, who feels the power of a gloom as deep as Johnson's but then wills himself free of it. Second, at greatest length, will be the graveyard poets Gray and Young, who soften and diffuse the shadows in which they bask. And, finally, I will touch on the novel and in particular on Fielding, whose good-natured optimism redeems the fallen world of mid-century. In connection with these responses, I will return to the four

characteristics of the shift from opera to oratorio itemized earlier: from secular to sacred, from a focus on individuals to a prominence of groups, from foreign to native, from embodiment in stage action to narrative or quasi-narrative report.

The prevailing philosophical systems in eighteenth-century England were empiricist. The core assumptions are familiar: there are no innate ideas, the mind is initially a blank slate or (as Locke ordinarily says) a sheet of white paper, there is nothing in the intellect that did not get there by way of the senses. Empiricist philosophers are freed of the necessity of demonstrating first principles but saddled with the responsibility of establishing any other kind of principles. They differ chiefly by how they use their freedom and how they face their responsibility.

Empiricism is inherently radical in the sense that it roots out prejudices and leaves no firm ground to rest on, though the radicalism usually precipitates a stabilizing reaction based on tradition or common sense. The father of British empiricism, John Locke, a notably cautious thinker, regularly compares philosophy to sailing and seeks the proper limits rather than the maximum reach for the exploring intellect.

> Thus Men, extending their Enquiries beyond their Capacities, and letting their Thoughts wander into those depths, where they can find no sure Footing; 'tis no Wonder, that they raise Questions, and multiply Disputes, which never coming to any clear Resolution, are proper only to continue and increase their Doubts, and to confirm them at last in perfect Scepticism. Whereas were the Capacities of our Understandings well considered, the Extent of our Knowledge once discovered, and the Horizon found, which sets the bounds between the enlightned and dark Parts of Things; between what is, and what is not comprehensible by us, Men would perhaps with less scruple acquiesce in the avow'd Ignorance of the one, and imploy their Thoughts and Discourse, with more Advantage and Satisfaction in the other
>
> (*Essay Concerning Human Understanding*, 1.1.7)

In Locke's hands philosophy is preeminently practical: "'Tis of great use to the Sailor to know the length of his Line, though he cannot with it fathom all the depths of the Ocean. . . . Our Business here is not to know all things, but those which concern our Conduct" (1.1.6). The *Essay Concern-*

ing Human Understanding is a conduct book for making do with imperfect reason: "The Candle, that is set up in us, shines bright enough for all our Purposes" (1.1.5).

Hume is to Locke as Johnson is to Pope or even to Dryden. Hume's premises are the same as Locke's, but they are pursued with an intensity that throws caution to the winds. Consequently, he devotes the first and most radical of the three sections of his *Treatise of Human Nature* to the mechanisms of reason. And since reason is not where our ideas start, it cannot carry them very far. Abstraction, Hume argues, is merely generalization, causation is merely habitual association, ideas are merely diffuse sense impressions. Hume probes relentlessly, but all he can clarify is that darkness surrounds our limited illuminations. There can be no universals in a world that begins with particulars.

> The mind is a kind of theatre, where several perceptions successively make their appearance; pass, repass, glide away, and mingle in an infinite variety of postures and situations. There is properly no *simplicity* in it at one time, nor *identity* in different, whatever natural propension we may have to imagine that simplicity and identity. (*Treatise*, 1.4.6)

Locke was wrong to imagine us as navigators on seas of thought, because that presumes that we can count on the validity of the mental tools with which we are equipped. But, as Hume's posthumously published *Dialogues Concerning Natural Religion* asks, "What peculiar privilege has this little agitation of the brain which we call *thought*, that we must thus make it the model of the whole universe?"[20] The more we study, the more we discover our own incapacities. "Methinks I am like a man, who, having struck on many shoals, and having narrowly escaped shipwreck in passing a small frith, has yet the temerity to put out to sea in the same leaky weather-beaten vessel, and even carries his ambition so far as to think of compassing the globe under these disadvantageous circumstances" (*Treatise*, 1.4.7). As you may well imagine, a thinker who sets the highest standards for truth has the least hope of satisfying them. And so, he collapses into what he movingly calls a "philosophical melancholy and delirium" (1.4.7). He concludes his investigation of reason in the deepest despair. "The *intense* view of these manifold contradictions and imperfections in human reason has so wrought upon me, and heated my brain, that I am ready to reject all belief and reasoning. . . . I am confounded with all these questions, and begin to

fancy myself in the most deplorable condition imaginable, environed with the deepest darkness, and utterly deprived of the use of every member and faculty" (1.4.7).

But no sooner has Hume exposed the debilities of reason than he recovers his equanimity. For, he argues, should we not be skeptical of our skepticism itself? Reason unaided digs itself a pit, but why should we not lend one another a helping hand? And so, having experienced the miseries of solitary speculation, "I dine, I play a game of backgammon, I converse and am merry with my friends," and the gloom dissipates. Purely logical investigation undermines confidence in reason, but the *Treatise of Human Nature* corrects the bleak logic of its first part with a redemptive psychology and ethics in its second and third parts. The solitary reasoner is by no means the exemplar of human nature. Quite the reverse: what Hume learns from his radical pursuit of empiricist principles is that such single-mindedness is self-limiting. Man is not fundamentally an isolated thinker. Hence, later, in the highly characteristic chapter "Of Our Esteem for the Rich and Powerful," he writes, "We can form no wish which has not a reference to society. A perfect solitude is, perhaps, the greatest punishment we can suffer" (*Treatise*, 2.2.5). A life's work that seems to begin with an analysis of the individual consciousness proves to be a paean to man's social destiny.

It is obvious that the movement of Hume's thought bears relevance to mid-century ideals of social consensus and to their embodiment in Handel's communitarian choruses. It is less easy to define Hume's relevance in a precise way. For all empiricist thought gives primacy to the social over the solitary. In theory the doctrine that all our knowledge comes through the senses could validate extremes of individual caprice, and empiricist philosophers were given to thought experiments about wild men and savage virtue. But in practice what comes through the senses mostly comes from other people. Hence, Hume's novelty was not his claim that man is a social being. Rather, it was his divorce of the social from the individual experience. Among the guiding principles of Pope's *Essay on Man* are these: "That true SELF-LOVE and SOCIAL are the same; . . . / And all our Knowledge is, OURSELVES TO KNOW" (4.396, 398). Hume's doctrine of the mind as a theater without simplicity undermines any such possibility of founding social values on individual principles. We can't know ourselves because there is no self to know. As Hume says, without hesitation, "The identity which we ascribe to the mind of man is only a fictitious one" (*Treatise*, 1.4.6). Hume's ideal is not knowing what we are but making or—as he

also says—feigning ourselves what we should be. Society is a convention and good breeding is its mainspring.

In spirit, Hume's *Treatise* is very close to Handel's masterpiece of the same year, *L'Allegro, il Penseroso ed il Moderato*. The twin poems of Milton that form the basis for the first two parts of Handel's triptych anatomized polar states of mind, distilling the competing essences of joy and melancholy. But by interweaving the two moods, breaking each up into numerous voices and contrasting numbers, and feeding the individual voices into choral summations, the librettist Jennens and the composer Handel utterly changed the work's character. They offer a Humean theater of moods that are not readily resolvable into individual states. To the extent that a polarization still governs, it is rather that of rural and urban, or, in other words, natural and social. At the end of part 2, as elsewhere, the chorus changes "I" to "we"; hence, even though the poetic text clearly favors solitude, the musical realization does not. Like Milton, Jennens begins his adaptation with joy and ends it with melancholy, but Handel sets joy's opening recitative in stunningly gloomy tones. Hence the two Miltonic parts of Handel's composition become a varied portrait of the isolated self looking for companionship, first in nature and then in culture. (One of Jennens's few substantive changes to Milton's text is the replacement of "Towred Cities" with "Populous Cities.") The added "moderato" section is abstract in both text and setting. It has never seemed an essential reconciliation of opposing moods, surely because contrasted emotions is not what the work is about. Rather, it is about melancholy and denials of melancholy, and Jennens then lacked the courage with which Hume affirmed a sociability independent of an unattainable foundation in rational orders.

In their melancholy aspects, Hume and Handel link up with the graveyard poems that constitute the poetic genre most closely identified with the 1740s. I will discuss the two most famous of them, Gray's "Elegy Written in a Country Churchyard," published in 1751, and Young's *Night Thoughts* of 1742–46. Darkness dawns at the opening of Gray's famous poem, yet without Johnson's gloom. The measured quatrains of the churchyard stanza alleviate the pressure of the encounter with the unknown. In *Isaiah* 40: 4, the leveled landscape declares the might of the Lord and leads into apocalyptic truths: "The grass withereth, the flower fadeth: but the word of our God shall stand forever" (40: 7). But in Gray's mid-century verse there is only tempered humility:

The Curfew tolls the knell of parting day,
The lowing herd wind slowly o'er the lea,
The plowman homeward plods his weary way,
And leaves the world to darkness and to me.

There are plenty of verticals in the poem, yet they don't soar; plenty of plain, straight paths in "the short and simple annals of the poor" that don't culminate in revelation. The poem's most distinctive feature is its lack of clarity. Sounds come from everywhere, pronouns and identities are famously confused, the villagers' human potentials are unrealized. Interpreters regularly try to clarify the muddles, but they shouldn't, for the darkness responds to the temper of the times. Obscurity seems regrettable yet remains reassuringly untragic.

At the end of the mid-century decades, in Burke's *Enquiry*, obscurity came to be associated with sublime terror and greatness. In mid-century, the most intriguing use of the concept of obscurity and confusion comes in the writings of the German philosopher Alexander Baumgarten, the inventor of the modern sense of the word aesthetic. In contrast to Descartes' clear and distinct ideas of reason, Baumgarten defined an aesthetic realm composed of the clear and confused ideas of the senses. They are clear because vividly perceived and confused because not rationalized and classified. This kind of obscurity is a softening, not a hardening of the gloom—a haze that deflects judgment.

In a country adrift, obscurity and confusion can be both revealing and reconciliatory. Lacking the firm if corrupt hand of Walpole, ruled with increasing impatience by a still German king while the Prince of Wales, who actually spoke English, waited in the wings, the country marked time without marching forward. That, at least, is the mood Gray summons. Politics is a dangerous game from which the poor are excluded, despite tendencies toward reproducing political conflicts in the smaller arenas of the home and the village. Hence their voice is universal—not divine but also not divisive. Johnson despised most of Gray's verse, but has this to say about the "Elegy": "The *Church-yard* abounds with images which find a mirrour in every mind, and with sentiments to which every bosom returns an echo." A poem that is about no one in particular is about everyone; its darkness protects and does not hide.

That way of dealing with darkness does have a cost. The poem's most famous quatrain surely is one of those whose sentiments Johnson found universal.

Full many a gem of purest ray serene,
The dark unfathom'd caves of ocean bear:
Full many a flower is born to blush unseen,
And waste its sweetness on the desert air.

These are memorable lines, but what do they mean? Would the daylight sully the gem? Would the flower prefer to blush exposed to all eyes? Without a doubt, the morality of these lines is meant for savoring, not for scrutinizing. Universality and ambiguity go hand in hand; it is a twilit soundscape that charms the sense to sleep. Ruth Smith has written about the political ambiguities in Handel's librettos as a technique for appealing to all parties and even for harmonizing them. That is a crucial insight, but it should not be restricted to politics. The diction of mid-century poetry commonly diffuses existential intensities like Hume's in the half-light of universal humanity. Anonymous solo roles function comparably in Handel's oratorios: a manner that is emotive yet not individualized converts deprivation into fellow-feeling.

The other great graveyard poem suggests further perspectives on Handel's aims and accomplishments. *The Complaint, or Night Thoughts on Life, Death and Immortality*, to give it its full title, was the blockbuster of the 1740s, as *The Seasons* had been the sensation of the previous decade. It begins in a mood of unrelieved gloom:

From short (as usual) and disturb'd Repose
I wake: How happy they, who wake no more!
Yet that were vain, if Dreams infest the Grave.
I wake, emerging from a sea of Dreams
Tumult'ous; where my wreck'd desponding Thought,
From Wave to Wave of *fancy'd* Misery,
At Random drove, her Helm of Reason lost:
Tho' now restor'd, 'tis only Change of Pain;
(A bitter Change!) severer for severe.
The *Day* too short for my Distress; and *Night*,
Ev'n in the *Zenith* of her dark Domain,
Is sunshine, to the Colour of my Fate.
(*Night Thoughts*, 1.6–17)

The parenthetical interpolations are hallmarks of Young's style. Amid the turbulence of immediate sensation, they crystallize the judgments of reflective thought. Here, though, reflection is the reverse of clarification; it only spreads the gloom ("as usual") or deepens it ("A bitter Change!"). In the theater of Young's very histrionic mind, it becomes impossible to tell natural from artificial illumination, life from death, sleep from waking, dream from reality. The progress of consciousness is entropic: the more you know, the more bewildered the world appears, and the mood is hard to distinguish from the cynical "universal Darkness" closing *The Dunciad* the following year.

Yet for Young, the consciousness that obliterates the material world simultaneously asserts *itself.* Hence, a self-satisfaction permeates the poem, which has often and not unjustly been accused of egotism, most flamboyantly and amusingly in a long attack by George Eliot. While Johnson's classicizing style tends to subordinate invention to tradition, Young's rhetoric is non-periodic and asymmetrical. The flow never stops. Gloom becomes a mental landscape to be explored and even celebrated. However unattractive to us, Young's poem discovers a self-sufficient mind rising above the ashes of a world in decline. If not exactly an intellect, it is at least a heightened sensorium. Here is his more consoling view of the period's gloom.

> What awful Joy! What mental Liberty!
> I am not pent in Darkness; rather say
> (If not too bold) in Darkness I'm embow'r'd.
> Delightful Gloom! the clust'ring Thoughts around
> Spontaneous rise, and blossom in the Shade;
> But droop by Day, and sicken in the *Sun.*
> *Thought* borrows Light elsewhere; from that *First* Fire,
> Fountain of Animation! whence descends
> URANIA, my celestial Guest! Who deigns
> Nightly to visit me, so mean; and *now*
> Conscious how needful Discipline to Man
> From pleasing Dalliance with the Charms of *Night*
> My wand'ring Thought recalls . . . !
> (*Night Thoughts*, 5.202–14)

Among the most astonishing passages in Young's enormous poem, these lines harness Milton to the service of eighteenth-century rationalism. Ura-

nia is Milton's muse, and Young scatters echoes, especially of the invocations to books 7 and 9 of *Paradise Lost*, in order to subsume the Fall of Man under the realm of natural grace. (In Milton, for instance, "charms" evokes satanic magic, not the delights of landscape.) Milton calls Urania his "Celestial Patroness, who deigns / Her nightly visitation unimplor'd" (9.21–22); but he does not indulge in Young's coyly punning "me, so mean," with its first-person pronoun in stressed position, and he remains Urania's client, not, like Young, Urania's host. Milton portrays the sin in nature and the supernatural guidance that comes to him from above in his blindness; Young portrays the nature found even in sin and the self-help that makes thought the homeopathic cure for melancholy. And while I don't know if this has been remarked upon, Young's mental scene-painting not only follows Milton but also foreshadows Keats's bowers, such as the "branched thoughts" of "Ode to Psyche," and the "Happy gloom! / Dark Paradise!" of the Cave of Quietude in *Endymion* (4.537–38). But the Milton in Young weighs down the Keats in Young: "Conscious . . . Discipline" lacks the unconscious spontaneity of the romantic imagination. In "Ode to a Nightingale," Keats fuses darkness and delight:

> I cannot see what flowers are at my feet,
> Nor what soft incense hangs upon the boughs,
> But, in embalmed darkness, guess each sweet
> Wherewith the seasonable month endows
> The grass, the thicket, and the fruit-tree wild.

Keats loves thinking about flowers; Young loves flowery thoughts, though he never seems entirely certain whether to attribute consolation to the light of imagination, to that of nature, to reason, or to grace. In its restless course, stretched between the sensibilities associated with Milton and with Keats, the poem enacts a double movement. On one side lies the gravity of the age—the inertial gloom of the post-1740 generation—on the other side, a reaching toward the light that remains unstable and anxious, self-inflated without being self-assured: Young means it when he qualifies "rather say" with the parenthetical apology "(If not too bold)." People speak of contrast and symmetry in the distribution of light and shade in Handel's oratorios, but that verges on a nineteenth-century organicist principle for a period with a different dynamic. The example of Young suggests regarding contrasts as asymmetrical. Grief surrounds us and is always waiting to

drag us in; the triumph that beats it back is heroic, unearned, or miraculous. Handel's *Samson* originally ended with obsequies and only subsequently with joy; the former is the natural tendency of the age, the latter its wished-for outcome.

Young's answer to *Isaiah* 40: 4 is a hymn to industry, couched not as a prophecy but as a vision from the empyrean.

> Come, my *Ambitious*! let us mount together,
>
> And from the Clouds, where Pride delights to dwell,
> Look down on Earth.—What seest thou? Wondrous things!
> Terrestrial Wonders, that eclipse the Skies.
> What Lengths of labour'd Lands! what loaded Seas!
> Loaded by Men, for Pleasure, Wealth, or War!
> Seas, Winds, and Planets, in to Service brought,
> His Art acknowledge, and promote his Ends.
> Nor can th'eternal Rocks his Will withstand;
> What level'd Mountains! And what lifted Vales!
> O'er Vales and Mountains sumptuous Cities swell,
> And gild our Landscape with their glitt'ring Spires. (6.761–73)

Writing before the invention of the balloon that would have made his fancy a possibility, Young here shows man accomplishing what the prophet merely foretold as a heavenly miracle. For while the masculine pronouns sound divine ("His Art," "his Ends," "his Will"), the only possible antecedent is the plural "Men," ruling over a nature that acknowledges the arts of trade, promotes the ends of commerce, and obeys the will of civilization. By subreption, the secular has become the sacred. These extraordinarily presumptuous lines flow on into a patriotic outburst, an exaltation of manufacture that is evidently also a manufactured exultation. Young is certainly far from the subtlest poet of these years, but his strains—and only Pope's and Handel's friend Aaron Hill pitched his verse higher—strain to reclaim both dignity and power in a world of loss.

Two points, then, about Young and what he represented to his countless readers. The first, simple point is that, having felt the Johnsonian gloom, he resisted it. Graveyard poem though it is, *Night Thoughts* is less an expression than a corrective of the dumps. The second, more complicated point is that while Young's salvation comes from turning to religion, his religion

proves an artificial, human construct. It celebrates man's achievement—and specifically English man's—not God's. Religion is an impulse toward the heavenly, but it comes to us from within or from around rather than in any immediate way from above. Pretty much across the religious spectrum, from the natural religion of the infidel Hume to the growing mysticism of William Law, the focus remains in this sense humanistic. Making a great noise unto the Lord may not get His attention, but it will get the audience's attention and hence make you a participant in a communal recovery from individual disempowerment.

Young's response to the darkness climaxes in the closing sequence of *Night Thoughts*. It is difficult to be brief in quoting a poet who so rarely gets to the point, and this passage is even longer than the other two I have quoted. But there is a good reason for the prolixity, since it correlates directly with the uncertain fluxes of feeling in the period.

The lines "Thus, *Darkness* aiding Intellectual Light, / And *Truth Divine* converting Pain to Peace" offer a clear hierarchy: reason unaided yields to imagination, and both are then sublated by revelation bringing what by 1746 could only be a highly nostalgic vision of a peace that had prevailed in Young's earlier adulthood. Uncertain in this ladder of goods is the precise locale of the intrusive pain: does it belong to the sharpness of the intellect in the age of satiric wit, to the aggrieved darkness, or to a factor besetting both reason and imagination from the outside? Certain at any rate is the salvation to be hoped for from above. Or so, at least, it seems for a moment, until the poet arrives not at the expected rescuer, God, but instead, remarkably, at this:

My Song the Midnight Raven has outwing'd.

Is his song then the truth divine that supersedes the darkness?

And shot, ambitious of unbounded Scenes,
Beyond the flaming Limits of the World.

The egotism here seems literally unbounded. The last line translates the most famous tag of Lucretius, a favorite of the century in general and of Pope in particular, but a philosopher and poet whose epicureanism was more conducive to humanist values than to religious transcendence. Again, however, all is not what it seems, for "shot," which is naturally intransitive,

suddenly acquires a direct object—"Her gloomy Flight"—deflating the egotism and further confusing the value system. I think here of Handel's notably irregular phrase structures, the way he delights in musical surprises that underscore turns in the words he is setting or that trope on them. One might be inclined to premise a norm of balance violated by structural surprises and ironies, but in the spirit of Young it is again more plausible to consider irregularity as the norm of the times. To be sure, Johnson wrote the most resonantly periodic prose our language has ever known, but, as I suggested above, his regularity is inseparable from his gloom, which flies only to sink.

Finally, speaking as Philander, the "lover of man," Young concludes a poem nearly as long as *Paradise Lost*.

> But what avails the Flight
> Of *Fancy*, when our *Hearts* remain below?
> *Virtue* abounds in Flatterers, and Foes;
> 'Tis Pride, to praise her; Penance, to perform.
> To more than Words, to more than Worth of Tongue,
> Lorenzo rise, at this auspicious Hour;
> An Hour, when Heav'n's most intimate with Man;
> When, like a falling Star, the Ray Divine
> Glides swift into the Bosom of the *Just*;
> And Just are All, *determin'd* to reclaim;
> Which sets that Title high, within thy Reach.
> Awake then: Thy PHILANDER calls: Awake!
> Thou, who shalt wake, when the Creation sleeps;
> When, like a Taper, all these Suns expire;
> When *Time*, like Him of *Gaza* in his Wrath,
> Plucking the Pillars that support the World,
> In NATURE's ample Ruins lies intomb'd;
> And MIDNIGHT, *Universal* Midnight! reigns.

At the end Young evokes the bleak close of the *Dunciad*. Young's falling star is a redeemed version of Pope's lines: "*Wit* shoots in vain its momentary fires, / The meteor drops, and in a flash expires" (*Dunciad*, 4.633–34). And his reign of darkness is Pope's realm of death: "And Universal Darkness buries All" (4.636).

But Young's sleeper awakes even amid the gloom. Light is snatched

from the very jaws of despair. The recoil, rebound, or reclamation—whatever you choose to call it—is Young's very most frequent tactic. Indeed, it is so commonplace that it never feels miraculous, even in what ought to be the concluding apocalypse, which despite turning from Pope remains beholden to momentary fires of vain wit ("'Tis Pride, to praise her; Penance, to perform"). There are countless passages in a similar vein. I picked this one for its echo of Pope, of course, but also for the allusion to Samson. Relieved of the roles of saint and reprobate alternately ascribed to him by traditional exegesis, Samson becomes instead a force of nature, with his emotion assimilated to the motions of the physical universe. Young was a man of the Church, and *Night Thoughts* counts as one of his numerous religious poems, but his religion remains a vision of humanity struggling to illuminate the darkness of the world around.

Seeing the dynamic of *Night Thoughts* in this way suggests an approach to Handel's sacred oratorios. His *Samson* concludes with a fugal chorus of redemption: "Let their celestial concerts all unite, / Ever to sound his praise in endless blaze of light." The fugue prays; it doesn't implement the prayer: it is, obviously, an earthly concert, not a celestial one. Handel's music in general is pulsing illumination, intermittently bright and somber; it is never endless blaze and rarely in any sense as blazing in the oratorios as in the more fiery music of the operas. The oratorios seek peace, with little of the flamboyant generosity that concludes the heroic drama and opera of the early eighteenth century. And at the famous moment in *Joshua* when a divine miracle stops the sun, the music itself grinds to a halt; endless blaze, when the sun stands still, is queasy quietude not harmony.

Despite all the obvious differences between Young and Handel, they share in this spirit of recovery toward the light without actually sunning themselves. They can both sound triumphant, but the triumph becomes compensatory and artificial in the economy of the whole. While Handel is good at noise, he is unequaled at calm simplicity. This spirit is best caught by the subdued tones of the Israelitish soloists in *Judas Maccabeus*—both the woman who sings:

> Pious Orgies, pious Airs,
> Decent Sorrow, decent Pray'rs,
> Will to the Lord ascend, and move
> His Pity, and regain his Love,

and the man who quietly intones words that must have been intended to be boisterous:

> And thus our grateful Hearts employ,
> And in thy Praise,
> This Altar raise,
> With Carols of triumphant Joy.

The indifferent verse offers darkness followed by triumphant exaltation; the magnificent music follows the darkness with a diffused reflection. Even at his most buoyant, Gray practices the same trick, as in lines on the reawakened spring in the unfinished "Ode on the Pleasure Arising from Vicissitude":

> But chief the Sky-lark warbles high
> His trembling thrilling ecstasy;
> And, less'ning from the dazzled sight,
> Melts into air and liquid light.

The strong individual soaring into the light is absorbed into a generalized radiance. "Air and liquid light" is not a periphrasis for choral song, and indeed Gray's modern editor does not read it as such. But in 1775 Gray's own friend and editor William Mason followed the lines just quoted with the following four that he found in a contemporaneous notebook:

> Rise my Soul on wings of fire
> Rise the rapturous Choir among
> Hark tis Nature strikes the Lyre
> And leads the general Song.

These poets respond to mid-century gloom by absorbing individual woes into a religiously tinged human universality. Handel's sacred choral epics precisely echo this mood of the times.

The spirit of the Age of Handel was reactive and compensatory. Cultural resources were felt to be diminished or enfeebled, and both religious and social emotions responded to a loss of confidence that threatened psychological isolation. Increasing cultural and political nationalism likewise had a consolidating tenor. The expeditionary forces portrayed in Smollett's

novels are cruel, even depraved; it seems miraculous that Roderick Random and Peregrine Pickle survive to return home and pick up their pieces. And Richardson's Clarissa spends the entire novel waiting for her cousin Colonel Morden to return from Italy to set her family straight. Tragically, he reaches her only when she is on the point of death. The moral is clear, even though it is not the central focus of the novel: internationalism contributes to disorder at home. Conversely, many plays of the time feature characters returning from abroad and bringing consolation or salvation home with them—often in the form of money. Such national motifs, like the social and religious ones, bespeak a polity lacking confidence in itself.

The nation is often threatened in Handel's oratorios, but of course also often triumphant. For this Handelian mood, the so-called rise of the novel forms the proper context. For it has become customary to see a self-celebration of the middle classes in Pamela's successful social self-promotion, in Clarissa's moral apotheosis, and perforce in the comic exhilaration of Fielding's *Joseph Andrews* and *Tom Jones*. To be sure, the customary story is complicated if the more nervous fictions by women are incorporated into it, but at least the male novelists seem to offer narratives of achieved identity. Both individual and national identities may be at risk, but class identities seem to redeem them. And in that context, a fruitful approach to Handel's oratorios may be in view. They could be said to participate in a shift of the cultural center of gravity from the drama to the novel and hence from the display of royal prerogative to the bourgeois judgment of private readers. *Susanna* might be a case in point: when the judging chorus takes over in the third part, the long, melancholy drama of passion and resistance yields to a rectifying clarification of the events and a consequent exoneration of the accused Susanna. The rhetoric is Christian, but the morality is strictly bourgeois:

A virtuous wife shall soften fortune's frown,
She's far more precious than a golden crown.

Smith compares *Susanna* to *Clarissa*, and for good reason.

However, the link scholars have forged between the eighteenth-century novel and bourgeois consciousness has been hasty and threatens to obscure the specificity of the mid-century cultural situation. Handel's oratorios do turn toward narration, but narration and novelization should not automatically be equated with one another.

For the fact is that the novel was not rising in the eighteenth century. It was getting itself born, but slowly. The word "novel" meant any kind of narrative, long or short; only at the very end of the century was it specialized to the kind of complex, well-plotted, multi-voiced narrative of social maturation that we now call a novel. *Clarissa* talks incessantly of angelic virtue and demonic vice; neither in that work nor in the story of the social-climbing Pamela is it proper to separate the bourgeois from the religious. And Tom Jones, the English Everyman, is likewise as much a spiritual quest figure as a socially specific class representative. Fielding defined the genre of his narratives as the "comic epic poem in prose" (Preface to *Joseph Andrews*), and the epic part should be taken seriously. Tom Jones progresses from his residence at Squire Allworthy's Paradise Hall to his eventual moral reformation and discovery of his true parentage in London. As he departs the Western world, the narrator echoes Milton's Adam and Eve leaving Eden. The confusing, partly frightening or salacious nocturnal events of the middle books evoke a dark world in which Tom's fundamental mettle is tested. Among other things, he encounters troops supposedly fighting the Highland invasion of 1745. Names suggesting the Highlands cluster here to a greater degree than I have seen recognized: not only the vicious Ensign *North*erton, but also the tumultuous Inn at *Up*ton, and the misanthropic ex-reprobate known as the Man of the Hill. Fragmentary allegories like these pervade the entire novel. It is hard to know exactly how seriously to take them, but it is surely wrong to write them off altogether as merely comic frivolity. The novelistic story of an emerging individual cannot be disengaged from the modern epic of a moral and spiritual quest. Most of the more prominent novels of these decades wear such an allegorical dimension on their title pages: *Roderick Random* and *Peregrine Pickle*, *Clarissa Harlowe*, *David Simple*, *Betsy Thoughtless*, *The Female Quixote*. With *Tom Jones* as the richest exemplar, they typically work through the travails of the period's melancholy to fashion a more or less triumphant emergence into a renewed moral order. If the long poems are the period's reckonings with its private anxieties, the works now usually designated novels are its reckonings with its public possibilities.

Smith, whose splendid study of Handel I have so often taken as a reference point, says that the oratorios were the remaining great epic works of mid-century. As characteristics of the epic she itemizes "didacticism, verse, allegory, the sublime, narrative, and fiction, or mixed history and fiction" (*Handel's Oratorios*, 140). Of these, verse was the least: two of the

most widely read moral allegories in the period were prose narratives, Bunyan's *Pilgrim's Progress* and Fénelon's *Télémaque*, the latter an explicitly Homeric work that profoundly influenced the form of *Tom Jones*. Fielding's generalizing, moralizing narrator serves the function of chorus to the events in his novels. It would be wrong to deny that the choice of prose or verse, comic or serious tone affects the presentation, but it is also wrong to overlook the affinities in aim and in audience between Handel and his great admirer Fielding.[21]

Just how earnestly are we to take the theatrics of "See the conqu'ring hero comes," or indeed of the Hallelujah Chorus? How much of their effect is to be reckoned to noble elevation, how much to sensual delight, or even manufactured excitement? Certainly, to the extent that the librettos omit the actions of the characters, they do not earn their exultations. As minor epics, with upbeat outcomes owing more to benevolence than to desert, they are fully of their time. Neither Hume's affability, Young's transport, nor Fielding's comic redemption can be said to have a secure and serious foundation. Perhaps Handel's exotic yet all-too-familiar librettos should be credited with a different and more immediate thrust. But if they survive, it can hardly be for their political allegory, though political good feeling and allegorical self-congratulation may well be a continuing part of their impact. The mid-century's despair shares with its triumph an aura of sublimity, but the mid-century sublime is distinctively empty and unthreatening. The moods are relaxing and enjoyable because they defuse the very emotions that they present. They are realistic in a way—not as the particularized representation of a richly perceived world, but through the creation of a vast space in which all can share. The hollowness so often perceived in the creations of this period is not their curse but their achievement in warding off the worries of excessive ratiocination.

Wallace Stevens said it better and more briefly than I can:

If thinking could be blown away
Yet this remain the dwelling-place
Of those with a sense for simple space.
 ("Like Decorations in a Nigger Cemetery," XVI)

≋ 8 ≋

Passion and Love

ANACREONTIC SONG AND THE ROOTS OF ROMANTIC LYRIC

When Beauty fires the blood, how Love exalts the mind.
—John Dryden, *Cymon and Iphigenia*

Mon corps est un enfant entêté, mon langage est un adulte très civilisé . . .
—Roland Barthes, *Fragments d'un discours amoureux*: "Cacher"

M Y topic is the eighteenth-century love lyric. That may seem a double impossibility. First, in the common view, the eighteenth century was "an era without poetry."[1] Good eighteenth-century poetry was satiric or didactic, bad eighteenth-century poetry was descriptive or odic, but, as Margaret Doody writes in a generally splendid survey, there was an "eclipse of the lyric" and "lyric itself becomes suspect."[2] And, second, there was no eighteenth-century love poetry. Love poems are confessional. In the "unlyrical or anti-lyrical culture" of the time, "the genuinely reflective love poem . . . became all but impossible."[3] If not always as direct as Pushkin's "I loved you," love poems begin, "I find no peace and all my warr is done" (Thomas Wyatt) or "My heart aches, and a drowsy numbness pains / My sense" (John Keats) or "How do I love thee, let me count the ways?" (Elizabeth Barrett Browning). The eighteenth-century tradition has no such poems to show, good or bad.[4]

It's true, some time ago someone discovered that Pope had feelings and added "Eloisa to Abelard" to the Norton Anthology. But nobody ever had to discover that Petrarch or Barrett Browning had feelings nor said of Keats (as Hippolyte Taine did about "Eloisa to Abelard") that his poetry was "the

199

noise of the big drum."[5] "Passion founded on esteem" is the concluding phrase and the ideal of James Hammond's rather affecting *Love Elegies*, and the reality that they mostly portray is passion founded on self-love.[6] A perusal of Matthew Prior's titles holds out equally little hope for spontaneity, where "Cupid in Ambush," "Venus's Advice to the Muses," and "Cupid's Promise" are mixed in with "The Remedy Worse than the Disease," "Husband and Wife," "The Mice," and "On a Fart, Let in the House of Commons."

To be sure, seventeenth-century poets could also be pretty cavalier in dealing with the emotions. But compared with the run-of-the-mill breeziness that pervades the poetry of Prior's day, in the cavalier poets, as Earl Miner says, "The tone is pure, the social relation sound."[7] The poems I will be discussing in fact want less to be pure or sound than simply bland. My essay, then, will give an overview of the eighteenth-century ordinary—the sort of insignificant poem any gentleman could write in his moments of leisure.[8] Inspired in part by Pierre Bourdieu's wonderful studies of the ordinary writers around Flaubert—about which I shall say a bit more later—I want to unearth what the eighteenth-century lyric represses without even appearing to struggle. Eighteenth-century poets, when they weren't spoofing Blowzelinda, wasted many shining hours singing of Chloe and Strephon. "How long shall every coarse mouth / in Anacreon's mode presume to sing of you?" one of them asks Venus, in the very act of joining the chorus.[9] I want to ask what the fuss was about.

THE SEVENTEENTH-CENTURY BACKGROUND

The tradition I will be surveying and discussing is that of Anacreontic odes. These are the simple lyrics of wine, women, and song that populate the nether regions of large anthologies of period verse from every European country. Indeed, their vogue lasted for three centuries. Under somewhat mysterious circumstances in the mid-sixteenth century, the great humanist Henri Estienne (Henricus Stephanus) discovered and published a collection of some sixty poems mistakenly attributed to the classical Greek master Anacreon. In fact, genuine texts of Anacreon survive only in almost entirely fragmentary reports, and Estienne's corpus actually derives from various anonymous post-classical writers. But the Anacreontea, as they are known, were long believed genuine and credited as a major rediscovery. Enormously popular and translated or imitated countless times from the

age of Ronsard and the Plé iade through the nineteenth century, Anacre-ontics should count as one of the leading poetic types during those cen-turies.[10] The Greek corpus is highly restricted in motifs, diction, and verse forms. But modern poets often blurred generic lines by assimilating the Anacreontic poems to the lighter amorous verse in Latin, especially the love poems of Catullus, Horace, and Ovid, and I shall be following their example.[11]

Airy frivolity is the Anacreontic stock-in-trade. Leporello's catalogue aria in *Don Giovanni* is an instance, deriving ultimately from Anacreon-tea 14. Here is another, from Abraham Cowley's delightful *Anacreontiques* (published 1656), the most influential of the earlier English imitations.[12]

> A mighty pain to love it is,
> And 'tis a pain that pain to miss;
> But, of all pain, the greatest pain
> It is to love, but love in vain.
> Virtue now, nor noble blood,
> Nor wit by love is understood;
> Gold alone does passion move,
> Gold monopolizes love;
> A curse on her, and on the man
> Who this traffic first began!
> A curse on him who found the ore!
> A curse on him who digg'd the store!
> A curse on him who did refine it!
> A curse on him who first did coin it!
> A curse, all curses else above,
> On him who us'd it first in love!
> Gold begets in brethren hate;
> Gold in families debate;
> Gold does friendships separate;
> Gold does civil wars create.
> These the smallest harms of it!
> Gold, alas! does love beget.
>
> (Chalmers, *English Poets*, 7: 85)

These are poems in which quantity replaces quality.[13] Physiological rather than psychological, reducing all things human to a common measure—

and I mean verse measure as much as material one—Anacreontics take the heart out of love. What is left is only pain, sensation rather than emotion.

Emptiness can, of course, be purifying. "Let what is graceless, discompos'd, and rude, / With sweetness, smoothness, softness, be endu'd," prays Robert Herrick, who, drunk or sober, is the great English poet of delight in small pleasures ("A Request to the Graces," 3–4).[14] Like Cowley, he wants to cumulate sensations, until they might have some effect: "*Numbers ne'er tickle, or but lightly please, / Unlesse they have some wanton carriages*" (7–8, Herrick's italics and wanton off-rhyme). But decorum pulls him back again into his tiny orbit: "This if ye do, each Piece will here be good, / And gracefull made, by your neate Sisterhood" (9–10, and end of poem). "*Herrick*, thou art too coorse to love" is what one dream mistress says to him ("The Vision," 22), but surely Herrick meant us to feel the reverse in writing glowingly, six lines earlier, of "The happy dawning of her thigh" (16). The best example of his Anacreontic sensibility is the fairy epithalamium to infant eroticism, "Oberon's Palace," but that is too long to quote and discuss here. In its place, here is "Love Dislikes Nothing."

Whatsoever thing I see,
Rich or poore although it be;
'Tis a mistresse unto mee.

Be my Girle, or faire or browne,
Do's she smile, or do's she frowne:
Still I write a Sweet-heart downe.

Be she rough, or smooth of skin;
When I touch, I then begin
For to let Affection in.

Be she bald, or do's she weare
Locks incurl'd of other haire;
I shall find enchantment there.

Be she whole or be she rent,
So my fancie be content,
She's to me most excellent.

Be she fat, or be she leane,
Be she sluttish, be she cleane,
I'm a man for ev'ry Sceane.

Herrick regularly used triplets for bantering poems whose tone is set by rhymes that are either banal (st. 1), anticlimactic (st. 3), or off (st. 5). However one parses the logic of the title, this poem works to reduce the stakes of the love-duel: it is only a human appetite, after all. Herrick digs himself—and then falls into—a shallow hole. Entangled in his misogynistic speculations, he seeks the whore in every woman, but not too much of a whore.[15] A mere object of sight and touch (not a speaking or aromatic subject), the woman here is hardly alive, and hence not excessively compromised or compromising. "Sceane"—the one rhyme-word that isn't a letdown—gives the game away as a game, the aesthetic distillation of the things seen: this is not a love-passion, but a love-admiration, a liking that can find the good in everything. "Cleane" smirks gently, but "sluttish" refuses to condemn. The whole poem is initiatory ("I then begin," "I shall find"), moving toward the empathy suggested by "rich or poor" and unhinging the finality of judgments. Hairless women can't really snare him; instead, he falls for his own fancies, as is not surprising in a retiring bachelor. It is a masterpiece of poetry at once gaily erotic ("other haire" is not far from Pope's "Hairs less in sight, or any Hairs but these," the last line in the fourth canto of *The Rape of the Lock*) and risk-free.

In such a poem, then, passion is manifest only under erasure: the Anacreontic aesthetic is anesthetic. With one gaudy exception ("A Nuptiall Verse to Mistresse Elizabeth Lee"), Herrick was not given to the Petrarchan love-war analogy, and his combination of royalism with discretion about the causes of discord is not naive, but a principled strategy for survival in a hostile polity. Masochism is not absent, but when he dreams of suicide it is with a "dainty" thread of precious metal ("Upon Love"), and when he seeks love's martyrdom it is—as he preemptively "confesse[s] / With Cheerfulnesse"—to be struck "With Flowers and Wine, / And Cakes Divine" ("An Hymne to Love"). While poems against fruition were popular and often bawdy, their message remains positive: prefer the life of (fore)play to the earnest but momentary death-heat of consummation.[16] Herrick's fellows found many ways to conciliate the contradictions of their emotions and their situations. John Suckling's hymns to "That foolish trifle of an heart" ("Song: I pr'ythee, spare me,"

English Poets, 6: 495) seem more callow than Herrick's, but so cynical they hardly even take their cynicism seriously. Alexander Brome, the "English Anacreon" (6: 637), gentles masochism into dalliance ("The Contrary," 6: 647) and assimilates politics to affection ("Plain Dealing," 6: 645, an anti-Petrarchan love lyric ending, "I'll love my country, prince, and laws, and those that love the king"). And Charles Cotton, underrated except by Miner, converting carpe diem into carpe somnum, animatedly praises "living without thinking" ("Anacreontic," 6: 713), spirituously celebrates surfaces over depths ("Whose thoughts can be dark when their noses do shine?" "Chanson à Boire," 6: 711), and invokes Horace's and Anacreon's "jolly lyre" in a festive song of "harmless mirth" for the king ("One love, one loyalty, one noise," "To Mr. Alexander Brome," 6: 762). Anacreontics provided the arms to write in self-defense without going on the defensive. The style's bright enamel is a protective coating.

The silent compromises were by no means always successful or always easy. Much routine blandness seems to have nothing worth hiding: it is hard to gainsay Johnson when he writes of John Sheffield, Duke of Buck-hinghamshire (author of "The Picture: In Imitation of Anacreon" and numerous other unvarnished trifles), that he "sometimes glimmers, but rarely shines, feebly laborious, and at best but pretty" (*English Poets*, 10: 76), and Whitehead, the poet laureate from 1757 (when Gray refused) to 1785, is no better than his reputation.

Uneven writers are a more interesting case. In "The Fair Traveller" (10: 33), a brief song to Astraea by John Hughes, a flaming forest is indistinguishably nature description, erotic innuendo, or neoplatonist allegory. It could be, respectively, original, delightful, or elevated, and so is not convincingly any of the three. And in the eighteenth century the lovable William Thompson would be worth reviving if his best lines had ever coalesced into a coherent poem. "He took her by the lily-hand, / Which oft had made the milk look pale" ("The Milkmaid," 15: 25) rings a delightful change on an erotic cliché, but the poem sinks into pieties; and the inspired phrase, "Feather'd lyric," that opens "The Morning Lark: An Anacreontic" (15: 26) cannot support the closing "Promise of eternal day." Such symptomatic authors either fall short of delight or else betray its delicacy in their striving to pawn it for something of more certain worth. Both poetic pathologies hint at what others achieved.

In the eighteenth century, the pressures on poetic statement receded and the occasion for Anacreontics became correspondingly less apparent. Consequently its repressions grew more obviously psychological and less political. The traditional name for the lower reaches of this mode is rococo.[17] "Namby-pamby" Philips is its representative English versifier,[18] as in his short-breathed (seven-syllable) couplets to the adorable child actress Signora Cuzzoni, or in a "Song" ("Why we love, and why we hate"), which attributes the "riddle" of love to "Random chance, or wilful fate," without confronting the antinomies in his paired terms, love-hate, chance-fate. Even Philips, though, finally (and nothing takes him long), wishes away the child and sighs for the man: "Leave us as we ought to be / Leave the *Britons* rough and free."[19] Such Anacreontics embody what one of the great pre–World War II comparatists called "literature as a means of defense."[20]

Another poet universally underrated, even by his contemporaries, William Shenstone names the buried truth of eighteenth-century Anacreontics in the last line of one of his songs (Song XI, "Perhaps it is not love"):

Oh! when did wit so brightly shine
In any form less fair than thine?
It is—it is love's subtle fire,
And under friendship lurks desire.[21]

Shenstone's "and" is a bomb in a nutshell. The fascination of these poems comes in the lurking fire that they identify with tactful self-awareness.[22] They adhere to a rococo ideal of taste, but expose "taste" as the period's discreet word for its repressed passion to devour. In "Nonpareil" by Prior (one of the most widely read and translated poets of the century), Phillis pleases Prior's "sight"; her eyes, bright and hot, darken the sun and nourish the apples of desire. "Yet so delicious is its taste," he concludes, "I cannot from the bait abstain."[23] It doesn't take much reading in these almost entirely unread poems to recognize their quite affecting energy of denial.

Morella, charming without art,
 And kind without design,
Can never lose the smallest part
 Of such a heart as mine.

Oblig'd a thousand several ways,
 It ne'er can break her chains;
While passion, which her beauties raise,
 My gratitude maintains.
 (Song XII; *Poetical Works*, 2: 320, quoted in full)

Suspicious first off is the denial by so stylish a poet of "art" and of "design." Prior means, of course, artifice and designing. But can he really mean that these are absent? Interior rhyme and echo (kind-design, part-heart) in the first stanza, close rhyme (ways-chains) and etymological pun (oblig'd, suggesting that the chained heart is tied) in the second make a showier surface than pastoral pretense should allow. How can we reconcile the passion of the monosyllabically chained heart with the polysyllabic formality of gratitude? The stylistic surface may be enamel, but the inside is human clay.

I hope that after these examples it can now be forthrightly claimed that love lyrics constitute one of the major expressions of eighteenth-century verse. While as large a proportion are bad or trivial as in any other tradition, much fine verse remains to be recovered. The few twentieth-century readers have been prone to privilege the surface wit at the cost of the sub-surface emotion; as one classic study formulates it, "Even when the verse is actually spoken from the perspective of the I, the feeling remains in the background."[24] While not inappropriate to its immediate pretext, the facile German Anacreontic poet Johann Wilhelm Ludwig Gleim, this judgment sells many other poems short, such as the two songs by Thomas Parnell titled "Anacreontic." The comic one, "Gay Bacchus," is an allegorical banquet of Bacchus, Comus, Love, and Jocus, in which high spirits mutate at stanza-end into high dudgeon.

And *Comus* loudly cursing wit,
 Roll'd off to some retreat,
Where boon Companions gravely sit
 In fat unweildy state.[25]

And the lovely serious one, "When spring came on," offers a heartfelt lesson in the interconnection of nature and passion, body and mind.

"The Sparrow and Diamond," by Matthew Green (*English Poets*, 15: 169–70), is the poem that first attracted me to the eighteenth-century love lyric.

Strange as it may seem to single out a totally unknown poem, after reading a lot of its congeners I do not hesitate to call it the masterpiece of its type. Sacrificing none of the Anacreontic polish, the song's narrative and diction are uniquely innovative and make it a singularly tantalizing exploration of the forces the Anacreontic exists to repress. Green, who died in 1737 at the age of forty-one, was a friend of Pope, who is regularly mentioned as the author of two extended tetrameter poems, "The Spleen" and "The Grotto." Four other poems by him are known, and not much besides.

I lately saw, what now I sing,
 Fair Lucia's hand display'd;
This finger grac'd a diamond ring,
 On that a sparrow play'd.

The feather'd play-thing she caress'd,
 She stroak'd its head and wings;
And while it nestled on her breast,
 She lisp'd the dearest things—

With chisell'd bill a spark ill-set
 He loosen'd from the rest,
And swallow'd down to grind his meat,
 The easier to digest.

She seiz'd his bill with wild affright,
 Her diamond to descry:
'Twas gone! she sicken'd at the sight,
 Moaning her bird would die.

The tongue-ty'd knocker none might use,
 The curtains none undraw,
The footmen went without their shoes,
 The street was laid with straw.

The doctor used his oily art
 Of strong emetic kind,
Th' apothecary play'd his part,
 And engineer'd behind.

When physic ceas'd to spend its store,
 To bring away the stone,
Dicky, like people given o'er,
 Picks up, when let alone.

His eyes dispell'd their sickly dews,
 He peck'd behind his wing;
Lucia recovering at the news,
 Relapses for the ring.

Mean while within her beauteous breast
 Two different passions strove;
When av'rice ended the contest,
 And triumph'd over love.

Poor little, pretty, fluttering thing,
 Thy pains the sex display,
Who, only to repair a ring,
 Could take thy life away.

Drive av'rice from your breasts, ye fair,
 Monster of foulest mien:
Ye would not let it harbour there,
 Could but its form be seen.

It made a virgin put on guile,
 Truth's image break her word,
A Lucia's face forbear to smile,
 A Venus kill her bird.

The early eighteenth century did not sharply distinguish song from ode, and "The Sparrow and Diamond" opens with a reduced ode formula of the type later adopted by Keats in "Ode to Psyche": "I lately saw, what now I sing." The first person occurs only here, but that is enough to claim the right to interpret the narrated incident. Still, the distance between knower and known is not great: "lately" is pretty recent, "sing" in rhyming position is an easy reduction of the epic "cano," and "Fair Lucia's hand display'd" is a

play of lights that almost anyone would notice and understand. The joking tone belies the exaggerations of the diction. Not all that much is really at stake. Knowledge here is merely worldly savvy and conscience, a liberating ally that colludes with Lucia's better nature, adding light to her light and displaying in her countenance what was not sufficiently displayed on her hand. Crucial to the effect is sublimation by upward displacement, from hand to breast and breast to mien, where evil is known and hence cured. The poem's first impulse is to make light of life.

But the alliance of speaker and subject is uneasy. Desire breaks out again in both the violence and the mythology of the last line.[26] You cannot easily be a virgin and a Venus at the same time: truth's image breaks its word, not just in Lucia but in the speaker, who appears more smitten than he would care to admit by Lucia's "beauteous breast"—the noun appears twice in the rhyme and a third time in the plural. Urbane compassion masks passionate involvement, as he puts the bird's feelings on show: "Poor little, pretty, fluttering thing / Thy pains the sex display." Whatever "the sex display" means here—"show up the cruelty of women," but surely not just that—it involves a certain risqué empathy. Clearly the speaker would like to be Lucia's flame.[27]

Now, as a story about the shining Lucia, the poem is weightless. Though lacking a flame, Lucia does have a spark, but the wrong kind. When the bird swallows the diamond as a digestif, Lucia, in ignorance of the habits of the feathered kind, nearly overwhelms it with her vaporous attentions and with the lascivious arts of the doctor and the apothecary; then, when it recovers, she "Relapses for the ring" and, proleptically literalizing a Wordsworthian conceit, murders the bird in order to dissect it. As the poem says, Lucia is torn between "two different passions," one natural and one artificial—and neither what Keats would call passion. With all her efforts devoted to getting the bird to disgorge or evacuate the stone, the evident kernel of her tale is no more than an unarticulated pun on "consuming passion."

But the poem can't be written off as a riddle, for the moralist's problem is earnest. His jocularity does not quite allow him to rise above it all. He feigns indifference with the casual opening—"I lately saw," "fair Lucia"—and by the end he has broadened from his allegorical naming to the universal "ye fair." Thus he devalues his praise of the individual woman. That is "truth's image," but it is not the truth itself. In fact, he sings because the whole affair matters to him. "I lately saw" proves his concupiscence: he would happily be either "dicky" or diamond, flame or spark, stroked by a finger or wrapped around one.[28] The generalized argument against avarice, leaving Venus in

command of the field as the master passion of the race, serves the private interests of seduction. Lucia may be foolish, but the speaker is fond, and he too is exposed and mocked; neither the "oily art" of rhetoric nor the allegorical moralization engineered from "behind" the scenes quite works for him. Like the bird, and like the woman, he too needs purging. The poem, then, has a concealed subject, which is not the anecdote but the speaker, not the frivolous portrayal of emotion but the revelation that knowledge itself is inextricably entangled in desire. "Itching curiosity," as Green's "Jove and Semele" more bluntly says, is "A lurking taint deriv'd from mother Eve." Visionary and mythological language aggrandizes private feelings: such poems are more personal and more bright than they wish they could be. The brilliant cleverness of the Anacreontic stands exposed as a ploy to hide in sunlight a darkened spirit.[29]

The two love stories in "The Sparrow and Diamond" can best be probed in sequence. If the speaker is a knowing sophisticate, Lucia is an unknowing naive. More clearly in view, her syndrome lends itself more readily to diagnosis. Her disorders, in succession, are hysteria in stanza 4, as she hallucinates the bird's imagined illness on her own body, melancholia in stanza 5, and sadistic paranoia in stanzas 9–10. Seeking immediate gratification at the breast, she proceeds from an oral phase toward the anal eroticism of the doctor and apothecary but stops short of any incipient phallicism.[30] Clearly, her sentimental education is a failure. Uncertain what to feel about the bird, she "relapses" into a primitive fetishism that cannot distinguish sexual object choice from narcissistic introversion. Avarice, the passion to possess and even (in this case) to consume, forestalls external acknowledgment. The sparrow is her toy; her panic appears multiply determined—not just because the sparrow has infringed her property, but because the bird has begun to separate from her. Not just playing and nestling, Dicky now engages in transitive and self-oriented actions, swallowing and pecking. What was an "it" in stanza 2 soon becomes a "he." Insufficiently determinate in his specific nature (bird, child, or lover) or indeed in his sexual identity (since "little, pretty, fluttering" all suggest feminine characteristics), the sparrow becomes the focus for a regression: Lucia builds no superego and remains in her melancholic state of impoverished selfhood. She may look adult, but psychically she is an Olympia figure, a whirling doll with automatic responses and unfocused libido. A creature of her desires, passive without receptivity, she fails to sort out, or "de-fuse," her drives and lacks what the third chapter of Freud's "The Ego and the Id" (his best analysis of

oral regression) terms "character."[31] Physically too mature for a nymphet, her toying sensibility leaves her a nymph, an adolescent girl-woman too unformed for any moral judgments to stick.

Lucia's story is a two-way contest: herself vs. Dicky, avarice vs. love. The speaker of the poem lives a more tangled and more sordid story, since he is caught in a triangle. At once identifying with the "poor . . . thing" and evidently violently jealous of him as well, he is even less able than Lucia to separate passion from lust, masochism from sadism, love from hate, oral from phallic desires.[32] The close-up in stanza 2 amplifies the more distanced observation of line 4, revealing an obsession that will not go away even after the bird has died. There is no time in the unconscious, no progression in what is sung from the bird's-eye perspective of "now," and hence his confusion exceeds Lucia's.[33] The choice of the childish Lucia as love object evidently derives from what in his case, too, is a still primitive libido. Hence the regressive envy of the stroking, nestling, and lisping gestures; as Freud says, "The ego must be developed. The autoerotic drives, however, are there from the earliest beginning [*uranfänglich*]."[34]

What complicates the picture still further, however, is that the speaker knows his rival is dead, and was indeed never a real rival. The Anacreontic enamel, then, glazes a fantasied regression, as many-layered and complex as those in Freud's essay, "A Child Is Being Beaten." While Lucia's passions are at least "different," the speaker's are more completely confounded and too repressed to be acknowledged or openly manifested. He fails to integrate his image of her, seeing only body parts (hand, finger, breasts, eyes), never the whole person. Indeed, it is only through the incoherent disorder of oneiric processes that his feelings can find vent. Dicky—initially passive, subsequently a conduit for revenge ("a spark ill-set / He loosen'd" might teach Lucia to play around), and increasingly confused in his roles as sinner, victim, and agent of retribution—is finally subject to a hallucinatory transformation that makes him the very embodiment of evil: in his hunger for diamonds, the pet at the breast is abruptly replaced by a more terrifying beast, avarice. The hidden form of nightmare emerges for an instant, then reverts to the moralizing, if not quite stable gloss ("kill" is pretty blunt) of the final stanza.

More than any other Anacreontic poem, "The Sparrow and Diamond" bares the complex human passions piled up beneath the civilized emotion of love. Access to the unconscious world beneath the gloss is tricky, for what enters our world does so as part of our world, and only through

the symptomatic traces of pun, imagery, and narrative incoherence can its more sordid universe be glimpsed. "The little" is a common name for the primitive condition in which eroticism, avarice, and anality are confused (see Freud's essay, "On Transformations of Drives, Particularly in Anal Eroticism"). But it shies from the light, in this case darkening even one named Lucia. The discretion of the Anacreontic is a key to its always furtive discovery. "The Sparrow and Diamond" is a hush-hush, "tongue-ty'd" world of lisping, moaning, and enforced silence. Prelinguistic, it is therefore also not capable of being brought to consciousness ("The Ego and the Id," chapter 2). Whereas, according to an old truism, Romantic lyric expresses feelings in their immediacy,[35] this poem elides the speech that intervenes between the traumatic seeing and the already reflective singing. The immediacy of drives is dark.[36]

Ultimately, it is hard to know whether to attribute the final two stanzas of "The Sparrow and Diamond" to the infatuated speaker or to the glib poet. The moralizing superego, at any rate, does not come easy to the incapacitated psyche. Exaggerating, pluralizing, mythologizing, it treats behavioral foibles not just as character flaws but as cosmic defects. It is here that Lucia becomes a symbol, representing her class (the fair), her sex, her species. But a hallucinatory moral is hardly more use than no moral at all. The indiscriminate terror of the superego is itself an agent of surplus repression, not of self-regulation.[37] Purely formulistic in genre and rhetoric, the Anacreontic is haunted by a formlessness that it knows better than any other form how to hint at. Aiming at pure melody ("what now I sing"), its sight is constitutionally deformed. Stylistically it is nothing but an image, a glossy picture, yet it knows that representation is the very source of the deceit that it wishes out of existence. Corruption is the way of the world for the eighteenth century, as, for Freud, trauma is the origin of psychic development. The word is always the broken image of an ever-receding truth.

It might seem odd to locate the manifestation of anarchic desires or unbound libidinal energies in so highly constrained and ritualized a genre as the Anacreontic. But form in these poems is reductive, regressive, and repetitive, not developmental, let alone binding. They harp on obsessions that they fail to define or limit. "The Sparrow and Diamond" is exceptional in its narrative precision, but even there what counts is the disorder of passions that fracture the formal surface through tonal inconsistencies or exaggerations. While his song is not an utterance of immediate inwardness,

the speaker remains too close to the events to transform repetition into recollection. He fears death but seeks narcosis, the *Reizschutz* on which Freud discourses at length in chapter 4 of "Beyond the Pleasure Principle." In this fashion Anacreontics both seek and fear an end: where no line can be drawn between intoxication and drunkenness, enough is too much, and the strategy of the poems is to be able to say little at length—and generally through multiplying poems rather than through extending individual songs. "Eh! quel nombre, dis-moi, peut suffire à l'amour" [Oh! tell me, what number may suffice for love], exclaims Claude-Joseph Dorat in "Les Baisers comptés," both hoping and fearing a last one:

Les huit premiers, accordés par toi-même,
Mettront le comble à ma félicité;
Mais je mourrai de plaisir au neuvième,
 Et surtout s'il m'est disputé.[38]

~

The first eight, granted by you,
will fill up my happiness;
but I will die of pleasure at the ninth,
 and especially if it is disputed.

The form of a litany is entirely inorganic and designed to liberate desire from its bondage to finite experience.

Anacreontics are trifles. Indeed, one popular volume, by Gotthold Ephraim Lessing, was originally entitled *Kleinigkeiten* (1751, with four subsequent separate printings, along with wide diffusion under the title "Lieder" in various editions of his works). With limited exceptions, its purveyors have nowhere remained household names: Hagedorn, Uz, and Gleim in Germany; Cadalso in Spain; Chaulieu and Dorat in France; Rolli, Fontana, and Vittorelli in Italy; and Kheraskov in Russia are no more familiar today than Prior, Shenstone, and Green. (The principal exceptions, which are discussed below, prove the rule: Lessing, whose youthful Anacreontics are hardly read; Goethe, who led the charge in the transformation of Anacreontic into Romantic lyric; Derzhavin, whose Anacreontics are generally considered works of his decline; and one genuinely important but brief work by Lomonosov.) Yet among the mere trifles, a great many poems imply resonances greater than subsequent readers have wished to know.

Lessing, for instance, exercises a nervous wit that lacks analytical depth but betrays itself by its insistence on getting the upper hand. His counting poem is entitled "Jealousy (Der Neid)."[39]

Der Neid, o Kind,	Jealousy, my child,
Zählt unsre Küsse:	counts our kisses:
Drum küß' geschwind	So swiftly kiss
Ein Tausend Küsse;	a thousand kisses;
Geschwind du mich	swift thou me,
Geschwind ich dich!	swift I thee!
Geschwind, geschwind,	Swift, swift,
O Laura, küsse	O Laura, kiss
Manch Tausend Küsse:	many thousand kisses,
Damit er sich	so that he
Verzählen müsse,	loses count,
Der ungeküßte Neid!	the unkissed jealous.

Self-consciousness turns a love poem into a pronoun lesson, while identical rhymes suggesting fusion are too cleverly counterpoised against an iconic unrhymed line for the unkissed jealousy. Lessing later omitted the last line and retitled the poem "Die Küsse" (The Kisses), not wanting to determine the enemy's profile so distinctly. In Friedrich von Hagedorn the wit turns sour when the unbound impulses of love lead to inconstancy ("Die Küsse," "Liebe und Gegenliebe"). In the effort to capitalize on the hidden wealth of the Anacreontic mode, both Hagedorn and Johann Peter Uz penned more linguistically inventive and (in Uz's case) more generically flexible a corpus than had been the norm. Meanwhile, the counting tradition continues in José Cadalso's "Cuartetas." Its four-line stanzas (hence the title, from a frequently self-conscious poet) transcribe the complaint of a shepherd "pondering to his beloved nymph the efficacy of his love" (ponderaba / Un inocente pastor / A la ninfa a quien amaba / La eficacia de su amor).[40] Consider, he says, how many flowers bloom, how much sand floats down the Tagus, how many birds sing, how many brooks flow, how many bees fly, and, finally, how many graces adorn your hand: I love you more than all. Affecting here is the idiomatic subtlety of the counting words: flowers are plural, sand singular, but then a collective singular is retained for all but the last of the remaining stanzas. Diminutives ("cuánta avecilla," "cuánto arroyuelo" [literally: how much little bird, how much brooklet]) belong to

the Anacreontic trifling, but also to the sense of an innumerable prolif-eration. Hence when the plural does return, it is almost antithetical to the effect of Cowley's hoard of curses—a miracle rather than a multiple: "Do you see how many graces the hand of the gods gave you?" Wonder is joined by admiring jealousy—the speaker who first called Filis adored, beloved, beautiful, and light of my life finally calls her "ungrateful and beautiful" and then, in a gender reversal, "tyrannical master"—as the thinkable proves inconceivable after all.[41] These are not paradoxes merely of cleverness or superficiality, but genuine tensions between sexes, generations, classes, and talents that the poets can only master by allowing them to be named in a fashion that cavalierly seems to ignore their reality.

It was in Russia that Anacreontics made their grandest claims. At mid-century, Mikhail Vasilievich Lomonosov's "Conversation with Anacreon"—a set of four translations together with partly isometric answers—established the possibility of ease in Russian verse as the ground for poetic power. The nation becomes Lomonosov's mistress. Lomono-sov, the first major poet in Russia (otherwise known for his sublime odes, and his chemical researches), had no native predecessors he could play off against, and so he creates the possibility of playing off himself. Self-con-sciousness then reaches one kind of apogee in the *Anacreontic Songs* of the early Russian Romantic poet Gavriil Romanovich Derzhavin. Derzhavin's Cupid-and-Venus allegories are accompanied by authorial decodings that identify their occasions in the life (not always the love-life) of the royalty and nobility. Trumpeting not just his connections but also his virtuos-ity (several poems dispense with the letter "r"), Derzhavin seems to have regarded his form's freedom-from as a libidinal and cultural freedom-to.[42]

The Anacreontic thus becomes a discipline, not just a relaxation, and as such it takes its place within the pantheon of poetic modes. In attending to the internal tensions of successful Anacreontic verse, we should also take note of its competitive relation to other poetic modes. It is not just in the ambitions of the Russian poets that the resonance of Anacreontic verse exceeds its occasions. Rather, it regularly borrows from greater modes and in return infiltrates them with its honey. Shenstone's line "Under friendship lurks desire" codifies Anacreontic resonances that complicate the etiology of Eloisa's guilt in Pope's most passionate poem.

Thou know'st how guiltless first I met thy flame,
When Love approach'd me under Friendship's name.[43]

Continuing to yearn for a language of innocence, Eloisa betrays herself in numerous ways as she weaves echoes of Anacreontic simplicity into her story of desire.

> *My fancy* form'd thee of Angelick kind,
> Some emanation of th' all-beauteous Mind.
> Those *smiling eyes*, attempting ev'ry ray,
> Shone *sweetly* lambent with celestial day:
> *Guiltless* I *gaz'd*; heav'n listen'd while *you sung*;
> And truths divine came mended from that tongue.
> From lips like those what precept fail'd to move?
> Too soon they taught me *'twas no sin to love*.
> Back through the paths of *pleasing sense* I ran
> Nor wish'd an Angel whom I lov'd a Man.
> Dim and remote the joys of saints I see,
> Nor envy them, that heav'n I lose for thee.
> How oft', when press'd to marriage, have I said,
> Curse on all laws but those which love has made!
> *Love, free as air*, at sight of human ties,
> Spreads his *light wings*, and *in a moment* flies.
> ("Eloisa to Abelard," 61–76)

Even though the diction as such avoids the clichés of the mode, the topics (italicized) and sentiments of Anacreontic verse (repression, decoration, pagan myth) undermine the uses to which Eloisa would put them. In what is not, but could be, an Anacreontic tale, we recognize a temptation that Pope's couplets resist. Flirting with shallows, they hint at the girl within the woman, the rake within the lover.[44] In this way, the Anacreontic functions as a possibility within (and often transcended by) the larger sphere of poetic production.

ROMANTICISM AND THE ANACREONTIC TRADITION

Apart from Derzhavin, the presence of the Anacreontic mode grows more shadowy in the Romantic period, but it was not forgotten. There were important translations of the Anacreontic corpus by Thomas Moore in England (1800) and later by Eduard Mörike in Germany (1864); Coleridge wrote an "Ode in the Manner of Anacreon" in 1792; Byron translated two of

the odes in his first volume, *Hours of Idleness*; and the sequence of the great odes in Keats's 1820 volume is interrupted by four light-hearted poems of fancy, love, and drink in the tetrameter couplets that had become standard for English Anacreontics.

An interesting case for the point to be made about Romantic verse is the prolific Spanish poet of sensibility, Juan Meléndez Valdés (1754–1817). Meléndez's sentimental odes repeatedly allude to the light-hearted Anacreontic condition by way of nostalgia or utopian imagination. "Mis ilusiones" is a memory of puppy love; "De mi vida en la aldea" pits a timeless village escape against the bustle of the town; "De mis versos" contrasts his amorous and bibulous joy to the jealous gloom of the "viejos tristes" (sad elders—even though in other poems he's often enough sad himself and though this ode fixes a mere moment of exhilaration as if it were a constant). And the delightful "El Amor mariposa" rehearses the Anacreontic topos of Cupid as a small winged creature but with an edge, for this butterfly carries a sting and his winged beauty is a double deceit: it's only a disguise and Cupid nevertheless is infected by the creature's inconstancy.[45] The Anacreontic mode becomes a background to measure the obviously tumultuous world of everyday. But of course the Anacreontic world itself is riven with "crazy tumult" ("loca algazara," "El Amor mariposa"), "delicious illusions" ("Mis ilusiones"), and joyful madness ("alegre enloquezco," "De mis versos"); the illusion glistens only from afar. The allusions incorporate the secret torment as well as the visible delight of the Anacreontic mode and thus realize within the poem the divisiveness of passion in the very attempt to imagine purity.

Anacreontic poetry was always a minor form. It is the poetry of the young, the recreation of the idle, the conviviality of the solitary.[46] But too much of this verse has been, as Pierre Bourdieu has said of Flaubert's minor contemporaries, "written out of literary history," when it should rather be acknowledged as a necessary substratum.[47] "The analysts," Bourdieu continues, who "know only those authors from the past recognized by literary history as worthy of recognition, are destined to an intrinsically vicious-circular form of explanation and understanding. They can only register, unaware, the effects of these authors they do not know on the authors that they claim to analyze and whose refusals they take up on their own account. They thus preclude any grasp of what, in their very works, is the indirect product of these refusals." The "unknowing poetics," as Bourdieu calls it, is a "double refusal," both rejecting the slighter mode and then con-

cealing its rejection. Bourdieu does not employ the Freudian language I have introduced here, but I think he well might, for the minor Anacreontic mode becomes in effect a textual unconscious of, let us say, Pope or (as I shall shortly suggest) Wordsworth and Keats. The Romantic utterance of pure feeling can thus be seen as both a private and a public expression of the psychological and cultural histories of feeling, if we only learn to grasp what they attempt to withhold. The recovery of noncanonical forms of writing has often served this kind of literary-historical purpose, for instance in reminding us of the covert agendas of poetry that is, constitutively, not feminine. But these studies have sometimes been biased by the assumption that the noncanonical is anti-conventional or otherwise disruptive. That is not the case for Anacreontic trifles and historically has not been the norm for other suppressed or excluded writing, which more often has sought acceptance through hyperconventionality. Rather than revolt, minor forms like the Anacreontic—a major tradition of minor writing, in this case—should alert us to the complexities of ferment within and to the competitive struggle that ruffles and animates greater writing.

"My heart aches," the sequence of Keats's odes begins, and one thing that it aches from is reading too much mediocre poetry. I have already identified the "I see and sing" of the Psyche ode as a transvalued Anacreontic chirp, and its continuation, "by my own eyes inspir'd," reflects the Bourdelian double refusal, pretending an absence of external sources of inspiration. For I think any comparative reading will show that the Keatsian language of blush is heavily contaminated with the rhetoric of Anacreon, specifically in the often reprinted version of Thomas Moore. Moore's florid adaptations of the entire Anacreontic corpus are more appealing if you come to them from immersion in earlier Anacreontics rather than from later and greater verse, but whatever the aesthetic judgment, it should be evident how much the language of the opening odes in particular foreshadows Keats.

> Let sylvan gods, in antic shapes,
> Wildly press the gushing grapes. (Ode 4)

> Let warm-eyed Venus, dancing near,
> With spirits of the genial bed,
> The dewy herbage deftly tread. (Ode 5)

As late I sought the spangled bowers,
To cull a wreath of matin flowers,
Where many an early rose was weeping,
I found the urchin Cupid sleeping. (Ode 6)

The locks upon thy brow are few,
And, like the rest, they're withering too. (Ode 7)

Scarce a breathing chaplet now
Lives upon my feverish brow;
Every dewy rose I wear
Sheds its tears, and withers there. (Ode 18)[48]

Even without its interpolated Anacreontics—the seldom-discussed poems "Fancy," "Bards of Passion and of Mirth," "Lines on the Mermaid Tavern," and "Robin Hood: To a Friend"—it would be clear that Keats's volume entails a reckoning with the poetry of wine and love. But despite the various attempts by John Bayley, Christopher Ricks, and Marjorie Levinson to reclaim his dictional gush as somehow personal, it must also be acknowledged to be not just conventional (as has never been ignored) but pointedly historical in its conventionality. The struggle to awaken, to realize himself, to *be*, reclaims for the psyche a set of feelings that had been societal and interpersonal. The odes are poems of encounter that conceal the derivation of the objects of their desire. As the clash of one poetic kind with another, the absorption of Moore's diction has a generalizing resonance and hence a class function, claiming for Keats the precise variety of arriviste's distinction that by 1820 Moore had fully acquired.

But Keats's Anacreontic style (and here my revision of Bourdieu) equally has a psychic function in constructing (not expressing) the Keatsian self. In Anacreontics, adolescence is an emotional condition that rules with unchanging force all stages of life: "Age is on his temples hung, / But his heart—his heart is young!" (Moore, Ode 39).[49] Keats reimagines their timeless simplicity as a repressive innocence that "dost tease us out of thought." Beneath its "Cold Pastoral!" the Grecian Urn actually tells a story of the violence of growing up, from a "still unravish'd" but legend-spooked childhood through the time-denying love of youth and maiden to post-coital maturity and sacrificial age. And the remaining odes are equally time-haunted. Keats thus perpetuates the Anacreontic mode through inversion:

what was warm surface is now cool depth (personal and cultural paradises lost), what was buried conflict is now narrative surface, yet retaining its veneer of wonder. Where passion had been caught in the antinomies of desire and disgust most fully articulated by libertine verse and "against fruition" songs and hence incompatible with affection, Romantic lyric makes it possible to transmute leaden-eyed despairs into golden dreams by giving love time to breathe.

Even the simplest achieved Romantic lyric communicates intensities never sought in the eighteenth century. That was the problem with which this essay began. But, as I have argued, the intensities are not missing from Anacreontics; instead, they are present in repression. Yet Romantic lyric, in its most innovative form, is also remarkably understated. One way to understand the force of song in poets like Wordsworth and Goethe is with respect to Anacreontic repression. While both traditions claim immediacy, the Romantic lyrics implicitly acknowledge the forces of contingency and competition that Anacreontics pretend to overcome.[50] Even as a winged creature, the Anacreontic Cupid poses as an other; whereas even as natural beings, Wordsworthian cuckoos and skylarks are subject to explicit identifications and projections. Critics are fond of puzzling over the almost unspeakably subtle ironies of the Lucy poems. These acknowledge what Anacreontics hide, the infantile and passional roots of adult emotions ("Three Years She Grew"). What makes them moving—destabilizes them—with respect to Anacreontic lyric is the uncertainly ironic power of their presence. Where Green's "what now I sing" fixes passion with analytical precision, Wordsworth's "now" slips and slides: "No motion has she now . . . , / Rolled round." Passion fuses with love in the precariousness of experience. In "She Dwelt Among the Untrodden Ways," the accomplishment can't be named because its temporality is the boundary state that conditions what is knowable: the verbs and adverbs do not name time (permanence or change) but instead are suffused with it, and the best that Wordsworth can do to identify his condition is "And, oh, the difference to me." But the refusal to draw a moral (or, in the case of "Strange Fits of Passion," the exclusion of the original moralizing conclusion) makes the fragility of love-passion an acknowledged part of the constitution of the self. Ongoingness is built into their language and hence into the feelings they evoke, drawing desire out from its pathologies into the delicate mixtures of Romantic feeling. If difference entailed denial, then it would make sense to classify Romantic rhetoric under the rubric of irony. But it's hard to keep it

there precisely to the extent that an earlier language of passion is absorbed rather than rejected by romantic love.[51]

Assessing just how much Romantic lyric absorbs and how much it rejects an Anacreontic stance is a difficult question for literary history, with potentially variable answers for different poets, or even different poems. In the English sphere the question has almost never been posed, apart from the essays cited in note 48. It ought to be an easier question in connection with Goethe, the greatest and most representative Romantic lyric poet, but even in his case it has hardly ever been broached except in terms of discriminations. Hence while the three major German studies land on different sides, they all acknowledge the same fence: Herbert Zeman most simply (and, within his limited definition, most accurately) grants to Goethe a continuing connoisseur's interest in Anacreontics while denying him any share in true Anacreontic naiveté; Paul Böckmann speaks of transmutations of wit into emblematic yet heartfelt emotion (in German, respectively, "Sinnbild-lichkeit" and "Seelenfülle," with the contradiction imperfectly reconciled by qualifying the former as "echt"); and Heinz Schlaffer posits a fusion of Anacreontic motility and Romantic idealization, without sufficiently clarifying how evanescence can be fixed without being falsified.[52]

Those who know the contexts will recognize that all such discussions address only Goethe's earliest and simplest verse, from before 1772. Categories of immediacy and permanence do not capture the flux of feeling so essential to the greatest examples of the lesser Romantic lyric. If one leaps to the poems of *Wilhelm Meisters Lehrjahre* (the reason will be evident shortly), one sees the persistence of Anacreontic sociability in Philine's song:

Singet nicht in Trauertönen	Sing not in tones of grief
Von der Einsamkeit der Nacht!	of night's solitude!
Nein, sie ist, o holde Schönen,	No, ye charming fair, she (night) is
Zur Geselligkeit gemacht.	made for sociability.

In evident opposition to such willed superficiality, the aged Harper rejects society in his solitary plaints; nothing could be further from his songs than Anacreon's hoary gaiety. And the child Mignon remains a mystery, with her gymnast's gleaming physicality hiding a guilty secret. (The two Mignon songs I allude to are "So laßt mich scheinen, bis ich werde" and "Heiß mich nicht reden, heiß mich schweigen, / Denn mein Geheimnis ist mir Pflicht" [So let me seem 'til I become; Bid me not speak,

bid me keep still, for my secrecy is my charge].) These poems bear at least a definable relationship to the Anacreontic tradition, if not necessarily a very complex one. But though Mignon's most famous song, "Kennst du das Land, wo die Zitronen blühn" (Know'st thou the land where lemons flower) echoes eighteenth-century verse (the oranges in the trees come from James Thomson's *Summer*), its child's plea for a heavenly, paternal beloved seems to belong to a different universe altogether. The mysterious depths of Romanticism seem to lie far off Anacreon's Continental shelf. Or do they? . . .

Following a couple of dedicatory verses, Goethe's collected poems, in his own ordering, begin with a 1774 Anacreontic called "Der neue Amadis," which relates a child's fantasy of the loves of Prince Pipi (same infantile pun in German as in English) and Princess Fish, of which I quote the conclusion, verses 5 and 6.

Und ihr Kuß war Götterbrot,	And her kiss was manna,
Glühend wie der Wein.	glowing like wine.
Ach! ich liebte fast mich tot!	Ah! I loved myself nearly to death!
Rings mit Sonnenschein	She was enameled all around
War sie emailliert.	with sunshine.
Ach! wer hat sie mir entführt?	Ah! who lured her from me?
Hielt kein Zauberband	Did no magic cord
Sie zurück vom schnellen Fliehn?	restrain her swift flight?
Sagt, wo ist ihr Land?	Say, where is her land?
Wo der Weg dahin?	Where the way there?

It is an astonishing poem, not least for the storm and stress crudeness with which it translates Anacreontic enamel into the juvenile salaciousness of its "warm hero" ("I built many a crystal fortress and destroyed it too"). But the whiplash of feeling becomes too strong for the childish imagination; in the last stanza he yearns for the magic wand that would preserve his lost masculinist paradise. Desperately Anacreontic is the only way one might adequately characterize this self-reckoning with Goethe's earliest style. But of course from here the way leads directly to Mignon, whose first and last lines ("Kennst du das Land," "Dahin möcht' ich . . . ziehn" [Know'st thou the land; thence would I go]) echo the end of "Der neue Amadis." If, for Wordsworth, the child is father of the man, Goethe's girl-child, underneath her

shell, reveals precisely the passionate infant that lies threateningly within loving adults. One glory of Romantic love lyric is that in its probing of the emotions of love, it simultaneously preserved and indeed brought into view the passional roots of steady feeling.

This is a many-faceted story, not to be captured in a few pages at the conclusion of a chapter. Nor is it news that romantic love was a passion. But in seeing its self-conscious cultural roots in their complexity, we can better appreciate both the developmental character of songs and odes too often taken to be immediate or timeless and the unmasking of individual and collective drives in emotions still too often taken to be integral or organic expressions of sensibility. It is the childishness of Anacreontics that the Romantic lyric still preserves, and that is lost in the world-weariness of love poetry later in the century.[53] Perhaps its last great flowering, indeed, is not in verse but in prose. For the mixture of social aspirations, surface polish, and subterranean ferment might well be said to reach its most elaborate and public exposure in the novels of Stendhal.

Nineteenth-century passion is matter for another essay.[54] However, the account of its roots that I have been giving can at least illuminate the central mystery of a very differently oriented study. In *The Passions and the Interests*, Albert O. Hirschman has provided an illuminating and influential account of the rise of rational economics in the eighteenth century. Taking as his frontispiece a political emblem of 1617 inscribed, "Affectus comprime" ("Repress the Passions," in his translation), Hirschman documents the rise of order and the calming effect of bourgeois industry guided by economic interest. Greed tames lust, as it does in the case of the shining Lucia of "The Sparrow and Diamond." However, Hirschman is unable to explain the failure of rationality to sustain itself.

> For as soon as capitalism was triumphant and "passion" seemed indeed to be restrained and perhaps even extinguished in the comparatively peaceful, tranquil, and business-minded Europe of the period after the Congress of Vienna, the world suddenly appeared empty, petty, and boring and the stage was set for the Romantic critique of the bourgeois order as incredibly impoverished in relation to earlier ages—the new world seemed to lack nobility, grandeur, mystery, and, above all, passion.[55]

This account does not explain how the passions that reason had successfully subjugated might suddenly appear noble or grand. But the poetry

shows us that passion was not at all extinguished; rather, it was repressed, and in repression it continued to ferment. Hirschman in fact does not analyze passion but treats the concept as a counter to be asserted, resisted, or conquered and forgotten; consequently, and not untypically for the enterprise, his history of ideas consists of alternations, denials, revivals, and repetitions. The life of the concepts is ignored, with no space for their working-through (in the Freudian sense) or for the dialectic in which they feed off of one another. Such dynamics are by no means absent from discursive texts, read with the requisite type of attention. But the life of the mind, like the life of the emotions, shows itself most directly in their poetic embodiment. The combat of the passions and the interests is a long but static moment, whereas the history of Anacreontic poetry is a chapter in the biography of European civilization.

≋ 9 ≋

Haydn's Whimsy:
Poetry, Sexuality, Repetition

IT is a truth universally acknowledged that the Enlightenment was not an age of successful lyric verse. That is the premise of chapter 8. But why should that matter to composers of songs? Schubert and Brahms had no difficulty making great music of paltry texts, nor did Fauré and Debussy. Why should Haydn, Mozart, and even Beethoven have left us so little song, and that so comparatively feeble; and why should C. P. E. Bach have left so much, and that so compulsively tedious? Traditions of composition and genre play their part, of course, as do conditions of performance. But consideration of the poems that such composers did and did not set can also illuminate aspects of their art.

The eighteenth-century ideal of poetry can hardly have encouraged composers. Consider Pope's famous couplet: "*True wit* is *Nature* to Advantage drest, / What oft was *Thought*, but ne'er so well *Exprest*" ("Essay on Criticism," 297–98). Composers don't depend on true wit in their verse. Music itself dresses the lines; it can adorn the most routine poems with beautiful expression, even as it tends to displace attention away from verbal refinement. But composers do depend upon situations. "What oft was thought" gives limited scope to variety of tone, mood, and affect. Composers don't always care so much about the words, but they do require invention—especially invention in the old sense of finding topics.

"Wit," in short, threatened to replace lyricism. In the opinion of many subsequent readers, indeed, it did. The greatest English poets of the Enlightenment hardly wrote settable texts at all, nor did their inferior Continental brethren. Pope's poems are almost all long; Swift's mostly are as well, and the occasional short ones are too harsh for domestic per-

formance. Satires, odes, and didactic verse are unpromising material for lieder. Of course, there were shorter, simpler poems. Dryden wrote many lovely songs for his plays. Closer to Haydn's day, even Oliver Goldsmith wrote one, though a composer might understandably hesitate to offer his noble patron's daughter a setting of "When Lovely Woman Stoops to Folly." The mid-century composer could have gone back to Shakespeare— if he knew him—or could pick carefully the more presentable trifles of Matthew Prior and his ilk. Or, finally, the composer could turn, as many did, to the Protestant hymnals of the German Lutherans and, in England, of Isaac Watts and the Methodists.[1]

Erotic and devotional verse in abundance. Those were the choices. They are not unusable. On the contrary, they form the basis for the great traditions of eighteenth-century opera, on the one hand, and cantata and oratorio on the other. Handel did not hesitate to set the highly erotic text of *Semele*; when Semele admires herself in the mirror ("Myself I shall adore"), instrumental echoes thrill to the vocal calisthenics of her jubilation. Yet except when he went back to Dryden or a much-simplified Milton, Handel's librettos are rarely better than low routine. Why did they work for longer forms but not for shorter ones? Are there any structural reasons why Haydn and Mozart could or would write so many operas but so few songs? For opera, the answer must lie partly or largely in virtuosity. Dressing the lines to advantage, expressing them well, means, for the opera singer, a kind of display rising far above the ordinariness of verse. With Gluck, the aria was converted into an air, a song with the simple naturalness that became the norm for the lied of the next century. But his songs, too, do not stand alone, any more than do the "Pious airs" of Handel's oratorios or the affect-laden solos of Bach. For cantata and oratorio—and also, to a very considerable degree, opera—rely on principles of contrast. It is perhaps no accident that the most familiar lieder of Schubert and Schumann—as well as of Wolf and Mahler, and also of Beethoven—so often come from cycles or collections of related poems typically performed together. Such songs often express a single mood and gain definition and enrichment from being set off against other tones and topics. The conventional anthology ditties of the eighteenth century offered, it seems, too little scope for the composers of the time.

Is there then anything to be said in defense of Haydn's songs? Three tasks follow from my preliminaries. First, and most generally, and despite the widely held impression, there really were a lot of short lyrics written in

the eighteenth century. They just didn't claim much status then and don't seem at all interesting to most readers today. Yet such poems were broadly if tepidly admired, and Haydn set characteristic examples of them. If they are as monotonous as is generally thought, they would be valueless. Indeed, whatever their limitations, Haydn's songs do cover a range of musical topics easily recognized from studies of musical rhetoric.[2] If the problem for the song composer is variety and character, the first task, then, is to discover kinds of variety and character in eighteenth-century lyrics. Second will be to take a new look at Haydn's music to see how it responds to the spirit of the poetry. Music and words mutually illuminate one another; the settings draw out distinctive elements of the various poems, and then conversely the words help to bring the simple strophic settings to life.

The third question will travel beyond the domain I have circumscribed so far. For, in fact, the decades of Haydn's songs were no longer those of the high Enlightenment; he was not a mid-century song composer but a late-century one. Already by the time of his earliest German songs, Klopstock and the young Goethe were the most famous poets of the time. Schubert set magnificently many poems that even a man of relatively little reading like Haydn must also have known. As in opera, so too in the lied, Haydn's taste was notably conventional, even old-fashioned. Hence, I want to ask what light, if any, might be cast on his sensibility in general by the choice of German texts or the manner of response to the English ones offered him by his hostess in London. Was Haydn simply left behind as a song composer—however talented he may have been at writing in the older manner—or might there be some continuity between his songs and his greater accomplishments? After examining the poems and the way the settings respond to them, consequently, I will turn to an instrumental movement written in the same spirit as the songs.

Haydn favored two genres for his songs, Anacreontic and sentimental.[3] Anacreontics are spirited songs of love and drinking, with a distinctive repertoire of topics including the faithless beloved, the stings of Cupid, the spring of love, and the ardor of the aged lover. Beyond these specific, constantly imitated topics, there is a prevailing Anacreontic tone, compounded of jocose simplicity, wistful ardor, and gentle, anecdotal moralizing. As with any poetic genre, the boundaries are fluid; Haydn's "Cupido" is true to type, whereas the F-minor "Trost unglücklicher Liebe" (Consolation for unhappy love) with its evocation of "die Qual, ein Mensch zu sein" (the torment of being a man) stretches the mode to its limits, in the direction of Haydn's

other favored genre, the sentimental lyric. Since women rarely wrote Anacreontics and in this period cultivated sentimental poems of the affections, Anne Hunter's poems are mostly in the same vein as "Trost unglücklicher Liebe." They are melancholic, inward-looking, wavering between wan hope and wan grief, limited in both prospects and emotional range.[4]

The gay Anacreontic and the somber sentimental lyric tend toward opposite moods and lend an impressive variety to the pacing and rhetorical coloration of Haydn's song collections. Still, both modes share conventional poses, generalized expression, and a remoteness from experiential immediacy; they shrink from strong situations and prefer implication to demonstration. Like the laughing neighbors in "Eine sehr gewöhnliche Geschichte" (A very common story), we know what Babett and Philint must have been doing together overnight in her room; no one needs or wants to say it. The characters and situations appear smaller than life: diminutives prevail and the emotional range is constricted. Anne Hunter's "Pleasing Pains," for instance, has a "throbbing bosom," but hardly a tormented one; the short-lived problem is but "Dear anxious days of pleasing pain," the solution "fairy joys and wishes gay," the goal "calm oblivion's peaceful source." Indeed, there is a strong tendency toward infantilization: "Cupido" is "Der kleine Bösewicht" (the little scoundrel) intruding on the feelings of a "kleines Mägdelein" and a "kleines Knäbelein" (a little girl-let and a little boy-let). This poem pretends access to grand emotions, but they are undermined by a colloquially truncated verb and short line, "Leidt [for: leidet] große Qual und Pein" (suffers great pain and torment). Passion is reduced to a dabbling in feelings. There is a general aura of indulgence and self-satisfaction.

Perhaps the most significant poem in this respect is "Trost unglücklicher Liebe" (Consolation for Unhappy Love) (Ex. 9.1).

Ihr mißvergnügten Stunden,	You discontented hours,
Wie groß ist eure Zahl!	How numerous you are!
So mehrt nur Schmerz und Wunden	So then increase my pain and wounds
Und tötet mich einmal!	And just kill me dead!
Ihr aber, sanfte Triebe,	But o, you gentle urges,
Kömmt, schlaft nur mit mir ein;	Come, fall asleep with me;
Denn jenes, was ich liebe,	For the object of my love
Wird doch nicht meine sein.	Never will be mine.

Du liebtest mit so warmem,	You loved me with so warm,
So vollem Herzen mich;	So full a heart;
Nun hält dich in den Armen	Now one happier than I
Ein Glücklichrer als ich,	Holds you in his arms,
Und meinen heißen Küssen,	And, Fate, thou hast torn her
O Schicksal, hast du sie	From my hot embraces
Wie dieser Welt entrissen!	As from this world!
Allein auf ewig nie!	But not for ever!
Dort, unter Himmels Lauben,	There, 'neath heavenly bowers,
Find' ich, Geliebte, dich:	My love, shall I find you:
O wonniglicher Glauben!	O blissful faith! You feed
Du nährst und stärkest mich,	And strengthen me withal,
Du hauchest meinem Herzen	You breathe into my heart
Neukräftigs Leben ein	Health and life anew,
Und milderst mir den Schmerzen,	And ease the pains, the torment,
Die Qual, ein Mensch zu sein.	Of the human lot.

In the first verse the lovesick speaker calls on death in preference to the long torment of hopeless love, then in the second verse he consoles himself with the love of a woman. Yet neither emotion seems profoundly sincere. The recovery is the more clearly imaginary. "O blissful faith," the lovelorn speaker exclaims, and the idiomatic present-tense verbs (necessarily translated with a future, "There, 'neath heavenly bowers, / My love, shall I find you") can be read equally as an experiential recent past, "I have found thee," or an optative proximate future, "may I find thee." He speaks twice of newfound strength, but ultimately only of ameliorated grief, at a far pole from, say, the ecstatic text and music of "O Sonne der Wonne! O Wonne der Sonne!" (O sun of bliss! O bliss of the sun!) in Brahms's "O liebliche Wangen," op. 47, no. 4 (a seventeenth-century text by Paul Flemming). Telling the hours, as the speaker does in Haydn's first verse, is a conventional gesture, and it suggests that the suicidal rhetoric is exaggerated self-pity. Indeed, the death wish commutes itself immediately into somnolence: "Come, fall asleep with me." The whole situation is fanciful. The passion is not at all concretized or validated, the unhappy love of the title becomes merely dissatisfied hours in the first line of the text, and the consolation correspondingly turns out to rest in a self-centered preoccupation with the speaker's own feelings.

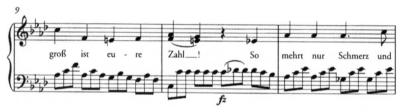

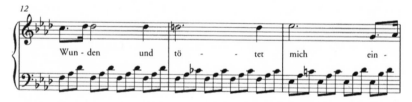

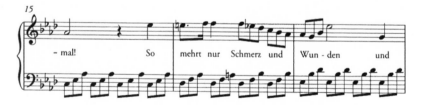

EXAMPLE 9.1 Joseph Haydn, "Trost unglücklicher Liebe," Hob. XXVIa: 9

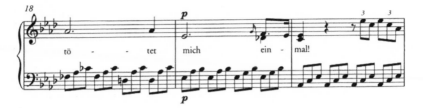

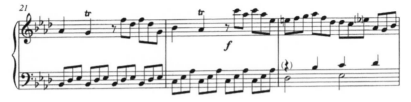

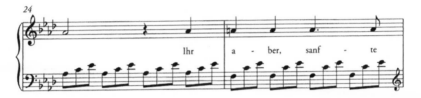

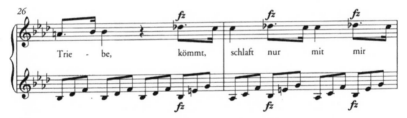

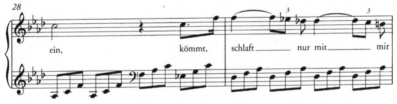

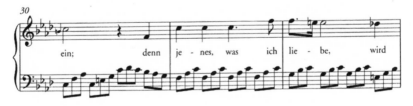

EXAMPLE 9.1 (cont.)

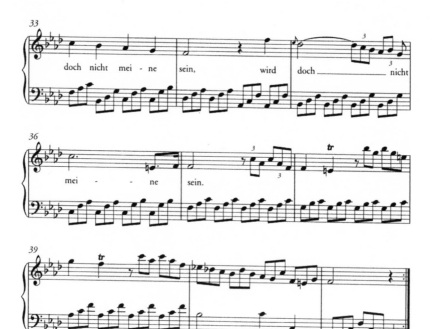

EXAMPLE 9.1 (cont.)

There are no emotional verities in such poems. They lack the kind of persuasive, individualized narrative or the highly profiled emotional situation that irradiates many romantic lieder, even those in strophic form. Schubert's anecdotal "Die Forelle," to choose a pertinent example, has a particularized setting, a cumulative force, and a psychological acuity missing from even an anecdotal Haydn song like "Eine sehr gewöhnliche Geschichte."[5] Romantic lyric is often described as based on experience rather than convention, and whatever the limitations of the term *Erlebnislyrik* may be—as discussed in chapter 4, "Negative Poetics"—it does mark a certain important departure from Enlightenment modes in the direction of specificity of occasion and circumstance.

But Enlightenment conventions can be redeemed by taking seriously their many tactics of avoidance. Leon Botstein points part of the way in an articulate defense of what he calls Haydn's "philosophical argument": "For the eighteenth-century connoisseur, hearing a Haydn symphony was a way not *into* subjectivity, but a way to *transcend* subjectivity."[6] Left unasked here is why one would feel impelled to transcend subjectivity. The

answer is that concealment rather than passionate utterance is a core value of Enlightened manners and of the lyric poems that correspond. Good breeding hides emotions. Thus, in a chapter of *A Treatise of Human Nature* entitled "Of Greatness of Mind," David Hume writes with wry conviction against sincerity: "No one who has any practice of the world, and can penetrate into the inward sentiments of men, will assert that the humility which good-breeding and decency require of us, goes beyond the outside, or that a thorough sincerity in this particular is esteemed a real part of our duty."[7] And the most widely read conduct book of Haydn's day, a pillar of bourgeois integrity written in a commandingly imperative style, continues to oppose expressing emotions: "Converse requires a certain equanimity and the self-denial to repress every outburst of passion and all obstinate resistance."[8] The wonderful line of William Shenstone quoted on page 205 says it all: "Under friendship lurks desire." There is a lurking, furtive quality intentionally covered by the playful or placid sentiments of both Anacreontic and sentimental lyric. Subjectivity is a consummation devoutly to be wished away. The poems offer few revelations but can fascinate through what they conceal. Nowhere more so, for sure, than at the end of *Così fan tutte*, where any "solution" of the erotic mystery reduces its power. They employ a rhetoric of suggestion, not (or not primarily) a rhetoric of declaration or of persuasion.

Notorious among British Romanticists is Kenneth Burke's Brooklyn enunciation of Keats's line "Beauty is truth, truth beauty," as "Body is turd, turd body."[9] Burke read the "Ode on a Grecian Urn" as if it were an Anacreontic. Often—and more plausibly—"Under friendship lurks desire" could be decoded as "Under emotion lurks sex." Such is spectacularly the case with "Trost unglücklicher Liebe." After countless dissatisfied hours, the speaker yearns for sudden release, "And just kill me dead." What kind of liberation does he dream of? "But O, you gentle urges, / Come, fall asleep with me." The only plausible itinerary leading from death to repose is the erotic satisfaction of desire. "The torment of the human lot" can only be the tension of the drives. The pains of love are corporealized—ever so discreetly, to be sure, but corporealized nonetheless. Death and bliss occur in the equivalent parts of their respective verses. In order to contrive a strophic setting adequate to the opposing effects at parallel moments in different strophes,[10] Haydn repeats the words so as to set the lines twice. First death strikes on a climactic diminished seventh, which may seem an eccentric underpinning for "nährst" in the repeat; in recompense, "stärkest

mich" lands first on an inversion of the tonic, but then—when the phrase is repeated in calm release—on a root-position tonic with the lowest note in the vocal part. Death is a moment of tension equivalent to nourishment; the poet says "einmal" but the singer sings it twice, and the sly significance is that this is not a moment of cutting off but an experience of fulfillment. (As an unstressed particle, "einmal" means "just," as I have translated it above; as a stressed adverb, it means "once.") Indeed, it is followed by a lyrical keyboard interlude.

The next lines of the text provide a similar duality: "kömmt, schlaft" is sung to the same sforzando diminished chord as "neukräftigs Leben." The music knows what the text conceals: this is the exciting death and sleep of sex. To the very end of the piece, the placid handling of the Sturm-und-Drang tonality of F minor is discretion itself—and needs to be.

Poetry like this indeed transcends subjectivity; it suppresses rather than expresses genuine emotion. Lacking sublimity, its sublimations are easily overlooked; that is why it has been so widely ignored or condemned by fanciers of Romantic depth. It is often childlike and equally often childish. In fact, the term "namby-pamby" (implying sentimental in a childishly trifling way) was coined from the first name of a notable early eighteenth-century Anacreontic poet, Ambrose Philips. But, as Freud taught the world, children's drives are no weaker than those of adults, just more naive in expression. We see the symptoms and hence are readily led to ignore the causes. That is what gives them their harmless aura and their transiently seductive appeal.

Little happens in these poems. Even where there is an anecdote, there are numerous strategies to defuse it. It is, for instance, "A Very Common Story." The time is compressed: it begins recently ("jüngst") and ends early ("früh"). The crucial moment is "swift," the passing night emptied out to a short line or two of waiting that is, indeed, soon rewarded and without surprise: "Er kam auch" (and he came). Present tense highlights the moment of entry through the locked door; the lead-up and the moralizing conclusion retreat into the narrative past. Elsewhere time is more evanescent yet. The "kleine Phyllis" (little Phyllis) of "Das strickende Mädchen" (German translation of an English poem by Sir Charles Sedley, "The Knotting Song") responds to years of pursuit by continuing her knitting. Whether she sits (first two verses) or stands (last verse), she is a miniature Penelope figure, without either threat or goal. No outcome is in sight, and the music to the refrain accommodates with rhythmic befuddlement. Yet whereas Penelo-

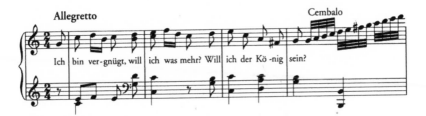
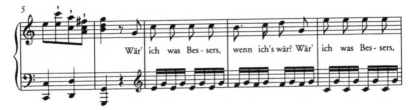
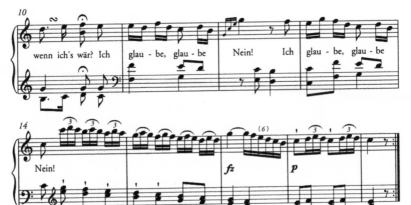

EXAMPLE 9.2 Joseph Haydn, "Zufriedenheit," Hob. XXVIa: 20

pe's embroidery suggests decorative reverie, Phyllis's knitting suggests the
erotic trap into which the speaker falls. Repetition distances satisfaction; it
idealizes and smirks all at once.

In problematizing mature feelings, the simple gestures of these poems
conduce to imaginary surrogates. What, after all, can compensate you for
unhappy love? Only fictive satisfactions. If your beloved won't come to you
and you can find her only in "blissful faith"; if the belief puts your drives to
sleep, kills you while instilling new life, and relieves your torment by sleep-
ing with you, what can be happening? What, indeed . . . ! Not all poems in
the Anacreontic and sentimental lines are as self-evidently masturbatory

as this one. But not a few are. And more broadly, the fretting that rubs emotions to a comforting warmth, or the jostling of suspicious parallels that strike sparks, the tender tone that totters on the brink of tinder, these all suggest how combustible are the seemingly desiccated feelings of sensibility. The fun or the delight of the poems and the songs come from the surprises at what constantly flickers through their scarcely ruffled surfaces.

The delightful "Zufriedenheit" to a text by the then-famous Johann Wilhelm Ludwig Gleim (Ex. 9.2) is a light-hearted renunciation of ambition, in six four-line stanzas in ballad meter, alternating tetrameter and trimeter. I would rather be an independent working man, says the speaker, than a slave to power and responsibility such as the king is.

Zufriedenheit	*Contentment*
Ich bin vergnügt, will ich was mehr?	I am content, why wish for more?
Will ich der König sein?	Why wish to be the king?
Wär' ich was Bessers, wenn ich's wär'	Would I be better if I were?
Ich glaube glaube Nein!	I think, I think not so!
Der König runzelt seine Stirn	The king in his chamber
Im Kabinett und schmält,	Furrows his brow and scolds
Wenn's seinen Räten an Gehirn	When his ministers lack
In ihren Köpfen fehlt.	Brains in their heads.
Und ist's denn so ein großes Glück,	And is it such great fortune then
Wenn er vom Pferde sieht	When from his horse he sees
Mit seinem adlerscharfen Blick	With his piercing eagle eye
Wo's fehlt ins dritte Glied?	What's missing through the ranks?
Was alle Bösen Böses tun	All the evil bad men do
Im ganzen Lande, liegt	Throughout the kingdom lies
Auf seiner Schulter; kann er ruhn?	Upon his shoulders; can he rest?
Macht Strafen ihn vergnügt?	Does he punish with delight?
Und nach der Arbeit Ruh, ist doch	And yet the best reward for work
Der Arbeit bester Lohn.	Is resting after work.
Ich mag es nicht, das Sklavenjoch,	I do not want a slave's yoke
Geknüpft an eine Kron!	Not even with a crown.

Als König hat er nichts als Schein,	As king he has but empty show;
Und hat er was als Held?	As hero has he more?
Ich wollte ja nicht König sein	I would not want to be the king
Um alles auf der Welt.	For anything in the world.

The song is a simple C-major lyric. The first two lines of each stanza occupy four measures, landing on the dominant; line 3 is repeated so as to occupy four measures that end with a hold on the second inversion of the dominant seventh; the shorter line 4 is likewise repeated, returning to the tonic in just under four measures, and there is a five-measure coda. The overall sense is of a question or a premise leading to simple reflection that gives a ready answer or conclusion, confirmed by the coda. There is little tension, dramatic or harmonic, yet the musical shape enriches the text by adding elements of deliberation and decision.

My description, however, has omitted the song's most distinctive characteristic, a rocket that ascends in measure four, following the second line of each stanza and extending the dominant cadence into two additional bars of forte excitement. The rocket follows and underscores the question or premise of most stanzas, introducing an exclamation point that is hardly suggested by either the poem or the title. Haydn shows great, if instinctive, insight into the poem here—as often in these songs—for he discovers a curve of feeling buried under the placid text. The meaning of the rocket is always evident and varies with the stanza. In the first stanza, it expresses excitement following the temptation to a royal identity, "Why wish to be the king?" In stanza two, it is the king's high-spirited rebuke, "The king in his chamber / Furrows his brow and scolds"; in stanza three, the quickness of his observation; in stanza four, perhaps a restlessness of concern correcting the verb "lies" and preparing the reflection, "can he rest?" Then, in the fifth stanza, the rocket is the reward for virtuous work, "the best reward for work." And the last stanza returns to imagined heroism, "As king he has but empty show; / As hero has he more?" Thus does a uniform gesture highlight variations among the stanzas. The speaker is less at ease than he pretends.

Three of the six stanzas feature explicit denials in their second half, one a scornful denigration, "when his ministers lack brains in their heads," and the other two, leading questions. Calm is not so much experienced as willed, and it comes in the mode of negation. The song's humor derives

from the insistent contrast between excitement and rational pleasure. The asymmetries thus become expressive; it takes an overbalance of deliberate reassurance to counteract the rocketing of enthusiasm. The gestural repetition of the rocket is as important to the effect as the variations in its meaning. However diverse the affirmations, a single emotionalism supports them. Thus the song turns an apparently simple piece of didactic verse into a dialogue of life and order, keyboard and voice, music and text, with neither side of the equation suggesting perfect, conscious ease. Haydn's handling of the strophic form discovers passion where the poet has seemingly put only piety.

There is another element, to be sure. As a performance the song provides an additional role for the listener. In the poetic text the "I" is participatory. As in a hymn, the reader is supposed to identify with the speaker who subordinates himself to the authority of the king and of the king's covert surrogate, the didactic poet, whose authority dictates the stance. But listeners to the song, even in a domestic setting, observe a singer performing submission. The keyboard postludes make the denials less definitive and consequently less self-evident. It becomes important that the song begins and concludes with questioning stanzas. The first question is answered hesitantly, "Ich glaube, glaube nein, ich glaube, glaube nein"; the last question is answered in a subjunctive reinforced by hyperbole, "Ich wollte ja nicht König sein, Ich wollte ja nicht König sein, um alles auf der Welt, um alles auf der Welt." Under performance conditions, consequently, the song yields an unstable balance of roles: the poet as pedagogue, the singer as uneasily deferential subordinate, the listener as happy judge. And all three roles are supervised by the authority represented conceptually by the king—whose position is reinforced by the insistent stanzaic returns with their reassuring negations—and ethically by the composer who has produced the order of the song within the harmonic and ideological system of the music's C-major simplicity.

Edward T. Cone's book *The Composer's Voice* is perhaps the most familiar source of the very fertile suggestion that a song's accompaniment may represent the protagonist's subconscious.[11] However, his rejection of the term "unconscious" betrays a rationalizing dependence on a never fully articulated norm of presence. *The Composer's Voice* is set in motion by the question, "If music is a language, then who is speaking?" (1). Music becomes an expression of what Cone calls virtual personae, and its immediacy sets it off from all other forms of expression. "We do not occupy the actual space

of a statue. We do not live inside the minds of characters. But music creates an environment that all share, for it surrounds and permeates all equally; it unifies characters, agents, and auditors in a single world of sound. That is why music, unlike poetry, can speak *to* us only as it speaks *through* us" (155). But "speaking" is altogether the wrong verb. Slighted is the recognition that music, like poetry, is written before it is voiced, representation before it is presentation. Poetry subsists in a reflective distancing from experience that enables it to clarify or even systematize the various—and historically varying—dimensions of the psyche. Unity of effect ("permeates all equally") is inseparable from multiplicity of significance. The layering is intricate and not readily fixable in a predetermined list of characters or roles (poet, singer, accompanist, composer); nor is the "union of work with self . . . clearly analogous to the experience reported by the mystic of his relations with the One" (157). Implied here and explicit in a subsequent modification is the claim that music enacts a dialectical transcendence of individualism: "my three original figures have collapsed into one: a unitary vocal-instrumental protagonist that is coextensive with the persona of the actual composer of the song."[12] But dialectical sublimation is not separable from the preservation of the constitutive elements. That is why I find more satisfying, as well as more supple, the multiple gestures of dialectical negation or elevation proposed throughout Lawrence Kramer's *Music and Poetry*. Kramer offers us, among others, "transmemberment," "overvocalizing," "naming and unnaming," and "chronophany"—all versions of the "liminality" that shimmers in textual, musical, and sung representations.[13]

Haydn's songs suffer from any presumption of the primacy of music. These songs cannot be convincingly subsumed into the composer's voice. Rather, the music should be thought of as embodying the poetry—giving it form and substance. To the extent that embodiment can be taken as a designation for the action of the music, critics such as Kramer and Susan McClary have set a persuasive agenda for contemporary accounts of musical communication. At the same time, too exclusive a concentration on the sexual or the political body can wildly distort perception. Talk of "the raw physicality of making music, above all in an urgent mutual rhythm that punctuates the score with accentual thrusts, the full weight of the players' bodies repeatedly borne down on the bodies of their instruments" may be legitimate in a given case but not if it sets up normative expectations.[14] However, as musicologists—or outsiders like myself—confront the issues in a range of examples, characterizations of the interaction of music

and text can grow both more supple and more precise. Bodies are sexual machines and economic engines, to be sure, but they are exclusively the former only for brief moments of the day or night and the latter only in larger or smaller segments of the population, and even there not for the entire week. In its transfiguring dimensions music can represent—and thus bring forward to sensuous awareness—instincts toward imaginative liberation just as well as those toward passionate dominion.[15] One recent attempt at a historically nuanced account that, at the appropriate moment, comes closer to Haydn's ethos, is Gary Tomlinson's introduction to Cartesianism in eighteenth-century opera: "the early modern envoicing of the supersensible realm is equivocal, at once indicating its presence for the subject and its transcendence of the subject."[16] Translate the baroque supersensible into Enlightenment psychology and you approach the mode of Haydn's songs. The characters are conventional types that remain alien to a sensibility schooled on Romantic individualism. But complex forces propel them even so. In the greatest of the (neglected) lyric poetry of the age, the lurking forces are actively represented within the verse; in countless more ordinary poems, they remain implicit and await embodiment in music of genius. Even with less fully realized poems, though, music can assist the words in embodying their potential and expressing their full meaning.

The key to the conventional poses and simple strophic forms of the songs lies in the handling of repetition. One might feel tempted to associate strophic and motivic repetition with reassurance and balance, or indeed even with Schönberg's "mere padding."[17] But clearly that is not how repetition works in successful examples of the Anacreontic and sentimental styles. Repetition is dynamic, not static or entropic. Duplication differentiates. Hence the perfect appropriateness in period performance of variations in the rocket figure and improvisations at the fermata. Kierkegaard pointed the way to a deeper understanding of the dynamics of repetition. As he wrote in the first paragraph of his 1843 book *Repetition*, "Modern philosophy teach[es] that the whole of life is a repetition. . . . Repetition and recollection are the same movement, only in opposite directions; for what is recollected has been, is repeated backwards, whereas repetition properly so called is recollected forwards. Therefore repetition, if it is possible, makes a man happy, whereas recollection makes him unhappy."[18] Another work of the same year shows that Kierkegaard's model for repetition is indeed the music of Haydn's era; its instantiation is Leporello's authentically Anacreontic catalogue aria in *Don Giovanni*, of which Kierkegaard writes, "sensu-

ous love . . . is essentially faithless . . . it becomes in fact only a constant repetition."[19] Repetition rubs; it can become fretful or even, when it rockets, create sparks. Sameness paves a smooth surface and hints at depths beneath. Whether in the form of suppressed ambition as in "Zufriedenheit" or of repressed coition as in "Trost unglücklicher Liebe," repetition is the cover for an erotics altogether different in character from the excited orgasmic discharges that some attribute to musical organicism. The distinguishing difference lies in the childlike naiveté of the eighteenth-century forms. Nineteenth-century narrative is characteristically a coming-of-age story, correcting errors of the imagination, whereas eighteenth-century forms often reinforce the order of nature. They evoke a primitive sensuality. But it is a genuine sensuality nonetheless. The enamel is precious, and fragile. It should not be mistaken for coldness or chintz, nor, conversely, assimilated to the wholly different sensibility of adult emotion confronted by the great works of the nineteenth century.

The songs are one locus for the nonclassical (or pre-classical) Haydn. The piano trios are another. Charles Rosen has written eloquently of the regressive character of Haydn's piano trios.[20] It would be a mistake to regard them as different from other works for merely technical or merely sociological reasons.[21] The regression is psychological as well as formal, and—as Rosen well says—capable of a temporal dynamic that reaches back "to the day before yesterday" in order to stretch forward "to find something newer and more progressive" (*The Classical Style*, 360). The first movement of the C-Major trio, no. 21, from around 1795, on which I will focus, features shortcuts that will leave a listener who expects dramatic development feeling shortchanged (Ex. 9.3). The movement is essentially "monothematic," with audibly related arpeggio figures defining the brief pastorale introduction, the suavely athletic first subject, and two variants in the second group. The segments are differentiated not by gender (masculine first subject vs. melting or lyrical second subject) but sociologically.[22] The pastoral is performed in unison by the strings and both hands of the piano, in a world of simple if ungrounded (unharmonized) togetherness. The first subject and the first dominant variant (m. 29) are hierarchical, with the violin and piano right hand in unison, accompanied by left hand and cello. But a later variant (m. 39) in the second group evokes a community performance, with its rustic accompaniment to a bumptiously virtuosic solo display in the piano. However, while in this description the modes sound rigorously segregated, a

EXAMPLE 9.3 Joseph Haydn, Piano Trio in C Major, Hob. XV: 21,
first movement, mm. 1-58

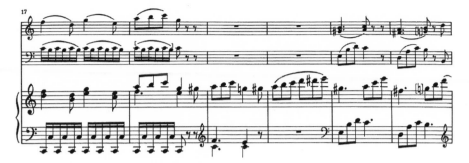

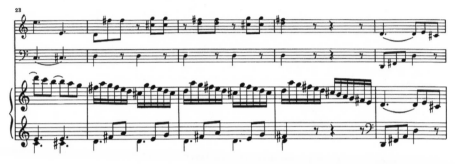

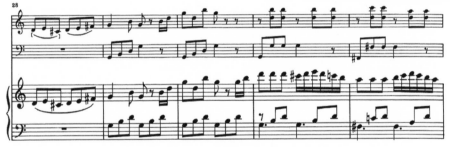

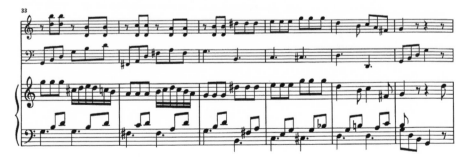

EXAMPLE 9.3 (cont.)

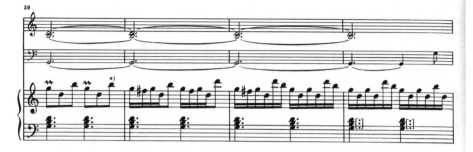

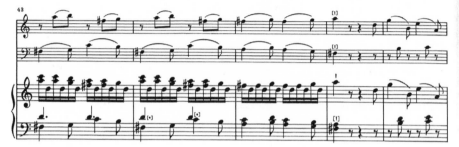

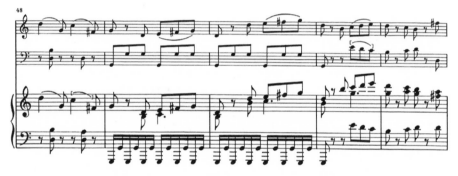

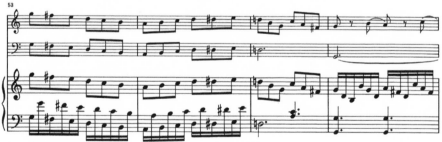

EXAMPLE 9.3 (cont.)

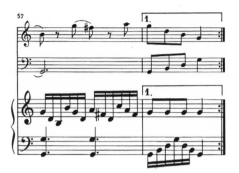

EXAMPLE 9.3 (cont.)

long bridge between the first and second groups breaks down the barriers. The first subject proper (mm. 7–10) is a completely typical antecedent-consequent period. The ensuing complementary four-bar phrase (mm. 11–14) grows more turbulent, with the left hand and the cello growing apart (two and a half bars with tremolo sixteenths in the piano, followed by a bar and a half with a sixteenth-note trill in the cello, introducing a B-C clash). The growing discord is followed by ten measures of transition through dominant and secondary dominant harmonies, arriving at two measures that too briefly recapitulate the allegro tune in the dominant (mm. 29–46), followed by a four-bar jig tune and five more chromatic bars landing back in the dominant, with the musette version of the original tune (mm. 39–46). The repeated dominant cadences thus never travel far from the movement's pastoral starting point. The exposition is as far as could be imagined from a dramatic narrative; rather, it is a run of false starts, structural jokes, and comminglings of what formally should be separate spheres. The Anacreontic tone functions as a light-hearted ideology critique, with the music-master—who has not forgotten his history of honorable servitude—showing how he can mix equally well with all comers.

However tactfully humorous the trio's statement, it does not lack fervor. In particular the musette theme proceeds as a rapidly animating set of repetitions—first a whole bar repeated with speeded-up notes, then a half bar repeated, then a half bar varied, then a more animated bar repeated, then half bars, and finally a crash followed by a pause to round off the eight-bar phrase. The crash ought to be on V^7 of V, but only F-sharp and A are played, followed by a grand pause, defusing the tension at the moment where the

excitement climaxes. The exposition concludes with variants on the long transition between the first and second groups—with the sinking figure in measures 47–48 troping that in measures 15 and 17, the scale figure in measures 49–50 repeating that in measures 16 and 18, with its bass repeating that of measures 14–16—followed by virtuoso octaves and arpeggios. In other words, it juggles the initial motifs ultimately derived from the introduction, in a succession of quick flashes and letdowns.

The development section of a sonata-allegro movement is conventionally the setting for "thematic work"; themes and motifs are broken apart, combined, and elaborated to display their "musical logic," that is, their combinatorial and emotive possibilities. But work is hardly compatible with Enlightenment pastoral. The trio movement thus continues with diversions that could not be accounted "process." The extended development section begins with three measures of harmonious dialogue of right hand and violin (mm. 59–61); after that, it is carried entirely by the right hand, sometimes joined by the violin, but more often accompanied by it. Phrases taken or altered from the main subjects are again strung together. The harmonies wander toward the expected relative minor (mm. 82–83),[23] and finally return via the rising chromatic scale in measure 91 to the tonic key. But the comically delayed tonic dissipates almost immediately; its consequent phrase is displaced by a long, increasingly cadenza-like secondary development in C minor—initially pensive but (given the vivace assai tempo) then increasingly precipitous—that finally returns to the recapitulation (mm. 96–117). The movement thus acquires the flavor of a rondo that never quite gets away from its starting point to constitute a dialectic and never sticks with it quite long or firmly enough for a lyric meditation.

Repetition here is never either doodling or practicing, never reverie or drama, but insistent or fretful; its driving energy both underpins and undermines the social good feelings suggested by the various dance topics of the exposition. As in the songs and in so many Anacreontic poems, moods flicker in and out to form the substratum of a decorous surface. Haydn scholarship sometimes refers to the tone by the German term *Laune* (properly translated as "whimsy").[24] The intellectual contexts are useful but should not be considered definitive. Rather, the music should define how the term is inflected or understood by Haydn (or, through Haydn, by us). In this trio the humor is something less than ironic formal self-consciousness, except perhaps at the instant when the first subject is immediately repeated in the minor mode (mm. 96–97), and something more moody

than Enlightened tolerance—rather more like the fretful rubbing of a subdued, not very troublesome yet irrepressible psycho-social instability. After six measures of slow introduction, fifty-two of exposition, and fifty-nine of "development," the thirty-three measures of recapitulation sound decidedly hasty. Enough of the first subject was already repeated earlier, so here Haydn allows only two measures to demarcate the structure (mm. 118–19), then jumps immediately to the jig, which had not previously been played in the tonic. The peasant dance is slightly extended in comparison to the exposition, and then a tonic-dominant coda over a tonic pedal (mm. 148–51) reiterates and intensifies a similar episode climaxing the exposition (mm. 56–57). The effect is not one of rounded or "organic" closure but rather of emergence of excited energies lurking from the start. Indeed, the conventional half cadence peacefully closing the introduction already concealed a latent dissonance not fully sublimated when the vivace assai starts up immediately in the tonic. As practically always in the late trios, the cello line merely duplicates the keyboard bass, yet in countless small ways it is nuanced to provide thrust for the keyboard line, often bouncing where the keyboard is legato or pausing with the violin where the keyboard continues on.[25] It assists in blending the violin with the keyboard; or, alternatively, it serves to distinguish the string mood from the keyboard to which the violin might otherwise be assimilated. The whimsy of the style is that these two descriptions cannot be disentangled from one another: accommodation or integration in the coalescence of cello and left hand retains a whiff of jaunty subversiveness. In all these ways, Haydn utilizes repetition so as to replace hints of conflict by fervent libido, as all the tunes coalesce in the coda into the purity of rapid arpeggios.

Music like this denies or cancels nothing. It is not interruptive, it mutes oppositions, it steers clear of the kind of ethical impulse—the interplay of demand and fulfillment—that makes the "classical" Beethoven and even Mozart such dramatic composers. As the negatives in the text of "Zufriedenheit" function in Freudian ways to vent desire, so the contrasts in pace and texture in this trio movement allow multiple crossings of affective and sociological identification: the pastoral adagio, the elegant first subject, and the folk-tone second subject are all one at heart. Pastoral here does not suggest unreality but rather a naturalness that the vivace then discovers in its full liveliness. Only the most delicate of maneuvers gives the movement a veneer of conclusiveness: in the third-to-last measure the arpeggio is displaced by a half bar, so that it comes to rest on the downbeat rather than

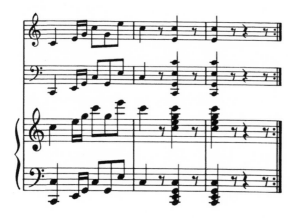

EXAMPLE 9.4 Joseph Haydn, Piano Trio in C Major, Hob. XV: 21,
first movement, mm. 158-160

in the middle of the measure, as happens everywhere else (Ex. 9.4).[26] But
the movement hardly feels closed down—and certainly not if the second
repeat is taken. The signal character of the movement is happy indulgence,
making it compatible with the melancholy indulgence that characterizes the
sentimental tone. This is a set of procedures and a musical style quite dif-
ferent from the classical norm, and brilliantly explored throughout Haydn's
career. It is not a simpler or more primitive style than classical organicism,
but rather a sophisticated performance in touch with different portions of
the individual and social psyche from those that classical style explores. The
pleasures of repetition, indeed, never die out, except for those who reject the
Blue Danube Waltz for not being the *Variations on a Theme of Haydn.*

Charles Rosen and James Webster have renewed our sense of Haydn's
link to the style of Beethoven. Many of his compositions feature motivic
development and an organic interdependence of small and large-scale
effects that foreshadow later norms. Still, there are reasons why it has taken
relatively recent analysis to foreground these structural complexities in
Haydn's works. For he also cultivated other delights that can be lost on
too rigorously "classical" (or Beethoven-centric) an ear. I would not contest
Scott Burnham's judgment that "the precedence of some of the material
features of Beethoven's heroic style in the works of Haydn permits us to
give a more defined shape to what is truly unprecedented in Beethoven."[27]

I would not even contest the first part of the consequence that is drawn: "Haydn's art feels lighter at every turn" (*Beethoven Hero*, 64). But to move from there to "the reigning perception is that there is less struggle and therefore less redeeming (in the fullest sense of the word) value" (64) is to equate value with guilt and redemption and "Beethoven's music" with "the voice of Music itself" (110). Kierkegaard was right to protest against the single-minded valorization of the ethical consciousness. Recent analysts have singled out the weight present even in Haydn, but his lightness represents a different cultural moment, with its own distinctive insights and pleasures. If we deny or depreciate them, we sacrifice both a part of our culture and a part of ourselves.

EXCURSUS ON *LAUNE*

Laune (derived from the Latin *luna*) refers to fitful changes of mood; it is neither irony nor wit, each of which suggests conscious play. When stabilized as "gute [or, schlechte] Laune," it can be translated "good [bad] humor," but not in its independent usage. "Humor" refers to a constant disposition. One's humor may be, of course, whimsical (or, in German, *launisch*), but if the two terms were equivalent, "whimsical humor" would be a pleonasm rather than a specification.

In her dissertation, "Fantasy and Fantasia: A Theory of the Musical Picturesque" (Cornell, 1995), Annette Richards uses the word "whimsical" in heading and text on page 213 for one of C. P. E. Bach's fantasias. The word disappears from the parallel section of her ensuing book, *The Free Fantasia and the Musical Picturesque*.[28] The book's discussion of *Laune* (131–36) rightly associates it with caprice, but then regularly translates it too diffusely with "humor." As one contemporary wrote, *Laune* is "not quite . . . an exact equivalent" of the English word "humor."[29] Another related term is *Seitensprünge*, translated in *The Free Fantasia* as "sideways leaps" and "digressions" (122–24). The latter translation is again too general; a *Seitensprung* is surely a capriole (OED: "a leap or caper, as in dancing"; also "a high leap made by a horse, without advancing"), and thus peculiar to the caprice, deriving from *capra*, "goat."

In Romantic usage, the German "humor" soon came to be applied to a more rarified form of liberated imagination, not necessarily comic at all. In "Beethoven, Shakespeare, and the 'Appassionata,'" Thomas Sipe draws on Jean Paul Friedrich Richter's account of "Humor" in a reading of

Beethoven's sonata, carefully distinguishing this kind of unfunny humor from *Laune* on page 75.[30]

Meanwhile, "whim" and its derivatives occur ten times in *Tristram Shandy*. Two modern translations that I consulted use derivatives of *Laune* for two of these, and the later of two early translations (1776 and 1810) uses "launig" once; other roots used are *Grille* (the commonest), *sonderbar/-lich*, *wunderlich*, etc.—nothing suggesting irony or wit. Two eighteenth-century bilingual dictionaries offered a similar range of terms, and the one two-way dictionary offered nothing resembling *Laune* for either "wit" or "humour" (except in the expression "good humour" = "gute Laune"). A particularly full contemporary account is C. F. Michaelis, "Ueber das Humoristische oder Launige in der musicalischen Komposition."[31] Bonds quotes this essay appropriately in "Haydn, Laurence Sterne, and the Origins of Musical Irony" (77–80), but then reverts to "irony" for his English equivalent, which associates Haydn with contexts that seem to me less appropriate.

≈ 10 ≈

Non Giovanni

MOZART WITH HEGEL

Form is immanently and intrinsically an ideology in its own right. . . . The
history of music provides the most dramatic examples of this process.
—Fredric Jameson, *The Political Unconscious*

T HIS chapter arises from thinking about *Don Giovanni* at a time when
I was reading and teaching Hegel's *Phenomenology of Spirit*. Hegel was
an avid opera-goer, and he had seen *Don Giovanni*, but the *Phenomenology*
does not discuss music as it does a number of important literary works.
So this is not in any sense intended as Hegel's "reading" of *Don Giovanni*.
Indeed, Hegel comes explicitly into the picture only toward the end, and
even there only with some necessary differentiation. Still, I found myself
reading *Don Giovanni* in what I hope is the spirit of Hegelian dialectic, with
its self-generating, self-transforming operators. Dialectical process, not ide-
ological substance, is the link here between Mozart and Hegel. While I will
discuss the libretto at greater length than the music, it will become evident
that the musical realization is crucial to the opera's dialectic, unfolding and
embodying the dynamic of the words. Indeed, at a number of points the
composed score emphasizes key words or even departs significantly from
the written libretto. That is why I will speak of Mozart's opera, even though
at its base lies Da Ponte's already fascinating text.

I will be discussing four or five talismanic words in Mozart's opera.
Already quite prominent in the text, these words are inescapable in the
musical realization. The word alluded to in my title will be the third. First
will come "battere," then "sentire." Only after these will I be ready to tackle

the indispensable dialectical term "no" and its correlative "sì." And then, at the end of my analysis, when the poles of the dialectic have collapsed into utter confusion, comes the resolving term that takes confusion as an outcome, "libertà." As the moving force in the opera, Giovanni appears to be its spirit of negation. But negation undermines itself in Giovanni's exposure and condemnation. I take him to be a failed negator. The hero of my reading is, rather, Giovanni's dark double Leporello, with whom the opera opens and with whom, at the far end, I shall close.

I take an indirect route into the topic of negation in *Don Giovanni* because the opera itself concerns forms of indirection. One can hardly speak of a route in *Don Giovanni*. An arch-picaresque character, the Don picks up adventures almost at random along the way, from all classes as he finds them, ten a day as he boasts at the end of his champagne aria, "diverse istorielle" (various little stories), as he promises to tell in the cemetery scene.[1] There's a gathering of the clans at the end, partly at his invitation, but in the darkness who knows what road leads there? That obscurity, the opacity of Don Giovanni, links him with many other moments in Mozart's operas, from the blackness of the moor in *The Abduction from the Seraglio*, through the garden maze at the climax of *The Marriage of Figaro*, and on to the dark queen and the trial by blindness in *The Magic Flute*. But none of these others is so confusingly plotted, so full of incident yet so empty of event as *Don Giovanni* is. It is understandable why Joseph Kerman would have condemned the opera for "accidental and unformed ambiguity," though my aim is to show how strikingly precise and dialectical the apparent ambiguities actually are.[2] I will work my way toward the opera's striking absences that prove, ultimately, to constitute a freedom whose content remains to be realized. It will take some patient sifting of text and music, full of details, but trying to keep the larger issues in sight as the view expands.

BATTERE

The most palpable of the opera's talismanic words is "battere." In the first instance, "battere" is an expression of violence. "Battiti meco" (fight with me), cries the Commendatore in the first scene to the unknown braggart. The word foretells danger and doom. The Commendatore immediately repeats "Battiti" (Ex. 10.1) and the musical figure he uses will reappear at the very end in his call for Giovanni to repent, "Pentiti" (in both cases a dotted quarter, then down an octave for eight and quarter, followed in

EXAMPLE 10.1 Wolfgang Amadeus Mozart, *Don Giovanni*, "Battiti"

EXAMPLE 10.2 *Don Giovanni*, "Pentiti"

the earlier scene and accompanied in the latter one by 32nd-note scales; Ex. 10.2). The soldier's world is marked by victory and defeat, defiance and repentance.

All the opera's beats are similarly conflicted. But they don't all start out looking that way. A contrasting kind of beat seems to surface later in Act 1 when Zerlina, the village maid, proves her Christian virtue by offering herself up as a victim ("Vien qui, . . . Ammazzami" [Come here, slay me], she says in recitative), submitting herself to a beating: "Batti, batti, o bel Masetto, / la tua povera Zerlina: / starò qui come agnellina / le tue botte ad aspettar" (Beat, beat, o fair Masetto, your poor Zerlina; I will stand here like a little lamb awaiting your slaps). Zerlina's rhythm is measured; her line a simple stepwise descent; her key a pastoral F major; her dance a stately gavotte; her accompaniment a placidly, even monotonously flowing obbligato, Mozart's only cello solo. Here, then, in defiance of the words, we may be supposed to hear the heartbeat of life. Indeed, the wishful gigue that forms the second half of the aria opens with the words, "pace, pace, o vita mia" (Peace, peace, o my life). Zerlina's pious submissiveness thus seems for a moment to tame the violence of the beat. Yet the course of love never did run as smooth as the suave but thin obbligato line. Behind the equanimity of the trial, after all, lies a masochistic challenge. Whenever one party wins, the other one suffers; such is the logic of the beat. And so, Zerlina closes her cavatina with a vision of triumphant delight. Echoing the rhythm and pitches of her earlier "batti, batti," she now sings "Ah, lo vedo, / Non hai core" (Ah, I see, you lack heart). Either he beats her or his heart gives out. Time, in fact, stops in the ecstatic gigue of the cabaletta: "In contento ed allegria / notte e dì vogliam passar" (In happiness and joy let us pass night and day), with extended melismas on "passar" and delirious, sixfold repetitions of "Sì, sì, sì, sì, sì, sì." Time passes and doesn't pass in the beat that wins and gives up. As innocent as she makes herself sound, Zerlina is engaged

in the battle of the sexes, and her man immediately confesses his defeat: "Siamo pure i deboli di testa" (We are weak in the head).

The complications concerning Zerlina don't end with her triumph, however. In the artificial light of the next scene, Giovanni ropes her into a contredanse, while Leporello drags her resistant suitor Masetto into a simultaneous German dance accompanied by a different band, in a famous moment of musical chaos. The ensuing mayhem gives Giovanni a head-ache: "È confusa la mia testa" (my head swims), as he cries out at the end of the act. His confused head verbally echoes Masetto's weak head, and the succeeding lines ending the first act foretell Giovanni's demise:

È confusa la mia testa,	My head is confused,
non so più quel ch'io mi faccia,	I no longer know what I am doing,
e un orribile tempesta	and a terrible storm,
minacciando, oh Dio, mi va.	oh God, is threatening me.
Ma non manca in me coraggio,	But my courage is not lacking,
non mi perdo o mi confondo.	I am not lost or confounded.
Se cadesse ancora il mondo,	If the world itself should fall,
nulla mai temer mi fa.	nothing will ever cause me to fear.

The sequence encourages taking Zerlina's encounter with Masetto not as a rapprochement but as one duel among many. (The libretto uses the verb "ammazzare" [to beat to death] for encounters between Don Giovanni and the Commendatore, Masetto and Zerlina, Giovanni and Leporello, Masetto and Leporello disguised as Giovanni, and Giovanni and Masetto.) Sense takes a beating, in defiance of Zerlina's dignified appeal to Masetto to test her fidelity.

Who, after all, can trust the heart and its beat? It is a deceiver. Elvira, in fact, tells hers to shut up, and it won't: "Ah taci, ingiusto core, / non palpitarmi in seno!" (Ah, keep silent, unjust heart, do not throb in my breast). She thus is a long way from the adolescent longings of Cherubino's "Ogni donna mi fa' palpitar" (Every woman makes me throb) in *The Marriage of Figaro*. Cherubino's whole being is brought into motion. But in *Don Giovanni* beating is never merely emotional in this way. It remains a physical sensation before all else. Giovanni kills the Commendatore by stilling his "seno palpitante" (throbbing breast), at which Leporello feels his own heart beat in terror: "Palpitar il cor mi sento" (I feel my heart throb).

In Act 2, Giovanni beats Masetto, who cries out: "Ahi ahi! la testa mia!

Ahi ahi! le spalle, e il petto" (Oh oh! my head! Oh oh! my shoulders, and my breast). Not even the breast and its heartbeat are internal. "Sentilo battere" (feel it beat), Zerlina sings to Masetto, and she here adopts a dotted rhythm and falling leap unmistakably reminiscent of the Commendatore's "Battiti" (Ex. 10.3). And, at the end, comes the thunderous pounding of the statue.

EXAMPLE 10.3 *Don Giovanni,* "Sentilo battere"

EXAMPLE 10.3 (cont.)

It knocks at the door, audibly and musically. But the knocking is preceded by Leporello's stunned, anticipatory mimesis. "Se vedeste che figura!— / Se sentiste come fa" (If you could see what a figure, if you could hear what it does), followed by meaningless syllables that are not in the libretto, "Ta ta ta ta," sung to driving, repeated half-note Cs. Noise takes over from articulate music, as Don Giovanni says he doesn't understand: "Non capisco niente affatto: / Tu sei matto in verità" (I really understand nothing / you are mad in truth). Chests beat, heads spin throughout the opera. But whose truth is the truth of madness? Whose music could give the sounds of noise? Is a bare C the heart of music or its destruction?

The talismanic "battere" refuses to decide on the role of the beat. *Don Giovanni* contains some of the most visceral music Mozart ever wrote—the pounding beat, the confusion of three orchestras playing at once in different meters, the screams at the statue's appearance, the haunting trombone accompaniment to the statue's pronouncement of doom, the raucous presto conclusion. Kierkegaard made famous the opera's appearance of spontaneity, but I cannot concur in terming it effervescent.[3] The presto champagne aria, for instance, proclaims mayhem: "Senza alcun ordine la danza sarà" (The dance will have no order). And the exquisite lyrical numbers are all fake: the seduction duet "Là, ci darem la mano," the seduction aria "Deh vieni alla finestra" sung to Elvira's maid by Giovanni masquerading as Leporello, even the tenor's "Il mio tesoro," with its punishingly showy melismas and its concluding mutation into a vengeance piece. From the grim opening chords of the Overture—the basses overhanging the upper voices as if refusing to relent—pure music here is anything but pure sentiment. Rhythm is set off against melody as body against spirit, musically constructing the pattern of opposition that runs through the libretto as well (Leporello vs. Giovanni, the boorish Masetto vs. the elegant Giovanni, the seducer Giovanni vs. the idealized lover Ottavio, and so forth). The oppositions shift and multiply: who can say whether the statue represents physical matter or transcendent judgment, whether the trombone music penetrates the ears or the soul? "Battere," rhythmically asymmetrical,[4] figures the division that makes music both possible and unable to come to rest.

Without pulse there is silence, with it there is noise.[5] A message may be written atop, but the code forever rears its ugly or fiery head, until the singers inevitably sink in frenzied exhaustion at the end. The last lines carry the moral of the music's beat: "E de' perfidi la morte / alla vita è sempre ugual" (The death of traitors is always equal to their life). So it is for the faithless, but in an opera where no one except the Commendatore keeps faith, the moral of the beat applies to all of us. Confusion is the order of the day. Death, the great antagonist, makes all lesser oppositions collapse into indistinction

Beat is the essence of music, but essence in the form of self-division and hence of self-consciousness. The Overture opens with a pounding resonance: forte with held wind chords, a timpani roll, and unison lower string (and bassoon) half notes pitted against syncopated half notes in the violins (Ex. 10.4). Equal-time divisions sound with equal emphasis, yet if parsed

into stressed and unstressed beats, they intimate the unequal contrasts to follow. Equal succession naturally generates inequalities as pulse becomes rhythm. Such is the foundation of the account of music in Friedrich Wilhelm Joseph Schelling's *Philosophie der Kunst*, lectures delivered in 1802/3 and 1804/5 and published in 1859. His discussion could find no better example than the opening of this Overture: "In general, rhythm is viewed as the transformation of an essentially meaningless succession into a meaningful one. Succession or sequence purely as such possesses the character of chance. The transformation of the accidental nature of a sequence into necessity equals rhythm, whereby the whole is no longer subjected to time but rather possesses time *within itself*" (4.79).[6] Differentiation is minimal at the start, as the I-V progression of the opening four bars resolves back to I, but then it proceeds to generate further discord: a pulsing, dotted-rhythm beat, menacingly hushed, with its renewed I-V progression (mm. 5 and 7) interrupted at each stage by diminished seventh chords (mm. 6 and 8). There are two elements in measures 5–8: the dotted strings beneath woodwind whole notes that descend by octaves. In combination, the elements will yield the dotted octave descent of "Battiti" and "Pentiti"—a synthesis driving the incipient dialectic toward its ultimate collapse. A further cadence lands back on the tonic, but this time in second inversion, and now with quarter-note syncopations in the first violins: a quivering beat, the half-step motion in the violin growing increasingly dissonant (violin F sits over horn A and lower string C-sharp at the start of measure 12; when repeated in measure 14, it jars against the added E-G in the bassoons).

The next return to the tonic (m. 15) leads into offbeat sforzandos. Eventually (m. 23) the dotted rhythm returns in the lower strings, with tremolo in the middle and scales on chromatically rising pitches in the violins—a trembling, surging mix of rhythms.[7] And even in the sociable babble of the Overture's allegro, pounding will dominate the development section (in particular, but not exclusively, mm. 85–90 and again mm. 129–33). Measure 23 offers melodic D-minor scales rising and falling. Measure 24 introduces a semitone dissonance, E-flat against the D in the brasses. The clash of E-flat against D is fundamental for the piece; it is repeated as the first color note in the allegro theme (m. 33, notated D-sharp), and it appears long range when the D of the Commendatore's "Battiti" is raised to the E-flat of "Pentiti."[8] (The extremely long-range, minor-second clash is not intuitively audible, of course. But at this point, mm. 537–38 of the Finale, the D to E-flat motion appears in all the second wind parts and the second

EXAMPLE 10.4 *Don Giovanni*, Overture, opening

Molto Allegro

EXAMPLE 10.4 (cont.)

violins, and production values should be able to bring out the affect.) Everything divides and subdivides to make musical motion possible. The outside ("Batti, batti") is the inside ("Sentilo battere"), the deceiver deceived, innocence wicked, authority both enfeebled and tyrannical (all the bassos). Smoothness is the slender flow of a solo cello or the tinkle of a mandolin; life inheres in conflict. One may start to infer a giddy resonance to the concluding moral. Betrayal is pure inertia; life is change, hence infidelity; change is beat; beat is death, restoring the fidelity of inertia.

SENTIRE

"Sentilo battere" also raises, of course, the question, how do we perceive the beat? Music *in itself*—anything beyond pure formless noise—is discord, or self-dividing, self-undoing concord. But what is music *for us*? "Sentire" is the second talismanic word, and it raises a host of additional issues, for the Italian verb is a very special one. It applies to all the senses except the rational sense of sight. Thus, it can refer to hearing: "Non mi voglio far sentir" (I don't want to be heard). To outward or inward touch: "Palpitar il cor mi sento" (I feel my heart throb). To smell: "mi pare sentir odor di femmina" (I seem to sense an odor of woman). And while it is not used in the libretto to mean "taste," the prominence of eating keeps this sense in view as well. And then, of course, the verb also applies frequently to emotional feelings. "Sentilo battere," after all, does not just mean "take my pulse rate." Zerlina is calling on Masetto to share in her feelings. Her aria begins by invoking sight, "Vedrai, carino" (You will see, dear). But while a visual emphasis might suggest that her remedy is a product of science or rational knowledge, in fact, it is not: "E lo speziale non lo sa far" (And the apothecary doesn't know how to make it). Rather, her remedy is natural, "È naturale." In saying that, Zerlina intimates that her beat belongs to a realm in which matter and feeling are inseparable from one another, and totally separate from consciousness.

The remedy is an infection. "Feel it beat, touch me here," the enchantress repeats over and over. A shared emotion is not a conscious feeling but its opposite, a seductive loss of self. "Sentire," in this sense, marks a generalized participation in the beat of nature, a beat or heartbeat that is so contaminated that it becomes life-denying. The movement from sight to sentiment is repeated in Leporello's terrified lines about the statue that I have already quoted: "Se vedeste che figura, / Se sentiste come fa" (If you

saw what a shape, if you heard what it does). One thinks back from Zerlina's seduction of Masetto in Act 2 to his bracing himself against her in Act 1. The vocabulary is the same. Zerlina opens the Act 1 dialogue with "Masetto, senti un po'" (Masetto, listen a moment). And he says, "Non mi toccar" (Don't touch me). And so, when she there calls on him to chastise her, in the melting aria, "Beat me, beat me, fair Masetto," it is a desperate attempt to bring their love to the dark life of the passions. "Lascierò cavarmi gli occhi" (I'll let you gouge out my eyes) is not just generalized masochism but a specific approach to passionate darkness.

Then, after seeing that Masetto lacks heart, Zerlina dreams of drowning her sorrows in passion. "Night and day let us pass," she sings, but, as for Leporello at the start of the opera, it is night that comes first and that clearly is what matters to these peasant figures of physical love and corporal seduction, a living death. No wonder that Masetto immediately calls her a witch ("strega"). And it is by this dark dream-logic of the piece that the dying fall of Zerlina's Act 2 aria, "Vedrai carino," is followed almost instantly by Elvira's unprepared reappearance, passionate in the dark, "Sola sola in buio loco / palpitar il cor io sento" (Alone, alone in a dark place / I feel my heart throb). Structural linguistics taught that sense is born in division, but in *Don Giovanni* the inevitable oppositions seem to beget only darkness, confusion, madness. Sentiment confounds sensation.

Don Giovanni dates from the end of the era when a Cartesian thinking actor was presumed to lord it over an opaque body. Don Giovanni himself remains Cartesian: ceaselessly active, if he is not a serial slayer of women, he certainly imagines himself a serial layer of them, and he prides himself on his superior calculation.

Chi a una sola è fedele	He who is faithful to one alone
verso l'altre è crudele;	is cruel to the others.
io, che in me sento	I, who within me feel
si esteso sentimento,	such extensive feeling,
vo' bene a tutte quante.	love them all.
Le donne poi che calcolar	Since women do not
non sanno,	know how to calculate,
il mio buon natural	they call my good
chiamano inganno.	nature deceit.

Yet, this Don Juan is notoriously unsuccessful. He is an outmoded aristocrat. For the true modern self, the "transcendental ego," as Kant termed it, was not a calculating intelligence but an obscure self-intuition that Kant, following Rousseau, called the "feeling of self." The transcendental ego is unknowable in itself and inferable only through its effects. It does not inwardly sense extended sentiment—whatever that self-canceling phrase might mean—but intuits an intensive internal being; musically speaking, it does not calculate or count a beat but experiences a pulse. In its modern senses as world-consciousness and self-consciousness, sentiment derives from this primal self hidden in the shadows. But the very same gesture that discovered a transcendental ego buried it in darkness. For what could be meant by an unknown knower? Indeed, Hegel criticized Kantian selfhood as a mere back-formation, a delusory notion coined as an empty ground of consciousness. On this account, it updated the ruses of Enlightenment without remedying them. "Good nature is deceit" was a commonplace of the later eighteenth century—the backbone of Lord Chesterfield's epistolary advice to his son, the ground of Enlightened politeness, and in Goethe's *Faust* the savvy of the demonic roué: "Im Deutschen lügt man, wenn man höflich ist" (line 6771; Politeness in German is a lie). From Rousseau's emotive sincerity to a hard epistemological and ethical authenticity lay a long road.[9] And where amid the dissolution of a dissolute world might authenticity crop up?

The aporias of selfhood are staged in the restless quests of Mozart's opera. Beat creates difference but destroys identity; sensation promotes awareness but sentiment smothers it. Such is the founding dialectic in the opera's primal words. Particularly revealing for a kind of hopeless idealization is the reversal of conscious sensation into obscure sentiment in "Vedrai carino." Like Giovanni, Zerlina's "È naturale" too invokes nature, and indeed her manipulations are no less seductive than his. When Zerlina first sings the imperative to feel her pulse, "Sentilo battere," it is measured in repeated eighth notes. The figure and rhythm are the same used at the start of the aria for the cognitive moment, "Vedrai carino." Yet a different accompaniment infects her disjunction between seeing and sensing: the opening phrase, sung on C, is supported by strings alone, with bare Cs in violas and bassi and parallel sixths in the violins, whereas "Sentilo battere" is sung on a G, accompanied by full orchestra and with a pulsing C serving as a dissonant bass to a dominant seventh chord. Consciousness here is tensed from the start. And then Zerlina's pace picks up: the initial eighth-note

rhythm (with a dotted eighth-sixteenth-eighth marking the unevenness of "battere") doubles in speed to sixteenth notes. "Sentilo" then becomes an upbeat to "battere." Hence, despite having come uneasily first, the sensation is now subordinated to the thing sensed, and even the word accent is displaced to the point of being lost altogether: the eighth-note pattern stresses the first syllable, in the normal Italian pattern, "Séntilo," whereas the sixteenth-note upbeats nervously displace—dis-stress—the word, making it sound like "Sentílo." And then, third, "Sentilo" becomes corrupted into the falling tritone of "battere" (the tritone was long associated with the devil and emphatically so at numerous points in *Don Giovanni*), its figure now seeming to follow "battere" rather than to precede it. Sensation is made equivalent to pulsation; verging on animal passion, Zerlina demands, "Toccami quà, quà, quà" (Touch me here), "Toccami quà quà, toccami quà quà." ("Fare qua qua" is Italian for "to quack." In repeating the locative, could Mozart have been consciously, as we now say, "signifying on" Da Ponte's libretto?) And the aria then subsides into repeated shards of the motifs that have constituted it previously.[10]

What then can be said about feeling in *Don Giovanni*? To call it hollow would not do justice to the intensity of emotions in the opera, yet fulfillment is belied by the opera's negativity throughout and especially by the frivolous sonorities of the epilogue. Nature is a seduction, and sensation is feeling in advance of its object, or it is consciousness without self-consciousness. The opening aria already intimates the paradoxes when Leporello declares himself to be the unsensed sentinel: "Ed io far la sentinella . . . Non mi voglio far sentir" (And I to act the sentinel . . . I don't want to be heard). But the witchery of sensation is perhaps best characterized with Don Giovanni's line, "I seem to sense an odor of woman," where sensation becomes an undemarcated fantasy of copulation. Calculation plays only the smallest part in it. One might well wonder, indeed, whether the calculation on which Giovanni prides himself really plays any role at all in the operations of this most distractable of villains. Visible knowledge itself becomes fantasmatic in the catalogue aria. "Look at this sizable book," Leporello says to Donna Elvira, and then he starts counting. But it's an upside-down aria, with its allegro march in the first half, where the counting occurs, followed by the Andante con moto minuet characterizing the passions that shift with the seasons, manically veering into patter at "la piccina la piccina la piccina la piccina la piccina la piccina la piccina la piccina la piccina" (who can book those repetitions?), and concluding with notably unspecified knowledge:

"Voi sapete quel che fa" (You know what he does) Leporello repeats seven times, solemnly but uninformatively. (It is pertinent that *The Marriage of Figaro* opens with seductive calculations: Figaro's measurement of a room that, to the pulsing of a bell, "Din din, don don," will become another venue of seduction.) The catalogue aria calls visible knowledge to account, and its yield for this most unsuccessful of Don Juans is dubious at best. Sensation and sentiment are all he has.[11]

On the one hand, the lack of content is the glory of sensation. Enlightenment made sensation precede experience; its founding doctrine is this: "There is nothing in the intellect that has not first been in the senses." The catalogue aria transforms knowledge into passion, as if it said that what the mind conceives the senses must first not just have noticed, but must have grabbed and made their possession. There is nothing value- or appetite-free, no innocent nature, no genuine simplicity. An accumulation of inert objects would not satisfy. Don Giovanni already possesses his fill of those; he consumes them seemingly without limit, as if they were ever-renewable resources. But they merely confine him in the prison of his dining chamber: they are not his if they are shared, as Leporello learns to his grief, and yet they fail to stir his senses if they already belong to him. The subject invests himself in his lacks, with a restlessness that is Don Giovanni's signature, celebrated in the frenzy of the champagne aria. Intention comes here invested with desire. The chase is the game. Only resistance "makes sense."

In fact, a self without limits has no core. A classic buffo number, the Bb-Major champagne aria goes nowhere.[12] Don Giovanni stands front and center barking orders, but the music ends with no less than 91 measures (well over half the piece) of relentless tonic-dominant alternations, varied only slightly by two interpolations, a single half-note G in measure 95 (itself merely a lengthening of passing Gs already heard many times), and a rising chromatic tetrachord in the bassoons in measures 117–20, perhaps echoing the rising chromatics accompanying "morte" in "Dalla sua pace," the immediately preceding aria in the Vienna version (and ultimately harking back to the ominously surging scales, rising by half steps, in mm. 23–29 of the Overture and to the ascending scales, arranged to trace out a chromatic descending fourth, that accompany the duel).

In Mozart's other operatic masterpieces, soliloquies like the Countess's "Porgi, amor," Ferrando's "Un' aura amorosa," or Tamino's "Dies Bildnis ist bezaubernd schön" give access to private feelings in an atmosphere of ecstatic

reverie. *Don Giovanni* originally had none such; its only soliloquy was Leporello's opening aria, which is not a reflection but a tryout for an interview with his master. To be sure, the 1788 Vienna version added Ottavio's "Dalla sua pace" and Elvira's scena and aria, "In quali eccessi" and "Mi tradì," but the first can best be described as a failed revenge aria,[13] and the others, with their self-dramatizing excess, are the reverse of the "dolce ristoro" so characteristic of the other works. (Donna Elvira's earlier vengeance aria, "Ah, chi mi dice mai," is another quasi-soliloquy, but not only is it equally turbulent, it is written as a trio, with Don Giovanni and Leporello in the shadows listening and commenting as she rants.) As there can be no knowledge of others in *Don Giovanni*, so there can be no knowledge of the self.

For in *Don Giovanni* sensation dissolves substance into energy. Think of how the division aria, "Metà di voi qua vadano, / e gli altri vadan la" (Half of you go here, and the others go there), produces frantic scurrying, "andate, fate presto, fate presto, fate presto, presto, presto, presto, presto" (go, hurry). Objects must be in motion, subject to pursuit, in order to fill up the sensorium; that is why they are constituted as objects of passion rather than as objects of knowledge. And subjects must prowl in order to latch onto the objects that must be continually fleeing, lest they be reduced to material fodder for the gullet; that is why the sensualist is also a sentinel. The Brownian motion of the plot, with its unpredictable comings and goings, is the reflex of the time and motion study that is the essence of this opera. Its heartbeats are, so to speak, no better than a constant flutter. (So Zerlina's last version of "sentilo battere" is a formless sixteenth-note trill, alternating D and C-sharp, returning beat to its origin in meaningless succession.)

That flutter is, however, the foundation of sense. As beat is the uneven gait so pervasive in the music and suggesting the unequal relations of power that give the electricity its charge, so the sensorium is the ongoing rush of time, before it comes to be divided into subject and object. Sense is mere sound and movement, without structure or opposition. Hence, the first moment following Don Giovanni's dispersal of the threatening crowd is given to silent listening: before Giovanni turns to work his will on Masetto, his recitative begins, unaccompanied, "Zitto, lascia ch'io senta" (Quiet, let me listen).[14] Man is the sensory animal, in the full meaning of the Italian word.

Sense figures most evidently at the opening of the main section of the Overture, the Molto Allegro. The Overture's slow, solemn introduction has

prefigured the pulsing, pounding, pummeling beat of the world of morality, though without the trombones that (by immediately recognizable musical association) eventually place the music in the transcendent realm. The introduction dissolves into empty time: whole notes in the winds, tremolo in the middle (properly played measured in the strings, but unmeasured in the timpani trill that joins them), uneven beat in cellos and basses. Then the Molto Allegro arrives with a measure of pure rhythm, nothing but eighth notes on the tonic. There is no content here; it is a mere "Lascia ch'io senta." The pace of these eighth notes can be identical to that of the preceding thirty-seconds, but the pressure has come off. (Many conductors change the pace, but there is a revelatory surprise if the Andante becomes Molto Allegro without any demarcation.)[15]

The Allegro of Mozart's Prague Symphony opens with the same unaccompanied D, but in the symphony it begins syncopated, to be understood as pure beat rather than, as here, mere undifferentiated sensation. In the first measure of the Molto Allegro in the *Don Giovanni* Overture the sound is heard, but it conveys nothing, not so much as the octave spread between viola and cello that is the norm in the preceding andante. It says, merely, listen up, get your ears ready, you are about to enter the world and something will follow. Sensation here is expectancy, tremulous alertness, attention, receptivity, nothing more. But that is, of course, not nothing; it is quivering with potential energy that soon enough breaks forth into loud excitement. It can be perfectly characterized by a passage in the episode of Hegel's *Phenomenology* called "The Inverted World": "This simple infinity, that is, the absolute concept, is to be called the simple essence of life, the soul of the world, the universal bloodstream, which is omnipresent, neither dulled nor interrupted by any distinction, which is to a greater degree itself both every distinction as well as their sublatedness. It is therefore pulsating within itself without setting itself in motion; it is trembling within itself without itself being agitated" (*Phänomenologie*, p. 125; trans. Pinkard, paragraph 162). This section of Hegel's treatise forms the transition from "Consciousness" to "Self-Consciousness"; the same may be said of the transition into the Molto Allegro of the Overture.

The sensorium must divide—in actual life physiologically into the different senses, here, phenomenogically, into the support and the thing supported, being and life, repetition and development. In the second measure of the Molto Allegro the first violins enter with a soprano D, sustained, over the continuing eighth-notes. They are all the same thing at the start, all the

same D, yet in the different aspects without which potential sensitivity is not transformed into actual sensation. They then differentiate further, as the violin D moves to its D-sharp. While identical in pitch to the E-flats discussed earlier, the D-sharp actually has a different expressive function, marked by its different spelling. Here it is not a hierarchical contrast or power relation, but a melodic passing tone; that is, not a conflict of opposing forces but a division remaining within the same, conveying a heightening of energy while remaining in the domain of expectation rather than release. Both voices here occupy the middle register, while the contrabasses have dropped out. And the syncopated rhythm that ensues (quarter-half-quarter in mm. 34 and 35) continues to mute oppositions, since nothing marks the contrastive third beat in the measures. The opening phrase of the Molto Allegro is altogether a bit tipsy. It can sound as if the first violin entrance in the second bar is a consequent and thus a weak beat within the larger phrase structure; heard as a structural downbeat, the D-sharp initiates the impression of sharp conflict that begins to ease up in the fourth measure. Indeed, if the fourth measure were omitted altogether, the Molto Allegro would open with a nicely rounded, eight-measure phrase, rising to the violins' high B in its fourth measure, with two measures for the violins to return to their original D, followed by two measures of wind fanfare. The Prague Symphony Allegro opens in very much this fashion: one measure of vamp on alto D in the first violins, three measures of legato (in the middle voices), two measures of eighth-note motion cadencing in the tonic, two measures of wind fanfare. Because of the additional measure, the *Don Giovanni* phrase has either eight bars in addition to the initial bar of vamp or an irregular nine bars with it. The uncertain bustle thus lacks synchrony until the wind fanfare resets the clock. Then ensues a more regular eight-measure phrase, with the accompanying eighth notes synchronized to the theme. Sensation opens unsure of itself, disoriented, comes to itself, then affirms its position in the world on the way to the Sturm und Drang minor episode in measures 67–76, then, beginning in measure 77, the alternation of punched sforzandos with coy pianos decorated with what English aptly names grace notes. The exploratory character of this whole section is unmistakable, in line with the tentative but strengthening affirmations associated with a sentimental existence.

I have said that sensing precedes knowing, and so it must; an object cannot be perceived in the absence of a perceiving faculty. Yet without a world, there is nothing for the subject to sense, and in that way it can also

be said that materiality logically precedes the mental acts that record it. So, in fact, *Don Giovanni* opens not with the sensorium of the Molto Allegro but with the beat of the Andante, here communicating the supersensual but not quite supernatural refractoriness of the thing itself. Prior to the kind of yardstick for measurement represented by the eighth-note pulse beginning the allegro, that too too solid flesh of sound hits us in the face, does it not, at the very opening? Yes, but is this not already a beat (hence, a sensation rather than pure matter)? It is, if parsed into strong and weak beats, as I said earlier. But it is not parsed. Upper winds hold through, and nothing awards greater resonance to the bass instruments on the half notes than to the violin double stops on beats 2 and 4. It might even be said that the violins take the lead: the entire orchestra sounds a chord, then the violins play two half notes, followed by the lower strings, also playing two half notes. The striking hold-over, with the lower strings releasing a beat later than the other instruments, can be heard as the indication that they are not leading the beat but rather following the example of the violins. To put the matter in other terms, the meter here sounds as if notated in an even, steady 4/4; only with measure 5 does the written cut time, with a slow half-note pulse and its strong and weak beats, take aural effect.

The opening four measures, then, in fact represent the indifference of beat and sense. They impress the ears and shake the floor. Sense and body are equally represented in the orchestra, equally thrust upon the spectators, who are thereby called to awareness of the issues to be presented to them in the opera. Not that any of this is or should be explicit in any kind of allegorical or semiotic sense. Rather, the opening orchestral forte is a hushing of the audience, who are not yet (as Lacan puts it) supposed in the know and who must wonder what is to come. Yet vacancy of mind is not exactly the state either. For the spectators do know the title and theme of the opera, and they cannot mistake the dark opening for anything other than a fatality to come. The absence of definition, or the indifference of sense and beat, itself defines a state of disorder, of suffering or at least (to invoke another Lacanian term) sufferance, that necessarily precedes the reaching out constitutive of sensation. In that way, the turmoil defines the order that it mocks, just as the opening chords define a beat and a mode of audition without positively articulating them. They are traumatic in the sense of compelling attention, but because there is nothing yet established to be overthrown, I would not hear them as shattering in the fashion proposed by Stefan Kunze, who speaks here of an "order shaken to its founda-

tions."[16] My itinerary, which will lead to a form of liberation rather than to a demolition, is predicated on rehearing the traumatic confusion in the opening measures as potentiation. The psychoanalytic analogy has been summarized as follows: "Rather than being controlled by a historical event, the truth of a symptom—including its very status of symptom—is pending, [or] *en souffrance*. . . . For the analysand, this Lacanian strategy implies that he is freed from the deterministic historical truth and introduced into a new realm of freedom."[17]

Once the fifth measure has separated object from subject, beat from sense, it is beat that comes first. In treating the primal matter as a pulse, Mozart reflects a romantic priority: the Enlightened self had begun immersed in outness (a term from Bishop Berkeley), whereas for Rousseau and Kant time has primacy as the ground of internalized self-awareness.[18] The pulse that takes over in the fifth measure of the Overture has the hierarchies of strong and weak that I described earlier; but in its mysteriousness, the beat here belongs to the noumenal realm, whereas the allegro of sense will prove to belong to the phenomenal world, portending the encounter of self with world. When the encounter does arrive, to be sure, it takes place with a certain violence, as the sforzandos in the Molto Allegro beat in upon the ears, then pound against one another. It is thus necessary to say that beat precedes sense in the order of being represented by the Andante (though following upon the first four measures that enact the indifference of beat and sense), even while sense precedes in the Molto Allegro order of life. The one is the reverse of the other. Impulse is the bimodal term that best captures the ambivalence so carefully staged and arranged here: the impulsion of things pulsating in the void, the impulses of the anxious heart, and finally the whimsical impulsiveness of the senses leading into the sociable chattering of a Mozartean allegro. The one thing excluded by impulse, and indeed called into question by the whole opera, is intention, choice, decision.

This is a cosmos without an artificer. It lives by fluttering spontaneity. And yet what a glorious cosmos! Milton's Uriel says that in the Creation "order from disorder sprung" (*Paradise Lost* 3.713), expressing what became a watchword of much Enlightenment theodicy. The Enlightenment's hope is surely invoked in the progression from D Minor to D Major, within the Overture and in the opera as a whole. But Uriel, "though Regent of the Sun," is here "beguil'd" by Satan (3.690, 689), and his problematic faith was already mocked in the bawdy context of Jonathan Swift's poem "The Lady's

Dressing Room," where "Order from Confusion sprung" (line 143) rhymes, in a manner not inappropriate to da Ponte's matter, with "gaudy Tulips rais'd from Dung" (144). Indeed, Mozart's Don Giovanni has never sat comfortably within an Enlightenment premise. The epilogue was generally felt to be musically too raucous for satisfactory closure; nor does the text give any real assurance of imminent equilibration, let alone restoration. On the other hand, revolution is certainly also not its project: the same characters whose lives Don Giovanni perturbed return to singing, as they themselves proclaim, "l'antichissima canzon" (the age-old song). Order neither springs by organic predestination from the dung of the characters' loose mores, ineffective longings, and hysterical posings; nor, on the other hand, does an unforeseen order con them out of their foibles, Hegel-wise. Historically, then, the opera must fall somewhere between Enlightenment optimism and Romantic rebellion. Voltaire's rapid-fire *Candide* would not be too extreme a stretch, in the sense that Da Ponte, in his satire on human foibles of all sorts, leaves his characters—rather the worse for wear—where they should have stayed, cultivating away at their gardens, with the harvest still in rather distant prospect: Donna Elvira is off to a convent; Anna and Ottavio are playing a waiting game; the peasants leave to dine but not necessarily quite yet to found a household; and Leporello, *en souffrance* to the very end, heads for an inn to find a new job, or at least, we may infer, some liquid consolation. After the last words are sung there come six soft measures of the trill motif that accompanied the words "Chi fa mal" (he who does evil), in a chromatic descent that touches on all twelve tones of the scale, then a quick five-bar forte cadence, firmly in the tonic, but too brief and formulaic to correct the undertone of freedom in the chromatics (Ex. 10.5). It is a heady representation of the maxim that all is for the best in the best of all possible worlds, but no more solidly grounded than Voltaire's.[19]

A fuller diagnosis of Mozart's nocturnal comedy positions it even closer to its own day. The confusion at the start of the Overture is of a very particular kind. Though auditors may be disoriented by the unconventional overhanging bass, it remains far from vertiginous. Confusion is by no means chaos. The layout is clear, the pace strong and deliberate. It is not a murmur from nowhere like the opening of Beethoven's Ninth Symphony, nor is it deracinated like the opening of Mendelssohn's *Midsummer Night's Dream* Overture. The coordinates are there, just not much implementation. Order is incipient, not denied. Specifically, then, the opening measures provide the principles of organization in time (unstructured pulse)

tion wanders into F major [mm. 251–58], where the bass notes are, for once, sustained, and the violin eighth notes underneath the wind motif are legato rather than detached. This excursus makes sense not organically but only as a forecast of the F major to come in Leporello's opening aria, which itself opens into the ensuing trio.) Thus, this Overture recapitulates in its form the analytical attitude I suggested for the opening measures of the Andante and of the Molto Allegro. At the start of the sections are positivities: the primary, noumenal positivity of the beat and the secondary, derived positivity of sensation, or else, undecidably, the primary positivity of the empirical faculties and the secondary positivity of the objects that modify and fill them. Beat then subdivides into inner pulse and outer domination, and sense subdivides into alertness and receptivity, without decision, without integration. In the larger structure of the Molto Allegro, the weak contrast of themes gives a similar impression of self-division rather than staged opposition. In the Overture the conflict is thus only prepared, not engaged. It ends weakly, without identity, hesitating between F and C and landing on a subdued plagal cadence that resolves only tentatively, and with a pulsed pedal-tone C that might be said to anticipate subliminally both Zerlina's C of pure sensation and Leporello's "Ta-ta-ta-ta" reporting the Commendatore's C of doom. The concluding subsidence leaves a hole; the Overture's abstractions await concrete content. Its end lacks the "attacca" designation that its musical content seems to imply and that would define the characters as filling a space designed for them.

NO (AND YES)

Into the void steps Leporello. I have quipped above ("Negative Poetics," chapter 4) that the first word in the libretto is "no." Those are, indeed, the first two letters of "Notte." More to the point are the dark and the hush, with the off-balance gavotte notation beautifully discussed by Wye Allanbrook in *Rhythmic Gesture in Mozart* and the abrupt forte bursts. Negation in *Don Giovanni* comes in a great many shades, including hesitation, suspension, evasion, resistance, contradiction, sarcasm, and (at this point merely imagined) confrontation. "Notte e giorno" is verbally abnormal. Day rhetorically precedes when Leporello echoes the formula at the start of Act 2: "Che strette, o Dei, che botte! / È giorno, ovver è notte?" (What squeezes, heavens, what slaps! Is it day, or is it night?) Night first is bad news in *The Marriage of Figaro*: "Non trovo pace / Notte né dì" (I have no peace, day

or night); "Non più andrai, farfallone amoroso, / Notte e giorno d'intorno girando" (You will no longer flit around night and day, amorous butterfly). Indeed, googling "notte e giorno" turns up predominantly examples of "giorno e notte," except for those deriving from da Ponte. What kind of servant, after all, puts his nighttime labors ahead of his daytime ones? Emptiness, darkness, and mystery thus immediately take shape as resistance and denial. "Non voglio," Leporello exclaims repeatedly: I don't want to serve, I don't want to be noticed. While Da Ponte's libretto is explicit enough, Mozart's setting is far more insistent: "E non voglio più servir, e non voglio più servir, no, no, no, no, no, no, non voglio più servir." The self-differentiation that typifies the Overture takes more pronounced shape in the negations that Leporello sets in motion. The first moments, to be sure, are just the beginning. Leporello's first negatives seem bravado more than substance: Mozart emphasizes the bluster, focusing on character and thus deemphasizing the real situation of dominance and subordination.

The first point to be made is that Leporello's entrance sets the stage for the whole opera. The next character, Donna Anna, enters with a negative, "Non sperar . . . Ch'io ti lasci fuggir mai!" (Hope not that I will ever let you escape!). Don Giovanni denies her in turn—"Chi son io tu non saprai!" (You will not learn who I am!)—and then tries to resist the Commendatore's challenge: "Va', non mi degno / Di pugnar teco" (Leave, I will not deign to fight with you). The first thing Masetto says privately to Zerlina is "Non mi toccar" (Don't touch me), and Zerlina responds by stiffly resisting his denials: "Ah no: taci crudele! io no merto da te tal trattamento" (Ah, no!, silence, cruel one, I do not merit such treatment). Act 2 opens with dismissal and counter-resistance. Giovanni: "Eh via buffone, non mi seccar!" (Away with you, buffoon, don't annoy me!). Leporello: "No no padrone, no no padrone, non vo' restar" (No, no master, I won't stay). This time Leporello repeats the "no" sixteen times in rapid patter. Repeated and interpolated negatives appear elsewhere as well, notably in Masetto's aria "Ho capito," in Zerlina's "Vedrai carino" ("E lo speziale non lo sa far" [And the apothecary does not know how to make it], with an interpolated "no" following), and in Leporello's Act 2 aria, "Ah, pietà": "Di Masetto non so nulla, non so nulla, nulla, nulla, nulla, nulla" (I know nothing of Masetto). And echoing throughout heaven and earth is Giovanni's final defiance to the statue—"Pentiti!" "No!" "Pentiti!" "No!" "Sì!" "No!" "Sì!" "No!" "Sì!" (echoed here by Leporello singing, "Sì! Sì!"), "No! No!"—followed by the statue's final condemnation, "Ah, tempo più non è" (Ah, there is no time left). Perhaps even more noteworthy

than these emphatic negations is the pervasive negative cast of the utterances. As the statue uses the negative rather than some formula such as, "Your time is up," so throughout there is a notable tendency to circuitous speech. Zerlina enters with a variant of the formula, gather ye rosebuds while you may, but in her version it reads, "Non lasciate che passi l'età" (Don't let the time pass you by). Masetto says "La Zerlina senza me non può star" (Zerlina cannot stay without me), and she says, "Non temere" (Fear not). And so it goes. While this generalization, like any one, will need subsequent qualification, the first careful impression is that the whole show is a tissue of negations.[21]

The void at the end of the Overture is filled, if that is the right term, with idiot music. Unisons sketch the most elementary of harmonies, completely devoid of the curve of intensity or complexity to be expected in any well-formed melody.[22] Allanbrook imagines the sentinel doing sentry duty and saluting at the forte scales. That could work, but the text, "I do not want to be noticed," suggests something more like a spy, and the subito forte is more plausibly an interruption from outside than Allanbrook's spontaneous impulse from within. (No dynamics are marked in Leporello's vocal part, and it is plausible for him to sing piano throughout this passage, ignoring the forte interruptions.) There is one difference between the initial orchestral statement and the exact repetition when Leporello sings: the first period ends with an orchestral hold, whereas in the second the dominant seventh landing point is cut short, followed by a hold on the rest. If Mozart had notated the aria as it sounds, beginning on a downbeat, the pause after Leporello's complaints would be a quarter note with fermata (hold); one result of the displaced beat is that the pause is lengthened in notation to three beats with fermata. Since a fermata can be of indefinite length, there is no necessary audible consequence to the displacement of the beat. But it is plausible to take the unusual notation of a three-beat fermata as marking an extended gap between Leporello's complaints and his resolution, "I want to play the gentleman." This is, then, a second void, a burlesque interruption of the discourse, not a dramatic moment filled with thought. (The critical edition proposes musical filler for the pause, which is common enough in Mozart but would spoil the comic effect of the long pause here. Better Leporello should scratch his head, seemingly forever.) Understood this way, Mozart's lengthened pause forecasts the verb of the ensuing line: Leporello does not wish to *be* a gentleman, but only to be like, or to act as, one. The resolution is not a consequence but a compensa-

tory gesture of bravado. The accompanying horns evoke aristocratic privilege—perhaps hunting, perhaps, as Allanbrook says, cuckoldry, imaginable to Leporello only as a diversion of his betters—but only symbolically, since Leporello uses one and the same musical line to characterize the noble life and his own suffering, and then, at double speed, to express sarcasm toward what he has just wished for. There is no substance to any of this. For Leporello is the slightest of negators. His world consists of perfect indifferences: night is like day, eating and sleeping are equally vexed, labor is merely another mode of endurance. He waits, watches, suffers, but does, precisely, nothing—an anti-Figaro, if ever there was one. He lives in a world of wishes that hardly rise to the level of concrete desires: I want to play at this, I don't want to do that, and I don't want to be noticed. His repeated nos mark out a tonic chord, in first inversion: negation is his fundamental, but remains rootless, its expression compounded of denial, resistance, and sarcasm. There is no personality, only a series of roles, no complexity but only a shadow of self, buffeted by the winds of circumstance.

Not even simple-mindedness is simple, to be sure. In this case, the nexus of identification and disidentification between Leporello and Giovanni is particularly complex. While the pervasive negations make a dialectical analysis natural, indeed almost inevitable, it would be a mistake simply to paste it into the obvious chapter of the *Phenomenology*.[23] Giovanni and Leporello bear little resemblance to Hegel's master and servant. Leporello is an employee, not a serf, a middleman, not a laborer. He experiences fear at moments of threat, but not the enduring current of anxiety for his very being that besets the Hegelian *Knecht*; conversely, he also produces nothing into which his identity could be sedimented and recognized. He is never his master's master. Eventually I shall argue for a kind of sublation in the opera, but there is no sublation of this relationship; hence Leporello's last word to Giovanni remains "Dite di no!" (Tell him no!), his last word at Giovanni's demise is "terror," in sympathy with his master's fate, and his last gesture is to seek another master. Leporello hates his master, but he does not detest him. Detestation is allied with dis-taste leading to dis-sension; it splits a couple apart. But hate, at least in the scientific language of Mozart's day, links opposites, like the negative and positive poles of a magnet that cannot join but also cannot exist in isolation from one another. Leporello hates Giovanni in himself, but he would also like to be in Giovanni's position. His envy thus is tantamount to self-loathing; what he really hates is himself, in his position as cringing subordinate. In this nighttime world, Leporello is

best characterized as Giovanni's shadow, least happy when he is tagging after his master or taking the rap for him, most in his element when he is silently miming Giovanni's seductions of Elvira and Zerlina—though, of course, he apes his master in both capacities. The dilemma confronting him, and confronting us through him, lies in the establishment of identity in a world of domination and seduction, of beat and sense.

Leporello's lack of self sets the tone. Parodying Hegel's parody of Schelling, one might well say that the pastoral of this *Don Giovanni* is a night in which all sheep are black. The women mostly appear weak, the men selfish, though the roles at times interpenetrate. Don Ottavio meltingly solaces Donna Anna for the murder of the Commendatore with the most self-centered of consolations: "You have a father and a lover in me." Is this weakness posing as selfishness, or the reverse? Elvira similarly manifests her self-centeredness as weakness, unable to resist a desire, whether for autonomy or for a lover, even if the object be Leporello dressed as Giovanni. Her irresoluteness is most fully realized in the Vienna scena, the minore B section exhausting itself in mid-line on the word "palpitando," the rondò form contributing to the indecisively fluctuating moods:

Quando sento il mio tormento,	When I feel my torment,
di vendetta il cor favella:	my heart speaks of vengeance,
ma se guardo il suo cimento,	but if I see his conflict,
palpitando il cor mi va.	my heart throbs.

(Leporello says of her earlier, "Pare un libro stampato" [She seems a printed book]; what he does not say is that the book is the libretto of *Don Giovanni*.) Earlier in the sequence, however, she is already utterly confused, taking Leporello for Giovanni and irrationally rhyming her beating heart with the fear of death that, physiologically, ought to quiet it:

Sola sola in buio loco	Alone, alone in a dark place,
Palpitar il cor io sento,	I feel my heart throb,
e m'assale un tal spavento,	and such fear besets me
Che mi sembra di morir.	that it seems I am dying.

Each of the women is caught between two men: Elvira between the true Giovanni and his impersonator Leporello, Zerlina between a true spouse and a false lover, and Anna between a true and a false father, the former

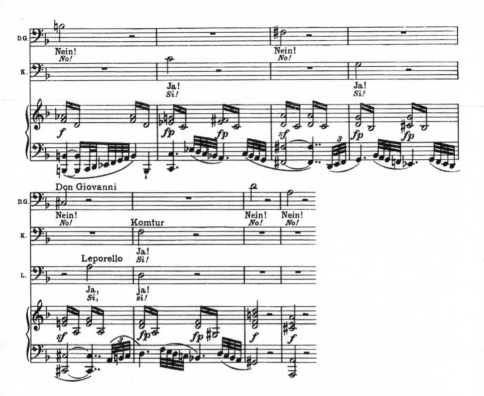

EXAMPLE 10.6 *Don Giovanni*, "No! Sì"

been established—his D-A reverses the A-D on which Leporello has sung his yeses just before—toward a deceptive cadence, where the statue, quietly but firmly, takes command of the music and steers it toward the beat of doom. After the palpitations of all the other characters, Giovanni declares his pulse to be unyielding: "Ho fermo il core in petto: non ho timor" (My heart is steady in my breast: I have no fear). In this opera, no affirms life, yes glories in death, but the apparent yield is the meaningless outburst of "Ah!" first from Giovanni, then identically echoed—but surely with a different meaning—by Leporello.

All points, then, back toward the suffering body, the materialism of the heart and the atomism of the senses. The seigneurial sì ("sì, si-gnor") is, so to speak, the Italian language's riposte to the French "non du père." It is the statue's statute, a sibilant sign that can range from a hiss to a sigh. It leads to an epilogue that, from the perspective of the affirmative, joins all the characters who have been under Giovanni's thumb into a gleeful crowd, singing

their full-throated relief as fast as they can. The delirium of the epilogue traditionally seemed hollow and inadequate to the drama that precedes it. We want a worldly conclusion, but we get one so exuberantly celestial as to defy genuine resolution. Giovanni's spirit has been destroyed, his body violated ("Chi l'anima mi lacera! Chi m'agita le viscere!" [Who tears my soul! Who shakes my bowels!], he sings at the moment of destruction), with too little left of the one, too much felt in the other. Leporello is unable to tell what has happened, except in stammering phrases of a depleted physicality: the statue kicked him ("diede il gran botto," using the masculine noun that echoes the feminine "botte" [slaps] that Zerlina begs for in "Batti, batti"), the devil gulped him down, "sel' trangugiò." Meanwhile, feelings shoot up to the stars (the language is very precise here, and to be taken literally: "Stelle! che sento!" ["Stars! what do I hear/feel!"]). Elvira leads the way in terming this very physical statue an "ombra" (shade); Ottavio, still possessively addressing his "tesoro," calls on the heavens; Zerlina and Masetto, like Leporello, still think of food. Body has not been joined to soul here; rather, each pole has been evacuated of its substance and left a giddy whirl.

But that is from the heavenly, affirmative perspective. Yet the last particle was not the statue's yes, but Giovanni's no, in thunder. It is now time, at last, to review the situation from the perspective of Giovanni. What is Giovanni's role in the outcome?

VIVA LA LIBERTA!

"Role" is perhaps the wrong word. The other figures are roles, striking attitudes deriving from the music of society, of the people, of the stage. They sing and dance, spectacularly to be sure, but along lines scripted by others. Their affirmation cannot be an affirmation of selfhood because it must affirm sentences and motifs handed down by tradition. Not just Elvira but all of them speak like printed books. (Indeed, that very utterance is copied from a book: in the second scene of Molière's play, Sganarelle says the same thing to Dom Juan, "Vous parlez tout comme un livre.") That is the observation so richly developed in Allanbrook's *Rhythmic Gesture in Mozart*. But it is then misleading to write of them, as she does, as if they represented living breathing subjects. And if they don't, then it is beside the point to lose faith in them when the epilogue deflates them into what, really, they always were, glorious voices. As Mary Hunter writes about endings in her

equally fine study of the intersection of sociology and form in opera buffa, "Probably the majority of arias . . . end in ways that are neither fully 'psychological' and individualizing, nor fully performative and typological but rather balance elements of these poles in a variety of ways. Aria endings in this repertory all juxtapose a dramatic context against a theatrical one, a character against a singer, and an individual against a type."[27]

It is Giovanni who disturbs the equilibria and brings them all into motion, one after another. After my title and the development of the argument to this point, one might expect him to be a grand nay-sayer; indeed, Allanbrook characterizes him repeatedly as "No-Man," and Steinberg allies him with the Commendatore "as negative forces" (*Listening to Reason*, 29). But in fact, until the very end, his nos are fairly routine. While a language without negatives is hardly imaginable, his are considerably less emphatic than those of the other characters, the most insistent being the self-referential double negatives denying fear that I quoted early in this chapter. For just as affirmations in *Don Giovanni* edge toward negation, so negations edge toward their opposite, from Leporello's first aria onwards. Saying no in one direction is tantamount to saying yes in another, as bodily chastisement is merely a vehicle toward emotional fulfillment, or the rejection of temptation a conduit for passion. All the other characters are fixated on their dreams, self-affirming and life-denying at once, with what Nagel calls "that double gaze which frames every detail twice."[28] To release them requires a different gesture, however, that Nagel's tragic realism does not properly encompass. Its name is not negation but freedom.

The Don Juan figure raised the libertine to mythic status and has been constantly revisited since the sixteenth century to rethink the relationship between freedom and power. He represents, undoubtedly, a top-down alternative to the much more ancient rituals of carnival, but his (sometimes) doubtful exploits and (mostly) tragic outcomes always offer more by way of challenge than by way of clarification. He is, indeed, always a figure of darkness, and it is always hard to decode his furtive seductions. He doesn't lie down easily with any party, political or otherwise.

Molière's Dom Juan says what he thinks. "J'aime la liberté en amour" (I love freedom in love) is his watchword (3.5). The play is insistently concerned with reasoning. It's true that "raisonner" in Molière's French relates more to the rhetoric of giving reasons than to the substance of thinking rationally and acting reasonably and that "sincerity" becomes a code-word for license. Still, the kind of freedom we call frankness is never in doubt: it

is always clear when the characters are saying what they really think, and stage directions remove any delusion that Dom Juan's last-act submission to paternal authority might be genuine. Dom Juan is a hypocrite—as actors are by etymology—and so is his servant Sganarelle, but his hypocrisy is only skin-deep; he calls hypocrisy "un vice à la mode" (a fashionable vice), and he is never hypocritical with himself. The statue comes to fetch him, he extends his hand, and is whisked off in a trice. Just previously, confronted with the specter of a woman that alarms Sganarelle, he is all defiance: "Nothing can impress me with terror," he says, and "No, no, let it never be said, whatever happens, that I am capable of repentance." Da Ponte's Don Giovanni, who ends by rhyming "orror" with "terror," is an entirely different beast. Early on, in lines I quoted on page 254, he denied fear, but defensively, following "my head swims . . . but," and his denial just before the statue seizes his hand, "Non ho timor" (I am not afraid), occupies less than a line of verse and less than a bar of music, without even promoting its noun into the readily available rhyme. Molière's play tests limits through articulate confrontations, sometimes exceeding the bounds of censorship but never confusing the issues, at least insofar as reasoning extends its grasp. It does have its radical side in the naturalism of the peasants (Charlotte to Pierrot, asking her to love him: "I will do what I can, but that has to come on its own") and in Sganarelle's earthiness, expressed in his last, censored line, "My pay! my pay! my pay!" But the aristocratic value system remains clearly defined.

"Viva la libertà" (Long live freedom) is the reechoing ensemble call led by Giovanni in the C-major Maestoso section of the Act 1 Finale, just before the chaotic dancing begins. Freedom is the ideal the libertine represents. Sexual freedom first off, of course. Then, too, musical freedom, as the multiple dance orchestras disrupt both the body's beat and the senses' pulse. And surely, as well, political freedom. Allanbrook argues against political readings of *Don Giovanni*, since none of the figures makes a plausible representative for any kind of coherent ideal. She claims that too many irreconcilable forces of tradition, of escapism, and of authority are arrayed against Giovanni for there to be any clear or meaningful political message. And that is true, so long as we think of the characters as real people, embodying real forces, and so long as we give them all equal weight. Still, after Da Ponte's adaptation of the tinderbox play *Figaro*, after the American Revolution, and during the run-up of discontent leading to the French Revolution, so emphatic an outburst (Beethoven's *Fidelio* proclaimed *Freiheit* in the

same key and at the same volume, less than two decades later) can hardly be thought neutral.[29] Giovanni, surely, does not speak for Mozart. But he speaks to all auditors. What is Mozart saying with him?

Absolute freedom, says Hegel in the *Phenomenology of Spirit*, is the end of Enlightenment.[30] The principle of Enlightenment (on his account) is utility. An object is defined as a thing out there, "for an other," and Enlightenment interprets objecthood according to a principle of universal rationality. Hence, according to the order of the world, each object serves its purpose in serving others. But in itself, regarded as though from the inside, the object is considered as a substance. From the object's point of view, the principle of utility is inverted: the world then does not look like a process fed by the object but as a resource that feeds it. Utility turned inward, utility "in itself," is utility "for me," and its manifestation is freedom. Substance is the center, and all things revolve around it. It all depends upon the angle of vision: the same process that makes an object generously serve others makes a subject freely use materials.

In an older order, the substantial center was understood as the divinity. But the generalized, utilitarian center of Enlightenment lacks such a unifying regulative principle. Religion had been conceived in terms of the reciprocal duties of moral agents (only at a later stage does Hegel redefine religion in terms of a substantive community); in the to and fro of Enlightenment utility, however, reciprocity is merely the contest for mutual advantage; religion is reduced to lip service, shriveling to a meaningless illusion, a ghost of itself, "an exhalation of stale gas, an exhalation of the empty *être suprême*" (p. 416; par. 586). And when utility becomes self-centered, so does the spirit of common humanity that had guided Enlightenment: "the universal will takes an inward turn and is the individual will, which is confronted by the universal law and universal work" (p. 416; par. 587). Enlightened individuals strive for fulfillment in a contest that can have only one winner. There can be only one genuinely free individual, and he must be a tyrant. Here is the paradox: absolute freedom claims to represent universality even as it actually embodies only its individual purposes. Hegel here is in fact analyzing the course of the French Revolution; therefore, he portrays absolute freedom as a legislative instance: "it is thus not making anything which is individual; it is merely making laws and state-actions" (p. 416; par. 587). But the principle of freedom applies to a point source, which might just as well be a hedonist as a Committee of Public Safety. Don Giovanni is, to be sure, no legislator, but he certainly embodies Enlight-

enment run amok as he turns benevolence and good will toward all into pretexts for his dark impulses. And in whatever guise, as individual or as collective ruler, Hegel's freedom itself proves both delusory and (like Da Ponte's Giovanni) impotent. "It follows from this that it cannot amount to a positive work, that is, it can neither amount to universal works of language nor to those of actuality, nor to the laws and the universal institutions of conscious freedom, nor to the deeds and works of willing freedom" (p. 417; par. 590). It can only reorganize, not rebuild; lacking respect for individuals it conceives otherness in general terms and so it divides the state into separate powers (an observation that is not relevant to the opera) and its inhabitants into classes (a stratification very much present in the opera). Hegel's relentless critique doesn't stop with this exposure of the intransitivity of self-absorbed freedom, but, as his dialectic is prone to do, it pushes to a complete collapse. Absolute freedom is empty of content; consequently, "Universal freedom can thus produce neither a positive work nor a positive deed, and there remains for it merely the negative act. It is merely the fury of disappearing" (p. 418; par. 589). A freedom that does not know how to work is condemned to insubstantiality.

The end of Don Giovanni is, surely, just the kind of furious and fury-haunted vanishing portrayed by Hegel's analysis. Giovanni can make nothing of other people but only rides roughshod over them. Absolute freedom produces only death, and death in the form of the pointless destruction of the terror, and thereby it comes to recognize itself as it truly is: as "this abstract self-consciousness which within itself destroys all distinction and all the durable existence of any distinction, . . . it is in its own eyes the object, and the terror of death is the intuition of its negative essence" (p. 419; par. 592). Don Giovanni is a perfect image of the dynamic whereby absolute freedom reveals its total, destructive vacuity. Beat creates the musical world by dividing into the unreconciled hierarchies of subject and object, consciousness and matter. Sensation links the poles, but only by collapsing externality back into inwardness. Negation strives to maintain the polarities but confuses its thrust by affirming difference, thus dissolving resistance into relationship. Each of these stages has its distinctive psychology: the oppressions of pulse, the indulgences of sensibility, the furtiveness and violence, glamorous fascination and horrified revulsion of denial. They are succeeded in turn by the liberation that Don Giovanni charts. In 1787, when the opera was written, the dialectic of freedom had not yet become mani-

fest as a social phenomenon, and the opera appears to represent it only as the self-destruction of an individual rather than as that of a society. "Viva la libertà" becomes the slogan by which Giovanni undoes his own effectiveness and ultimately undermines his very existence. To be sure, Hegel's formula for the splitting of the self into its components is rather different from the words of the libretto; he says "the predicate-less absolute" divides into "pure thought" and "pure matter" (p. 420; par. 592). But the beat is simply the musical form of materiality, and since pure thought is mental activity without content, it does not differ markedly from the pure feeling that is the other pole of the opera's dialectic; indeed, not many pages previously, in his chapter on the Enlightenment proper, Hegel identifies the components of "pure self-consciousness" in terms more reminiscent of the opera, namely as "pure feeling" and "pure thinghood" (p. 408; par. 574). In its negative face, absolute freedom self-destructs, seeming to throw Spirit "out of this tumult . . . back to its starting-point" (p. 420; par. 594). That is exactly how the statue's revenge and the epilogue look as materialities, that is, if the opera is understood as a psychological drama of real persons. But the absolute freedom that Giovanni represents has a positive spin-off as well, a distillate that forms the transition to the next stage of the dialectic and (so Hegel supposed in 1807, too soon to know the full consequences of the Revolution) the progress of history toward justice. Hegel identifies the outcome as a "non-actuality" where "freedom counts as truth" (p. 422; par. 595).

It seems paradoxical to assert moral progress at the end of *Don Giovanni*. The myth is compatible with redemption, which is granted at the end of José Zorrilla's romantic 1844 play, *Don Juan Tenorio*. But the double end of da Ponte's "dramma giocoso" seems grimly baroque in its tragic vengeance and giddily rococo in its buffo epilogue. Singing the ancient song can hardly advance the cause of justice. Hence Allanbrook calls the epilogue "the rite of the *vaudeville*"; she wrongly labels the end of the libretto doggerel and says that it leaves the opera "inadequate as social history" and successful instead as a celebration of the timeless "artifice of opera" (*Rhythmic Gesture*, 322–25). Kerman says "the epilog only goes to show how drab life is without the Don" (*Opera as Drama*, 122); Kunze says it loses its bearings, like "a second, a final damnation" (*Mozarts Opern*, 329); Nagel bypasses it altogether; and, most recently, Richard Taruskin has enthusiastically seconded Kerman's judgment, blaming the failure of the epilogue on "the cynical 'gender politics' of Mozart's time."[31] So many imposing scholars,

sensitive musicians, insightful directors, can't be wrong. The ending is textually regressive and not musically uplifting, what with the quiet, fluttering tag-ends of descent that follow the final chorus and the too-brief blaze of D-major pomp (also marked by a descending scale) in the final five measures. Later, *The Magic Flute* was to preach virtue—but not this opera. All these readings look to individual characters and recognizable social forms to measure the opera's accomplishment.

Hegel's "moral spirit" is located in a different sphere. What matters to him in his account of 1793 is not individual reformation but potential community. Opera buffa characteristically climaxes in elaborate ensembles, and so my account of the close of *Don Giovanni* will be tuned to the formation of the group, not to the individuals. I believe that one should recognize in the epilogue to *Don Giovanni* a rendering of some such dialectical outcome. That would be a positive outcome resulting when the spirit of negation is finally consolidated by Giovanni's defiance (in contrast to the negative outcome of singers falling back into the emptiest version of their indecisive sociability). To be sure, the pre-Revolutionary image of the dialectic is not and probably cannot be identical to Hegel's account. Allanbrook is surely right that the opera is not a political allegory in the usual sense. Its explicit vision remains individual, not social, giddily comic, not tragically redemptive. Still, the work's form is much more peculiarly episodic even than the *Don Juan* plays were, and rethought as a constellation rather than a drama, the epilogue can be recognized as a reconstitution. What matters is not what happens to the individual characters—which is, after all, precisely nothing—but rather how they form a group. To that end, I propose to conclude my reading with an account of the composite.

Giovanni pursues three women. None of the seductions is consummated during the action of the opera, but they fail in different ways. Anna is the only one who resists; Giovanni has pursued her unsuccessfully before the action begins, and she remains stalwartly loyal to the two men in her life, her father and her betrothed. Earlier, and in another city, Giovanni proposed marriage to Elvira, then abandoned her after three days. She remains torn, spending much of the opera repetitively proclaiming his perfidy, yet still nursing the flames of passion that are reignited by Leporello disguised as Giovanni. Zerlina is seduced on stage, but rescued in time by Elvira. While the catalogue aria reports (truthfully? or hyperbolically?) Giovanni's indiscriminate affairs with women of all classes, the spectrum of the opera relegates the seduction of the upper-class characters to the past and shows

him now smitten with a peasant girl. The two who yield to his advances are related by his promise to marry them; Anna and Zerlina are both engaged to marry. There are too many cross-cutting affinities, too small a statistical sample, for obvious generalizations.

The picture simplifies, however, in light of the fifth leading role, Leporello. Leporello is not seduced by Giovanni, but he is commanded and even magnetized by him. He is not a woman, but he is beaten as Zerlina imagines herself to be; he is undressed by Giovanni, and he dances with Masetto. Just as, in terms of character, he is even more shadowy than the others, so in terms of relationship to the central figure he is in the position of a lesser—and less independent—accessory. With him included, Giovanni appears surrounded by a clear instance of what Fredric Jameson, following Algirdas Greimas, has described in *The Political Unconscious* as a semiotic rectangle (166–69, 253–57).[32]

There are two past seductions of upper-class women, one successful and continuing, the other resisted, and there are two present encounters with lower-class characters, one briefly successful, the other (Leporello) resisted and ongoing. The brief romances are with women protected by lovers, the continuing dramas are with unattached individuals. Three of these are represented as amorous encounters, the fourth is at best the shadow of one. Leporello, that is, holds the place of an unrealized dynamic within Giovanni's existence. At least as represented in this opera, Giovanni is moving from high status to low and attaching himself most successfully to those without amorous alliances. Leporello is the most closely bound to Giovanni but also the most determinedly resentful. He joins the statue in the concluding yeses hurled at Giovanni. The most commanding figure, representing a dead past, is here seconded by the most abject figure, representing a future waiting to be unleashed.

Leporello thus occupies the position of Giovanni's political unconscious. It is unconscious because it is an unrealized or unacknowledged eroticism. And it is political because, while directly subordinate to Giovanni, Leporello is the one figure who yearns for the very liberty that Giovanni celebrates. Leporello is not the proletariat waiting in the wings of history. The opera is not that kind of direct allegory, and in any event Leporello is too subservient for that role. The wily, entrepreneurial Figaro is a more plausible revolutionary, though even in his case, symbol of revolution might be a more reasonable label; Don Alfonso and his sidekick Despina are more plausible agents of anarchy. Rather, Leporello represents a pressure on the

aristocratic system that is unrecognized because unformed, and conse-
quently only potential, not real.

The three women define aristocratic energy. In Anna, Giovanni has
encountered a social equal who restrains his impulses, within a context
of limited self-actualization that includes a weak lover and a delayed mar-
riage. Such an economy of limitation defines the aristocratic system in its
normal functioning. Elvira illustrates the weak side of the aristocratic sys-
tem, where human law is inoperative, character yields to fate, and only a
postulated divine presence (as avenger or as heavenly father) stabilizes the
social order. And Zerlina and Masetto, taken together, show the ground-
ing of aristocratic impulse in unequal status. For the aristocrat to activate
his energies, he needs a victim, yet the victim can only exist, can only be
engendered, within the relative stability of her own social system. Energy
requires an object, yet objects bring a certain inertia with them, without
which they are merely opposing energies, the subjects of duels or rapes,
but not of the vanity of seductions. A particular quality of selfhood is cir-
cumscribed by these three women—self-regarding, self-testing, restlessly
brilliant, never at ease. That is what the catalogue aria is all about. The
free aristocrat who is here represented by the aristocratic libertine, is not
a libertarian, nor does he exist outside of a social structure; indeed, social
forms like the duel, the serenade, and the banquet regulate his freedom in
numerous ways.[33] The dramatic side of the *dramma giocoso* reveals a drive
doomed to frustration by the very contexts of its success. To satisfy itself,
to verify its status, it needs a whipping boy, and that it has in Leporello.
Yet freedom is also not satisfied by crushing a dependent other. It must
change clothes, change positions, validate its freedom through deprivation.
A willed and temporary deprivation, of course, is not a true denial. The
aristocracy is too successful for its own good. Giovanni exists with aban-
don but is incapable of production. He does not embody enough negativity
to function either as hero or as cynic. And that is the "logical paradox,"
the "intolerable closure" (*Political Unconscious*, 167) for which Leporello
provides, at the shadow level of the unconscious, the glimmer of a solution.
Leporello holds the place of a laborer, the kind of other that a master needs.
Except that at this stage of society, Leporello has no labors to accomplish
that are not strictly self-reflexive, not so much as cutting a beard. There is
as yet no true alienation, consequently no class of which Leporello is the
delegate. He only knows how to complain and then, when push comes to
shove, to second the father's yes. It is enough to push Giovanni over the

edge, in a fatality that he had coming to him from the invention of the story, but it is not yet enough to limn the shape of a future polity.[34]

The sextet in the conclusion forms the perfect ending for so unfinished a dilemma (Ex. 10.7). Traitors die as they live, the sextet sings together over and over again, completing the circle opened with the Overture. The different classes come together, singing the same old song, in a burst of energy showing that society must change but is not yet ready to do so. Notably, the singing begins with the weak characters—the two seduced women, the two suffering spouses. Anna enters next, savoring vengeance, then Leporello iterating Giovanni's disappearance. The measures sung by the quartet (mm. 605–17) are grouped in accelerating and intensifying phrases: four then three measures of unison asking where he is, then a repeated two-measure harmonized phrase desiring to release anger, with the repetition cut off a beat early. The last line of text is then repeated, but now begins on an upbeat rather than waiting for the downbeat, and an accented second beat (marked *mfp*) lurches forward toward Anna's entrance. Anna begins quicker, with the trisyllabic (*sdrucciolo*) verse ending of "mirandolo" confined to a single measure rather than landing on a subsequent measure like the quartet's "perfido." They have wandered into the dominant; her progression echoes theirs at first by moving from the tonic G to E and C, though with more defined harmonies, but then she returns to a settled tonic as she closes on "calma darò" ("will calm" her pains). She has not yet joined them, that is, but still asserts a more settled independence. Leporello, at his entrance, is not settled at all, but repeats his two-measure tonic-dominant refrain under repeated Ds in the violas until concluding with unisons (decorated by arpeggiated quarter notes in the violins) that push toward the dominant. In short, three different gestures resound at the start of the epilogue. Following the Larghetto with its amorous duos and its declarations of various future intentions, the group finally assembles as a unit for the final triumph. The villain's disappearance negates his "no" and allows all to join hands for a moment of wild celebration. But the opening of the epilogue has already shown how fragile, perhaps even factitious the ensemble is. And at the end Elvira announces her retreat to a gavotte melody in E minor; the identical melody in D major then serves for Zerlina's announcement that she and Masetto will go off to dine; and finally in A major it accompanies Leporello's declaration that he intends to seek a new master. Three divergent proposals, all in the same courtly voice, though to

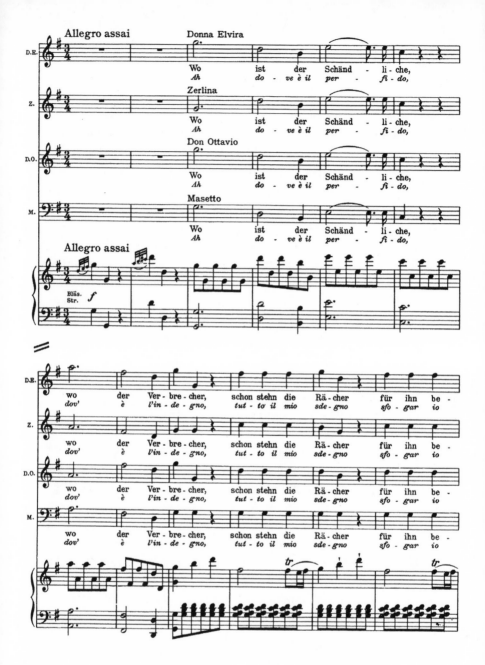

EXAMPLE 10.7 *Don Giovanni*, Epilogue, opening

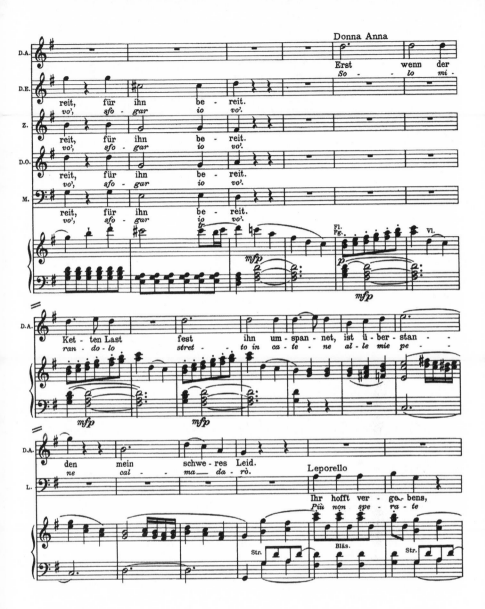

EXAMPLE 10.7 (cont.)

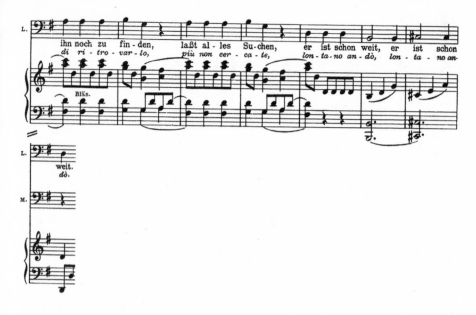

EXAMPLE 10.7 (cont.)

be sure it is Leporello, the servant, who has it in the dominant key. This is certainly only a whiff of transformation in a world that remains, in Hegel's sense, unreal. Society is not healed; the comedy is headily restorative but not cathartic; and a more authentic negation waits in the wings.[35]

In his lectures on the sociology of music, Theodor Adorno issued a challenge to ideological readings of Mozart:

> In the case of Mozart, in whose music the standoff between late Enlightenment absolutism and bourgeois sensibility—deeply allied with Goethe—echoes, it is only by forcing, or occasionally, that antagonistic aspects can be musically identified. Rather, the force with which his music returns into itself is, sociologically, a distancing from the empirical. As though afraid of losing itself at the slightest contact, Mozart's music wards off abased forms of life, leaving the economy, unleashed and threateningly storming in, sedimented in his form, without the pretense of any content beyond the human means with which it replenishes itself: without Romanticism.[36]

Like so much else in Adorno, everything here is right except the tone. There have been rich sociological and psychosocial readings of Mozart's

operas, notably by Ivan Nagel and (briefly but brilliantly) by Jean Starobin-ski, as well as, earlier, by Ernst Bloch, but without detailed attention to the music. Conversely, the finest musicological studies (Kunze's, Allanbrook's, and Hunter's, though Hunter's prime masterwork is *Così fan tutte* and she comments on *Don Giovanni* only in passing) lack the dimensions of the imaginary, the unconscious, and the utopian. Hence in her section entitled "Opera Buffa's Social Reversals" (71–92), Hunter foregrounds the conserva-tive results of the genre's carnivalesque tendencies, while finally allowing more force to (feminine) bourgeois sentimentality. In this view, there are no unsublimated remainders. I have tried to show by contrast how deeply ingrained in the music of *Don Giovanni* is an ideological impulse, that is, a resistant set of fundamental human stances toward the human environ-ment. The level of abstraction at which beat, sensation, affirmation and denial, and freedom are sedimented leaves them as inconspicuous as they are pervasive; in that sense, there is indeed a marked distance from the empirical. To that extent, Adorno's formulation is as precise as it is bril-liant. Beethoven announces his opinions with open trumpet fanfares, but Giovanni's freedom chorus is ironic both on the surface and in the depths.

Mozart looks to almost all his modern interpreters like a consum-mately worldly composer, to whom nothing human is alien, but who lacks the pathos of individual striving, let alone the utopian imagination of a distant perfection that Adorno associated with Beethoven and Schubert, respectively. Adorno brilliantly identifies form itself as the transcendent dimension that imagines knitting all the compositional investments into a kind of unity quite different from the more discursive Haydn (whose monothematic structures tend to the conversational rather than the dia-lectical) or the more transformative Beethoven. Adorno implies that sonata form is Mozart's invisible hand, regulating the commerce of themes and motifs with a sovereign appearance of laissez-faire. But Adorno is sensa-tionally wrong to invoke fear in connection with the political aspirations of Mozart's music. Mozart, the striver, always sought a better, more humane, and sociologically renovated future. In that sense it is much closer to the mark to characterize his jocose drama as utopian rather than desperate. Happiness, for him, lies somewhere around the corner, even though, as with any utopia, we may not know the road to it. Still, utopia doesn't quite capture the frivolity of *Don Giovanni*'s conclusion. Jameson conflates the literary imagination of the political unconscious with the political imag-ining of utopias, but I think, as *Don Giovanni* would seem to illustrate,

that he deludes himself there. The finale is too brief and too giddy to offer a concrete vision. But it is neither hopeless nor fearful, and its very gaps encourage auditors to look beyond the limitations of the characters and the music's antique song. The pulse, finally, belongs to life, sensation to human sentiment, denial to triumph over the seducer's tyranny, and freedom to an unresolved carnival that is not just an opiate of the masses. Mozart's Olympian mastery—so deeply resonant (I would respond to Adorno) to the slightly older Goethe's—does remain disengaged from empirical social solutions; his music does not call for the release of prisoners nor, except in the most trivial and compromised fashion, for accommodation with the Turks. But it does something arguably more visionary yet, which is only possible when the empirical world is held at bay: it holds itself open, stylistically, psychologically, and politically, to the future.

Notes

INTRODUCTION *Music and Abstraction*

1 Jacques Attali, *Noise: The Political Economy of Music*, trans. Brian Massumi (Minneapolis: University of Minnesota Press, 1985), 57.

2 G. F. W. Hegel, *Phänomenologie des Geistes*, ed. Johannes Hoffmeister (Hamburg: Meiner, 1952), 163; in the translation by Terry Pinkard (modified in places), this is paragraph 217. Hegel's italics are omitted throughout.

3 Much later in the *Phenomenology* (p. 372, par. 521) there is a passing discussion of the "madness of the musician" in Diderot's dialogue *Rameau's Nephew*. The negativity here distorts Diderot's own meanings, as John T. Hamilton shows in *Music, Madness, and the Unworking of Language* (New York: Columbia University Press, 2008), 85–97.

4 Between the two passages discussed, *Andacht* appears only once, in a passing allusion with respect to the Enlightenment critique of religion (p. 405, par. 571). These passages are well discussed in similar terms in Simon Jarvis, "Musical Thinking: Hegel and the Phenomenology of Prosody," *Paragraph* 28 (2005): 57–71; the valuable, broader overview in Daniel Chua, *Absolute Music and the Construction of Meaning* (Cambridge: Cambridge University Press, 1999), 227–32, highlights Hegel's disparaging negatives and overlooks the linkage between the absolute and the (more productive) abstract, a term that is missing from Chua's copious index. (Translating Hegel is always a problem. Pinkard translates *Genuß* as "consumption" rather than "enjoyment." Since *Genuß* in this passage responds both to desire and to labor, both its emotional and its physical aspects are pertinent. In the musical context of par. 709 [p. 495], however, work is rewarded with *Freudigkeit* ["joyfulness"], so I prefer the subjective translation for the earlier passage. In the later context, Pinkard leaves *marklosen* ["marrowless"] untranslated.)

5 "The truth is the bacchanalian revel where not a member is sober," *Phänomenologie*, p. 39; par. 47.

6 Donald Verene discusses Tieck's play as a background to Hegel's topsy-turvy world in *Hegel's Recollection: A Study of Images in the "Phenomenology of Spirit"* (Albany: SUNY Press, 1985), 50–53. In *Hegel's "Phenomenology": The Sociality of Reason* (Cambridge: Cambridge University Press, 1996), 359, Terry Pinkard objects that the topos is ancient and that Tieck's play was "obscure and unperformed." It was indeed unperformed, but it was not obscure. Verene offers possible biographical links to Hegel, and the work's distinct if mod-

est resonance in the Romantic period is documented in Ludwig Tieck, *Die verkehrte Welt*, ed. Karl Pestalozzi (Berlin: de Gruyter, 1964), 133–37. Hegel's chapter does not derive from Tieck's farce, but there is no distortion in comparing the two, as Verene does and I undertake.

7 For a nice overview, see Karin v. Maur, *The Sound of Painting: Music in Modern Art* (Munich: Prestel, 1999). I thank Marek Wieczorek for lending me this book and more generally for getting me into abstraction and helping me out with it again. The paintings mentioned in this paragraph are illustrated in color in *Picasso and Braque: Pioneering Cubism*, ed. William Rubin (New York: The Museum of Modern Art, 1989).

8 Clement Greenberg, "The Crisis of the Easel Picture" (1948), in *Collected Essays and Criticism*, ed. John O'Brian, 4 vols. (Chicago: University of Chicago Press, 1986–93), 2: 224. Greenberg's characterization of Schoenberg is not without problems, but they are not relevant to the fascination of abstract painters with music.

9 For a succinct and nontechnical introduction to Schenker, still the reigning divinity of American music theory, see Joseph Kerman, *Contemplating Music: Challenges to Musicology* (Cambridge, Mass.: Harvard University Press, 1985), 79–90.

10 Carl Dahlhaus, *Esthetics of Music*, trans. William Austin (Cambridge: Cambridge University Press, 1982), 53.

11 For one trajectory of abstraction, see the beautiful account of "the democratizing of abstraction," W. J. T. Mitchell, "Abstraction and Intimacy," in *What Do Pictures Want? The Lives and Loves of Images* (Chicago: University of Chicago Press, 2005), 222–44; the quote is on page 236.

12 Nathaniel Hawthorne, *The Marble Faun*, chapter 49, in *The Complete Writings of Nathaniel Hawthorne*, 22 vols. (Boston: Houghton Mifflin, 1900), 10: 338. My reading of Claude Lorrain takes its cue from "Claude's Allegories and Literary Neoclassicism," in Jane K. Brown, *The Persistence of Allegory: Drama and Neoclassicism from Shakespeare to Wagner* (Philadelphia: University of Pennsylvania Press, 2007), 15–45.

13 Unfortunately, it has not been possible to provide a color reproduction of the Stella painting for this book. The versions currently reproduced on the web are colored very differently and rotated ninety degrees. My thanks to Kelly Baum of the Princeton University Art Museum for help in describing the image.

14 Johann Wolfgang Goethe, *Neue Gesamtausgabe der Werke und Schriften*, 22 vols. (Stuttgart: Cotta, 1950–68), 21: 15.

15 I give page numbers for "Who Thinks Abstractly?" trans. Walter Kaufman, *Hegel: Texts and Commentary* (Garden City, N.Y.: Anchor, 1966), 2: 575–81, followed by "Wer denkt abstrakt?" in *Werke*, ed. Karl Markus Michel and Eva Moldenhauer, 20 vols. (Frankfurt: Suhrkamp, 1969–79), 2: 114–18.

16 Ernst Bloch, "Hegel und der Humor," in *Über Methode und System bei Hegel*, ed. Burghart Schmidt (Frankfurt: Suhrkamp, 1970), 136–40.

17 See Hamilton, *Music, Madness, and the Unworking of Language*, 92–93.

18 *The Poems of Emily Dickinson: Variorum Edition*, 3 vols., ed. R. W. Franklin
 (Cambridge, Mass.: Harvard University Press, 1998), no. 373. I borrow the
 phrase "almost nothing" from D. A. Miller, *Jane Austen, or the Secret of Style*
 (Princeton: Princeton University Press, 2003), 13, 38. Miller's term for an
 abstractionist is a "stylothete" (8). He traces a line from Austen through Flau-
 bert and Joyce to Hitchcock and Fellini. Here is his analysis of the hurt that is
 expressed and masked by abstraction (though he does not use the term): "the
 condition for the development of a style is a subject (a self, a topic) with *almost
 nothing to say for itself,* and this 'almost nothing' corresponds to social abjec-
 tion that, but for this powerful feat of indifference to it, the stylothete would
 have to suffer" (38). His icon for the stylothete, not so remote from my icon, is
 Robert Ferrar's toothpick case in *Sense and Sensibility* (9–20), the stylothete's
 collection of mini-styluses.

 In *Dickinson's Misery: A Theory of Lyric Reading* (Princeton: Princeton Uni-
 versity Press, 2005), Virginia Jackson denies that Dickinson was an abstract
 poet. But she puts abstraction at the modernist end of a two-valued scale
 between personal expression and impersonality, without recognizing the ele-
 ment of performance. Dickinson is not abstract, she argues, because there is
 no clear dividing line between lyric and other utterance and because the (very
 interesting) manuscript scraps at the core of Jackson's argument bear material
 traces of their situations of composition and address. I agree that Dickinson
 is anything but an impersonal poet (whatever that might be), but the very
 oddness of her expression in both finished poems and scraps is surely itself a
 kind of abstraction. The notion of abstraction is not in Jackson's index and is
 addressed explicitly only at the end of her book, pages 228, 236, and (very last
 sentence) 240.

19 Morse Peckham, *Man's Rage for Chaos: Biology, Behavior and the Arts* (New
 York: Schocken, 1967). On the Hegel phrase, though turning in a different
 direction, see Geoffrey Hartman, "Remnants of Hegel," in *Scars of the Spirit:
 The Struggle Against Inauthenticity* (New York: Palgrave Macmillan, 2002),
 41–52. On markedness in music, see Robert S. Hatten, *Musical Meanings in
 Beethoven: Markedness, Correlation, and Interpretation* (Bloomington: Indi-
 ana University Press, 1994).

20 The relevant information concerning Dickinson's interest in the distant war
 is collected in Shira Wolosky, *Emily Dickinson: A Voice of War* (New Haven:
 Yale University Press, 1984), and subsequently in "Public and Private in Dick-
 inson's War Poetry," in *A Historical Guide to Emily Dickinson*, ed. Vivian R.
 Pollak (Oxford: Oxford University Press, 2004), 103–31. Via the background
 of Methodist hymn writing, Wolosky's book absorbs the background of
 public militancy into a general stance of (as her fourth chapter title terms it)
 "metaphysical revolt"; the essay plays up the public contexts resonating within
 the conflicts and tensions of Dickinson's diction and imagery. With a corpus
 as large as Dickinson's, more than one emphasis will always be possible; the
 poems I select portray a much less dramatic stance. See also Judy Jo Small,

Positive as Sound: Emily Dickinson's Rhymes (Athens: University of Georgia Press, 1990); the first chapter (29–70) is entitled "A Musical Aesthetic," but phonetics and metrics are the real focus. Thanks to Vivian Pollak for valuable advice on Dickinson.

21 Neurosis is the explicit tenor of the torment (and again associated with twilight) in Grandmougin's poem "La Musique allemande," where he writes: "Ou [j'aime] que Schumann, l'ami des subtiles névroses, / Me dise, en courts sanglots, son obstiné tourment, / Quand à travers les vitres closes / Le grand ciel violet s'étoile lentement" (Or [I love] when Schumann, / The friend of subtle neuroses, / Tells me, in short sighs, his persistent torment, / When through the closed panes / The broad, violet sky slowly stars up), *Nouvelles poésies* (Paris: Calmann Lévy, 1881), 248.

22 See Jacques Derrida, *La Voix et le phénomène* (Paris: Presses Universitaires de France, 1967), 58–62 (ideality), 56 (presencing), 91 ("Le moment de la crise est toujours le moment du signe"). On turning points, see my "Errours Endlesse Traine," in *Turning Points: Essays in the History of Cultural Expressions* (Stanford: Stanford University Press, 1997), 3–30.

23 Jacques Derrida, "'This Strange Institution Called Literature': An Interview with Jacques Derrida," trans. Geoffrey Bennington and Rachel Bowlby, in Derrida, *Acts of Literature*, ed. Derek Attridge (New York: Routledge, 1992), 47, 46.

24 Marcel Proust, *Remembrance of Things Past*, trans. C. K. Scott Moncrieff, Terence Kilmartin, and Andreas Mayor, 3 vols. (New York: Vintage, 1981); *A la recherche du temps perdu*, 3 vols., ed. Pierre Clarac and André Ferré (Paris: Gallimard, 1954). Proust's readers have sought the original for Vinteuil's music in instrumental works by Fauré, Debussy, and Reynaldo Hahn. As far as I know, they have not thought to look at a different genre (though there is no specific generic model for Vinteuil's Septet), but the verbal correspondences with Grandmougin's poem are inescapable.

25 Jerome McGann, *Are Humanities Inconsequent? Interpreting Marx's Riddle of the Dog* (Chicago: Prickly Paradigm Press, 2009), 67–69.

26 See, in particular, Lawrence Kramer, *Music as Cultural Practice, 1800–1900* (Berkeley: University of California Press, 1990).

CHAPTER 2 *Music and Fantasy*

1 Lawrence Kramer, *Why Classical Music Still Matters* (Berkeley: University of California Press, 2007), 197.

2 Eduard Hanslick, *Vom musikalisch Schönen: Ein Beitrag zur Revision der Ästhetik der Tonkunst* (Wiesbaden: Breitkopf und Härtel, 1966), 7–8.

3 Lawrence Kramer, "Hands On, Lights Off: The 'Moonlight' Sonata and the Birth of Sex at the Piano," *Musical Meaning: Toward a Critical History* (Berkeley: University of California Press, 2002), 29–50.

4 Immanuel Kant, *Anthropologie in pragmatischer Hinsicht*, §28, B80. Quotations from Kant (ignoring Kant's typographical emphases) are cited in stan-

dard form, by section number and by page number in the original editions (A = first edition; B = second edition). Section numbers in *Anthropology* diverge in different editions.

5 In general, as I have argued in *The Gothic Text* (Stanford: Stanford University Press, 2005), 69–104, I look in Kant's writings toward places that "push toward the margins of his thought and hint at the poetic vision that is chastely excluded from his rational discourse, perhaps even from his conscious thought" (71).

6 Paul Guyer offers a fine description of the difficulties surrounding imagination in "The Harmony of the Faculties Revisited," *Values of Beauty: Historical Essays in Aesthetics* (Cambridge: Cambridge University Press, 2005), 77–109. But in the desire to systematize Kant's account (and despite his musical title), Guyer elides the productive tensions. He claims that judgment presumes a concept and that Kantian "aesthetic judgments . . . are about particular objects, which can only be individuated by means of such concepts" (95). But how determinate can Kant's notion of "the parrot, the hummingbird, the bird of paradise" have been (*Critique of Judgment*, §16, B49), way up there in the North?

7 Guyer, *Values of Beauty*, 79. Also see David Wellbery, "Stimmung," in *Ästhetische Grundbegriffe*, ed. Karlheinz Barck et al., 7 vols. (Stuttgart: Metzler, 2003), 5: 703–33, stressing the musical resonance of the term, especially in Kant; on "proportionierte Stimmung," see 709.

8 For summaries of most of the important eighteenth-century writers on the physics of music, consult the pages on "Musik" listed in the index of Joachim Gessinger, *Auge & Ohr: Studien zur Erforschung der Sprache am Menschen, 1700–1850* (Berlin: de Gruyter, 1994).

9 Charles Rosen, *Sonata Forms* (New York: Norton, 1980), 310, 314.

10 Rosen, *The Romantic Generation* (Cambridge, Mass.: Harvard University Press, 1995); John Daverio, *Nineteenth-Century Music and the German Romantic Ideology* (New York: Schirmer, 1993), 46.

11 Joseph Kerman, *The Beethoven Quartets* (New York: Knopf, 1967), 121.

12 For very suggestive speculations about irony and about Beethoven's endings, see Daniel K. L. Chua, *Absolute Music and the Construction of Meaning* (Cambridge: Cambridge University Press, 1999), 199–217 and 257–86, respectively.

13 Jean-Pierre Richard, *L'Univers imaginaire de Mallarmé* (Paris: Seuil, 1961), 569.

14 David Code, "Hearing Debussy Reading Mallarmé: Music 'après Wagner' in the 'Prélude à l'après-midi d'un faune,'" *Journal of the American Musicological Society* 54 (2001): 493–554, and "The Formal Rhythms of Mallarmé's Faun," *Representations*, no. 86 (Spring, 2004): 73–119; Elizabeth McCombie, *Mallarmé and Debussy: Unheard Music, Unseen Text* (Oxford: Oxford University Press, 2003), an admirable project, though unevenly successful in the execution.

15 On the music of decadence, see Yopie Prins, "Sappho Recomposed: A Song Cycle by Granville and Helen Bantock," in *The Figure of Music in Nineteenth-Century Poetry*, ed. Phyllis Weliver (Aldershot: Ashgate, 2005), 230–58. The essay relates the Bantocks' songs to Verlaine's *Art poétique*; my quotations come from Helen

Bantock's song text, Carolyn Abbate, and a tribute by Kennedy Scott included in Myrrha Bantock's memoir of her parents, quoted by Prins, 254, 255, 258. On unheard melodies and structuration, see my essay, "Unheard Melodies: The Force of Form," in *Turning Points: Essays in the History of Cultural Expressions* (Stanford: Stanford University Press, 1997), 239–67.

16 I take my cue concerning the symphonic poem from Carl Dahlhaus. See the essays grouped under the title "Aporien der Programmusik," in *Klassische und romantische Musikästhetik* (Laaber: Laaber, 1988), 365–413. In English, see Dahlhaus, *Esthetics of Music*, trans. William W. Austin (Cambridge: Cambridge University Press, 1982), 57–63, arguing that Liszt's works are progressive in intention but regressive in method.

17 See Dahlhaus, "Lieder ohne Worte," *Klassische und romantische Musikästhetik*, 140–44, relating to Hanslick and Liszt a well-known letter by Mendelssohn claiming that music portrays feelings more precisely than words can.

18 See Alexander Main, "Liszt after Lamartine: 'Les Préludes,'" *Music and Letters* 60 (1979): 130–48.

19 Verlaine's *Sagesse* (a volume almost entirely devoid of the *rimes impaires* recommended in "Art poétique") has several music-related examples of the sanctimonious tone into which he often fell: see number 16, beginning "Ecoutez la chanson bien douce," and, in number 19, "Et j'ai revu l'enfant unique," see the line "Et tout mon sang chrétien chanta la Chanson pure."

20 Lawrence Kramer, *Music as Cultural Practice, 1800–1900* (Berkeley: University of California Press, 1990), 102–34.

21 Rudolf Stephan comments briefly but pointedly on the equivalence of major and minor in Mendelssohn, in "Über Mendelssohns Kontrapunkt: Vorläufige Bemerkungen," *Vom musikalischen Denken: Gesammelte Vorträge*, ed. Rainer Damm and Andreas Traub (Mainz: Schott, 1985), 57–58. Stephan wants to defend Mendelssohn from the charge of superficiality, but my account would set the accents differently: the value of surfaces is precisely what was sought by a widespread nineteenth-century culture of refinement.

22 Lawrence Kramer, *Franz Schubert: Sexuality, Subjectivity, Song* (Cambridge: Cambridge University Press, 1998), 5, 38, 131, 141. Kramer associates scoring with the Lacanian Real, manifested through "disclosure . . . by means of an incongruity" (131). Another pun with related impact but antithetical gestation is "jamming," in Kramer, *After the Lovedeath: Sexual Violence and the Making of Culture* (Berkeley: University of California Press, 1997), 60. Jamming harmonizes with the improvisational conduct of *After the Lovedeath*, but the dialectic of score and performance remains fundamental to Kramer's conception of classical music, which "always addresses the listener against the possibility or memory of other note-for-note renditions" (*Why Classical Music Still Matters*, 82). Yet another version of musical fantasy, this time drawn from Wittgenstein, is "lighting up" (*Aufleuchten*), in Kramer, *Opera and Modern Culture: Wagner and Strauss* (Berkeley: University of California Press, 2004), 70–71. Kramer here links lighting to hermeneutic perspective; it is important

to keep in mind that *Aufleuchten* implies light flaring from within not from the interpreter's searchlight, which would call for the transitive form *Beleuchtung*. Mendelssohn's ophicleide flares from within the work, just as do the "loud cymbal clashes" in the Prelude to *Lohengrin* (71). Of course, the scoring can be further highlighted or else downplayed in performance.

While using these notes to record my infinite debt to Kramer's work, I should also pay tribute to his generosity of spirit by recording my finite reservation. Scoring, after all, hurts. What Kramer says about Schubert seems to apply generally to his own work: "affirmative moments are rare," and "the fullness of counternormative subjectivity is more often attained in the arena of pain" (*Franz Schubert*, 128). Joy is inevitably *jouissance*, and hence orgasmic: sensual pleasure is "visceral," indeed, "literally visceral"; it "ripples throughout the whole body" to overcome the risk of being "skeletal, literally superficial, without the addition of the inner voices"; and (quoting Ligeti on Chopin), it is "felt as a tactile shape, as a succession of muscular exertions" (*Why Classical Music Still Matters*, 74, 78, 153, 162). This body without surface doesn't dance (the late Nietzsche, admirer of Bizet, seems not to figure in Kramer's pantheon); its joy is too earnest for delight. In Kramer's accounts, as far as I can see, although play and irony can detoxify a tumescent masculinity (*After the Lovedeath*, 122), they become civilizing ends only in Mendelssohn, who offers "uninhibited play in which social and bodily energies merge and circulate" (*Classical Music and Postmodern Knowledge* [Berkeley: University of California Press, 1995], 139). Yet even in the work here under discussion, Mendelssohn's cantata *Die erste Walpurgisnacht*, the joy is "inextricable from the nightmare image of its other" and "claims . . . that patriarchy can humanize itself by recasting that nightmare as a midsummer night's dream" (141). I suppose that in this spirit one might etymologize Mendelssohn's ophicleide to interpret it as a threateningly patriarchal snake in the grass, but to my ear it's a hoot.

All the same, I can't imagine a richer conception of intimacy than Kramer's songfulness, when "voice addresses itself in its sensuous and vibratory fullness to the body of the listener, thereby offering both material pleasure and an incitement to fantasy" ("Beyond Words and Music: An Essay on Songfulness," *Musical Meaning*, 54).

23 For Bloch's critique of formalism, see Ernst Bloch, *Geist der Utopie: Zweite Fassung* (Suhrkamp: Frankfurt, 1964), 146–52. Bloch is not an antiformalist, but regards form as an epiphenomenal sedimentation of the artistic essence, which is "will."

24 On cheerfulness, a cardinal principle of German classicism, see Harald Weinrich, *Kleine Literaturgeschichte der Heiterkeit* (Munich: Beck, 2001). *Heiterkeit* mixes the Latin qualities *serenitas* and *hilaritas*, which perfectly encompass the spirit of Mendelssohn.

25 See in particular Lawrence Kramer, *Music and Poetry: The Nineteenth Century and After* (Berkeley: University of California Press, 1984), 234–41; also see

Joseph Kerman, "Taking the Fifth," in *Write All These Down: Essays on Music* (Berkeley: University of California Press, 1994), 207–16, and (arguing that the symphony moves from thematic-universal "thought" to motivic-contemporary "deed"), Peter Gülke, *Zur Neuausgabe der Sinfonie Nr. 5 von Ludwig van Beethoven: Werk und Edition* (Leipzig: Peters, 1978), 49–71.

26 Although arguably an extreme case, the ambiguities in the Fifth Symphony are also representative of Beethoven's "new path," as analyzed by Carl Dahlhaus in *Ludwig van Beethoven: Approaches to His Music*, trans. Mary Whittall (Oxford: Clarendon Press, 1991), 166–80. So, commenting on the D-Minor Piano Sonata, op. 31, no. 2, Dahlhaus writes: "Nearly all the formal sections occupy a twilight world, in which it is difficult or impossible to make pronouncements about their functions." And he draws the conclusion: "the ambiguity should be perceived as an artistic factor—an attribute of the thing itself, not a failure of analysis" (170).

27 Kerman, "Taking the Fifth." Scott Burnham says the first movement "eschew[s] preamble," *Beethoven Hero* (Princeton: Princeton University Press, 1995), 33, yet the whole opening section is "an opening," with "tonics that act as points of departure rather than points of arrival and closure" (39). The symphony, that is, lacking a preface, keeps on starting, all the way to the coda in the last movement that keeps on beginning to end (well described by Burnham on pp. 57–59). More generically, introductions are problematized in Peter Gülke, "Introduktion als Widerspruch im System: Zur Dialektik von Thema und Prozessualität bei Beethoven," *Deutsches Jahrbuch der Musikwissenschaft* 40 (1969): 5–40, though I found this essay less accessible than the later essay by Gülke cited in note 25.

28 For suggestive literary readings, see Susan J. Wolfson, *The Questioning Presence: Wordsworth, Keats, and the Interrogative Mode in Romantic Poetry* (Ithaca: Cornell University Press, 1996).

29 Heinrich Schenker, *Beethoven: Fünfte Sinfonie* (Vienna: Universal, 1969).

30 I am alluding here not so much to Frank Kermode's well-known account of the stabilizing tick-tock of narrative form, in *The Sense of an Ending: Studies in the Theory of Fiction* (London: Oxford University Press, 1966), 44–46, as to the correction that motivates Stuart Sherman's wise and witty *Telling Time: Clocks, Diaries, and English Diurnal Form, 1660–1785* (Chicago: University of Chicago Press, 1996), 9–11.

31 "Gaps" is Lydia Goehr's term for "suitable regulative or formal ideals that have been neither overdetermined nor closed by ideological content"; see *The Quest for Voice: On Music, Politics, and the Limits of Philosophy* (Berkeley: University of California Press, 1998), 37. While Goehr's brand of vitalism privileges lives over works in ways I would question, it would be hard to better her celebration of the freedom inherent in expression.

32 Rainer Cadenbach, "5. Symphonie c-Moll Op. 67," in *Beethoven: Interpretationen seiner Werke*, ed. Albrecht Riethmüller, Carl Dahlhaus, and Alexander L. Ringer (Laaber: Laaber, 1994), 486–502.

33 *Remembrance of Things Past*, trans. C. K. Scott Moncrieff, Terence Kilmartin, and Andreas Mayor (New York: Vintage, 1981), 3: 381. In *Proust musicien* (Paris: Bourgois, 1984), Jean-Jacques Nattiez quotes this passage (137–38) toward the climax of his argument linking music in Proust with Schopenhauerian timelessness. Suffice it to say that *ivresse* (here translated "exhilaration") is the French equivalent to a Nietzschean term, *Rausch*, and is incompatible with Schopenhauer's aesthetics.

34 Gilles Deleuze and Félix Guattari, *A Thousand Plateaus*, trans. Brian Massumi (Minneapolis: University of Minnesota Press, 1987), 300.

CHAPTER 3 *German Romanticism and Music*

1 See (with useful footnotes) Simon Richter, "Intimate Relations: Music in and around Lessing's 'Laokoon,'" *Poetics Today* 20 (1999): 155–73.

2 In *Kalligone* (1800), his angry riposte to the *Critique of Judgment*, Herder complains about Kant's neglect of music. Herder's chapter (2.4) is a good source for Sensibility commonplaces: music is *Schwingung*, rooted in mathematics, the dance, the sounds of nature, and the voice of the people; its attributes are spirit, devotion, and movement. Herbert S. Lindenberger gives a superb overview of interart competition and interaction in "Literature and the Other Arts," in *Cambridge History of Literary Criticism*, vol. 5, ed. Marshall Brown (Cambridge: Cambridge University Press, 2000), 362–86.

3 Friedrich Schiller, "Über Matthissons Gedichte," in *Sämtliche Werke*, vol. 5, ed. Gerhard Fricke and Herbert G. Göpfert (Munich: Hanser, 1960), 998–99.

4 The most sustained attempt at a music aesthetics building directly on Kant is in the voluminous (also, in my judgment, labored and confused) writings of Christian Friedrich Michaelis, beginning in 1795 and collected in *Über den Geist der Tonkunst und andere Schriften*, ed. Lothar Schmidt (Chemnitz: Gudrun Schröder, 1997).

5 E. T. A Hoffmann, "Beethovens Instrumental-Musik," in *Fantasie- und Nachtstücke*, ed. Walter Müller-Seidel (Darmstadt: Wissenschaftliche Buchgesellschaft, 1971), 41.

6 The indispensable studies of the cultural meanings of the music of the period are Charles Rosen, *The Classical Style: Haydn, Mozart, Beethoven* (New York: Norton, 1997), and *The Romantic Generation* (Cambridge, Mass.: Harvard University Press, 1995).

7 Wilhelm Heinrich Wackenroder, "Wie und auf welche Weise man die Werke der großen Künstler der Erde eigentlich betrachten und zum Wohle seiner Seele gebrauchen müsse," *Sämtliche Werke und Briefe*, 2 vols., ed. Silvio Vietta and Richard Littlejohns (Heidelberg: Winter, 1991), 1: 108; the phrase is, "die mächtigen, majestätischen Säulen, mit ihrer lieblichen Erhabenheit."

8 The *Herzensergießungen* is identified as H, the *Phantasien über die Kunst* as P. The sections are identified by short title (and chapter number for the Berglinger novella). A bracketed initial identifies W(ackenroder) or T(ieck) as author. All

quotations come from volume 1 of the Vietta and Littlejohns edition.

9 Christian Friedrich Daniel Schubart, *Ideen zu einer Ästhetik der Tonkunst*, ed. Fritz and Margrit Kaiser (Hildesheim: Olms, 1990), 3, 5.

10 See Christine Lubkoll, *Mythos Musik: Poetische Entwürfe des Musikalischen in der Literatur um 1800* (Freiburg: Rombach, 1995), 125–60.

11 Daniel K. L. Chua's brilliant, sometimes exasperating *Absolute Music and the Construction of Meaning* (Cambridge: Cambridge University Press, 1999) has particularly revealing discussions of Romantic views on the temporal effects of music; see, for instance, the section "On Politics," 162–66, on utopian futurity. The standard study is Carl Dahlhaus, *The Idea of Absolute Music*, trans. Roger Lustig (Chicago: University of Chicago Press, 1989); also useful is Dahlhaus's *Esthetics of Music*, trans. William W. Austin (Cambridge: Cambridge University Press, 1982).

12 See, in particular, Rudolf Schäfke, *Geschichte der Musikästhetik in Umrissen* (1933; Tutzing: Hans Schneider, 1964), 324–71—almost his entire Romanticism chapter—where the sections about art and those about music in the *Effusions* are quoted indiscriminately.

13 On Moritz, see Carl Dahlhaus, "Karl Philipp Moritz und das Problem einer klassischen Musikästhetik," *Klassische und romantische Musikästhetik* (Laaber: Laaber, 1988), 20–43.

14 See the little-known but meticulously informative essay by Hermann Güttler, "Kant und sein musikalischer Umkreis," in *Beethoven-Zentenarfeier: Internationaler musikhistorischer Kongress*, ed. Guido Adler (Vienna: Universal, 1927), 217–21. Other treatments of Kant on music include Herbert M. Schueller, "Immanuel Kant and the Aesthetics of Music," *Journal of Aesthetics and Art Criticism* 14 (1955): 218–47; Giselher Schubert, "Zur Musikästhetik in Kants Kritik der Urteilskraft," *Archiv für Musikwissenschaft* 32 (1975): 12–25; Herman Parret, "Kant on Music and the Hierarchy of the Arts," *Journal of Aesthetics and Art Criticism* 56 (1998): 251–64.

15 Norbert Elias gives an eloquent, somewhat overstated account of Mozart's drive to independence (ignoring the earlier example of Handel in England) in *Mozart: Portrait of a Genius*, ed. Michael Schröter, trans. Edmund Jephcott (Berkeley: University of California Press, 1993). More soberly informative, along fundamentally similar lines, is Andrew Steptoe, *The Mozart–Da Ponte Operas: The Cultural Life and Musical Background to "Le Nozze di Figaro," "Don Giovanni," and "Così fan tutte"* (Oxford: Clarendon Press, 1988), 33–52.

16 On Wackenroder's notion of the "power" of music, see John T. Hamilton, *Music, Madness, and the Unworking of Language* (New York: Columbia University Press, 2008), 122–29. On battle symphonies and mass music, see Richard J. Will, *The Characteristic Symphony in the Age of Haydn and Beethoven* (Cambridge: Cambridge University Press, 2002), 188–241. In England the cult of volume is linked with Handel and with Burkean sublimity; see Claudia L. Johnson, "'Giant Handel' and the Musical Sublime," *Eighteenth-Century Studies* 19 (1986): 515–33.

17 E. T. A. Hoffmann, *Schriften zur Musik*, ed. Friedrich Schnapp (Darmstadt: Wissenschaftliche Buchgesellschaft, 1971), 369.

18 Handel often had three dozen players, but in some seasons less; the point is that the operas don't require so many and use the orchestra very differently from the operas that Romantics heard. Handel's more spectacular operas were also staged with many supernumeraries and noisy effects supplementing the more limited power of music. For information, see Mark W. Stahura, "Handel and the Orchestra," and Winton Dean, "Production Style in Handel's Operas," in *The Cambridge Companion to Handel*, ed. Donald Burrows (Cambridge: Cambridge University Press, 1997), 238–48 and 249–61. For Mozart's orchestra, see Manfred Schmid, *Mozarts Opern: Ein musikalischer Werkführer* (Munich: Beck, 2009), 39–48.

19 In the chapter "Ueber das Instrumentiren" of his influential polemic in favor of early music, *Über Reinheit der Tonkunst* (1825; Darmstadt: Wissenschaftliche Buchgesellschaft, 1967), Anton Thibaut complains at some length about "thundering drums and blaring trumpets" (57).

20 George Eliot, *The Mill on the Floss* (Boston: Estes and Lauriat, n.d.), 321–22 (bk. 5, ch. 1, "In the Red Deeps"), 390 (bk. 6, ch. 1, "A Duet in Paradise").

21 Friedrich Schlegel, *Kritische Schriften*, ed. Wolfdietrich Rasch (Munich: Hanser, 1964), 87.

22 See Leo Spitzer, *Classical and Christian Ideas of World Harmony: Prolegomena to an Interpretation of the Word "Stimmung,"* ed. Anna Granville Hatcher (Baltimore, Md.: Johns Hopkins University Press, 1963), and also 705–12 in David Wellbery, "Stimmung," *Ästhetische Grundbegriffe*, ed. Karlheinz Barck et al., 7 vols. (Stuttgart: Metzler, 2003), 5: 703–33. A recent survey of Schlegel's comments on music is Mirko M. Hall, "Friedrich Schlegel's Romanticization of Music," *Eighteenth-Century Studies* 42 (2009): 413–29. Schlegel's core theories, of course, deeply influenced musicians; the fullest treatment is John Daverio, *Nineteenth-Century Music and the German Romantic Ideology* (New York: Schirmer, 1993).

23 The relevant fragments by Friedrich Schlegel and Novalis are usefully selected, along with other texts of Sensibility and early Romanticism, in Barbara Naumann, *Die Sehnsucht der Sprache nach Musik: Texte zur musikalischen Poetik um 1800* (Stuttgart: Metzler, 1994), from which my quotations are drawn. For rich background, see John Neubauer, *The Emancipation of Music from Language: Departure from Mimesis in Eighteenth-Century Aesthetics* (New Haven: Yale University Press, 1986). For Novalis, a good starting point is Dennis F. Mahoney, "'Heinrich von Ofterdingen' oder Die Macht der Musik," in *Novalis: Poesie und Poetik*, ed. Herbert Uerlings (Tübingen: Niemeyer, 2004), 81–92.

24 See Rita Terras, *Wilhelm Heinses Ästhetik* (Munich: Fink, 1972), 115–18.

25 For abundant information on eighteenth-century music reviewing, see Mary Sue Morrow, *German Music Criticism in the Late Eighteenth Century: Aesthetic Issues in Instrumental Music* (Cambridge: Cambridge University Press, 1997).

26 A cardinal contention of Dahlhaus's essay collection *Klassische und roman-tische Musikästhetik* is the inseparability of Classicism and Romanticism; see especially his "Einleitung," 9–14. An example would be the Romantic Hoff-mann's praise of "the classic manner" of unification in Beethoven's *Egmont Overture*.

27 All the relevant plots are diligently summarized in George C. Schoolfield, *The Figure of the Musician in German Literature* (Chapel Hill: University of North Carolina Press, 1956).

28 See Herbert Lindenberger, *Opera: The Extravagant Art* (Ithaca, N.Y.: Cornell University Press, 1984), 145–96.

29 A good starting point for music in Hoffmann's fiction is Klaus-Dieter Dobat, *Musik als romantische Illusion: Eine Untersuchung zur Bedeutung der Musikvorstellung E.T.A. Hoffmanns für sein literarisches Werk* (Tübingen: Niemeyer, 1984).

30 Arthur Schopenhauer, *Werke in zwei Bänden*, ed. Werner Brede (Munich: Hanser, 1977), 1: 337, 342, 344.

31 The fullest study, with copious bibliography, Alain Patrick Olivier, *Hegel et la musique: De l'expérience esthétique à la spéculation philosophique* (Paris: Champion, 2003), shows that Hegel's own rougher and less well informed lecture texts were much edulcorated by his editor. For a good brief account of the semiotics of music in Hegel, see Helmut Müller-Sievers, "Generalpause: Ein langer Umweg von Hegel zu Bruckner," in *Hegel: Zur Sprache, Beiträge zur Geschichte des europäischen Sprachdenkens*, ed Bettina Lindorfer and Dirk Naguschewski (Tübingen: Gunter Narr, 2002), 121–29. For music in Hegel's *Phenomenology*, see chapter 1.

32 Hoffmann, *Fantasie- und Nachtstücke*, 326; *Die Serapions-Brüder*, ed. Walter Müller-Seidel and Wulf Segebrecht (Darmstadt: Wissenschaftliche Buch-gesellschaft, 1970), 38. Of course (as Nicholas Saul reminded me), the moral valence in Hoffmann is equivocal at best.

33 Robert Schumann, *Gesammelte Schriften über Musik und Musiker*, 2 vols., ed. Martin Kreisig (Leipzig: Breitkopf und Härtel, 1914), 1: 371, 418.

34 A useful overview of the music of sound is Giovanni di Stefano, "Der ferne Klang: Musik als poetisches Ideal in der deutschen Romantik," *Euphorion* 89 (1995): 54–70. With particular reference to Tieck's lyrics, see also Manfred Frank, *Einführung in die frühromantische Ästhetik: Vorlesungen* (Frankfurt: Suhrkamp, 1989), 380–462. Frank puts sound (*Klang*) above semantics and "content" (427). There are more variegated readings of Romantic prose with musical subjects in Steven P. Scher, *Verbal Music in German Literature* (New Haven: Yale University Press, 1968).

35 Franz Grillparzer, *Sämtliche Werke*, ed. Peter Frank and Karl Pörnbacher, 4 vols. (Munich: Hanser, 1963–65), 3: 887. Translinguistic communication and nostalgia are topics now usefully surveyed by Andrew Bowie in "Romanticism and Music," *The Cambridge Companion to German Romanticism*, ed. Nicholas Saul (Cambridge: Cambridge University Press, 2009), 243–56.

CHAPTER 4 *Negative Poetics*

1 Barbara Herrnstein Smith, *On the Margins of Discourse: The Relation of Literature to Language* (Chicago: University of Chicago Press, 1978), 27. See also 31: "A poem is never spoken, not even by the poet himself. It is always re-cited; for whatever its relation to words the poem *could* have spoken, it has, as a poem, no initial historical occurrence." Or, as the German modernist poet Gottfried Benn writes, a modern poem (I would say, any poem) "does not arise in a weepy mind during a sunset mood, it arises with awareness, it is a product of art, it is made," "Vortrag in Knokke" (1952) in *Gesammelte Werke*, ed. Dieter Wellershoff, 4 vols. (Wiesbaden: Limes, 1962), 1: 545.

2 Benn, "Probleme der Lyrik" (1951), *Gesammelte Werke* 1: 515.

3 Dieter Lamping, in *Das lyrische Gedicht: Definitionen zu Theorie und Geschichte der Gattung* (Göttingen: Vandenhoeck und Ruprecht, 1989), defines lyric poetry as "versified speech" ("Rede in Versen," 23) and comments, with more emphasis than precision, on the value added by line divisions; when a prose text by Novalis is versified it becomes "richer in meanings" and "more sustained" and it acquires connotations of sublimity and "symbolic meanings" (53). Lamping grounds "the peculiarity of lyrical communication" on its "distinctive monolog character" (66). Yet he criticizes the noted genre theorist Käte Hamburger in particular for her belief that the lyric speaker is "a real I" and "more or less identical with the poet's I" (61). Surely the conclusion must be that the poet's I divides the speaker's prose into verse and adds the value that is not in the prosaic communication.

4 Murray Krieger, "The Ekphrastic Principle and the Still Movement of Poetry; or *Laokoön* Revisited," *The Play and Place of Criticism* (Baltimore, Md.: Johns Hopkins University Press, 1967), 105–28.

5 William Wordsworth, "She Dwelt Among the Untrodden Ways," "A Slumber Did My Spirit Seal," "Lines Composed a Few Miles Above Tintern Abbey"; John Keats, "Ode to a Nightingale," "Ode on Melancholy"; Percy Bysshe Shelley, "To a Sky-Lark"; Eduard Mörike, "Auf eine Lampe" (Still undisturbed, O lovely lamp).

6 Francesco Petrarca, *Rime* 104 (I find no peace, nor have I to make war); Shakespeare, Sonnet 116; John Donne, "A Valediction, Forbidding Mourning"; Alfred, Lord Tennyson, song from *The Princess*; Gerard Manley Hopkins, "Spring"; William Butler Yeats, "Sailing to Byzantium"; Rainer Maria Rilke, *Sonnette an Orpheus* 2.4 (O this is the animal that does not exist); Gottfried Benn, "Grenzenlos" (Flower of the primary / genuine No / to utility chimeras / to development existence).

7 Indeed, Hugo Friedrich's foundational study, *Die Struktur der modernen Lyrik: Von Baudelaire zur Gegenwart* (Hamburg: Rowohlt, 1965), has no doubts that "modern poetry is far more precisely described with negative categories than with positive ones" (16). Friedrich associates negation with uncovering of essence (99) and, in turn, with music in the sense to be developed here, namely: "less in audible figures than in gradations of intensity, in absolute

movements of ascent and descent, in the alternation of blockage and release" (69, on Rimbaud, and cf. 89, on Mallarmé's "contrapuntal prose").

8 Gaston Bachelard, *La Philosophie du non: Essai d'une philosophie du nouvel esprit scientifique* (Paris: Presses Universitaires de France, 1988), 9–10.

9 Skepticism comes, of course, in many flavors. As used in this essay, it refers to a posture that is inquisitive rather than denunciatory and concerned with knowledge rather than identity. The volume in which an earlier version of this chapter appeared, *Skepsis und literarische Imagination*, ed. Bernd Hüppauf and Klaus Vieweg (Munich: Fink, 2003), illustrates the whole range of skeptical positions. The link with curiosity is touched on in Michael Hammerschmidt, "Skeptische Poetik und ihre literarischen Tropen bei Johann Karl Wezel, Herman Melville und Robert Walser," 168. Blumenberg is analyzed in a pertinent (though not identical) way in Eva Geulen, "Passion in Prosa," 153–63; the playful side of skepticism is the topic of Klaus Vieweg, "Komik und Humor als literarisch-poetische Skepsis—Hegel und Laurence Sterne," 63–74.

10 Alain Badiou predicates skeptical negation as the special case of a postmodernist poet: "in contrast to the strictly dialectical image of negation in Mallarmé, there is in Pessoa a *floating negation* destined to infect the poem with a constant equivocation between affirmation and negation," *Handbook of Inaesthetics*, trans. Alberto Toscano (Stanford: Stanford University Press, 2005), 39. Jean-Pierre Richard has an illuminating discussion of negativity in *L'Univers imaginaire de Mallarmé* (Paris: Seuil, 1961), 184–208. He takes negation existentially: "Each negation realized outside of himself also traverses him personally, shakes him like an electric shock, and Mallarmé arranges for us to be electrocuted as well" (185). Yet Jean Hyppolite as cited in a note to this very passage strikes a very different tone: "Let us imagine . . . Hegel's *Logic,* turned into its very own self-questioning . . .[then] we will have an idea of the Mallarméan temptation" ("*Le coup de dés de Mallarmé et le message,*" *Cahiers Philosophiques*, no. 4 [1958]: 463–64, cited in Richard, *L'Univers*, 233). Cartesianism become dialectical self-questioning is the kind of skeptical distance I aim to describe, and is indeed closer to the "happy Mallarmé" at whom Richard's book later arrives than Richard himself sounds here. Surely, far from exclusive to Pessoa, Badiou's "constant equivocation" is tantamount to the lesson that deconstruction learned from existentialism. A signal, little-known instance is Paul de Man's 1960 Harvard dissertation, notably titled "Yeats, Mallarmé and the Postmodernist Dilemma." Of the "douteuse perception" and "équivoque" [dubious perception, equivocation] evoked in the second section of Mallarmé's *Igitur*, for instance, de Man writes, "To be conscious of death is to be conscious of the self as *becoming* . . . ; it is a knowledge of a not-knowing" (60). And the Mallarmé section concludes: "Poetic language endures forever, as the eternal calling into question of Being" (125, followed by a Greek quotation from the pre-Socratic philosopher of flux Heraclitus).

11 The questioning begins in the second song, titled "Wohin?" (Whither?). The song is in G major, but it edges up to a B-major cadence when the question

is posed: "O Bächlein, sprich, wohin? wohin?—sprich, wohin?" (B major, the key of "Der Neugierige," is also that of the opening song, "Das Wandern," and hence is identified from the start with the youth's restlessness.) Not only does the key of "Der Neugierige" evoke this moment, but a similar ascent by half-tones confirms the echo: the notes of the question in "Wohin?" are A–A#–B, as the question in "Der Neugierige" is introduced by the sequence B–B#–C# (m. 48). The question word "wohin?—initially rising—is repeated with a falling gesture, D#–B (mm. 40 and, again, 41): thus both songs present the question as if it were its own answer, or, one might say, present the question usurping on the place of the answer. Of course, the poems lack the repetitions, let alone the marked inflections that carry the expression.

12 Most of the songs in *Die schöne Müllerin* are either fully or largely strophic, with five complete repetitions in the slow concluding lullaby sung by the brook to the suicidal lover. Only two songs change tempo: no. 5, "Der Feierabend," where a quickening tempo marks the high spirits of release at the end of the work day, and then no. 6, "Der Neugierige," where the slowing that drags the spirits down is the payback.

13 I thank David Kopp in particular for the observation that measure 42 is a second inversion of the tonic, with F-sharp in the bass rather than the typical B. A second inversion of the tonic, late in a movement, he has written me, is "normally . . . the high point of a phrase, containing an accumulation of tension" to be followed by release in a cadence or (in a larger movement) in an extended cadenza. Here, he continues, "following the crescendo there is a subito pianissimo, a negative accent." Making "the second inversion the quietest point in the phrase [is] a very conspicuous musical negation," somewhat laborious to describe in words but unmistakably uncanny in a good performance.

14 Anne Ferry's copious study, *The Title to the Poem* (Stanford: Stanford University Press, 1996), categorizes titles grammatically. Both "Unqualified Nouns" (191–97) and "Nouns Qualified by Articles" (197–203) are repeatedly described as neutral and impersonal. "Indecisive" might be better. Articles, in particular, can single out an individual ("Der Neugierige" = this one in particular) or assimilate him to a group ("Der Neugierige" = the type). By virtue of its isolation before the poem, the title—this one in particular, and titles in general—leaves you wondering. On the "kinetics" of articles, see Gustave Guillaume, *Langage et science du langage* (Paris: Nizet, 1969), 143–83.

15 As its name suggests, the subdominant (fourth tone of the scale, so F in relation to C or, here, E in relation to B) conventionally serves in common-practice harmony as a relaxation of energy; the converse (dominant) relation increases energy. The question may arise here (as, in more extreme form, in the discussion of "Pentiti" and "Battiti" in chap. 10) whether listeners can be expected to hear tonal relations long distance. The general answer is no, but performers should recognize them and structure their interpretations to communicate the implied feelings.

16 Cf. Richard Kramer, *Distant Cycles: Schubert and the Conceiving of Song*
 (Chicago: University of Chicago Press, 1994), a rich, if highly technical, study:
 "With a temporal accuracy unknown to poetry, music, in the rich texture of
 temporalities that is innate in it, realizes the narrative across its diachronic
 axis. How these two aspects of song maintain a balance, how the one (the
 synchronic, we might call it) would be constrained from violating the other
 (the diachronic), is the agon at the essence of song cycle" (216). All the musical
 effects I have described that are called for in the score can be heard (though
 transposed) in the finely detailed performance by Dietrich Fischer-Dieskau
 and Gerald Moore, recorded for Polydor in 1972 and currently available as
 Deutsche Grammophon 415 186–2.

17 See Vladimir Jankélévitch, *Music and the Ineffable*, trans. Carolyn Abbate
 (1961; Princeton: Princeton University Press, 2003), for a rich account of
 music's various ways of avoiding meaning. The second half of the book, to
 be sure, refrains from attributing any particular accomplishments to music,
 and along the way there are some diatribes against formalism and detailed
 accounting of musical effects, e.g., 53: "Fauré's *En Sourdine* is coextensive with
 Verlaine's poem and nevertheless does not tangle itself up in the details of
 the text." A better sustained rerun of many of the same ideas may be found in
 Jankélévitch's subsequent book, *La Vie et la mort dans la musique de Debussy*
 (Neuchâtel: Baconnière, 1968). Lydia Goehr's informative essay, "Radical
 Modernism and the Failure of Style," *Representations* 74 (Spring 2001): 55–82,
 begins with a more pointed negation, but follows a related itinerary toward the
 notion of shadowing forth the Idea.

18 Lawrence Kramer, *Music and Poetry: The Nineteenth Century and After*
 (Berkeley: University of California Press, 1984), 132. Kramer's subsequent
 Franz Schubert: Sexuality, Subjectivity, Song (Cambridge: Cambridge Univer-
 sity Press, 1998), 129–51, persuasively reads the suspensiveness of *Die schöne
 Müllerin* as the mark of masochism; his revised account of neoplatonic sexu-
 ality in "Ganymed" is on pages 118 to128. See also the chapter "Beyond Words:
 An Essay on Songfulness," in Kramer, *Musical Meaning: Toward a Critical
 History* (Berkeley: University of California Press, 2002), 51–67; the terms
 songfulness and overvocalizing are compared on pages 63–64. Less resonant
 are the echo effects resumed in Bruce R. Smith, *The Acoustic World of Modern
 England:Attending to the O-Factor* (Chicago: University of Chicago Press,
 1999), where voice is preemptive: "The object the audience hears in a human
 voice is character." "Through the sound of their voices alone, such characters
 establish a subject position the auditors have no choice but to share" (245, 281).

19 Music does not inevitably stand aside and still the emotion it portrays. A par-
 ticularly interesting test case is the opening song of Schumann's *Dichterliebe*.
 The poet here sings of the yearning of love, and no satisfaction is in sight; the
 piano postlude slows down but ends—not quite uniquely but certainly aston-
 ishingly—on a dissonance. For an interesting discussion of the "reciprocal
 clarification and enrichment" of words and music in songs, see George Steiner,

After Babel: Aspects of Language and Translation (Oxford: Oxford University Press, 1998), 438–46 (quote from 446).

20 Hans Blumenberg, *The Legitimacy of the Modern Age*, trans. Robert M. Wallace (Cambridge, Mass.: MIT Press), 403–35. "The 'Trial' of Theoretical Curiosity" is the title of the last of the book's three parts.

21 Still unmatched, to my knowledge, is the dissection of lyric simplicity in the 1933 essay by Max Kommerell, "Das Volkslied und das deutsche Lied," in *Dame Dichterin und andere Essays*, ed. Arthur Henkel (Frankfurt: Deutscher Taschenbuch Verlag, 1967), 7–64. While Kommerell does not speak of skepticism, the section on Goethe in particular (12–21) focuses on themes of self-presentation (as opposed to self-expression), self-conscious construction, and musical commentary in the Lied, in ways that illuminate the present essay. I would dissent only from the quasi-Schillerian account of a kind of second naiveté in Eichendorff on pages 40–51, for reasons given below.

22 "Eichendorff's Times of Day," *German Quarterly* 50 (1977): 485–503, originally drafted in 1969 as part of my dissertation.

23 German has two words for lightning. The dramatic form is *Blitz*. *Wetterleuchten* (the word in Eichendorff's poem) is the remote flashing of summer clouds.

24 "The soundless gathering call, by which Saying moves the world-relation on its way, we call the ringing of stillness," Martin Heidegger, "The Nature of Language," in *On the Way to Language*, trans. Peter D. Hertz (New York: Harper and Row, 1959), 108; "Das Wesen der Sprache," *Unterwegs zur Sprache* (Pfullingen: Neske, 1959), 215. Even more emphatic is the italicized formulation, "Die Sprache spricht als das Geläut der Stille" (Language speaks as the ringing of silence), "Die Sprache," *Unterwegs*, 30, not included in the English translation.

25 Drawing on a different poem, Thomas Pfau's subtle account of Eichendorff's style (*Romantic Moods: Paranoia, Trauma, and Melancholy, 1790–1840* [Baltimore, Md.: Johns Hopkins University Press, 2005], 236–46) puts it this way: "This paradox of escapist desires not concealed but curiously accented in lyric speech ultimately is not so much symptomatic of the romantic lyric as constitutive of it. That is, far from being a mere rhetorical accident randomly vitiating the expressive agenda of a given poem, the paradox in question is being rehearsed *by* the text and *for* an audience whose longing for a state of pure inwardness the text itself qualifies rather than indulges" (242–43). I agree perfectly with Pfau that lyric heightens self-consciousness by foregrounding its devices and that (as Pfau critiques de Man) its mode is constructively reflexive, not deconstructive. In this section of his book, Pfau might be thought to imply that the mode that he terms "hypersimulation" (239, 242) is specific to the times, "an allegory of lyric production during the postrevolutionary era" (245). I suggest that his hypersimulation is my skepticism and characterizes lyric generally. Constitutive of late Romanticism are not the mode but the contents, Pfau's "escapist desires," fully analyzed with reference to Eichendorff in his subsequent chapter (246–306).

26 I allude or refer in sequence to the following views of the lyric. The locus clas-
 sicus for *Erlebnisdichtung* is the section on lyric poetry in Hegel's *Aesthetics*;
 for a particularly useful discussion, see Hiltrud Gnüg, *Entstehung und Krise
 lyrischer Subjektivität: Vom klassischen lyrischen Ich zur modernen Erfah-
 rungswirklichkeit* (Stuttgart: Metzler, 1983), 29–42. Irony: Cleanth Brooks,
 The Well-Wrought Urn: Studies in the Structure of Poetry (New York: Har-
 court, Brace, 1947). See also Richard Macksey, "'To Autumn' and the Muse
 of Mortality: 'Pure Rhetoric of a Language without Words,'" in *Romanticism
 and Language*, ed. Arden Reed (Ithaca, N.Y.: Cornell University Press, 1984),
 263–308, which refers "the essential negativity of all linguistic constructs" to a
 Schlegelian "irony of objectivity and detachment" so far from wit that it seems
 identical to what I have been terming skepsis (quotes from 305). Critique:
 Theodor W. Adorno, "On Lyric Poetry and Society," in *Notes to Literature*, ed.
 Rolf Tiedemann, trans. Shierry Weber Nicholsen, 2 vols. (New York: Columbia
 University Press, 1991), 1: 37–54. "Parataxis," a later essay on Friedrich Hölder-
 lin, however, communicates a subtler view of lyric style: "The transformation
 of language into a serial order whose elements are linked differently than in
 the judgment is musiclike," *Notes* 2: 131. Deconstruction: Timothy Bahti, *Ends
 of the Lyric: Direction and Consequence in Western Poetry* (Baltimore, Md.:
 Johns Hopkins University Press, 1996). Paul H. Fry, *A Defense of Poetry: Reflec-
 tions on the Occasion of Writing* (Stanford: Stanford University Press, 1995),
 especially chapter 3 (50–70), "The Hum of Literature: Ostension in Language."

27 The same issues are expanded in Wordsworth's elegy for his drowned brother,
 "Elegiac Stanzas Suggested by a Picture of Peele Castle, in a Storm, Painted
 by Sir George Beaumont" (1805). Goethe's terror-stricken quiet is split in two
 through Wordsworth's confrontation of the utopian but deadly calm of the
 ocean he observed and the animated yet enduring storm in the painting. See
 the interpretation by Marjorie Levinson, *Wordsworth's Great Period Poems:
 Four Essays* (Cambridge: Cambridge University Press, 1986), 101–34, esp. on
 skepticism, 109 ("in that the narration belongs to a speaker who, by his own
 emphatic account, has lost his Paradise, my skepticism should be taken to
 amplify his"), and on negation, see pages 126–27.

28 "Die Nebel zerreißen, / Der Himmel ist helle, / Und Äolus löset / Das ängstli-
 che Band. / Es säuseln die Winde, / Es rührt sich der Schiffer. / Geschwinde!
 Geschwinde! / Es teilt sich die Welle, / Es naht sich die Ferne; / Schon seh
 ich das Land!" (The mists divide, / The sky is clear, / And Eolus loosens / The
 anxious bond. / The winds rustle, / The helmsman stirs. / Swiftly! Swiftly! /
 The wave divides, / The distance nears; / Now I see land!)

29 One might characterize lyric skepticism as an ironic authority. See, in
 particular, the sustained characterization of romantic poems in terms of a
 disjunction between poet and speaker in David Simpson, *Irony and Author-
 ity in Romantic Poetry* (Totowa, N.J.: Rowman and Littlefield, 1979). On page
 16, Simpson promises a discussion of philosophical skepticism, though I don't
 think that the hesitant deconstruction of causality and identity on pages

113–37 really delivers. In a similar spirit, more delicate in its readings, though without ever invoking skepticism by name, is Albert Cook, *Thresholds: Studies in the Romantic Experience* (Madison: University of Wisconsin Press, 1985). Begin with the critique of vulgar (non-Derridean) deconstruction in the preface and with the characterization of poetic discourse in connection with Emily Dickinson on pages 199–200. To call such delicate mastery skepticism is to follow Bernd Hüppauf's linkage of the skeptical and aesthetic traditions of thought in "Literatur nach der Skepsis," *Cultura Tedesca* 9 (1998): 181–207. This is different from the "radical skepticism" leading to "the world's vanishing at a touch," made familiar by Stanley Cavell—here I cite "The Uncanniness of the Ordinary," in *In Quest of the Ordinary: Lines of Skepticism and Romanticism* (Chicago: University of Chicago Press, 1988), 158—which forgets that Hume was skeptical even of his radical doubt and continued happily beyond the moment of "philosophical melancholy and delirium" concluding the first book of the *Treatise of Human Nature*.

30 Helen Vendler, *The Art of Shakespeare's Sonnets* (Cambridge, Mass.: Harvard University Press, 1997), 26. I regard Vendler's "irony" here as equivalent to my skepticism; it is more existential than rhetorical.

31 William Wordsworth, *The Literary Criticism of William Wordsworth*, ed. Paul M. Zall (Lincoln: University of Nebraska Press, 1966), 57–58. Like Wordsworth, Wilhelm Dilthey associates poetry as much with craft as with expression, despite often being presented as the apostle of *Erlebnisdichtung*. See the pages on "Erlebnis und Dichtung," in *Das Erlebnis und die Dichtung* (1877 as essay, 1905 as book; Göttingen: Vandenhoeck und Ruprecht, 1970), 138–42.

32 Northrop Frye, *Anatomy of Criticism* (New York: Atheneum, 1966), 278. "The association with music" is more particularly developed in Frye, "Approaching the Lyric," in *Lyric Poetry: Beyond New Criticism*, ed. Chaviva Hošek and Patricia Parker (Ithaca, N.Y.: Cornell University Press, 1985), 31–37 (quote from 34). A number of the contributions in this collection are relevant to the present essay, above all Herbert F. Tucker, "Dramatic Monologue and the Overhearing of Lyric" (226–43), a conjoint critique of both immediacy and persona theories, along with rich documentation of their presence in Victorian and modern aesthetics and criticism. Charm is also a central term for the aspect of Jankélévitch's thought that I depart from. The parallel in the German realm is Emil Staiger, *Grundbegriffe der Poetik* (1946; Zurich: Atlantis, 1963), 13–82, an unrepentant account of meaningless musicality, full of talk about the "Zauber der Eingebung" (24) and the like, in which aura is insistently evoked as mere "Stimmung." Even more egregious is the notion of a "concerto for thought and orchestra" in Tamara Sil'man, "Misl'–Obraz–Chuvstvo–Zvuk," *Zametki o lirike* (Leningrad: Sovetskii Pisatel', 1977), 46–74 (quote from 48); Sil'man reduces music to "sound painting" (*zvukopis'*)—echoing sounds, devoid of thought. For a more self-conscious, more structural rendition, see Kenneth Burke, "On Musicality in Verse," in *The Philosophy of Literary Form* (New York: Vintage, 1957), 296–304.

33 Jorge Luis Borges, *This Craft of Poetry*, ed. Calin-Andrei Mihailescu (Cambridge, Mass.: Harvard University Press, 2000), 85–86. Decades before, Borges had sounded a similar note, less ironically, in the poem "Arte poética," from the 1960 volume *El Hacedor*: "Convertir el ultraje de los años / En una música un rumor un símbolo, / . . . tal es la poesía / Que es inmortal y pobre" (To convert the outrage of years / into a music a murmur a symbol, / . . . such is poetry / which is immortal and poor).

34 Skepticism is not a familiar term in the Herbert criticism, where theological issues are more immediate than philosophical ones. And his poetry does not scrutinize psychological emotions so much as religious ones such as faith and despair. Still, the skeptical attitude of looking in wonderment that I have been evoking is commonly suggested in writings about the poet. Richard Strier, for instance, says that "a quintessential Herbert poem," *The Holdfast*, dramatizes "the strangeness and the wonder of faith alone"; *Love Known: Theology and Experience in George Herbert's Poetry* (Chicago: University of Chicago Press, 1983), 73, and see the virtuoso reading of "The Collar," 219–27. A relevant essay is Douglas Trevor, "George Herbert and the Scene of Writing," in *Historicism, Psychoanalysis, and Early Modern Culture*, ed. Carla Mazzio and Douglas Trevor (New York: Routledge, 2000), 228–58, which focuses on the related question of self-observation. On Stevens, I follow the lead of James Lucas's brilliant essay, "Fiction, Politics, and Chocolate Whipped Cream: Wallace Stevens's 'Forces, the Will, and the Weather,'" *ELH* 68 (2001): 745–61. Lucas treats Stevens's "nougat" as, in effect, a pun on naught, and he ends with Beckett's "Mr. Knott," after characterizing one kind of skeptical stance as follows: "Stevens produces a further, potentially available subject position, which remains immune to political influence *and* to charges of escapist irrelevance *because* it is never developed" (759).

35 R. P. Blackmur, "Lord Tennyson's Scissors," *Form and Value in Modern Poetry* (Garden City, N.Y.: Doubleday, 1957), 369.

36 R. P. Blackmur, *Form and Value*, 188–89. Virtually identical in his characterization of the knowing unknowingness of the lyric aura (which he invokes in a punning italic) is Henri Meschonnic, *La Rime et la vie* (Lagrasse: Verdier, 1989), 203: "This *air* passing between the words without being in any of them taken singly, this musical metaphor that we seem not to be able to do without, and not just because of routine, indeed signifies what in language escapes meaning, that is, the model of the sign." And, along the same general lines, Julia Kristeva, *La Révolution du langage poétique* (Paris: Seuil, 1974), writing about the "negativity" of lyric, as opposed to "negation as the act of a judging subject" (28): "indifferent to language, enigmatic and feminine, this space underlying writing is rhythmic, let loose, irreducible to its intelligible verbal translation; it is musical, prior to judgment, but restrained by a single guarantor—syntax" (29).

37 Jean Lunn, "A Conversation with James Merrill," *Sandscript* 6 (1982): 4–5, quoted from Mark Bauer, "Between Lives: James Merrill Reading Yeats's

Prose," *Contemporary Literature* 43 (2002): 98–99.

38 Susan Stewart, *Poetry and the Fate of the Senses* (Chicago: University of Chicago Press, 2002), 3, 12.

39 See Susan J. Wolfson, *The Questioning Presence: Wordsworth, Keats, and the Interrogative Mode in Romantic Poetry* (Ithaca, N.Y.: Cornell University Press, 1988).

40 "Er vernimmt die Ur-Kunde dessen, was dem dichterischen Sagen aufgegeben, als das Höchste und Bleibende zugesagt und doch vorenthalten ist. Die Erfahrung, die der Dichter mit dem Wort macht, könnte er nie durchmachen, wenn sie nicht auf die Trauer gestimmt wäre, auf die Stimmung der Gelassenheit zur Nähe des Entzogenen, aber zugleich für eine anfängliche Ankunft Gesparten." Martin Heidegger, *On the Way to Language*, 66; *Unterwegs*, 169.

41 W. R. Johnson, *The Idea of Lyric: Lyric Modes in Ancient and Modern Poetry* (Berkeley: University of California Press, 1982), 176. For a very differently angled, yet ultimately convergent critique of the tragic view of poetry, see Christopher Nealon, "The Poetic Case," *Critical Inquiry* 33 (2007): 865–86.

42 M. M. Bakhtin, "Discourse in the Novel," in *The Dialogic Imagination*, ed. Michael Holquist, trans. Caryl Emerson and Michael Holquist (Austin: University of Texas Press, 1981), 286–88, 324–31. The key passage is on pages 327–28: "The poetic word . . . also has a double, even a multiple, meaning. It is this that basically distinguishes it from the word as concept, or the word as term. The poetic word is a trope, requiring a precise feeling for the two meanings contained in it." So far Bakhtin seems to me exactly right. But the continuation falls into an impoverished notion of symbolic ambiguity. "But no matter how one understands the interrelationship of meanings in a poetic symbol (a trope), this interrelationship is never of the dialogic sort; it is impossible under any conditions or at any time to imagine a trope (say, a metaphor) being unfolded into the two exchanges of a dialogue, that is, two meanings parceled out between two separate voices. For this reason the dual meaning (or multiple meaning) of the symbol never brings in its wake dual accents. On the contrary, one voice, a single-accent system, is fully sufficient to express poetic ambiguity." This is still true, so long as voice is identified with linguistic code, historically and corporeally determined. But it does no better than Cleanth Brooks in accounting for the mysteriously haunting aura of a poem. For an admirable new attempt to rescue Bakhtin for poetry, see Donald Wesling, *Bakhtin and the Social Moorings of Poetry* (Lewisburg, Pa.: Bucknell University Press, 2003). Wesling's thrust is, however, radically different from mine. He aims to preserve Bakhtin's categories by bridging from verse (in which he includes, for instance, Chaucer) to prose. I see the fault line, instead, as lying between lyric and narrative, and I suggest adapting Bakhtin's categories to allow for a lyric dialogism that is not located in the social dimension nor limited to a conflict or alternation of idioms or idiolects.

43 Georges Poulet, *The Interior Distance*, trans. Elliott Coleman (Ann Arbor: University of Michigan Press, 1964), 256. Indeed, very little changed in the

meaning when, in revising his sonnet "Ses purs ongles," Mallarmé substituted "le Néant" for "le rêve"; see Stéphane Mallarmé, *Oeuvres complètes*, ed. Henri Mondor and G. Jean-Aubry (Paris: Pléiade, 1961), 68 and, variant, 1488.

CHAPTER 5 *Rethinking the Scale of Literary History*

1 Lawrence Lipking, "A Trout in the Milk," in *The Uses of Literary History*, ed. Marshall Brown (Durham, N.C.: Duke University Press, 1995) 1.

2 Emory Elliott made the case for collaborative history in explaining his plan for the Columbia History. See Elliott, "New Literary History: Past and Present," *American Literature* 57 (1985): 611-21; "The Extra: The Politics of Literary History," *American Literature* 59 (1987): 268-76.

3 Joel Fineman, "The History of the Anecdote: Fiction and Fiction," in *The New Historicism*, ed. H. Aram Veeser (New York: Routledge, 1989), 49–76. On this much-discussed topic, see also Catherine Gallagher, "Counterhistory and the Anecdote," in Catherine Gallagher and Stephen Greenblatt, *Practicing New Historicism* (Chicago: University of Chicago Press, 2000), 49–74.

4 Such is the aim of one recent proposal, Robert Hume's *Reconstructing Contexts: The Aims and Principles of Archaeo-Historicism* (Oxford: Clarendon Press, 1999), a usefully pugnacious book that erects high barriers girded with warning examples before encouraging us to work at scaling them. Typical of the tone is this: "I reiterate: to write a legitimate 'sequential-explanation history,' one must be able to isolate the subject from fundamental outside factors and one must be able to demonstrate necessary connection among the elements that have been thus isolated. I do not believe that this means that *all* attempts at sequential explanation in literature are wrong" (113).

5 Paul de Man, "Literary History and Literary Modernity," *Blindness and Insight: Essays in the Rhetoric of Contemporary Criticism* (New York: Oxford University Press, 1971), 142–65. I am not aware of many accounts of de Man's discussions of literary history from this period in his career. Frank Lentricchia, for instance, says that "de Man's would-be historicism [is] fundamentally negative" and "points us away from history as an undesirable condition," which is true but doesn't explain why de Man concerned himself with the topic: *After the New Criticism* (Chicago: University of Chicago Press, 1980), 309–10. Similar in this respect is Jonathan Arac, "Paul de Man and Deconstruction: Aesthetics, Rhetoric, History," *Critical Genealogies: Historical Situations for Postmodern Literary Studies* (New York: Columbia University Press, 1987), 240–59. Gregory S. Jay, in "Paul de Man and the Subject of Literary History," in *The Textual Sublime: Deconstruction and Its Differences*, ed. Hugh J. Silverman and Gary E. Aylesworth (Albany: SUNY Press, 1990), 123–38, proposes the topic but then repeatedly diverges from it on the grounds that "the attempt to write literary history has once more ended in a meditation on the impossibility of the task" (128). The critique is true both of the particular passage under discussion and in general, but does not adequately explain de Man's

insistence around this time in addressing literary history. Kevin Newmark initiates a discussion of the topic in "Paul de Man's History," *Reading de Man Reading*, ed. Lindsay Waters and Wlad Godzich (Minneapolis: University of Minnesota Press, 1989), 121–35, but diverges into de Man's reading of Baudelaire's "Correspondances" and concludes rather formulaically that "his own historical discourse is inscribed ironically, that is, rhetorically, in an aimless stutter" (134). Other essays in this volume glance at the question of literary history; perhaps best is Geoffrey Hartman, "Looking Back on Paul de Man," 8: "De Man's failure to pass from the activity of reading to literary history has the effect of keeping the historical dimension free."

6 The quarrel between literature and history is beautifully portrayed in Linda Orr, "The Revenge of Literature: A History of History," in *Studies in Historical Change*, ed. Ralph Cohen (Charlottesville: University Press of Virginia, 1992), 84–108, originally published in 1986. The essay does not cite de Man, but bears evident marks of his influence, especially in a topic to which I will shortly turn: "The figure of stenography best incarnates the oxymoronic, even mythical impulse" (95).

7 J. Hillis Miller, *Black Holes*, published together with Manuel Asensi, *J. Hillis Miller; or, Boustrophedic Reading* (Stanford: Stanford University Press, 1999), 383.

8 For a convergent diagnosis of de Man's problem with literary history, coming from a different angle, see Russell A. Berman, "Literary History and the Politics of Deconstruction: Rousseau in Weimar," *Cultural Studies of Modern Germany: History, Representation, and Nationhood* (Madison: University of Wisconsin Press, 1993), 89–111. Expressly equating history with politics, Berman arrives at a different cure from mine. He plays the surgeon of deconstruction ("cut it out"); I, perhaps the psychoanalyst ("talk to me; sing to me"). Not long after de Man, A. J. Greimas distinguished historicity (as micro-events on the surface) from history (as the deep structural truth). Greimas's structuralism—opposed to de Man's deconstruction in its valuation of the levels of existence yet concordant in its analysis—suggests the mold from which de Man wanted to break free. See A. J. Greimas, "Sur l'histoire événementielle et l'histoire fondamentale," *Sémiotique et sciences sociales* (Paris: Seuil, 1976), 163.

9 See especially de Man, "Form and Intent in the American New Criticism," *Blindness and Insight*, 20–35. "Intentional structure" in relationship to phenomenology rather than history was the topic of "Structure intentionnelle de l'image romantique," *Revue Internationale de Philosophie* 14 (1960): 68–84, frequently reprinted in English translation from 1970 onward. A useful discussion of intention, literature, and history can be found in David Scott Kastan, *Shakespeare after Theory* (New York: Routledge, 1999), 38–42, directed in critique both of New Critical reductions to self-contained textual meaning and New Historical projections of a uniform and constraining social body. By understanding intention as authorial intention, however, Kastan is forced to delegate meaning-construction to contexts, with respect to which the text is

passive: "the text as it is both written and read is necessarily context-rich and context-dependent, and this is the source of its meaning" (195–96). De Man's more dynamic "intentionality" can point the way out of dependency toward a more active and originative sense of literature's contributions.

10 See Jürgen Habermas, *Knowledge and Human Interests*, trans. Jeremy J. Shapiro (Boston: Beacon, 1971). The German title (which translates as *Knowledge and Interest*) is more faithful to the abstract and conceptual cast of the analysis.

11 Claude Lévi-Strauss, *The Savage Mind* (Chicago: University of Chicago Press, 1966), 257.

12 See R. G. Collingwood, *The Idea of History* (London: Oxford University Press, 1956), 113–22, where a critique of Hegel's bias toward political history ensues upon an articulate rectification of and defense against the vulgar misreading of Hegelian teleology as complacent and closed-minded.

13 G. W. F. Hegel, *Vorlesungen über die Philosophie der Geschichte*, in *Werke in zwanzig Bänden*, ed. Eva Moldenhauer and Karl Markus Michel, vol. 12 (Frankfurt: Suhrkamp, 1971), 105. Except insofar as what he labels paradox is logic itself, Jacques Derrida approaches a related stance when he writes, "given the paradoxical structure of this thing called literature, its beginning *is* its end," "'This Strange Institution Called Literature': An Interview with Jacques Derrida," in *Acts of Literature*, ed. Derek Attridge (New York: Routledge, 1992), 42.

14 Marc Bloch, *The Historian's Craft*, trans. Peter Putnam (New York: Vintage, 1953); the two sections are 39–43 and 43–47, respectively.

15 See Bloch's *The Historian's Craft*, 60–78, and, for the process at work in all its acribia and would-be objectivity, *The Royal Touch: Sacred Monarchy and Scrofula in England and France*, trans. J. E. Anderson (London: Routledge, 1973).

16 See my *Turning Points: Essays in the History of Cultural Expressions* (Stanford: Stanford University Press, 1997), 52–54.

17 A lot of ink has been spilled over what I take to be Ranke's modesty topos. Two essays directly concerned with it are Walther Peter Fuchs, "Was heißt das: 'Bloß zeigen, wie es eigentlich gewesen'?" *Geschichte in Wissenschaft und Unterricht* 30 (1979): 655–67, and Michael-Joachim Zemlin, "'Zeigen, wie es eigentlich gewesen': Zur Deutung eines berühmten Rankewortes," *Geschichte in Wissenschaft und Unterricht* 37 (1986): 333–50. Zemlin in particular parses the motto word for word to pump it up into a proud claim, but his readings are strained, as in the telltale omission of the adverbial "merely" from his title. In English, a fine, detailed appreciation of Ranke can be found in Anthony Grafton, *The Footnote: A Curious History* (Cambridge, Mass.: Harvard University Press, 1997), 34–93.

18 Stephen Greenblatt, *Shakespearean Negotiations: The Circulation of Social Energy in Renaissance England* (Berkeley: University of California Press, 1988), 20.

19 Noise as result: *"an anxiety-ridden quest for lost difference, following a logic*

from which difference is banished," Jacques Attali, *Noise: The Political Economy of Music*, trans. Brian Massumi (Minneapolis: University of Minnesota Press, 1985), 5. Noise as origin: "There is noise in the world before we give ours voice," Michel Serres, *Rome: The Book of Foundations*, trans. Felicia McCarren (Stanford: Stanford University Press, 1991), 13. For more sustained meditations, see, for instance, Serres's *The Parasite*, trans. Lawrence R. Schehr (Stanford: Stanford University Press, 1982), on *bruit* (Attali's word) and *parasite* (static), and his *Genesis* trans. Geneviève James and James Nielson (Ann Arbor: University of Michigan Press, 1995), on *noise* (damage, irritation, noise).

20 Michel Foucault, *The Order of Things: An Archaeology of the Human Sciences* (New York: Random House, 1973), 340.

21 James Clifford, *The Predicament of Culture: Twentieth-Century Ethnography, Literature, and Art* (Cambridge, Mass.: Harvard University Press, 1988), 201.

22 Clifford Geertz, *Works and Lives: The Anthropologist as Author* (Stanford: Stanford University Press, 1988), 29, from an attack on Lévi-Strauss. The ensuing chapter exalts Evans-Pritchards's "enormous capacity to construct visualizable representations of cultural phenomena—anthropological transparencies," "the intensely visual quality of [his] style," his "drastic clarity—luminous, dazzling, stunning . . . blinding" (64, 68). While the last word suggests some reserve toward visuality, I don't see that Geertz ever follows up; rather, he grows wistful about the "loss of confidence" among today's scholars who are "harassed by grave inner uncertainties, amounting almost to a sort of epistemological hypochondria" (72, 71).

23 Clifford Geertz, *The Interpretation of Cultures* (New York: Basic Books, 1973), 6–7, concerned with how to interpret a wink.

24 Kohut, *Local Knowledge: Further Essays in Interpretive Anthropology* (New York: Basic Books, 1983); cockfight: *The Interpretation of Cultures* (New York: Basic Books, 1973), 416 ("Not only were we no longer invisible," but a "kind of immediate, inside-view grasp" of the villagers opened to him).

25 Geertz's early book *Islam Observed* (New Haven: Yale University Press, 1968), however, is historical rather than visual, and its title refers to observance rather than to observation.

26 Matthew Greenfield, "What We Talk About When We Talk About Culture," *Raritan* 19 (1999): 95–113, perceptively discusses "anthropology's antihistorical tendencies" (102) in relationship to problems of literary history.

27 Lévi-Strauss's anti-historical utterances are collected in François Dosse, *A History of Structuralism*, trans. Deborah Glassman, 2 vols. (Minneapolis: University of Minnesota Press, 1997), 1: 261–62. This work is a remarkably readable and comprehensive, if also rather journalistic, historian's overview of its topic. The second volume is particularly informative about Foucault's resistance and eventual return to history. Still, with Foucault, as with Lévi-Strauss, the breathless survey leaves little room for more detailed analysis.

28 Claude Lévi-Strauss, *Structural Anthropology*, trans. Claire Jacobson and Brooke Grundfest Schoepf (New York: Anchor, 1967), 12–13, originally pub-

lished in 1949. Fernand Braudel comments on this line of Lévi-Strauss's in *On History*, trans. Sarah Matthews (Chicago: University of Chicago Press, 1980); a useful overview is Marc Gaboriau, "Anthropologie structurale et histoire," *Esprit*, no. 31 (1963): 579–95. For a defense of Lévi-Strauss against Foucault, in an ambitious book devoted to a "casuistic" account of literary history, see James Chandler, *England in 1819: The Politics of Literary Culture and the Case of Romantic Historicism* (Chicago: University of Chicago Press, 1998), 67–100.

29 Claude Lévi-Strauss, *From Honey to Ashes*, trans. John and Doreen Weightman (New York: Harper, 1973), 474–75. The paragraph (and, with it, the book) ends in the high pathetic mode by speaking of "the powerful inanity of events." I shall be arguing that meanings, not events, are the level on which to recapture history.

30 Claude Lévi-Strauss and Didier Eribon, *De près et de loin* (Paris: Odile Jacob, 1988), 96.

31 Similarly, in *The Way of the Masks*, trans. Sylvia Modelski (Seattle: University of Washington Press, 1988), 32: "Far from turning its back on history, structural analysis makes a contribution to it." For a practical application, see pages 152–62. The book backpedals in its conclusion (226), on the grounds that historical reconstruction is problematic in the limited area of the Pacific Northwest, with tribes that have always lived in close proximity. No spatial separation, no historical orientation. Even here, then, the point is not a superiority of space over time, but a coordination of the two.

32 French and German theorizing has both suffered and benefitted from the lack of a word corresponding to *pattern*. The closest general terms are *modèle* and *Muster*, but, like the even more specialized French cognate *patron*, these are dress patterns—imagined or designed Forms that precede observation, rather than regularities derived from it. Ruth Benedict's *Patterns of Culture* goes into French as *Echantillons de culture*—samples. Jacques Lacan falls back on the English word in "La méprise du sujet supposé savoir," *Scilicet* 1 (1968): 31: "La chose admise, tout est bon pour servir de modèle à rendre compte de l'inconscient: le *pattern* de comportement…"

33 "How often have I noted—after the fact—that in listening to a work I stopped hearing it while an idea popped up! After this temporary separation that autonomized it ["it" could be either the musical work or the idea], my thoughts re-engaged with the work, as if the mental discourse had momentarily relayed the musical discourse, even while remaining in complicity with it" (*De près et de loin*, 246). Is it necessary to point out that this musical culmination of the memoir portrays an unconscious creativity?

34 Carl Woodring, *Literature: An Embattled Profession* (New York: Columbia University Press, 1999).

35 Alvin Kernan, *In Plato's Cave* (New Haven: Yale University Press, 1999), 191. The author of *The Death of Literature*, Kernan is speaking specifically about deconstruction here, but subsequent developments don't seem to please him any better.

36 For two edgy accounts of cultural studies relevant to the ensuing discussion,

see J. Hillis Miller, "What Are Cultural Studies," in *Illustration* (Cambridge, Mass.: Harvard University Press, 1992), 13–19, and, slyer, Jonathan Culler, "What Is Cultural Studies?" in *The Practice of Cultural Analysis: Exposing Interdisciplinary Interpretation*, ed. Mieke Bal (Stanford: Stanford University Press, 1999), 335–47.

37 While I have basically left the text of this chapter in its condition as of 2000, the questioning obviously has not stopped. For one, more or less random, instance, see the commentary-essay by Jennifer L. Fleissner, "When a Symptom Becomes a Resource," *American Literary History* 20 (2008): 640–55. Fleissner initiates the discussion proper with a question posed by Brook Thomas, "What's literature have to do with it?" (642), and while music is not a topic, she concludes with remarks inspired by an essay on "song-poems": "History will always produce the affective leftover: how arresting, how moving, how as-yet-unexplained, we think . . ." (652).

38 *What Is Literature?* trans. Bernard Frechtman (New York: Harper and Row, 1965), 2.

39 I am thinking of Andrew Welsh's Poundian speculation on time and timelessness, *Roots of Lyric: Primitive Poetry and Modern Poetics* (Princeton: Princeton University Press, 1978), a suggestive enterprise yet a disappointing book for the literary historian because its "spatialization of time" (90) disjoins the primitive from the past.

40 This may be the best point at which to insert a reminder that I have chosen masculine pronouns to echo those in the works I have been discussing. While my chapter doesn't discuss the possible relationship of (say) engagement to masculinity in Sartre, it is important to keep the possibility of such questions alive by accurately reflecting the gendering of earlier texts.

41 The case is made in Geoffrey Galt Harpham, "Late Jameson," in *Shadows of Ethics: Criticism and the Just Society* (Durham, N.C.: Duke University Press, 1999), 162–79. In the same volume, the essay "History and the Limits of Interpretation" (145–61) illuminates some of the problems facing a literary history in the age of depth interpretation. Still valuable are the essays collected in the special Jameson issue of *Diacritics*, no. 12 (Fall 1983), especially, for present purposes, Terry Eagleton, "Fredric Jameson: The Politics of Style," found on pages 14–22.

42 Fredric Jameson, *Marxism and Form: Twentieth-Century Dialectical Theories of Literature* (Princeton: Princeton University Press, 1971), 223.

43 Fredric Jameson, *The Political Unconscious: Narrative as a Socially Symbolic Act* (Ithaca, N.Y.: Cornell University Press, 1981), 45.

44 Woodring, *Literature: An Embattled Profession*, 73. In a similar spirit, but more constructively argued, is Eugene Goodheart, *Does Literary Studies Have a Future?* (Madison: University of Wisconsin Press, 1999). One of Goodheart's preliminary essays—it will come to seem almost inevitable—is called "The Music of James"; by music, to be sure, he means only "the internal logic" (*Literary Studies*, 97).

45 In *The Meaning of Literature* (Ithaca, N.Y.: Cornell University Press, 1992),
 a splendidly detailed study that goes curiously unmentioned in the books
 discussed below, Timothy J. Reiss has argued that the notion of the timeless
 masterpiece of universal import is itself a time-bound idea, prevalent from
 Corneille until Marx. Within these centuries, he maintains, there were "no
 essential changes" (179); Hegel merely "continued the aesthetic thought of
 his predecessors," pursuing links "forged in the late seventeenth century"
 (335–36). Intended as a loose Foucauldianism of *longues durées* without formal
 ruptures, Reiss's account seamlessly bridges the divide between the earlier
 rhetorical conception of literature as belles lettres and the Romantic concep-
 tion of literature as a separate sphere of imaginative creation. Whether such
 an account satisfies will depend upon the needs of the moment; my essay, in
 any event, seeks to grasp both literature and history on a different scale.

46 Peter Widdowson, *Literature* (London: Routledge, 1999), 113.

47 Diane Elam, "Why Read?" *CCUE News*, no. 8 (June, 1997): 12, 13, cited in Wid-
 dowson, *Literature*, 129, 205.

48 Ross Chambers, *Loiterature* (Lincoln: University of Nebraska Press, 1999), 53.

49 Paul H. Fry, *The Reach of Criticism: Method and Perception in Literary Theory*
 (New Haven: Yale University Press, 1983), 204. Fry's subsequent book, *A
 Defense of Poetry: Reflections on the Occasion of Writing* (Stanford: Stanford
 University Press, 1995), exemplifies the Benjaminian stance in a series of read-
 ings and reflections that often foreshadow those of Chambers. See in particu-
 lar the opening chapter of the latter, "Non-Construction: History, Structure,
 and the Ostensive Moment in Literature" (11–30); subsequent chapters have
 resonating titles that include "One Last Theme: Literature as Insignificance,"
 "The Hum of Literature," "Clearings in the Way," "Nil Reconsidered," and "The
 Ethics of Suspending Knowledge."

50 On music in Kant, see Arden Reed, "The Debt of Disinterest: Kant's Critique
 of Music," *MLN* 95 (1980): 563–84, and (less interesting) John Sallis, "Nature's
 Song," *Revue internationale de philosophie* 45 (1991): 3–9. The equivalent—
 loiterly, cynical, musical—moment in Chambers's other foundational text,
 Tristram Shandy, is the story of the abbess of Andoüillets in 7.21–25. For
 an argument that Sterne struggles against such loitering, in this story and
 through the novel, see my *Preromanticism* (Stanford: Stanford University
 Press, 1991), 261–300.

51 Denis Diderot, *Rameau's Nephew: D'Alembert's Dream*, trans. Leonard Tan-
 cock (Harmondsworth, UK: Penguin, 1966), 105.

52 *Black Holes*, 311; Miller's suspension points, at the end of his chapter on Trol-
 lope.

53 See, for instance, Malcolm Bowie, "What Is Literature?" *Raritan* 19 (1999):
 15–26, a fine discussion of the problems of fragmentation and continuity in
 Denis Hollier's *New History of French Literature* and in a newly translated
 collection of his essays. Bowie images the older history as "reaching after the
 long legato line," traditional literary form as "mere inventiveness, through-

composition and fluency," and Bataille's disruptiveness as "a tour de force in the handling of variation form" (20, 18, 22). As the contemporary ideal he instances Michel Leiris, quoting "almost at random" a long passage about the power of song and melody that culminates in a proleptic response to Miller's black sun: "an unexpected combination of mirrors, lenses, and prisms shattering the light in order to make it rise up again from the negative summit of its blackest depths" (23–24). Music as strange attractor indeed, "more baffling than any of the experiments described in books of physics-for-fun!" (24).

54 The quote comes from Richard Anthony Leonard, *A History of Russian Music* (New York: Macmillan, 1957), 131. In his *Oxford History of Western Music*, 6 vols. (Oxford: Oxford University Press, 2004), 3: 107–13, Richard Taruskin comments on the rarity of the key, links the Unfinished to the Pathétique, and calls Schubert's symphony a "virtual textbook" of the way "'lower' forms . . . could affect the 'higher' forms and infect them with *Innerlichkeit*" (113).

55 I follow Charles Rosen's *Classical Style* (New York: Norton, 1997), 115–19, here taking heed of Rosen's further justification in the New Preface, xiv-xv. The judgment about the quartet's historical position is not uncontested, though the characterization of its witty dynamism seems secure.

56 *Kafka: Toward a Minor Literature*, trans. Dana Polan (1975; Minneapolis: University of Minnesota Press, 1986), 18.

57 Gilles Deleuze and Félix Guattari, *A Thousand Plateaus: Capitalism and Schizophrenia*, trans. Brian Massumi (1972; Minneapolis: University of Minnesota Press, 1987), 23–24.

58 Gilles Deleuze, *Proust and Signs*, trans. Richard Howard (1964; New York: George Braziller, 1972), 109.

59 Walt Whitman, "Italian Music in Dakota," quoted in Lawrence Kramer's "Introduction" to *Walt Whitman and Modern Music: War, Desire, and the Trials of Nationhood*, ed. Lawrence Kramer (New York: Garland, 2000), xviii.

60 A good survey of the literary challenge to historical realism since the eighteenth century is Lionel Gossman, "History and Literature: Reproduction or Signification," in *The Writing of History: Literary Form and Historical Understanding*, ed. Robert H. Canary and Henry Kozicki (Madison: University of Wisconsin Press, 1978), 3–39.

61 *Redgauntlet*, ed. G.A.M. Wood, with David Hewitt (Edinburgh: Edinburgh University Press; New York: Columbia University Press, 1997), 360.

62 Northrop Frye, *The Secular Scripture: A Study of the Structure of Romance* (Cambridge, Mass.: Harvard University Press, 1976), is centrally concerned with Scott as mythmaker: "It was said that his characterization was what was important and that his plots were of secondary interest: this is nonsense of course" (5). Mark Phillips, "Macaulay, Scott, and the Literary Challenge to Historiography," *Journal of the History of Ideas* 50 (1989): 117–33, discusses Scott's reputation as a creator of characters after presenting his role in the shift from an ideal of objectivity to one of vividness. David Brown, "Historical Authenticity in the Waverley Novels," in *Walter Scott and the Historical Imagination*

(London: Routledge and Kegan Paul, 1979), 173–94, emphasizes how crucial characterization and particularization are to Scott's sense of history, but the book as a whole reveals why this is a half truth; it leaves *Redgauntlet*, for instance, as a Fieldingesque satire (151–72). More extreme, as its title indicates, is James Kerr, *Fiction Against History: Scott as Story-Teller* (Cambridge: Cambridge University Press, 1989).

63 See in particular Ina Ferris, "Authentic History and the Project of the Historical Novel," *The Achievement of Literary Authority: Gender, History, and the Waverley Novels* (Ithaca, N.Y.: Cornell University Press, 1991), 195–236, though *Redgauntlet* is not discussed. Particularly close to my account is the thesis statement: "The frame releases an activity of imagination that fills in the gaps and silences of the historical record, and this too is crucial to the history-effect. It signals, of course, a different kind of history" (207). An eloquent general study is Bruce Robbins, *The Servant's Hand: English Fiction from Below* (New York: Columbia University Press, 1986; see especially pages 131–65, "The Servant as Instrument of the Plot." See also Paul Hamilton, "*Waverley*: Scott's Romantic Narrative and Romantic Historiography," *Studies in Romanticism* 33 (1994): 611–34, a chaotic but often illuminating essay about Scott's resistance to recuperating Revolutionary meanings. The Scott chapter in Avrom Fleishman, *The English Historical Novel: Walter Scott to Virginia Woolf* (Baltimore, Md.: Johns Hopkins University Press, 1971), 37–101, by contrast, points out the recurrent patterns in Scott's portrayal of the development from the Middle Ages to the present, allying him with Scottish Enlightenment historians and finely illuminating the grand scheme while overflying the texture of narration and causation.

64 On the linkage of literary history to the nation, I could instance the other essays in the volume where this chapter was originally published, *Rethinking Literary History*, ed. Linda Hutcheon and Mario Valdés (Oxford: Oxford University Press, 2002). The subsequent reference is to Walter D. Mignolo's essay, "Rethinking the Colonial Model," *Rethinking Literary History*, 155–94. Fortunately, in the last few years a number of calls have been issued to break free of the national straitjacket, notably Pascale Casanova, *The World Republic of Letters*, trans. M. B. DeBevoise (Cambridge, Mass.: Harvard University Press, 2004; published in French in 1999), and Wai-Chee Dimock, *Through Other Continents: American Literature Across Deep Time* (Princeton: Princeton University Press, 2006). Casanova, like Mignolo, wants to replace a centrifugal history (her center is emphatically Paris) with centrifugal histories; Dimock opts for more generalized diffusion.

65 On Scott's integrationist response to national narrative traditions, see the magisterial essay by Katie Trumpener, "National Character, Nationalist Plots: National Tale and Historical Novel in the Age of *Waverley*, 1806–1830, *ELH* 60 (1993): 685–731. With respect to *Redgauntlet,* the case that Scott believed in a British future even while he loved the Scottish past was influentially made in David Daiches, "Scott's *Redgauntlet*," in *From Jane Austen to Joseph Conrad:*

Essays Collected in Memory of James T. Hillhouse, ed. Robert C. Rathburn and Martin Steinmann Jr. (Minneapolis: University of Minnesota Press, 1958), 46–59. The alternative, colonialist view might be represented by Saree Makdisi, "Colonial Space and the Colonization of Time in Scott's *Waverley*," *Studies in Romanticism* 34 (1995): 155–87, which reads *Waverley* in the light of the Clearances of the Highlands, yielding a highly—to my mind, crudely— dichotomized view of Scott's stance. The Lowlands rout the Highlands; the present, the past; metropolitan culture, rural nature. Two facts trouble this account. One is historical and emerges in passing from the documentation: the Highlanders were regarded as Irish, hence not truly aboriginal and natural at all. The other is textual: *Waverley* never mentions the Clearances. While Scott's silence might be regarded as complicity—"clearing" the Clearances, so to speak—it may also be regarded as revelatory, in that the novel "opens up" to sympathetic view what was covered over by the uniform actions of the government. A fuller account would give us some of both. The complexity of literature's history resists formulation in terms of simple alternatives such as Makdisi's modernization vs. expulsion.

66 Benedetto Croce, "La 'letteratura comparata,'" *Saggi filosofici*, vol. 1: *Problemi di estetica* (Bari: Laterza, 1949), 75: "I do not see what difference there is . . . between 'literary history' pure and simple and 'comparative literary history,' unless the pleonasm 'comparative' is meant to express the demand for a literary history that would be truly complete and would take cognizance of the entire extent of its task."

67 Antony Easthope, *Englishness and National Culture* (London: Routledge, 1999), 228. One chapter in this book, "An Empiricist Tradition," offers a reductio ad absurdum of literary history: it attends to style in a way that crudely levels all differences, making Locke and Margaret Thatcher relays of the Puritans and Milton (92–93) and Richard Littlejohn—skewering Princess Di in a tabloid—a reborn Alexander Pope (98–102). It shows what an empiricism without specificity might look like. A strong case for cosmopolitanism has, however, now been made by Anthony Appiah in *Cosmopolitanism: Ethics in a World of Strangers* (New York: Norton, 2006). Similarly broad and wise is the angle of Homi K. Bhabha in *The Location of Culture* (London: Routledge, 1994), 13: "Private and public, past and present, the psyche and the social develop an interstitial intimacy. It is an intimacy that questions binary divisions through which such spheres of social experience are often spatially opposed. These spheres of life are linked through an 'in-between' temporality that takes the measure of dwelling at home, while producing an image of the world of history. This is the moment of aesthetic distance. . . . And the inscription of this borderline existence inhabits a stillness of time and a strangeness of framing that creates the discursive 'image' at the crossroads of history and literature, bridging the home and the world." Like the postcolonialist critics I cite at the end of the chapter, Bhabha's whole book is splendidly sensitive to the uncannily (un-homely, un-Homily) destabilizing power of literature. I

"con [sic] Violoncello," when the cello enters: the meaning is that the cello's rhythm will be free and the piano will have to follow along "with" it. Eight measures before the movement ends, the piano finally begins playing faster notes, as the cello had done, with a part marked "espress[ivo]," indicating the change in character. Finally, the exhaustion appears in various technical manifestations but is most visible in the repeated pianissimo chords with which the piano concludes the movement. The regression is temporary only: the last movement starts (and mostly continues) loud, fast, and wild.

80 For a more differentiated and more technical overview of the Bach-Mendelssohn relationship than I can present here, including scattered comments on the ideological issues that I emphasize (especially Mendelssohn's modernizing impulses) and concluding with op. 7, no. 5, see Wilhelm Dinglinger, "Aspekte der Bach-Rezeption Mendelssohns," in *Bach und die Nachwelt*, ed. Michael Heinemann and Hans-Joachim Hinrichsen, vol. 1 (Laaber: Laaber, 1997), 379–420. Another example of Mendelssohn's complexly historicized encounter with Bach is discussed in John Michael Cooper, "Felix Mendelssohn Bartholdy, Ferdinand David und Johann Sebastian Bach: Mendelssohns Bach-Auffassung im Spiegel der Wiederentdeckung der 'Chaconne,'" *Mendelssohn-Studien* 10 (1997): 157–79. Also useful, in a more desultory way, is Rudolf Stephan, "Über Mendelssohns Kontrapunkt: Vorläufige Bemerkungen," in *Das Problem Mendelssohn*, ed. Carl Dahlhaus (Regensburg: Gustav Bosse, 1974), 201–9.

81 Charles Rosen, *The Classical Style* (New York: Norton, 1997), 141–42; Carl Dahlhaus, *Ludwig van Beethoven: Approaches to His Music*, trans. Mary Whittall (Oxford: Oxford University Press, 1995), 81–90; Susan McClary, *Feminine Endings: Music, Gender, and Sexuality* (Minneapolis: University of Minnesota Press, 1992), 127–30.

82 The overture to *A Midsummer Night's Dream* is the perfect instance of Mendelssohn's smug yet winningly precocious poise, particularly in the way it reimagines program music (such as the ass's braying) in an abstract concert form. A similarly smug yet winning nationalism is evidenced in the other two named symphonies, the Scottish and the Italian, where allied nations (not yet nation-states in either case) become the object of gently exoticized symphonic form, perhaps most tactfully and sovereignly in the slow movement of the Italian Symphony, where chorale appears in the guise of a pilgrim's march. There is a lucid and detailed account of the complex and shifting terrain of national identification in the decades leading up to Mendelssohn's Bach revival in Celia Applegate, "How German Is It? Nationalism and the Idea of Serious Music in the Early Nineteenth Century," *19th Century Music* 21 (1998): 274–96, and an equally commanding presentation of the century-long run-up to the 1829 Passion performance in Applegate's *Bach in Berlin: Nation and Culture in Mendelssohn's Revival of the "St. Matthew Passion"* (Ithaca, N.Y.: Cornell University Press, 2005). Sketchier but also useful is Arno Forchert, "Von Bach bis Mendelssohn," in *Bachtage Berlin: Vorträge 1970 bis 1981* (Neuhausen-Stutt-

gart: Hänsler, 1985), 211–23. For the ideological position of the Bach revival within Mendelssohn's career, see John Edward Toews, *Becoming Historical: Cultural Reformation and Public Memory in Early Nineteenth-Century Berlin* (Cambridge: Cambridge University Press, 2004), 207–78, and Michael P. Steinberg, *Listening to Reason: Culture, Subjectivity, and Nineteenth-Century Music* (Princeton: Princeton University Press, 2004), 97–122. On Toews's persuasive account, Mendelssohn's historicism aimed to rescue the past from history by translating it into aesthetic universals.

83 Paul H. Fry, "Beneath Interpretation: Intention and the Experience of Literature," in *The Arts and Sciences of Criticism*, ed. David Fuller and Patricia Waugh (Oxford: Oxford University Press, 1999), 164–79. Arguing eloquently that "the anxiety of interpretation" blinds us from seeing "what literature is" (179), Fry offers no account for the difference among works as they resist explication. I offer the musical element, in all its rich variety, as the necessary supplement. In this I follow George Steiner's extraordinary demonstration of the historical power of nuance and tone in *After Babel: Aspects of Language and Translation* (Oxford: Oxford University Press, 1998), 1–17, culminating in a discussion of Noël Coward's "musicality": "The *presto* and the *andante* in *Private Lives* are as time-bound as the fox-trot. A wholly different metronome beats in our present phrasing" (17).

84 Paul de Man, "Tropes (Rilke)," in *Allegories of Reading: Figural Language in Rousseau, Nietzsche, Rilke, and Proust* (New Haven: Yale University Press, 1979), 20–56. There is a long methodological critique of this essay in Gerhard Kaiser, *Geschichte der deutschen Lyrik von Heine bis zur Gegenwart*, vol. 2 (Frankfurt am Main: Suhrkamp, 1991), 898–908 (thanks to William Waters for telling me about it), and an incisive ideological critique, concentrating on the topics of musicality and mechanism, in Fredric Jameson, *Postmodernism: or, The Cultural Logic of Late Capitalism* (Durham, N.C.: Duke University Press, 1991), 252–54. My own critique is more pragmatic than either, but ultimately also systematic in grounding de Man's errancy in tone-deafness. In a section of *Feeling in Theory: Emotion after the "Death of the Subject"* (Cambridge, Mass.: Harvard University Press, 2001) entitled "Nobody's Passion: Emotion and the Philosophy of Music" (92–99), Rei Terada builds on de Man's essay to revive the old argument "that it is because we don't know why these emotional-sounding signs are being made, or even what emotions they incite, that music is so intensely affecting" (97). I prefer to seek the specificity of music, denying the hollowness that (as will be seen) de Man wrongly imputes to Rilke's violin.

85 "Pure sound," I suggest, is how poetry functions when you don't know the language. It is not how the language of poetry functions, nor, in my view, is it how music functions. (For the best statement of an opposing view, see Fry, *A Defense of Poetry*, 44–47.) James Rolleston's extended reading of "Am Rande der Nacht" characterizes music as an eternal absolute, at the opposite pole from de Man's notion of music as semantic deprivation; see *Rilke in Transition:*

An Exploration of His Earliest Poetry (New Haven: Yale University Press, 1970), 156–66. Rolleston takes Rilke's "abysses" to be inside the violin (165), but surely the poem's "clefts" are the F-holes through which the sound emerges *from* the violin and *into* the world.

86 De Man's reading of Baudelaire's "Correspondances" may be found on pages 243–52 of the posthumous essay "Anthropomorphism and Trope in the Lyric," in *The Rhetoric of Romanticism* (New York: Columbia University Press, 1984), 239–62.

87 According to Judith Ryan, Rilke "had been reading [Eichendorff] since his school days," *Rilke: Modernism and Poetic Tradition* (Cambridge: Cambridge University Press, 1999), 161. The relationship remains uninvestigated, apart from Ryan's own discussion of an early poem, "Auf der Kleinseite," as an imitation of another widely anthologized Eichendorff poem, "In Danzig."

88 On the poetic "thou," see William Waters, *Poetry's Touch: On Lyric Address* (Ithaca, N.Y.: Cornell University Press, 2003), esp. 144–63.

89 "Rauschen"—the verb de Man mistranslates as "roaring"—is Eichendorff's constant word for the rustling of nighttime waters. And the prepositional phrase, "ohne Ende," that de Man takes to be adjectival ("depths without end") could as readily by read adverbially: the light "falls endlessly into the ancient depths," thus illuminating them. Decades later Rilke used "fällt" again as the italicized last word of the Duino Elegies, in the unambiguously upbeat, redemptive context of a spring shower of rain: "Und wir, die an *steigendes* Glück / denken, empfänden die Rührung, / die uns beinah bestürzt, / wenn ein Glückliches *fällt*" (and we, who think of *rising* fortune, would feel the emotion that nearly stuns us when something fortunate *falls*).

90 "Diagonality" is a term of Deleuze and Guattari, *A Thousand Plateaus*, 297–98, where Barthes's "Rasch" is cited at length. François Dosse invokes Deleuze on Webern's diagonality, rather mal à propos, in his *History of Structuralism*, 2: 241, in connection with the ahistoricism of Foucault's *Archaeology of Knowledge*. Continental drift is the title phrase of Emily Apter's Deleuzian literary history, *Continental Drift: From National Characters to Virtual Subjects* (Chicago: University of Chicago Press, 1999). See also Srinivas Aravamudan's image of post-national literary history as "fragmenting the continental shelf of literature before me into manageable textual archipelagoes," *Tropicopolitans: Colonialism and Agency, 1688–1804* (Durham, N.C.: Duke University Press, 1999), 12. The image is repeated on page 25; less appropriate is the more structuralist image of a constellation of texts (24), since there is no natural proximity in stars, only an arbitrarily assigned and figural denotation. For the dynamizing role of music in the first great exponent of national and racial literary history, see pages 77–78 in my essay, "Why Style Matters: The Lesson of Taine's *History of English Literature*," in *Turning Points*, 33–87, contrasting with Apter's fine account of the tone-deaf misuse of Taine by Barrès and his successors, *Continental Drift*, 25–37.

91 One last account of "Literature" worth mentioning here is Gayatri Chakra-

vorty Spivak, *A Critique of Postcolonial Reason: Toward a History of the Vanishing Present* (Cambridge, Mass.: Harvard University Press, 1999), 112–97 (this section of the book was mostly published as articles between 1985 and 1991). Though an admirer of Deleuze and Guattari, Spivak sees in them only disruption, not flow; her hermeneutic method depends on "unframing" (143) by highlighting characters "in the undisclosed margins of the text" (154); her trajectory "attempt[s] to persuade through the discontinuity of odd connections or reconstellation" (65) and "to imagine or construct (im)possible practices [by] re-constellat[ing] classics into implausible or impertinent readings" (336) so as "to see if the magisterial texts can now be our servants" (7). There is a risky utopianism in the pervasive rejection of history that surfaces notably in the critique of Jameson (312–26) and in moments such as this: "human historicity is shown here to be of limited usefulness as explanatory or verificatory model" (52). Permanent parabasis is less ironic, hence less enabling than in Chambers or even Miller: "A caution, a vigilance, a persistent taking of distance always out of step with total involvement, a desire for permanent parabasis, is all that responsible criticism can aspire to. Any bigger claim within the academic enclosure is a trick" (362). Standing after the chapter "Philosophy" and before the chapters "History" and "Culture," literature has no special status in the enterprise. While Spivak's ethical and intellectual commitments are genuinely highminded, not least in their response to the totalization to which de Man (to whom the book is dedicated) is prone, they have their own illusions. The illusions, partly utopian and partly nostalgic (see 207–9, 306, and 318–19 on the nostalgia haunting Spivak), are marked by the following incoherence: "High theory 'passing' as 'resistance' is part of the problem" (398), yet . . . "Yet, against all straws in the wind, one must write in the hope that it is not a deal done forever, that it is possible to resist from within" (113, at the beginning to "Literature"). The resistances that Spivak often brilliantly finds are, to my mind, inscribed in the texts, not imperiously or magisterially imposed upon them—"In the story itself," she says at one point, lies "resistance to Development . . . as aboriginal resistance" (142)—and I would prefer to see them used in the service of directed movement, not just of her kind of destabilizing deconstruction.

CHAPTER 6 *Mozart, Bach, and Musical Abjection*

1 Thomas Mann, *Doctor Faustus*, trans. H. T. Lowe-Porter (New York: Knopf, 1948), 77; translation modified.

2 Alfred Einstein, *Mozart: His Character, His Work*, trans. Arthur Mendel and Nathan Broder (London: Cassell, 1966), 153. Mann reports reading the English translation in *The Story of a Novel: The Genesis of "Doctor Faustus,"* trans. Richard and Clara Winston (New York: Knopf, 1961), 125. Stanley Sadie finds Einstein's view of the encounter with Bach "exaggerated": see *The New Grove Mozart* (New York: Norton, 1981), 90.

3 For a more general discussion of musical formalism, see my review of John Daverio, *Nineteenth-Century Music and the German Romantic Ideology*, in *Nineteenth Century Music* 18 (1995): 290–303.

4 Harold Bloom, *The Breaking of the Vessels* (Chicago: University of Chicago Press, 1982), 82.

5 Lawrence Kramer, *Classical Music and Postmodern Knowledge* (Berkeley: University of California Press, 1995), 33–66; the quoted phrases appear on page 35, in an account of Leo Treitler's work.

6 Michel de Certeau, *Heterologies: Discourse on the Other*, trans. Brian Massumi, foreword by Wlad Godzich (Minneapolis: University of Minnesota Press, 1986). The quotations come from "The Freudian Novel: History and Literature," 23; Foucault is the subject of "The Black Sun of Language: Foucault," 171–84; Godzich invokes Lyotard and (perhaps less plausibly) Geertz on page xv.

7 On the late-eighteenth-century view of Bach as an archaic composer, see Reinhold Hammerstein, "Der Gesang der geharnischten Männer: Eine Studie zu Mozarts Bachbild," *Archiv für Musikwissenschaft* 13 (1956): 1–24.

8 Warren Kirkendale, *Fugue and Fugato in Rococo and Classical Chamber Music* (Durham, N.C.: Duke University Press, 1979), 180. Fugal charm is the topic of Wilhelm Seidel, "Der Triumph der Anmut: Über das Finale des Streichquartetts in G-Dur, KV 387, von W. A. Mozart," in *Musicologia Humana: Studies in Honor of Warren and Ursula Kirkendale*, ed. Siegfried Gmeinwieser et al. (Florence: Leo S. Olschki, 1994), 513–35. Charming in its easy cadential effects, the quartet movement is, however, seductive in its unharmonized chromatics—so different from the balancing, contrary-motion chromatics typical of Bach, such as, in the first fugue of K. 404a, the cello line of measure 11 or the first violin in the final measures—and explosive in its unleashing of dynamic contrasts. A final judgment of the quartet movement depends on how you reconcile the energizing with the controlling gestures—indeed, on whether you reconcile them.

9 Overall the proportion of C to C-sharp is more than 2 to 1, and highest in the cello part. While this statistic does not in itself determine the harmonic flux, it is indicative.

10 Thus, viola part, measures 6–7: dotted quarter followed by three eighths, twice in succession; in a descending pattern; violin part, two beats later, similar rhythm, ascending pattern.

11 The trills do not appear in the published versions of *The Well-Tempered Clavier*, but all except those in measure 11 appear in the manuscript Mozart is presumed to have used; Mel Unger of the Riemenschneider Bach Institute at Baldwin-Wallace College, where the manuscript is now housed, kindly checked it for me.

12 My description of linearity aims to reformulate the account given by Charles Rosen in *The Classical Style: Haydn, Mozart, Beethoven*, expanded edition (New York: Norton, 1997), 29: "Linear form is essentially the isolation of the elements of music."

13 On subdominant harmonies in classical-period music, see Charles Rosen, *Sonata Forms* (New York: Norton, 1980), 275–80.

14 The motifs develop in ways best described in James Webster's account of "thematicism": see *Haydn's "Farewell" Symphony and the Idea of Classical Style: Through-Composition and Cyclic Integration in His Instrumental Music* (Cambridge: Cambridge University Press, 1991), especially 194–204. However, he does not recognize a relationship between the "fluid, ever-changing complexes of motives" (203) and the fluid, ever-changing textures of baroque fugues.

15 The culmination of the effort to make polyphony textural rather than structural is the end of the Divertimento for String Trio, K. 563, where ricocheting double stops create a momentary polyphony out of mere rhythmic alternation, even in the total absence of melodic motion.

16 Julia Kristeva, *Powers of Horror: An Essay on Abjection*, trans. Leon S. Roudiez (New York: Columbia University Press, 1982), 16.

17 This is perhaps the point for a reminder that the attribution of K. 404a is far from certain. (Warren Kirkendale predicates another attribution on the genuineness of K. 404a in "More Slow Introductions by Mozart to Fugues of J. S. Bach?" *Journal of the American Musicological Society* 17 [1964]: 43–65. He backs off in an appendix to *Fugue and Fugato*, 333–34, though the new evidence presented there does not seem momentous.) I have been speaking of "Mozart" throughout, for ease of exposition and also because I really do believe the pieces genuine. Friedhelm Krummacher likewise finds their quality unmistakable and gives them a crucial role in the discussion of Mozart's relation to Bach that concludes *Die Musik des 18. Jahrhunderts*, ed. Carl Dahlhaus (Laaber: Laaber, 1985), 392–93. However, nothing central to my argument depends on the composer's identity.

18 "Une *abjection* dont s'absente l'identité," *Pouvoirs de l'horreur: Essai sur l'abjection* (Paris: Seuil, 1980), 66. The published translation, "becomes absent," treats the French reflexive as passive in meaning. That is a possible rendering if identity precedes abjection, but the French requires no such presumption. Similarly, in the previous quotation, the published rendering of "nos tentatives les plus anciennes de nous démarquer de l'entité maternelle" (*Pouvoirs*, 20) is "our earliest attempts to release the hold of *maternal* entity," again implying two identities in conflict rather than one emerging from the other, "Before the Beginning," as the section title has it. Such nuances of translation can easily color the reception of an author in far-reaching ways.

19 Julia Kristeva, *Tales of Love*, trans. Leon S. Roudiez (New York: Columbia University Press, 1987), 253.

20 See Elaine Sisman, *Mozart: The "Jupiter" Symphony* (Cambridge: Cambridge University Press, 1993), for an elaborate and generally sound discussion of the symphony's sublimity. On pages 71–74, the quartet finale is assimilated to the analysis, without enough acknowledgment of its more romping character.

21 Musical reminiscence has become a topic for analysis; see, for instance, Webster, *Haydn's "Farewell" Symphony*, 284–87 (with citations of earlier essays),

. and Charles Rosen, *The Romantic Generation* (Cambridge, Mass.: Harvard University Press, 1995), 166–74. So has allusion as a historicizing gesture; see, for instance, John Daverio, *Nineteenth-Century Music*, 144–54, where Brahmsian allusion is related to self-conscious modernity. Informational rather than speculative is Christopher Alan Reynolds, *Motives for Allusion: Context and Content in Nineteenth-Century Music* (Cambridge, Mass.: Harvard University Press, 2003). K. 404a differs from both reminiscence and allusion in the way it reimagines cultural encounter as private experience. It is a subdued predecessor of what Rosen says Beethoven put on display: "he . . . continu[ed] a late eighteenth-century style that he so transformed into the sensibility of a new age that he seemed to have reinvented it" (*The Classical Style*, 460).

22 In a relevant context (the quasi-fugal finale to Mozart's G-Major String Quartet, K. 387), Wye J. Allanbrook writes, "The first fugal exposition is decomposed into the contredanse," but she does not develop the implications of her term. See "'To Serve the Private Pleasure': Expression and Form in the String Quartets," in *Wolfgang Amadè Mozart: Essays on His Life and His Music*, ed. Stanley Sadie (Oxford: Clarendon Press, 1996), 135. For the concept of minor writing, see Gilles Deleuze and Félix Guattari, *Kafka: Toward a Minor Literature*, trans. Dana Polan (Minneapolis: University of Minnesota Press, 1986).

23 Maynard Solomon, *Mozart: A Life* (New York: Harper Collins, 1995), 121.

24 For a discussion of history as event vs. history as process—states of mind to be analyzed "under a microscope" and "in slow motion"—see Andreas Suter, "Histoire sociale et événements historiques: Pour une nouvelle approche," trans. Pierre-G. Martin, *Annales* 52 (1997): 543–67. The issues are debated in *Geschichte: Ereignis und Erzählung*, ed. Reinhardt Koselleck and W.D. Stempel (Munich: Fink, 1973).

25 For incantatory variations on these themes, see Michel Serres, *Genèse* (Paris: Grasset, 1982), which discusses *noise* (an obsolete French word), the birth of time out of the spirit of music ("The work is made of forms, the masterwork is a formless fountain of forms, the work is made of time, the masterwork is the wellspring of time, the work is a sure chord, the masterwork trembles with noise [*bruit*]. He who has not heard this noise has never composed sonatas," 39), and the turbulence of process (especially in the section "Solides, fluides" in the chapter "Naissance du temps," 175–82).

26 "Abjection, broadened in a sense into subjective diachrony, *is a pre-condition of narcissism*" (Kristeva, *Pouvoirs*, 21). Narcissism, as I understand Kristeva, does not belong to abjection but follows it after the abject enters into temporal development.

27 "Kunstwerke sind die bewußtlose Geschichtsschreibung des geschichtlichen Wesens und Unwesens," Theodor W. Adorno, "Selbstanzeige des Essaybuchs 'Versuch über Wagner,'" in *Die musikalischen Monographien, Gesammelte Schriften*, vol. 13, ed. Rolf Tiedemann (Frankfurt: Suhrkamp, 1971), 506. My version tries to reflect the untranslatable pun at the end of Adorno's sentence. The passage continues: "Understanding their language and reading them as

such a historiography is the same thing. The path is indicated by the artistic technique, the logic of the image, its success or its fragility." This splendid brief text has not been translated and deserves to be better known.

CHAPTER 7 *Moods at Mid-Century*

1 The argument that Handel's oratorios are pitched precisely to the taste of his immediate contemporaries is briefly and cogently made by Friedhelm Krummacher in *Die Musik des 18. Jahrhunderts*, ed. Carl Dahlhaus (Laaber: Laaber, 1985), 191.

2 Theodor Wolpers, "Händel und die englische Kultur seiner Zeit: Aspekte einer Begegnung, vornehmlich aus literarischer Sicht," *Göttinger Händel-Beiträge* 6 (1996): 1–35. "Weitgespannt" (far-reaching) is a term from Wolpers's last sentence.

3 Dorothea Siegmund-Schultze, "Alexander Pope und Händel," *Händel-Jahrbuch* 4 (1958): 81–103; Philip Brett and George Haggerty, "Handel and the Sentimental: The Case of 'Athalia,'" *Music & Letters* 68 (1987): 112-27.

4 Jürgen Heidrich, "Händel, —ein Forstchrittlicher?" *Göttinger Händel-Beiträge* 10 (2004): 17–29, an argument for "originality in little" (19); Johanna Rudolph, "Über das Verhältnis von Aufklärung und Klassik bei Händel," *Händel-Jahrbuch* 17 (1971): 35–42, making Handel out to be a predecessor of the French Revolution on the basis of one line in the libretto of *Jephta*. (The *Händel-Jahrbuch* is based in his native city of Halle, at that time in East Germany, whose politics are reflected here.)

5 Walther Siegmund-Schultze, "Epochenbegriffe der Musik des 18. Jahrhunderts," *Händel-Jahrbuch* 17 (1971): 7–23, divides the century into Enlightenment (1710–50), early Classicism (1750–75), and late or full Classicism (1775–1815). Whatever their suitability for Germany, these divisions lack any basis in England. The pervasive hostility of the great Handel scholar Winton Dean to the intellectual culture of the Enlightenment renders his work on this topic unhelpful.

6 See two collections of essays on periodization, "Periodization: Cutting up the Past," *Modern Language Quarterly* 62 (December 2001): 4, and "La périodisation en histoire littéraire: Siècles, générations, groupes, écoles," *Revue d'Histoire Littéraire de la France* 102, no. 5 (September–October 2002).

7 Naturally, variations in scale offer perspectives that can be complementary rather than competing. For one such alternative, see James Webster's well-argued case for a Europe-wide, style-defined period dated 1720–80 and identified as Enlightenment-galant: "The Eighteenth Century as a Music-Historical Period?" *Eighteenth-Century Music* 1 (2004): 47–60.

8 See Robert Hume, "Construing and Misconstruing Farinelli in London," *British Journal for Eighteenth-Century Studies* 28 (2005): 361–85.

9 Marshall Brown, "The Urbane Sublime," in *Preromanticism* (Stanford: Stanford University Press, 1991), 22–39.

10 I quote the last line as it stood from 1730 to 1738 and would have been known to the composer. It was later revised to "And his unsuffering kingdom yet will come."

11 Ruth Smith, *Handel's Oratorios and Eighteenth-Century Thought* (Cambridge: Cambridge University Press, 1995).

12 The threatening aspects of the prophecy come from *Isaiah* 51: 6. The mountains, however, come from the more hypothetical and gentler strains of *Isaiah* 54: 10, where they do not melt: "For the mountains shall depart, and the hills be removed; but my kindness shall not depart from thee."

13 John Sitter, *Literary Loneliness in Mid-Eighteenth Century England* (Ithaca, N.Y.: Cornell University Press, 1982), 185–87, gives a useful, compact overview of the late additions to *The Seasons*, which also heighten the poem's nationalism and its exploration of the world of the imagination. Sitter's fine book remains the one focused survey of the writing of the 1740s and 1750s.

14 James Osborn comes to Pope's defense in a note to anecdote 398 in Joseph Spence, *Observations, Anecdotes and Characters of Books and Men*, ed. James M. Osborn (Oxford: Oxford University Press, 1966), 1: 175. But Osborn's main evidence (apart from this highly equivocal anecdote itself) is his assertion that Pope "considered Handel's music 'ravishing' *(Corresp.* [i.], 338)." However, the letter cited here by Osborn says: "I am to pass three or four days in high luxury, with some company at my Lord Burlington's; We are to walk, ride, ramble, dine, drink, & lye together. His gardens are delightfull, his musick ravishing" *(Correspondence*, ed. George Sherburn [Oxford: Clarendon Press, 1956], 1: 338). The editor calls the dating of the letter "mere guess-work"; there's no evidence that Pope heard music by Handel, nor indeed that he heard any music at all: since the visit is in the future, this is clearly common report that he is sharing, not personal judgment.

15 James Boswell, *The Life of Samuel Johnson, L.L.D.*, ed. Herbert Askwith (New York: Random House, n.d.), 353–54.

16 Louis I. Bredvold, "The Gloom of the Tory Satirists," in *Pope and His Contemporaries: Essays Presented to George Sherburn*, ed. James L. Clifford and Louis Landa (Oxford: Clarendon Press, 1949), 1–19.

17 The *Rambler* titles are taken from the edition by A. K. Chalmers, vol. 16 in his collection, *The British Essayists* (Boston: Little, Brown, 1856).

18 Walther Siegmund-Schultze, *Georg Friedrich Händel: Sein Leben, Sein Werk* (Munich: List, 1984), 305–6.

19 The changing image of Handel is discussed on the basis of statues by Louis François Roubiliac in Suzanne Aspden, "'Fam'd Handel Breathing, tho' Transformed to Stone': The Composer as Monument," *Journal of the American Musicological Society* 55 (2002): 39–90. The "rococo" Handel was introduced with a 1738 Vauxhall Gardens statue by the young and then little-known Roubiliac, in "almost parodic vein" and characterized by "a sense of urbane humanity" (51); along with a simultaneous image in the frontispiece to Handel's *Alexander's Feast*, it promotes "the social virtues appropriate to a modern

nation" (65). Roubiliac's 1862 Westminster Abbey monument gives a more conventional representation of the composer as "moral exemplar and teacher" (75). Perhaps this image too anticipates the reputation that was consolidated after all the personal anecdotes that Aspden also mentions faded into the background, or perhaps it merely reflects the site and the nature of the commission; in any event, the documentation makes it clear that the monument was a carefully contrived image; Langhorne's commemorative poem (which she mentions only in another connection and at second hand) is closer to the ground.

20 David Hume, *Dialogues Concerning Natural Religion*, ed. John Martin Bell (Harmondsworth: Penguin, 1990), 58.

21 The praise of Handel in *Tom Jones* 4.2 is clearly genuine, in a way that can hardly be claimed for Pope's line in the *Dunciad*: "you the feathered choristers of nature, whose sweetest notes not even Handel can excel." And in 4.5 the boorish Squire Western is ridiculed for his temerity in criticizing Handel.

CHAPTER 8 *Passion and Love*

1 "Une Epoque sans poésie" is a chapter title in Paul Hazard's classic work, *La Crise de la conscience européenne* (Paris: Boivin, 1935), 351–73. Not to put too fine a point on it, Hazard says that "poetry died, or seemed to have died" (352; only "seemed" because, after its century-long seizure, it did finally reawaken). Hazard does make the most gingerly of exceptions for Matthew Prior (discussed below), whose talents, he says, while "not vigorous," survived the ill effects of polishing by Anacreon and Horace (361). Still, despite Prior and a few unnamed others, Hazard concurs with Giosuè Carducci (Italy's Matthew Arnold) that "there has hardly ever been a less lyrical period than the first fifty years of the eighteenth century" (362).

2 Margaret Anne Doody, *The Daring Muse: Augustan Poetry Reconsidered* (Cambridge: Cambridge University Press, 1985), 57, 61.

3 Leopold Damrosch Jr., "Burns, Blake, and the Recovery of Lyric," *Studies in Romanticism* 21 (1982): 659, 651. Impervious to wit, this essay does give a richly resonant appreciation of the music of Burns's verse.

4 There are, of course, countless eighteenth-century poems *about* love or the charms of the beloved, and a fair number about sex, the palace jewel being John Armstrong's Miltonic masturbation manual, "The Economy of Love." The closest approach to confessional love lyrics that I know of from within the Enlightenment tradition are the songs by the Russian poet and playwright Alexander Sumarokov (1718–77), the most famous of which begins "Liubov', liubov'" (Love, love). While their posture is confessional, these are role-playing songs in a generalizing diction (some, including this one, are in a female voice) that remain utterly disjunct from the aging aristocrat's turbulent personal life, which included a divorce and marriage to a servant after she bore him children.

5 Hippolyte Taine, *History of English Literature*, trans. Henri van Laun, 2 vols. in 1 (New York: A. L. Burt, n.d.), 2: 255.

6 Where not otherwise specified, English poets are cited from *The Works of the English Poets from Chaucer to Cowper*, 21 vols., ed. Alexander Chalmers (London: C. Whittingham, 1810). Chalmers's texts are normalized and the works sometimes selected for moral or aesthetic reasons; both features can, of course, help to distill the representative self-image of the period. The Hammond line is Chalmers, *English Poets*, 11: 146.

7 Earl Miner, *The Cavalier Mode from Jonson to Cotton* (Princeton, N.J.: Princeton University Press, 1971), 12. Along related lines, Eric Rothstein acknowledges the influence of the Anacreontea and has a nice account of what he calls the "urbane" style in his *Restoration and Eighteenth-Century Poetry 1660–1780* (Boston: Routledge and Kegan Paul, 1981), 74–77, including in his inventory of examples "certain kinds of love poem" (75), not further specified. And his seemingly encyclopedic, year-by-year synopsis of poetic publication neglects Anacreontic verse or any similar mode, even in the digests of Prior's collections.

8 Women poets are all but unrepresented in the major anthologies until very recently, and the poets I discuss in this essay on subcanonical (rather than noncanonical) verse are all men. To the best of my knowledge, the women who were popular in the period (such as Behn and Finch in England and, later, Karschin in Germany) did not write Anacreontics. Indeed, while there are occasional Prioresque songs in Roger Lonsdale's edition, *Eighteenth Century Women Poets: An Oxford Anthology* (Oxford: Oxford University Press, 1989), there are no unquestionable Anacreontics. Only in Italian collections have I come across Anacreontics by women. There is a song by Gaetana Passerini, beginning "Lesbina semplicetta," in *Anacreontici e burleschi del secolo XVIII*, ed. Andrea Rubbi, vol. 52 of *Parnaso italiano ovvero Raccolta de' Poeti classici italiani* (Venice: Antonio Zattae Figli, 1791), 58–59, about a female Narcissus; and the luxury volume *Il fiore de' nostri poeti anacreontici* (Venice: Picotti, 1814), which is dedicated to a countess, opens with nine decorous lyrics by Agliaja Anassilide and a "Coro boschereccio" (pastoral rather than Anacreontic) by Batista Guarini. While there may be selection bias, it would not be surprising if a genre in which drinking-songs were prominent was not cultivated by women.

9 Johann Peter Uz, "An Venus," lines 3–4, in *Anakreontiker und preussisch-patriotische Lieder*, ed. Franz Muncker, 2 vols. in 1, vol. 45 of *Deutsche National-Litteratur* (Stuttgart: Union, n.d.), 2: 34: "Wie lang soll jeder rauhe Mund / Im Ton Anakreons dich zu besingen wagen?"

10 The most scholarly account of the rediscovery and diffusion of the Anacreontea is Herbert Zeman, *Die deutsche anakreontische Dichtung: Ein Versuch zur Erfassung ihrer ästhetischen und literarhistorischen Erscheinungsformen im 18. Jahrhundert* (Stuttgart: Metzler, 1972), 8–56. A less chaotic account may be found in Michael Baumann, *Die Anakreonteen in englischen Übersetzungen:*

Ein Beitrag zur Rezeption der anakreontischen Sammlung (Heidelberg: Winter, 1974). Much the most penetrating criticism is Gordon Braden, *The Classics and English Renaissance Poetry* (New Haven: Yale University Press, 1978), 196–213. Braden's conclusion about Anacreon's repetitive style and themes is germane to what I shall have to say: "'Anacreon's' loves are . . . a very private and, ultimately, tame affair—as we would now say, masturbative fantasy moving toward impotence" (212–13). While less imaginative, Patricia A. Rosenmeyer, *The Poetics of Imitation: Anacreon and the Anacreontic Tradition* (Cambridge: Cambridge University Press, 1992), gives a thorough classicist's scrutiny of the ancient corpus in its context and appends a literal translation of the complete Anacreontea.

11 While Zeman confines himself to poems deriving specifically from the Anacreontea (and is informative about their distinctive character), Baumann, for instance, takes the broader view. The best book on the broader tradition (even including some prose) is Heinz Schlaffer's carefully titled *Musa iocosa: Gattungspoetik und Gattungsgeschichte der erotischen Dichtung in Deutschland* (Stuttgart: Metzler, 1971).

12 Tom Mason, "Abraham Cowley and the Wisdom of Anacreon," *Cambridge Quarterly* 19 (1990): 103–37, though limited in analysis and devoid of reference to other relevant scholarship, is well worth reading for its judicious appreciations of Cowley's stylistic delights, in comparison to a number of other (sometimes unfairly deprecated) translators and imitators.

13 See Gordon Braden's beautiful study (not in his book), *"Vivamus, mea Lesbia* in the English Renaissance," *English Literary Renaissance* 9 (1977): 199–224. Highly suggestive is the section untranslatably titled "Comblement" (accumulating, filling up, overwhelming) in Roland Barthes, *Fragments d'un discours amoureux* (Paris: Seuil, 1977), 65–67: the full sum of pleasures is tantamount, by a kind of coincidence, to an excess of pleasures, a transport beyond utterance, into the domains of the Imaginary and the Will—such is one logic by which quantity becomes quality. Period examples can be found in Italian versions of the 25th Anacreontic, addressed to a swallow (and not originally a counting poem). Francesco Saverio de Rogatis has the following, in "Ad una rondinella": "Chi mai nel cor sentito / Ha tanti Amori, e tanti? / Il numero infinito / Tutto ridir chi può?" (Who has ever felt so many and so many Loves in his heart? Who could recount the whole infinite number?). And Pietro Metastasio, evidently trumping him, writes in "Il Nido degli Amori": "cresce la turba a segno, / Che già quasi è infinita, / E a numerarla impazzirebbe Archita" (the crowd grows to the point that it is almost infinite, and Architas would go mad counting it). Both quoted from *Il fiore de' nostri poeti anacreontici*. But quantity can be a loose cannon. The 1744 collection *Versuch in scherzhaften Liedern*, which was the first publication of Johann Ludwig Wilhelm Gleim, the most prolific of the German Anacreontic school, has numerous inventory poems, some with titles like "Der Rechenschüler," "Der Sammler," "Die Revue," and "Der Wert eines Mädchen" (the arithmetic pupil, the collec-

tor, the review, the value of a maid). Gleim's style is accumulative (abetted by the loose flow of the unrhymed verse), hence devoid of hierarchies and value criteria, and his morality is as vapid as one might fear: he was equally known for militaristic "Kriegslieder."

14 Herrick is cited by title from *The Poetical Works of Robert Herrick*, ed. F. W. Moorman (London: Oxford, 1921).

15 In misogyny, as in all things, Herrick tries out various poses. Perhaps his harshest words are palliated by the qualifier in the title set over them, "Upon Some Women." The most curious pose (in the context) is the homoerotic "Women Uselesse." And one poem, "In Praise of Women," shortly before "Love Dislikes Nothing," if it does not counterbalance the ten or so poems in dispraise, at least states the contrary position: "Of creatures, woman is the best." Playing countless transient roles, Herrick hides or blunts whatever true or lasting feelings he may have had. That's not a weakness, in this case, but the aim of the poetry.

16 See Joshua Scodel, "The Pleasures of Restraint: The Mean of Coyness in Cavalier Poetry," *Criticism* 38 (1996): 239–79, a very learned overview.

17 See Helmut Hatzfeld, "Rokoko als literarischer Epochenstil in Frankreich," *Studies in Philology* 35 (1938): 532–65, a rich inventory of badinage and forms of unseriousness.

18 Gleim actually rhymes nonsense words: "Dudeldum und dudeldei" in "Der erste Mai," "Dal de Dall, / Schön sang uns die Nachtigall!" in "Die Erinnerung." So, at the start of the century, does the timid libertine Guillaume Amfrye de Chaulieu, in his "Dialogue entre deux perroquets." And in his twenty-eight Anacreontic odes (1762), the Russian Mikhail Matveevich Kheraskov obsessively places simplicity next to godliness.

19 Ambrose Philips, *Pastorals, Epistles, Odes, and Other Original Poems* (1748; London: Scolar, 1973), 76–77.

20 Fernand Baldensperger, "La Littérature 'moyen de défense,'" *Etudes d'histoire littéraire*, 4 vols. (1939; Geneva: Slatkine, 1973), 4: 1–27. See the fine sleuthing for echoes and influences in "L'Anacréontisme du jeune Goethe et la 'poésie fugitive' française" (4: 185–203), where the function is specified—but still in too blandly "rococo" a spirit—as "défense contre la fuite du temps" (203).

21 *The Poetical Works of William Shenstone*, ed. Charles Cowden Clarke (Edinburgh: William P. Nimmo, 1868), 177, poem dated 1744. In *Love as Passion: The Codification of Intimacy*, trans. Jeremy Gaines and Doris L. Jones (Stanford: Stanford University Press, 1998), Niklas Luhmann argues that "the eighteenth century found it necessary to . . . distinguish between" love and friendship (80). Luhmann's systems theory is a kind of neo-structuralism predicated on differences--"the individual person needs the *difference* between a close world and a distant, impersonal one," and so forth (16)--and consequently is blind to lurking forces: desire is not even a topic in his study. Luhmann says "the behaviour of characters in novels is code-oriented" (11), but I suspect the fixture of types is inseparable from his decision to "make a point of looking for

second- and third-rate literature" (11), which misses the point of complex literary interactions. We might conjecture, for instance, that under the bashfulness of Metastasio's "L'Amor timido," "Vorrei dirle ch'io l'amo, e non vorrei" (I would like to tell her I love her, and I wouldn't like to), his successor as the great Italian librettist found lurking the passion of the seduced Zerlina in *Don Giovanni*, "Vorrei e non vorrei."

22 Friendship became incendiary in the Romantic period; see (fundamental, among many recent studies) Mary A. Favret, *Romantic Correspondence: Women, Politics, and the Fiction of Letters* (Cambridge: Cambridge University Press, 1993). On the long-lasting difficulties in imaging innocent friendship between men and women, see Victor Luftig, *Seeing Together: Friendship between the Sexes in English Writing from Mill to Woolf* (Stanford: Stanford University Press, 1993).

23 *The Poetical Works of Matthew Prior*, 2 vols., ed. John Mitford (Boston: Little, Brown, 1853), 2: 280. I don't cite the critical edition, *Literary Works*, ed. H. Bunker Wright and Monroe K. Spears, 2 vols. (Oxford: Clarendon Press, 1971), because it prints datable poems in chronological order and relegates a great many others to the category "Unknown Date," without providing contents lists for eighteenth-century editions, thereby making it impossible to reconstruct the original reading experience; the texts are identical in substantives. Parallel occurrences of "taste" can be found in Songs 18 ("Nanny blushes") and 20 ("Phillis, give this humour over"), 2: 324, 325. See Faith Gildenhuys, "Convention and Consciousness in Prior's Love Lyrics," *Studies in English Literature, 1500–1900*, 35 (1995): 437–55, for a sympathetic survey of shades of emotion, restraint, and self-awareness, concluding with what ought to be a program for critical exploration: "Convention . . . becomes a subtle means of exploring the contradictions and limitations of the myths of masculine desire" (453). I have found one prior essay in appreciation that is more superficial, though more polished: Maynard Mack, "Matthew Prior: *Et multa prior arte . . . ,*" *Sewanee Review* 68 (1960): 165–76. Mack likes Prior's clear-sighted portrayal of the world's illusions, even if the poet has little to say about them; he does not recognize the emptiness as a form of discretion.

24 Paul Böckmann, "Das Formprinzip des Witzes in der Frühzeit der deutschen Aufklärung," *Formengeschichte der deutschen Dichtung*, vol. 1 (no more published): *Von der Sinnbildsprache zur Ausdruckssprache: Der Wandel der literarischen Formensprache vom Mittelalter zur Neuzeit* (Hamburg: Hoffmann und Campe, 1949), 471–552. The translation of the quoted phrase (523) cannot capture the impersonality of subjectless speech in the German: "Auch wenn wirklich vom Ich aus gesprochen wird, bleibt das Gefühl im Hintergrund." The argument of the section "Die Bedeutung der Lehre vom Witz für die Dichtung der Rokokozeit" (518–29) is that Anacreontics sunder wit from morality, so that morality can remain uncontaminated; hence rococo is not faded baroque but a distinct culture of wit. Heinz Schlaffer's *Musa iocosa* answers Böckmann in rich detail; both emphasize role-playing, but Schlaffer

is interested in what the disguise covers up. However, both critics share an aim of defining and distinguishing styles, and so even Schlaffer underplays the tensions within and around Anacreontic verse. In particular, his section called "Einschränkung: Scherzhafter Stil" (124–32) cordons off the moderate, middle style of these poems from both high and low styles, which he regards as mutually convertible. There is too much snickering in Anacreontic verse, and too much felt adoration, for me to find this element of his book persuasive. A useful introduction in English to German Anacreontic verse is Robert Browning, *German Poetry in the Age of Enlightenment: From Brockes to Klopstock* (University Park: Pennsylvania State University Press, 1978), 68–133.

25 *The Poetical Works of Thomas Parnell* (Boston: Little, Brown, 1854), 24.

26 Excluded from Chalmers "on account of its indelicacy" (15: 162) is Green's other Anacreontic, "Jove and Semele," which could count as an aberrant exemplar of the "against fruition" tradition. Courted by Jove in human guise, Semele pleaded for transcendent pleasure and was then mortally stunned by the "flaming splendours" and "excess of bliss." The violence in "The Sparrow and Diamond" is more oblique, with more realistic complexity. "Jove and Semele" may be found in *The Poets of Great Britain*, 17 (London: Pitt and Green, 1807), 177–78.

27 The story is told from the bird's perspective in Giuseppe d'Ippolito Pozzi's wonderful "Dolce amabil rossignuolo," which (separated from other Pozzi lyrics, evidently as a genre-defining display piece) opens *Anacreontici e burleschi del secolo XVIII*, pp. 1–3. Spreading beyond the genres named in the title, the splendid volume includes sonnets, satires, Arcadian lyrics, and mock-romance and mock-epic, indicating some of the affinities granted to Anacreontics in the period.

28 Eric Partridge's *Dictionary of Slang and Unconventional Usage* (New York: Macmillan, 1950) dates "dicky-bird" from the mid-nineteenth century; the OED cites a 1781 letter of Horace Walpole (and 1851 for its earliest independent use of "dicky" in this sense). (Dick = penis is late nineteenth-century military slang.) "Engineer'd" as a finite verb appears to be a neologism; "undraw" is cited earlier only from a bilingual dictionary. In addition to these undocumented innovations, Green is cited for the earliest usage in seventeen OED definitions, including rare neologisms and grammatical deformations like "tarantulated," but also a number of words or senses that have become common: blinkers, careen, chiseled, crusade (first instance of the verb), and stoker. For comparison, Dryden, with an incomparably vaster corpus (though, to be sure, recorded chiefly for very common words between *m* and *p*), appears as innovator only for two French words, *politique* and *poudré*.

29 A worthwhile comparison poem is Suckling's song, "'Tis now, since I sate down" (*English Poets*, 6: 497), which shares motifs, movement, and diction with "The Sparrow and Diamond"—Suckling's "My tongue was engineer" seems a likely source for Green's introduction of the verb "engineer'd"—but

it takes the measure of the speaker's feelings more directly and openly, hence less lasciviously.

30 The poem could be subdivided further, in accord with Karl Abraham's division of the oral phase into two stages, sucking and biting, the latter sadistic and at the root of melancholia. See chapter 3, "Der Introjektionsvorgang in der Melancholie: Zwei Stufen der oralen Entwicklungsphase der Libido," in *Versuch einer Entwicklungsgeschichte der Libido auf Grund der Psychoanalyse seelischer Störungen, Psychoanalytische Studien*, 2 vols., ed. Johannes Cremerius (Frankfurt: Fischer, 1971), 1: 134–42.

31 The term *Entmischung* is introduced in chapter 4 of "Das Ich und das Es" (Sigmund Freud, in *Studienausgabe*, 11 vols., ed. Alexander Mitscherlich et al. [Frankfurt: Fischer, 1982], 3: 308), in connection with the love-death fusion; an editor's note refers back to *Jenseits des Lustprinzips*, chapter 4 (3: 262–63), where the topic is love-hate.

32 Unhelpful, to my mind, is the overly categorical account of desire given by Catherine Belsey: "In the end desire is not of the other, but of the Other, and its gratification is both forbidden and impossible," *Desire: Love Stories in Western Culture* (Oxford: Blackwell, 1994), 182. That, in the end, two-valued quandary, collapsing all others into a singular Not-same, is, according to Belsey, why we need deconstruction. Fair enough. But if we began with more supple terms, we wouldn't so imperiously need to undo them. More suggestive about the complexities of possession and identification, jealousy and emulation, in "The Sparrow and Diamond," are the discussions in Julia Kristeva's essay "Freud and Love: Treatment and Its Discontents" (*Tales of Love*, trans. Leon S. Roudiez [New York: Columbia University Press, 1987], 21–56) of narcissism as a structured unconscious and in particular (initially on p. 26 and scattered throughout the volume) of the tension between "having" and "being-like."

33 Parnell's "When Spring came on," which was mentioned earlier in the text, well exemplifies Anacreontic timelessness: it begins in a narrative past tense (line 4: "'Twas then"), moves to a generalized present (line 29: "'Tis thus, when Spring renews the Blood"), reverts to a more immediate past reminiscent of Green's "I lately saw"—lines 49–50: "All this (as late I chanc'd to rove) / I learn'd"—and concludes with a twelve-line present-tense speech by Love about the order of things. Cited from *Collected Poems*, ed. Claude Rawson and F. P. Lock (Newark: University of Delaware Press, 1989), 133–38.

34 Sigmund Freud, "Zur Einführung des Narzißmus," in *Studienausgabe* 3: 44.

35 "Die Unmittelbarkeit der Gefühlsaussprache in der Lyrik" is the title of the first section of Böckmann's chapter on Goethe's lyrics, *Formengeschichte*, 628–35. For a general discussion, see the section entitled "Lyric as Poetic Norm," in Meyer H. Abrams, *The Mirror and the Lamp* (New York: Norton, 1958), 84-88.

36 Of greatest relevance are Freud's remarks on silence in "Das Ich und das Es." He reports the "impression that the death drives are predominantly mute and the noise of life proceeds from Eros," then concludes, "The id . . . has no means to attest its love or hate to the ego. It cannot say what it wants. . . . We could

represent it, as if the id stood under the mute but powerful death drives that want rest and that wish to bring the troublemaker Eros to rest following the hints of the pleasure principle, but we are concerned that we might thereby underestimate the role of Eros" (*Studienausgabe* 3: 313, 325). A poetic genre that is urbanely terrified of death and in which love can sing but not speak would seem to capture perfectly this analytic complexity. In *The Legend of Freud* (Minneapolis: University of Minnesota Press, 1982), 129, Samuel Weber shrewdly argues that this silence of the death-drive "might be just another form of the narcissistic language of the ego."

37 "Surplus-repression" is Herbert Marcuse's term for the socially induced regulation and structuring of the primary instincts, as opposed to biologically necessary controls—a useful precursor to the more intricate abstractions of Foucault. See Marcuse, *Eros and Civilization: A Philosophical Inquiry into Freud* (New York: Vintage, 1962), 32, 34–35, 80–81, 205–06.

38 Claude-Joseph Dorat, *Les Baisers* (1770), nos. 8 and 5 ("La Réserve"), in *Petits poèmes érotiques du XVIIIe siècle*, ed. F. de Donville [François Tulou] (Paris: Garnier, 1880), 246, 242. "Les Baisers comptés" wants an infinity rather than the magic 9.

39 *Gotthold Ephraim Lessings sämtliche Schriften*, vol. 1, ed. Franz Muncker (Stuttgart: Göschen, 1886), 86.

40 *Noches lúgubres* (Buenos Aires: Emecé, 1943), 86–87. The volume is titled after a different and better-known work; Cadalso's Anacreontics are not lugubrious.

41 A passage in Mary Shelley's 1826 novel *The Last Man* reflects the fate of computations of love in the Romantic period. "The affection and amity of a Raymond might be inestimable; but, beyond that affection, embosomed deeper than friendship, was the invisible treasure of love. Take the sum in its completeness, and no arithmetic can calculate its price; take from it the smallest portion, give it but the name of parts, separate it into degrees and sections, and like the magician's coin, the valueless gold of the mine is turned to vilest substance. There is a meaning in the eye of love; a cadence in its voice, an irradiation in its smile, the talisman of whose enchantments one only can possess; its spirit is elemental, its essence single, its divinity an unit." *The Last Man*, ed. Anne McWhir (Peterborough, Ont.: Broadview, 1996), 99–100.

42 Though she does not persuade me, Leslie O'Bell tries to rescue Derzhavin's Anacreontic verse in the face of a general preference for his earlier and more ambitious works, in a useful overview, with quotes in English, "The Spirit of Deřavin's Anacreontic Verse," *Die Welt der Slaven* 29 (1984): 62–87.

43 Alexander Pope, "Eloisa to Abelard," 59–60, cited from *The Poems of Alexander Pope*, ed. John Butt (New Haven: Yale University Press, 1963).

44 On this little-recognized edge to Pope's verse, see James Grantham Turner, "Pope's Libertine Self-Fashioning," in *The Eighteenth Century: Theory and Interpetation* 29 (1988): 123–44, as well as, more generally, James G. Turner, "The Properties of Libertinism," *Eighteenth-Century Life*, n.s. 9 (1985): 75–87. *The Rape of the Lock*, in explicit paraphrase, becomes the curious pretext for

a *carpe diem* seduction poem called "La maschera" by the Bolognese Anacreontic poet Ludovico Savioli Fontana. It can be found (together with a selection of Savioli's rather ornately precious love poems) in *Poeti del settecento*, ed. Raffaella Solmi (Turin: Unione tipografico, 1989), 297–301.

45 Cited from *Poesías*, ed. Pedro Salinas (Madrid: Espasa-Calpe, 1955). The editor characterizes a cycle of similar odes as Anacreontic (51), though I would say they only yearn for Anacreontism.

46 Another Spanish poet, Gaspar Melchor de Jovellanos, writes in the prologue to his poems: "Amidst the inclination that I have for Poetry, I have always regarded its lyric part as little worthy of a serious man, especially when it contains no greater object than love. I know very well that youth prefers love in its compositions, and I do not reprove it. It is natural for a young poet to seek the object of his compositions from among those that most sweetly occupy his heart. . . . Thus it is that we see those who are born to be great poets making their trials in tender and amorous poetry, and I am persuaded that we would not have the great poems whose beauty has for many years enchanted and amazed us if its authors had not squandered many lines on frivolous and petty objects." *Poetas líricos del siglo XVIII*, ed. Higinio Capote (Zaragoza: Ebro, 1963), 231–32. Jovellanos (1744–1810) wrote sentimental complaints in the form of pastoral epistles and Sapphic and other odes, not Anacreontics, though an excerpt from his first Idyll, "Anfrisa a Belisa," is mistitled "Anacreóntica" in this anthology. Notable among Anacreontic bachelors are Herrick and Uz.

47 The quoted phrase and the following come from Bourdieu's essay, "Flaubert's Point of View," in *The Field of Cultural Production: Essays on Art and Literature*, ed. and trans. Randal Johnson (New York: Columbia University Press, 1993), 197.

48 Thomas Moore, *Poetical Works* (London: George Routledge, n.d.). The Keatsian words in my quotations (such as the "withering" and "feverish" that suggest "La Belle Dame sans merci") are in every case Moore's ornamentation of the spare Greek. A pair of original poems entitled "Anacreontique" ("Press the grape" and "Friend of my soul!") anticipate the weeping tone of the "Ode on Melancholy"; another "Anacreontic," beginning "She never look'd so kind before," concerns an unfaithful beloved named Lamia, though it is not otherwise reminiscent of Keats's narrative. Jonathan Bate, "Tom Moore and the Making of the 'Ode to Psyche,'" *Review of English Studies* 41 (1990): 325–33, summarizes the available information about Keats's interest in Moore's 1806 *Epistles, Odes, and Other Poems*, which the Mathew sisters read with him in 1815, and argues that the volume is a model for the form of the Psyche Ode, though not particularly for its diction. E. E. Duncan-Jones presents another poem as a source for the repeated "happy" of the Grecian Urn, in "Moore's 'Kiss à l'Antique' and Keats's 'Ode on a Grecian Urn,'" *Notes and Queries*, n.s. 28 (1981): 316–17.

49 Moore's Anacreon ends with a group of old-age poems—not part of the

accepted sixty Anacreontea—that acknowledge aging, but still in a light-hearted way.

50 Even in the landscapes of the early Blake one can sense an ongoing argument with Anacreon. A good comparison is the song from *Poetical Sketches*, "How sweet I roam'd from field to field," with Shenstone's Song 2, "The Landscape," beginning, "How pleased within my native bowers / Erewhile I pass'd the day."

51 See the subtle reckoning with Romantic negation as a transumption of irony in John Baker Jr., "Grammar and Rhetoric in Wordsworth's 'A Slumber Did My Spirit Seal': Heidegger, de Man, Deconstruction," *Studies in Romanticism* 36 (1997): 103–23.

52 Zeman, *Die deutsche anakreontische Dichtung*, 266–314; Böckmann, *Formensprache* 1: 552 ("echte Sinnbildlichkeit") and 628–35; Schlaffer, *Musa iocosa*, 181–94. Zeman documents the introduction of the French word "naïf" as a kind of technical term for feelings not subsumed by rational understanding; he quotes Ludwig Friedrich Heidemann, writing in 1732: "eine Eigenschaft . . . , die dem Ansehen nach bloß von der innerlichen Empfindung des Geistes herrührt, ohne daß die Vernunft dabey beschäfftigt gewesen zu seyn scheinet" (90) (a quality . . . that in appearance derives only from the inner feeling of the spirit, without the reason seeming to be active). Both Böckmann and Schlaffer focus, among others, on the 1771 lyric, "Kleine Blumen, kleine Blätter." One might see the central Goethean theme of "Dauer im Wechsel" (endurance through change) as a Romantic answer to an Anacreontic question: "La beauté qui vous fait naître, / Amour, passe en un moment; / Pourquoi voudriez-vous être / Moins sujet au changement?" (The beauty that gives birth to you, Love, passes in a moment; why would you wish to be less subject to change?). Chaulieu, "Apologie de l'inconstance," *Poésies* (Paris: d'Hernan, 1803), 114.

53 On the child in Romanticism, see Judith Plotz, *Romanticism and the Vocation of Childhood* (New York: Palgrave, 2001), and my essay, "*Frankenstein*: A Child's Tale," *Novel* 36 (2003): 145–75.

54 The essay on Stendhal to which I allude has, in spirit, been written: see the late essay of Roland Barthes, "On échoue toujours à parler de ce qu'on aime," *Tel quel*, no. 85 (Autumn 1980): 32–38. See also the slier exposé by Julia Kristeva, "Stendhal and the Politics of the Gaze: An Egotist's Love," *Tales of Love*, 341–64. An Italian "anacreontica" is quoted at length in chapter 31 of Stendhal's *De l'amour*.

55 Albert O. Hirschman, *The Passions and the Interests: Political Arguments for Capitalism before Its Triumph* (Princeton: Princeton University Press, 1977), 132. On greed and lust, see page 41; on the "sweetness" (or calming effect) of economic interests, see pages 56–66.

CHAPTER 9 *Haydn's Whimsy: Poetry, Sexuality, Repetition*

1 There was also, indeed, the new genre of folksongs, of which both Haydn and Beethoven made popular arrangements on commission. The term *Volkslied*

was coined by Johann Gottfried Herder; the OED supplement first records "folk-song" in 1870 ("A German Folk's Song" somewhat earlier, 1847). Folksongs were not yet subjects for serious composers.

2 Haydn consciously sought variety. A letter of October 18, 1781, to his publisher Artaria says: "I would like 3 new tender texts for songs, since the others are all comic in nature; the content can be sad, so that I have shade and light, as with the earlier twelve" (Joseph Haydn, *Gesammelte Briefe und Aufzeichnungen*, ed. Dénes Bartha [Kassel: Bärenreiter, 1965], 104). Thanks to Tom Beghin for this reference. For a nice overview, see Katalin Komlós, "Miscellaneous Vocal Genres," in *The Cambridge Companion to Haydn*, ed. Caryl Clark (Cambridge: Cambridge University Press, 2005), 164–75.

3 The preceding chapter surveys Anacreontic verse. The best study of the lyric of sensibility (though only in English poetry) is Jerome McGann, *The Poetics of Sensibility: A Revolution in Literary Style* (London: Oxford University Press, 1996). It should be said that the revolution McGann envisions is something close to the lyric impulse as such; it is an antirationalist privileging of "language as *affective* thought" (6) really opposed only to outmoded views of an unemotional Enlightenment and actually, as I see it, embodied in lyric and musical expression throughout the eighteenth century. In short, while McGann's readings are wonderful, I don't think there was a revolution—or at least not anything like the revolution he describes—and Haydn's taste in poetry would be incomprehensible if we posited such a disconnection between the Anacreontic and sentimental modes.

4 For a fine discussion of forms and moods in Haydn's settings of Hunter, see pages 52–77 of A. Peter Brown, "Musical Settings of Anne Hunter's Poetry: From National Song to Canzonetta," *Journal of the American Musicological Society* 47 (1994): 39–89. For a broadly (and successfully) deconstructive reading of three of the more somber songs, see William Kumbier, "Haydn's English Canzonettas: Transformations in the Rhetoric of the Musical Sublime," in *The Scope of Words: In Honor of Albert S. Cook*, ed. Peter Baker, Saray Webster Goodwin, and Gary Handwerk (New York: Peter Lang, 1991), 73–94. Haydn's melancholy (in the English songs and elsewhere) is discussed as a reflective and sometimes ironic stance in Nancy November, "Haydn's Melancholy Voice: Lost Dialectics in His Late Chamber Music and English Songs," *Eighteenth-Century Music* 4 (2007): 71–106. Hunter has been only casually noticed by scholars of women's poetry or of British Romanticism. For instance, the preface to *The Cambridge Guide to Women's Writing in English* features her as an "example of what's not here" (accessed on 7 Aug 2001 at http://uk.cambridge.org/literature/features/sage/preface.htm). There is, however, an informative account of her life on pages 437–57 of John Koegel, "'The Indian Chief' and 'Morality': An Eighteenth-Century British Popular Song Transformed into a Nineteenth-Century American Shape-Note Hymn," in *Music in Performance and Society: Essays in Honor of Roland Jackson*, ed. Malcolm Cole and John Koegel (Warren, Mich.: Harmonie Park, 1997), 439–508. I am grateful to Professor Cole for this reference.

5 Schubert set a great many poems from Haydn's era, "Die Forelle" among them. Its poet, Christian Friedrich Daniel Schubart (1739–91), was, however, a political radical who inserts a more emotive "I" into the anecdote than can be found in any of Haydn's songs. Schubert assists the effect by following the syntax rather than the strophic pattern in his (radically varied and turbulent) third verse and by omitting a more conventionally moralizing fourth verse: "Die ihr am goldnen Quelle / Der sichern Jugend weilt, / Denkt doch an die Forelle . . ." (Ye who dwell at the golden fount of secure youth, think on the trout . . .).

6 Leon Botstein, "The Demise of Philosophical Listening: Haydn in the Nineteenth Century," in *Haydn and His World*, ed. Elaine Sisman (Princeton: Princeton University Press, 1997), 275; also in the revised version, "The Consequences of Presumed Innocence: The Nineteenth-Century Reception of Joseph Haydn," in *Haydn Studies*, ed. W. Dean Sutcliffe (Cambridge: Cambridge University Press, 1998), 29.

7 David Hume, *A Treatise of Human Nature* (1740; Garden City, N.Y.: Doubleday, 1961), 531.

8 Adolf Freiherr von Knigge, *Über den Umgang mit Menschen* (1788; Halle: Hendel, n.d.), 42.

9 Kenneth Burke announces his "joycing" of Keats's line in *A Rhetoric of Motives* (1950; Berkeley: University of California Press, 1969), 204.

10 Heinrich W. Schwab documents composers' and theorists' expressed concern for problems of strophic correspondence in *Sangbarkeit, Popularität und Kunstlied: Studien zu Lied und Liedästhetik der mittleren Goethezeit, 1770–1814* (Regensburg: Gustav Bosse, 1965), 50–54.

11 Edward T. Cone, *The Composer's Voice* (Berkeley: University of California Press, 1974), 36. See, earlier, Theodor Adorno, *In Search of Wagner*, trans. Rodney Livingstone (1952; London: Verso, 1991), 101, 148, 155; Adorno's term is "unconscious."

12 Edward T. Cone, "Poet's Love or Composer's Love?" in *Music and Text: Critical Inquiries*, ed. Steven Paul Scher (Cambridge: Cambridge University Press, 1992), 182.

13 Lawrence Kramer, *Music and Poetry: The Nineteenth Century and After* (Berkeley: University of California Press, 1984). For transmemberment (a term from Hart Crane), see pages 125–27; the other terms are indexed. With reference to poetry Kramer writes of "subliminal vistas of . . . an erotic union miraculously transposed into the register of spirit," *After the Lovedeath: Sexual Violence and the Making of Culture* (Berkeley: University of California Press, 1997), 198–99.

14 Lawrence Kramer, *After the Lovedeath*, 201, about Beethoven's "Kreutzer" Sonata—debatable there and more so when Kramer writes about Mozart's Divertimento for String Trio, K. 563, that it "renders palpable the muscular effort of arms and fingers, the rhythmic sway of the players' torsos," *Classical Music and Postmodern Knowledge* (Berkeley: University of California Press, 1995), 27. Charles Rosen writes more eloquently of Chopin's physicality in *The*

Romantic Generation (Cambridge, Mass.: Harvard University Press, 1995), 383.

15 The prejudice that favors passion and tragic domination over imagination and comic liberation is the topic of Laura Quinney, *Literary Power and the Criteria of Truth* (Gainesville: University Press of Florida, 1995). The book's main axis runs from Samuel Johnson to Percy Shelley. With relation to Haydn, James Webster contests the parallel prejudice in "Haydn's Symphonies between *Sturm und Drang* and 'Classical Style': Art and Entertainment," in *Haydn Studies*, ed. W. Dean Sutcliffe, 218–45, though he concentrates on form at the expense of meaning.

16 Gary Tomlinson, *Metaphysical Song: An Essay on Opera* (Princeton: Princeton University Press, 1999), 41.

17 Mark Evan Bonds quotes Schoenberg's slur in "Rhetoric versus Truth: Listening to Haydn in the Age of Beethoven," *Haydn and the Performance of Rhetoric* (Chicago: University of Chicago Press, 2007), 118. For an informative and illuminating survey of issues of repetition in eighteenth-century music theory as well as in modern critical theory, see Elaine Sisman, *Haydn and the Classical Variation* (Cambridge, Mass.: Harvard University Press, 1993), 1–18. Sisman treats variation as an aesthetic-formal vehicle of delight, differing fundamentally from the accepted model of organic sonata form and consistent with the notion of Haydn as an agreeable, entertaining, or affecting composer ("ingenious, pleasing, and heart felt," in the words of Charles Burney, cited on page 109). I supplement her perspective with functions of repetition conveying more psychodynamic power. After all, how sharp a line can be drawn between jokes for us and jokes on us? The legend of the Farewell Symphony certainly credits Haydn with designs that go beyond pleasing; as Daniel Chua writes in a wise essay, "If you hear only happiness in Haydn, then the joke is on you," "Haydn as Romantic: A Chemical Experiment with Instrumental Music," in *Haydn Studies*, ed. W. Dean Sutcliffe, 150; reprinted in Chua, *Absolute Music and the Construction of Meaning* (Cambridge: Cambridge University Press, 1999), 216. Other comments on repetition may be found in Gretchen A. Wheelock, *Haydn's Ingenious Jesting with Art: Contexts of Musical Wit and Humor* (New York: Schirmer, 1992), 175–78. With the reminder that repetition is characteristic of both practicing and doodling, Wheelock associates it with a "nexus of distraction and engagement" (176). I hope to have made a case in this chapter that Haydn's music can be beguiling and seductive—qualities that break down innocent aesthetic distancing. There is nothing antiformalist in this account, it must be said, but rather a different understanding of form.

18 Søren Kierkegaard, *Repetition: An Essay in Experimental Psychology*, trans. Walter Lowrie (New York: Harper, 1964), 33.

19 Søren Kierkegaard, *Either/Or*, trans. David F. Swenson and Lillian Marvin Swenson, 2 vols. (Princeton: Princeton University Press, 1971), 1: 93.

20 Charles Rosen, *The Classical Style: Haydn, Mozart, Beethoven* (New York: Norton, 1997), 351–65.

21 Sociologically, the piano trios appear to be private women's music, in contrast

to the more public and more masculine style of the string quartets. But compositional factors confound a merely mechanical distinction of the genres; it would be more appropriate to say that they represent private vs. public styles rather than that they unselfconsciously fall into them. For a good discussion, see Mary Hunter, "Haydn's London Piano Trios and His Salomon String Quartets: Private vs. Public?" in *Haydn and His World*, ed. Elaine Sisman, 103–30.

22 Gender associations were incipient in Haydn's final decades and not yet well established; see Matthew Head, "'Like Beauty Spots on the Face of a Man': Gender in 18th-Century North-German Discourse on Genre," *The Journal of Musicology* 13 (1995): 143-67 (with speculative extension to Haydn at the end).

23 See Charles Rosen, *Sonata Forms* (New York: Norton, 1980), 251–63, on the uses of the relative minor in the retransition.

24 See David P. Schroeder, *Haydn and the Enlightenment: The Late Symphonies and Their Audience* (Oxford: Clarendon, 1990), with some helpful English philosophical backgrounds, tenuous links to Haydn himself, and limited analysis; Mark Evan Bonds, "Haydn, Laurence Sterne, and the Origins of Musical Irony," *Journal of the American Musicological Society* 44 (1990): 57–91, where the intellectual Sterne overshadows the sentimental Sterne; and Wheelock, *Haydn's Ingenious Jesting with Art*, which juxtaposes almost entirely English intellectual context with abundant and well-described examples of musical pranks, but without enough mediation between its two elements. One discussion of Haydn that does repeatedly invoke whimsy is Lawrence Kramer's "The Kitten and the Tiger: Tovey's Haydn," in *The Cambridge Companion to Haydn*, ed. Caryl Clark, 239–48, which reclaims Haydn for proto-Kantian and even Blakean play, "a spirit indifferent to the presumed niceties of civilization" (247). Perhaps this account recaptures Tovey's Haydn, but not quite mine: Kantian play, after all, is never moody, and Blakean play is never decorous.

25 On such matters of sonority in the piano trios, there are many valuable comments (though no mention of the C-Major trio) in W. Dean Sutcliffe, "The Haydn Piano Trio: Textual Facts and Textural Principles," in *Haydn Studies*, ed. W. Dean Sutcliffe, 246–90.

26 The Peters edition puts the arpeggio in steady eighths in the piano and cello, with the more rapid movement only in the violin. The contrasting rhythms heighten the effect.

27 Scott Burnham, *Beethoven Hero* (Princeton: Princeton University Press, 1995), 65. More recently, though, Burnham has contested "the ingrained critical habit of treating Haydn as an innocent predecessor of composers whose music descends more deeply into the realms of human experience," or as a mere "warm-up act"; "Haydn and Humor," in *The Cambridge Companion to Haydn*, ed. Caryl Clark, 75.

28 Annette Richards, *The Free Fantasia and the Musical Picturesque* (Cambridge: Cambridge University Press, 2001), 121–4.

29 Johann Karl Friedrich Triest, "Remarks on the Development of the Art of

Music in Germany in the Eighteenth Century" (1801), trans. Susan Gillespie, in *Haydn and His World*, ed. Elaine Sisman, 373.

30 Thomas Sipe, "Beethoven, Shakespeare, and the 'Appassionata,'" *Beethoven Forum* 4 (1995): 73, 96. The fundamental study of the term, not cited there, is Wolfgang Preisendanz, *Humor als dichterische Einbildungskraft: Studien zur Erzählkunst des poetischen Realismus* (Munich: Eidos, 1963).

31 C. F. Michaelis, "Ueber das Humoristische oder Launige in der musicalischen Komposition," *Allgemeine musikalische Zeitung* 46 (1807): 725–29.

CHAPTER 10 *Non Giovanni*

1 Translations from the libretto are my own. They are intended only as pointers to the Italian; with no pretense to making good English, I have been stonily faithful to Da Ponte's lexicon, such as the distinction between *battere*, rendered as *beat* or as *fight*, and *palpitare*, rendered as *throb*. Text and music alike are cited from the critical edition of the score by Wolfgang Plath and Wolfgang Rehm, in Wolfgang Amadeus Mozart, *Neue Ausgabe sämtlicher Werke*, vol. 8 (Kassel: Bärenreiter, 1991).

2 Joseph Kerman, *Opera as Drama* (New York: Vintage, 1956), 122.

3 Kierkegaard's last word about Don Giovanni: "His life is like this, effervescent as champagne." He calls the champagne aria "the keynote of the opera." Søren Kierkegaard, *Either/Or*, vol. 1, trans. David F. Swenson and Lillian Marvin Swenson (Princeton: Princeton University Press, 1971), 134.

4 In German "schlagen" also refers to certain birdsongs. They, too, are characteristically represented with dotted rhythms, as in Beethoven's Pastoral Symphony or his song "Der Wachtelschlag." In the Andante Grazioso duet "Il core vi dono" in *Così fan tutte*, which celebrates the completion of Guglielmo's seduction of Dorabella, the beating heart is represented first by a steady sixteenth-note trill ("Perchè batte, batte, batte qui"), the trill being the opera's sign of instability, most explicitly in the mesmerism scene in the Act 1 Finale and in Guglielmo's original, now rarely-performed aria "Rivolgete a lui lo sguardo," with the text, "Se cantiam col trillo solo facciam torto all'usignuolo" (If we sing, we outdo the nightingale with our trill alone), then by staccato eighths marked with destabilizing second-beat accents.

5 In *Becoming Historical: Culture, Subjectivity, and Nineteenth-Century Music* (Princeton: Princeton University Press, 2004), Michael P. Steinberg calls the opening chords of the Overture "shocks" that "can never be heard" (28) and speaks of the course of the Andante as "the birth of consciousness through the spirit of music" (29). My account here could be regarded as filling in his details, though with a more abstract aim than the confrontation of Catholic baroque and Protestant Enlightenment cultures that he asserts in close correspondence with Ivan Nagel, *Autonomy and Mercy: Reflections on Mozart's Operas*, trans. Marion Faber and Ivan Nagel (Cambridge, Mass.: Harvard University Press), 42. Related allegorizations of the opening chords can be

found in the richest music-text study of the operas, Stefan Kunze, *Mozarts Opern* (Stuttgart: Reclam, 1984), 373, and in Nicholas Till, *Mozart and the Enlightenment: Truth, Virtue and Beauty in Mozart's Operas* (New York: Norton, 1993), 341.

6 Friedrich Wilhelm Joseph Schelling, *The Philosophy of Art*, trans. Douglas W. Stott (Minneapolis: University of Minnesota Press, 1989), 111 (chapter 4, §79).

7 For comments on chromatic descents and ascents in *Don Giovanni*, see Daniel Heartz, *Mozart's Operas*, ed. Thomas Bauman (Berkeley: University of California Press, 1990), 181, 205, 210–15. I mention other chromatic moments below.

8 Wye Jamison Allanbrook says that E-flat is located "at odd angles to the 'real' (D major) world" of the opera; see her *Rhythmic Gesture in Mozart: "Le Nozze di Figaro" and "Don Giovanni"* (Chicago: University of Chicago Press, 1983), 240; the topic is developed further on page 252.

9 See Lionel Trilling, *Sincerity and Authenticity* (Cambridge, Mass.: Harvard University Press, 1972).

10 In *Mozarts Opern*, 357–59, Kunze presents the message of "Vedrai, carino" as pacification *(Befriedung)*, stressing its C-major simplicity. To my ear, pacification here comes close to dissolution. And the four opening Cs (counting the appoggiatura note that begins the second measure), with voice supported by strings and horn, are the same scale note and, potentially, the same metronome marking as the four Cs of Leporello's "ta, ta, ta, ta," his terrified announcement of the statue, supported by strings and horn. Kunze prefers, of course, other parallels within the opera. I indicate the occasional points of disagreement precisely because his book is so thoughtful and generally persuasive; I hope the debates may help especially musically unpracticed readers to see how close reading of a musical text interlaces with hermeneutic understanding of it.

11 For sources and analogues to the Catalogue Aria in the innumerable Don Juan operas, see Hans Albert Glaser, "Don Giovannis Liste: Zur Textgeschichte der Registerarie," *Mozarts Opernfiguren: Grosse Herren, rasende Weiber—gefährliche Liebschaften*, ed. Dieter Borchmeyer (Berne: Paul Haupt, 1992), 93–114, and John Platoff, "Catalogue Arias and the 'Catalogue Aria,'" in *Wolfgang Amadè Mozart: Essays on His Life and Music*, ed. Stanley Sadie (Oxford: Clarendon Press, 1996), 296–311. The widely recognized impression of comic braggadoccio, however, surely begins with the extra-operatic source that Da Ponte would have known well, the fourteenth Anacreontic Ode (which, in the 1800 translation by Thomas Moore, begins, "Count me on the summer trees, / Every leaf that courts the breeze"). For more on the Anacreontic tradition, see chapters 8 and 9 in this volume.

12 Buffo arias "either exhibit remarkable poverty of invention over stretches of musical time, or they juxtapose contrasting ideas in places and ways that do not assist the communication of tonal or textual structures," Mary Hunter, *The Culture of Opera Buffa in Mozart's Vienna: A Poetics of Entertainment* (Princeton: Princeton University Press, 1999), 124.

13 "Dalla sua pace" was appended to an exit recitative in which Don Ottavio "feels" the stirrings of revenge: "I hear [sento] in my breast the duty of a betrothed and a friend calling to me: I shall either undeceive her, or avenge her." The middle of the minor-key B-section rises to a forte on the words, "È mia quell' ira" ([Her] rage is mine). But the lines that include this movement toward revenge are sung only once, and the old-fashioned da capo form falls back into Ottavio's usual passivity. This is depletion, not repletion; its musical motto comes at the end, with a four-step chromatic ascent and descent, the former associated throughout the aria with death, the latter its collapse into exhaustion, and both here appearing in the emblematic form of broken octaves.

14 Musically, the aria ends with (1) repetition (fourfold identical vocal repeat of Giovanni's last words, "e già vedrai cos'è"), followed by (2) a musical epilogue that grows ever higher and lighter, mimicking the dispersal of the crowd, but with persistently pulsing first-violin syncopations, and concluding with (3) a loud (in this context, meaninglessly crashing) eighth-note cadence, with repeated flute Cs on top and empty alternations G-A-G-A-G-A in the lead instruments, first violin and oboe. Giovanni has evaded danger but, even before the recitative, he has returned only to the material, sensory world of beat and pulse, not to placid confidence. Repetition, syncopated beat, and alternation are devoid of sense, but not devoid of sensation. He is back to square one, not to a null point. In Mozart's manuscript the stage direction has Giovanni take Masetto with him, but it doesn't say where. The printed libretto specifies that they leave the stage and then immediately reappear to begin the recitative. In my experience, an empty stage here is never dramaturgically convincing, and if my analysis is persuasive, vacancy is not what Giovanni accomplishes, but a return to alertness. He and Masetto should be there, holding the audience's attention as the scene holds theirs. The Prague and Vienna librettos are photographically reprinted in *The Librettos of Mozart's Operas*, ed. Ernest Warburton, 7 vols. (New York: Garland, 1992), 3: 105–92.

15 Charles Rosen makes the identical point about a similar transition in Beethoven's Piano Sonata in C Minor, opus 111: "Since the trill begins in the Maestoso as thirty-second notes and continues unbroken into the Allegro as sixteenth notes, one would imagine that no intellectual effort would be required to conclude that the Allegro is exactly twice as fast as the Maestoso, that the trill should be played at a uniform speed throughout, and that the transition should not sound as if one had just shifted from first into fourth gear." *The Frontiers of Meaning: Three Informal Lectures on Music* (New York: Hill and Wang, 1994), 84.

16 Kunze, *Mozarts Opern*, 373: "The monumental beginning of the Overture . . . stands despite its forcefulness under the sign of an order shaken to its foundations. This is the threatening sense in the syncopated displacement of the two opening chords, directed against the order of the bar and of time." In my reading, by contrast, there is on account of the unparsed beat as yet

no order to be shaken, but rather a massive presence without order and so without a definable threat (or any other definition whatsoever). Nor, in the absence of trombones, is it yet specifically "the intrusion of the supernatural power," as Kunze says. I have translated Kunze's prose as mechanically as I could, but a lot of premises are finessed in his untranslatable phrase "gegen die Takt- und Zeitordnung." "Ordnung" in the previous sentence meant the order of existence or of nature shaken by the supernatural power; in this sentence "Zeitordnung" means primarily the ordering of musical time disrupted by syncopation, but it also implies a judgment about the order of "the time," that is, of temporal experience. The linguistic ruse imports ideology into analysis. I agree with the principle of importation, disagree about the analysis, and in this note have taken the trouble to articulate the moment of covert hermeneutics.

17 Dany Nobus, *Jacques Lacan and the Freudian Practice of Psychoanalysis* (London: Routledge, 2000), 86.

18 I have argued elsewhere that Mozart, a few years earlier, had joined Kant and Rousseau in portraying the constitutive originality of time. See "Mozart and After: The Revolution in Musical Consciousness," in my *Turning Points: Essays in the History of Cultural Expressions* (Stanford: Stanford University Press, 1997), 138–55.

19 Andrew Steptoe describes the final measures quite differently in *The Mozart-Da Ponte Operas: The Cultural and Musical Background to "Le nozze di Figaro," "Don Giovanni," and "Così fan tutte"* (Oxford: Clarendon Press, 1988), 204: "Mozart's conception transcends this natural conclusion [damnation] and aims at a higher humanity in equilibrium. . . . As the singers of the moralistic canon depart about their business, the trilled violin accompaniment of the 'presto' theme is miraculously transformed to suggest the bustle of everyday life and the return of normality . . . and the re-emergence of the humdrum world." Steptoe's paraphrase is noteworthy because his book is multifaceted, well-informed, and generally perceptive, yet often fails to integrate its commentary into an organic argument: he grabs for conclusions he does not earn. And so it is here. To claim a happy end requires equating normality with transcendence, a higher humanity with the humdrum world, "l'antichissima canzon" with "a confident belief in the beneficence of existence," the characters' upcoming pauses of relaxation and delay with "the bustle of everyday life," and the piano slithering chromatics abruptly followed by a forte orchestral outburst as an example of "the most sophisticated musical gestures." The incoherences of Steptoe's account are evidence against any triumphalist (or, in Steptoe's term, "Olympian") reading of the opera's outcome.

20 "Mozart and After"; "Mozart, Bach, and Musical Abjection," chapter 6 above.

21 Negation in *Così* is not merely far less prominent, but invariably supports confident (if often misguided) assertion, beginning with the opening lines: "My Dorabella is incapable. . . . My Fiordiligi does not know how to betray me." There is nothing at all comparable in *Figaro*, where desire rather than power is

the prevailing issue; hence the fantasmatic aura around Cherubino ("Non so più cosa son, cosa faccio," "Non più andrai, farfallone amoroso"), Figaro's teasing denials of the letter in Act 2, the double negatives of seduction in the Act 3 duet between the Count and Susanna ("Non mancherai?" "No, non mancherò, no, / Non vi mancherò"), and Figaro's reiterated "no" of comic discretion in Act 4 ("Il resto non dico"). Negation in Figaro is manipulative, not confrontational.

22 Allanbrook, *Rhythmic Gesture*, 203, offers a "conventional" rewrite, presented as inferior. It consists of two 2-bar phrases followed by two 1-bar phrases and then a 2-bar cadence. It speeds up and slows down. The actual music is (comically) weaker.

23 "Leporello relishes the master-slave relationship thrust upon him," Geoffrey Clive, "The Demonic in Mozart," *Music and Letters* 37 (1956): 3; "Both Don Giovanni and the Marquis de Sade . . . commit the same fallacy as the master in Hegel's dialectic of master and slave," Carlo Strenger, *Individuality, the Impossible Project* (Madison, Conn.: International Universities Press, 1998), 97; "Master and servant, almost master and slave: Don Giovanni and Leporello are their ghastly emblem," Matthew Gurewitsch, "Who's the Boss? In Mozart You Can't Always Tell," *New York Times*, Oct. 25, 1998, accessed Dec. 24, 2007, at http://query.nytimes.com/gst/fullpage.html?res=9E0DE2DB153DF936A15753 C1A96E958260.

24 Contrast the similar-sounding formula in Don Alfonso's brief aria in *Così*, "Vorrei dir, e cor non ho, / Balbettando il labbro va" (I would like to speak, and I have no heart, / My lip stammers). Guglielmo knows exactly what destiny awaits: his hesitation here concerns only speaking out; the palpitation affects only the lip.

25 Manfred Schmid discusses interpolations in *Italienischer Vers und musika-lische Syntax in Mozarts Opern*, Mozart Studien 4 (Tutzing: Hans Schneider, 1994), 137. He gives syntactic reasons why it was far more common generally to interpolate a "no" than a "sì." He does not investigate the particular tactics of interpolation in *Don Giovanni* or in other operas.

26 See Harald Weinrich, "Politeness and Sincerity," in *The Linguistics of Lying*, trans. Jane K. Brown and Marshall Brown (Seattle: University of Washington Press, 2004), 124–28.

27 *The Culture of Opera Buffa in Mozart's Vienna*, 109. On final choruses as self-congratulatory celebrations of community, see pages 28–30.

28 *Autonomy and Mercy*, 44. Nagel, however, does not recognize a utopian dimension such as I conclude with.

29 Gunthard Born argues briefly but cogently from reception evidence for the political resonance of "Viva la libertà" in *Mozarts Musiksprache: Schlüssel zu Leben und Werk* (Munich: Kindler, 1985), 44–46. Bernard Williams objects to political readings on psychological grounds: "Giovanni certainly lives off the land, but does so in an individual way that firmly refuses any such historical question. . . . Giovanni himself entertains no such aspiration, nor does he

reject it: he is not reflective in that style at all," "Don Giovanni As an Idea," in Julian Rushton, *W. A. Mozart: "Don Giovanni"* (Cambridge: Cambridge University Press, 1981), 87. Here it is clear that the disagreements come down to this: do we interpret the character, or do we interpret the work?

30 What follows is a digest of the chapter in the *Phenomenology* entitled "Die absolute Freiheit und der Schrecken" (Absolute Freedom and Terror).

31 Richard Taruskin, *The Oxford History of Western Music*, 6 vols. (Oxford: Oxford University Press, 2005), 2: 495. Taruskin's reading, which assigns weight to Giovanni's undeniable allure and none to the resistance to it, would have difficulty accounting for the succession of Lessing plays about strong women that Mozart must have known (*Miss Sara Sampson, Minna von Barnhelm, Emilia Galotti*), let alone Gluck's operas. (Taruskin details the influence of Gluck's *Alceste* on Mozart's *Idomeneo* on pages 466–70.) Music may be "a social mirror" (the title for the subsection on Act 1 of *Don Giovanni*, 487–92), but only if "mirror" can encompass its older, pedagogical sense (as in "a mirror for princes") alongside its modern, mimetic sense. There is no time and place whose politics can be summed up in a word, and surely not the moment of the French Revolution.

32 Jameson, *The Political Unconscious: Narrative as a Socially Symbolic Act* (Ithaca, N.Y.: Cornell University Press, 1981), 166–69, 253–57.

33 Here I follow Allanbrook, *Rhythmic Gesture*, 287: "His licentiousness may think itself anarchic, may cry for things *senza ordine*, but it dwells most securely as a parasite on conventions and forms."

34 At a certain stage Theodor Adorno read the opera as potentially, shadowily bourgeois. See his brilliant essay of 1952, "Homage to Zerlina," translated and elucidated in Berthold Hoeckner, "Homage to Adorno's 'Homage to Zerlina,'" in *The Don Giovanni Moment: Essays on the Legacy of an Opera*, ed. Lydia Goehr and Daniel Herwitz (New York: Columbia University Press, 2006), 211–23. Perhaps the closest link to my reading of an unrealized potential is Hoeckner's comment about the epilogue, "The plot is finished, but not the story whose untied threads point to an uncertain future" (217). Nikolaus Bacht places the Zerlina essay in the context of Adorno's numerous brief comments on the opera in "Adorno and the Don," *The Don Giovanni Moment*, 225–38.

35 In the course of a review essay convicting a number of leading books of arbitrary analytical and interpretive moves, James Webster calls the finale of *Don Giovanni* "harmonious on all levels, with at most an echo of past troubles overcome." Given that the six characters are screaming the words about the just punishment of deceased traitors, I suggest that "at most an echo" is too seraphic an understatement. See Webster, "Mozart's Operas and the Myth of Musical Unity," *Cambridge Opera Journal* 2 (1990): 208.

36 Theodor W. Adorno, *Einleitung in die Musiksoziologie* (Frankfurt: Suhrkamp, 1975), 88.

Index

Illustrations and musical examples are indicated by page numbers in italics.

Beat, 42, 61; in *Don Giovanni*, 252–98 passim, 355n1, 357n14

Beethoven, Ludwig van, 42, 50, 78, 297, 338n21, 355; Choral Fantasia, 40; in *Doctor Faustus*, 141, 143; *Eroica* Symphony, 69; ethical impulse, 247; and fantasy, 40, 44; *Fidelio*, 286–87; Fifth Symphony, 56–62, 68, 73, 306nn26–27; and German Romantic authors, 68, 73, 77, 310; and Haydn, 248–49; and Hegel, 6; "Kreutzer" Sonata, 352n14; Ninth Symphony, 89, 271; *Pastoral* Symphony, 38, 61, 355n4; Piano Sonata (op. 54), 69; Piano Sonata, op. 81a ("Les Adieux"), 47; Piano Sonata, op. 111, 357n15; and Rossini, 6, 144; songs, 225–26, 350n1; unity, 42; String Quartet, op. 59 (no. 2), *43–44*; op. 135, 47; in Wackenroder, 66; *Wellington's Victory*, 69

Belatedness, 143, 182

Belsey, Catherine, 347n32

Benjamin, Walter, 94, 96, 118; and distraction, 101

Benn, Gottfried, 80, 311n1

Berkeley, George, 270

Berlioz, Hector, 39

Berman, Russell A., 321n8

Bhabha, Homi K., 329–30n67

Blackmur, R. P., 95, 318n36

Blake, William, 350n50

Blanchot, Maurice, 96

Bloch, Ernst, 19, 56, 297, 305n23

Bloch, Marc, 104–5, 322n15

Blumenberg, Hans, 89, 312n9

Böckmann, Paul, 221, 345n24, 347n35, 350n52

Bonds, Mark Evan, 250, 35317, 354n24

Borges, Jorge Luis, on lyric, 94, 318n33

Born, Gunthard, 359n29

Boswell, James, 171, 177

Botstein, Leon, 232

Bourdieu, Pierre, 200, 217, 219

Bowie, Malcolm, 326–27n53

Braden, Gordon, 343n10

Brahms, Johannes, 42, 229, 248, 331n74, 338n21; and Schubert, 225; and Wagner, 6

Braque, Georges, 7–12, *8*, *9*

Bredvold, Louis, 179

Brentano, Clemens, 75, 77

Brome, Alexander, 203

Brown, Marshall, 173, 272, 302n22, 303n5, 303n15, 315n22, 330n70, 334n90, 358n18

Browning, Elizabeth Barrett, 199

Bruckner, Anton, 6

Bunyan, John, 198

Burke, Edmund, 170, 181, 187, 308n16

Burke, Kenneth, 107, 233, 317n32, 352n9

Burnham, Scott, 248–49, 306n27, 354n27

Byron, George Gordon, Lord, 47, 216

C

Cadalso, José, 214–15, 348n40

Cadenbach, Rainer, 61

Callot, Jacques, 39–40

Carlyle, Thomas, 125

Cecilia, Saint, 63, 65, 70, 75

Certeau, Michel de, 46

Cervantes, Miguel de, 126

Chambers, Ross, 117–19, 326n49, 335n91

Chang, Kang-I Sun, 99

Chaucer, 171, 319n42

Chaulieu, Guillaume Amfrye de, 213, 344n18, 350n52

Cherubini, Luigi, 147

Childishness: of Anacreontics, 223; and Freud, 234

Chomsky, Noam, 15

Chopin, Frédéric, 77, 305n22, 352n14

Chua, Daniel, 299, 353n17

Clifford, James, 107–8, 126

Closure: and *Don Giovanni*, 271, 292; in music, 42, 144, 247, 306n27

Code, David, 45, 303n14

Coleridge, Samuel Taylor, 42, 216

Collingwood, R. G., 322n12

Collins, William, 170

Community: in *Don Giovanni*, 281–82, 287, 290, 359n27; and Mozart, 162–63; and poetry, 98

Cone, Edward T., 238–39

Consciousness: in Hegel, 4–5, 106, 145, 267, 288–89; in Hume, 185; in Kierkegaard, 249; and literature, 102; and music, 110, 246, 257, 261, 263–64, 272–73, 355n5; in the novel, 164; in poetry, 93–94, 96, 212, 214–15, 315n25; in Sartre, 112; and sentiment, 263; and truth, 90; in Young, 189

Cotton, Charles, 204

Cowley, Abraham, 201–2, 215, 343n12

Cramer, J. B., 39

Croce, Benedetto, 329n66

Czerny, Carl, 39

D

Da Ponte, Lorenzo, 83, 251, 264, 271, 275, 280, 286, 288–89, 355n1, 356n11

Dahlhaus, Carl, 68, 304n16, 310n26; on Beethoven, 134, 144, 306n26; on Schlegel, 76

Daverio, John, 309n22, 336n3, 338n21; on Schumann, 42, 331n76

de Man, Paul, 100–103, 124, 312n10, 315n25, 322n9, 335n91; historicity of texts, 115, 123; "Literary History and Literary Modernity," 100–101, 320–21n5, 320nn8–9; "Tropes (Rilke)," 136–40, 333n84, 334n86, 334n89

De Sanctis, Francesco, 100

Debussy, Claude, 38, 225

Deconstruction, 34, 92, 163, 136–37, 312n10, 324n35, 347n32. *See also* de Man, Paul; Derrida, Jacques; Spivak, Gayatri Chakravorty

Deleuze, Gilles, 62, 122, 136, 334n90, 338n22

Derrida, Jacques, 34, 302n22, 322n13

Derzhavin, Gavriil Romanovich, 213, 215–16, 348n42

Desire: in Anacreontics, 205–6, 209–16, 233, 247, 344–45n21, 345n23, 347n32; in *Don Giovanni*, 265, 277–78, 358–59n21; in Hegel, 299n4; in music, 56, 74; in Romantic lyric, 219; in Schubert, 84, 89

Dialectical negation, 83, 101, 239

Dialectics, 4–6, 12; abstraction as, 15–16; in Dickinson, 34–35; in *Don Giovanni*, 251–52, 258, 263, 277, 288–90, 359n23; in the history of ideas, 224; in literary history, 101–2, 105, 114, 120–21; master-servant, 20–21, 25, 145–46, 160, 277, 359n23; in modernism, 83; in music, 42, 76, 89, 239, 304n22; in musical history, 144; in poetry, 95–97, 312n10; in Stella, 18. *See also* Hegel, Georg Wilhelm Friedrich

Dickens, Charles, 125, 128

Dickinson, Emily, ix–x, 21–26, 97–98, 301n18, 301n20, 317n29

Diderot, Denis, 17, 107, 20; *Rameau's Nephew*, 118–19, 299n3

Dorat, Claude-Joseph, 213, 348n38

Droste-Hülshoff, Annette von, 71

Droysen, Gustav, 129

Dryden, John, 172, 176–78, 199, 226, 346n28

Dürer, Albrecht, 64

Dvořák, Antonín, 47, 60

E

Easthope, Antony, 329n67

Eichendorff, Joseph von, 74, 90, 315nn21–25, 334n87; "Der Abend," 90–92; "From the Life of a Good-for-Nothing," 75; "Wünschelrute," 76–77, 136–38

Einstein, Albert, 141–43, 335n2

Elam, Diane, 116

Elias, Norbert, 308n15

Eliot, George, 69, 164; on *Night Thoughts*, 189

Empiricism: in the eighteenth century, 169, 183–86; in Easthope, 329n67; and music, 75; and New Musicology, 142

Enlightenment, 168–69; and lyric, 225, 232–33; and music, 40, 77, 240; and philosophy, 41, 89, 263; in Sartre, 112

Ense, Rahel Varnhagen von, 129

Erlebnislyrik, 90–91, 232

Estienne, Henri (Henricus Stephanus), 200

Ethos: baroque, 153; of Haydn, 240; of Mendelssohn, 135; in music, 133–36

Expression: artistic, 26, 102–3, 118–20, 139–40; baroque, 153; and history, 106–7; and music, 3, 6, 29, 36, 42, 62, 73, 75, 77, 142–44, 160–62, 169, 228, 238–39, 277, 306n31; in poetry, 22, 33–35, 89, 96, 206, 218, 223, 301n18, 317n31

F

Fancy, 44–45; in Mendelssohn, 50, 56

Fantasia, 249; in titles, 39–40

Fantasy, 121, 144–45, 249; in Beethoven, 56–61; derivation from Greek, 39; and imagination, 39–42; in Kant, 40–42; in Kramer, 304–5n22; in Mendelssohn, 48–56; and music, 39–62; in Novalis, 70; in Proust, 61–62; vagueness of, 44–46

Fauré, Gabriel, 26–35, 225, 302n24, 314n17; op. 21/1, "Rencontre," 29–32

Feminization, 145, 147

Fénelon, François, 198

Ferris, Ina, 328n63

Ferry, Anne, 313n14

Fielding, Henry, 170, 182; and *Don Quixote*, 126; and Handel, 198; novels of, 196–98

Fineman, Joel, 100

Flaubert, 27–28, 164, 301n18; and

Bourdieu, 200, 217, 349n47; and Jameson, 114; and Sartre, 112

Fleishman, Avrom, 328n63

Fleissner, Jennifer L., 325n37

Flemming, Paul, 229

Flutter, in *Don Giovanni*, 266, 270, 290

Flux: in Kristeva, 163–64; in literature, 117; in lyric, 221, 312n10

Form, organic, 47, 223; in *Don Giovanni*, 271, 273, 358n19; in Haydn, 247–48, 353n15

Formalism, 144, 305n23; and abstraction, 12; in Kant, 63, 111; and literary criticism, 143; and Mendelssohn, 56; musical, 130, 142

Foucault, Michel, 106, 146, 323–24nn27–28, 334n90, 336n6, 348n37

Frame: in literature, 328n63; in music, 56; in painting, 16, 44

Frank, Manfred, 310n34

Free play: of imagination, 41–42, 67

Freud, Sigmund, 143, 162, 217, 224, 247; "Beyond the Pleasure Principle," 213; on children's drives, 234; "A Child Is Being Beaten," 211; contrasted with Foucault, 146; "The Ego and the Id," 210–11, 347n31, 347–48n36; "On Transformations of Drives, Particularly in Anal Eroticism," 212

Friedrich, Hugo, 311–12n7

Fry, Paul, 91–92, 135–36, 326n49, 333n83

Frye, Northrop, 107, 327n62; on lyric, 94, 317n32

Fussell, Paul, 107

G

Garrick, David, 170

Geertz, Clifford, 107–10, 146, 323n22

Genius: cult of, 64–65; Handel as, 181; in Johnson, 177, 179–81; Mendelssohn as, 48, 331n76; Mozart as, ix, 7, 69, 77; music and, 66, 71

German Romantics, and music, 63–78

Gildenhuys, Faith, 345n23

Glass, Philip, 61

Gleim, Johann Wilhelm Ludwig, 206, 213, 343–44n13; "Zufriedenheit," 236–38

Gluck, Christoph Willibald, 15, 65, 73, 169, 226, 360n31

Goehr, Lydia, 306n31

Goethe, Johann Wolfgang, 4, 19, 33, 67, 68, 77, 227, 296, 298, 315n21, 316n27; *Egmont*, 66; *Die Farbenlehre*, 19; *Faust*, 74, 95, 263; "Glückliche Fahrt," 93; "Mailied," 74; "Meeresstille," 92–93; "Der neue Amadis," 222; and Romantic lyric, 213, 220–22, 344n20, 347n35, 350n53; *Wilhelm Meisters Lehrjahre*, 221

Goffman, Erving, 107

Goldsmith, Oliver, 170, 226

Goodheart, Eugene, 325n44

Goodman, Nelson, 108

Grandmougin, Charles, "La Rencontre," 26–28, 33–35, 302n21

Graveyard poets, 182, 186–95

Gray, Thomas, 170, 177, 182, 195, 204; "Elegy Written in a Country Church-yard," 186–88

Green, Matthew, 26, 206–13, 346–47; "Jove and Semele," 210, 346n26; "The Sparrow and Diamond," 206–13, 220

Greenberg, Clement: on abstraction, 12–13, 18; and "essence," 12; on Schoen-berg, 300n8; and "sheerness," 14

Greenblatt, Stephen, 106–8

Greimas, Algirdas, 291, 321n8

Grieg, Edvard, 60

Grillparzer, Franz, 71, 77; on *Der Freis-chütz*, 78

Guattari, Félix, 62, 122, 136, 334n90, 338n22

Guyer, Paul, 41, 303n6

H

Hagedorn, Friedrich von, 213–14

Hammond, James, 200

Handel, Georg Friedrich: *L'Allegro, il Penseroso ed il Moderato*, 186; compared to Hume, 186; compared to Johnson, 182; compared to Young, 188, 190–91, 194–95; and Gluck, 169; image of, 65, 340–41n19; literary culture, 166–70, 339; *Judas Mac-cabeus*, 194–95; *Messiah*, 174; and Mozart, 147; national celebrations, 25, 37; oratorios, 181, 194–95, 226, 339n1; and Pope, 174–76, 340n14; as reduced modern genius, 181–82; in relation to the novel, 195–98, 341n21; *Samson*, 191, 194; *Semele*, 226; and volume, 69, 308nn15–16, 309n18

Hanslick, Eduard, 12, 15, 39, 304n17

Hartman, Geoffrey, 321n5

Hawthorne, Nathaniel, 15

Haydn, Joseph: and Beethoven, 248–49; "Cupido," 227; as discursive, 297; "Eine sehr gewöhnliche Geschichte," 228, 232, 234; and embodiment in his songs, 239–40; fantasy, 39; fugues, 147; humor in, 42, 134; and German Romantic authors, 68, 73; *Laune*, 246, 249–50, 354n24; in *The Mill on the Floss*, 69; Piano Trio in C Major (no. 21), 241–48, 353–54n21, 354n25; and repetition, 240–41, 246; songs, 225–27, 351n2, 351n4; String Quartet (op. 33, no. 1), 121; and Thomson, 172; "Trost unglücklicher Liebe," 227–34, 241; "Zufriedenheit," 235–38, 241, 247

Hazard, Paul, 341n1

Hegel, Georg Wilhelm Friedrich, 33, 125, 296, 326n45; on abstraction, 12–13, 15; *Aesthetics*, 76, 129, 316n26; on alterity, 145–46; on flux, 163; on historiography, 100, 104–6, 322n12; on Kantian selfhood, 263; *Lectures on the Philosophy of History*, 104; *Logic*, 145; on music, 4–6, 65, 68, 76, 129, 310n31; *Phenomenology of Spirit*, 4–7, 12–13, 19–21, 22–23, 25–26, 36, 145–46, 251,

7; *Così fan tutte*, 49, 233, 296, 355n4, 358n19, 358–59n21; as court servant, 68; Dissonance Quartet, 272; in *Doctor Faustus*, 142; *Don Giovanni*, 83, 251–98 passim, 355–60; drive to independence, 308n15; and Einstein, 141; ethical impulse of, 247; and fantasy, 40, 42, 62; and German Romantic authors, 65, 68–69, 73, 76–77; and Hegel, 267, 277–78, 287–90; *Jupiter Symphony*, 163, 272, 337n20; K. 404a, 147–64, 337n17; *The Magic Flute*, 252, 272, 290; *The Marriage of Figaro*, 252, 254, 265, 274–75, 359–60n21; Mozart effect, ix–x; opera seria, 166; Prague Symphony, 267–68; songs, 225–26

Music: absolute music, 66, 129, 299, 308n11; and abstraction, 3–7, 26–37; and aesthetics, 42, 63–78, 130, 333n82, 353; and consciousness, 110, 246, 257, 261, 263–64, 272–73, 355n5; and dialectic, 42, 76, 89, 239, 304n22; and expression, 3, 6, 29, 36, 42, 62, 73, 75, 77, 142–44, 160–62, 169, 228, 238–39, 277, 306n31; and feeling, 73, 75, 77, 89, 161, 261, 263–65, 289; and imagination, 38–40, 45, 47–48, 51, 60; and power, ix, 35–36, 42, 63, 65–66, 68–69, 75, 142, 144, 165, 308n16, 309n18, 327n53, 357–58n16; and space, 165, 272–74; and time, 128–36

Musical logic, 42, 48, 246

Musorgsky, Modest Petrovich, 38

N

Nagel, Ivan, 285, 289, 297, 355n5, 359n28

Narcissism, 164–65, 210, 348; in Kristeva, 161, 338n26, 347n32

Nattiez, Jean-Jacques, 307n33

Nature: in Dickinson, 21–23; in *Don Giovanni*, 261, 263–64; and eighteenth-century forms, 241; and genius, 179; and history, 104; in

poetry, 190, 194; in Pope, 225; and Romanticism, 64, 74, 76, 90–94

Negation: abstraction as, 14; in Badiou, 312; calm as, 237; in de Man, 101; dialectical, 5, 239; and domination, 145; in *Don Giovanni*, 251–98, 355–60; in Friedrich, 311–12; and lyric, 79–98, 311–20; in Richard, 312n10

Negativity, 145, 312n10, 316n26; of abstraction, 14; of art, 36–37; in *Don Giovanni*, 264, 292; of lyric, 318n36; of music, 4

New Criticism, 101, 124, 321n9

New Historicism, 100, 107, 110, 321–22n9

New Musicology, 130, 142

Newmark, Kevin, 321n5

Nietzsche, Friedrich, 6, 65, 305n22, 307n33; as composer, 71; forgetting, 111, 124; on music, 76; "On the Use and Abuse of History," 101–2

Nightingale: and music, 42, 71, 355n4; and poetry, 79–80, 190

Novalis (Friedrich von Hardenberg), 70–71, 309n23, 311n3

Novel: and Anacreontics, 223; in the eighteenth century, 169–70, 182, 195–98; and literary history, 123–28, 328n63, 328–29n65; in Miller, 120; and poetry, 98; Sartre on, 113–14

O

O'Bell, Leslie, 348n42

Olivier, Alain Patrick, 310n31

Originality: in Bloom, 143; in Johnson, 180; of time, 358n18

Orpheus, 63

Orr, Linda, 321n6

Osborn, James, 340n14

Otherness: as alterity, 144–47; in Bloom, 143; in ethnography, 107; in Hegel, 288; in Miller, 119. *See also* Alterity

Owen, Stephen, 99

Todd, R. Larry, 330–31n72
Tolstoy, Leo, 125; *War and Peace*, 96, 164
Tomlinson, Gary, 240
Transcendental ego, 263, 272
Trauma, 212, 269–70
Trilling, Lionel, 107
Trollope, Anthony, 119–20
Turning points, 34, 111, 302n22

𝒰

Unity: in Adorno, 297; of art, 135; of
 effect, 239; formal, 12, 144; in Hegel, 6;
 in Hoffmann, 73; in Liszt, 47; in Schil-
 ler, 63–64; Schumann's critique of, 42;
 in symphonic poems, 47
Utopia, 308; and the Anacreontic ode,
 217; in Bloch, 56; in Jameson, 113, 297,
 335n91; in Mozart, 296–98, 359n28; in
 Sartre, 112–13, 117; in Schlegel, 70; and
 timelessness, 115
Utterance: in Diderot, 119; in *Doctor
 Faustus*, 143, 165; historical meaning
 of, 139–40; in music, 34; in poetry,
 79–80, 91, 94–96; of pure feeling,
 217–18
Uz, Johann Peter, 213–14, 342n9, 349n46

𝒱

Valdés, Mario, xi, 99
Valdés, Juan Meléndez, 217
Vendler, Helen, 93–94, 317n30
Verene, Donald, 299n6
Verlaine, Paul, 45–48, 99, 303–4n15
Vischer, Friedrich Theodor, 39
Vittorelli, Jacopo, 213
Voice: in Bakhtin, 319n42; in Cone, 238–
 39; in Dickinson, 25; of feeling, 64; in
 Gray, 187; in Greenblatt, 106; in Han-
 del, 37; in Kramer, 305n22, 314n18; in
 lyric, 77–98, 311–20; machined, 62; of
 music, 249; of spirit, 106
Voltaire, 89, 271

𝒲

Wackenroder, Wilhelm Heinrich, 64–67,
 70, 307–8n7; image of music, 74
Wagner, Richard, 72; absolute music,
 66; and Brahms, 6; and Heinse, 72;
 operas, 36
Walpole, Horace, 170, 346n28
Walpole, Robert, 169, 170, 179, 182, 187
Watteau, Antoine, 65
Watts, Isaac, 226
Weber, Carl Maria von, 77
Webster, James, 248, 337n14, 339n7,
 353n15, 360n35
Weinrich, Harald, 305n24
Wellbery, David, 100, 303n7, 309n22
Welsh, Andrew, 325n39
Wesling, Donald, 319n42
Wheelock, Gretchen A., 353n17
Whimsy: in Haydn, 225–50, 350–55. See
 also *Laune*
Whistler, James McNeill, 19
Whitehead, William, 204
Widdowson, Peter, 116–17
Widor, Charles-Marie, 39
Williams, Bernard, 359–60n29
Williams, Raymond, 116, 167
Wilmot, John, 172
Wit: in Anacreontics, 205–6, 213–14, 221,
 345–46n24; and fancy, 45; in Herbert,
 95; Johnson on, 180; and *Laune*,
 249–50; and lyric, 94, 225, 316n26;
 in music, 225; Pope on, 193–94, 225;
 and repressed passion, 205–6, 213–14;
 transmutation into emotion, 221; in
 the urbane sublime, 173–74; in Ver-
 laine, 46; in Young, 192–94
Witt, Friedrich, 72
Wolf, Hugo, 226
Wolosky, Shira, 301n20
Woods, Gregory, 99
Wordsworth, William, 80, 169, 182, 209,
 217, 222, 316n27, 317n27, 317n31; "Lines
 Written a Few Miles above Tintern

Abbey," 64; Lucy poems, 98, 220;
on poetic composition, 93–94; *The
Prelude*, 110
Wyatt, Thomas, 199

Y

Z